Jason Allen-Paisant, Vivienne Bozalek// Sarah Jane Cervenc Derrida//Annie Dillard//Dwayne Donald// English//Kate Fletcher//Laura Grace Ford//Susan Gibb//Édouard Glissant//Steve Graby//Antje von Graevenitz//Stefano Harney//Emily Hesse//Tehching Hsieh//Elise Misao Hunchuck// Kathleen Jamie//Tom Jeffreys//Steffani Jemison//Carl Lavery//JeeYeun Lee// Myriam Lefkowitz//Michael Marder//Chus Martínez// Siddique Motala//Fred Moten//Giordano Nanni// Camilla Nelson//Gabriella Nugent//Sonia Overall// Roger Owen//Julie Pellegrin//Isobel Parker Philip// Jane Rendell//Issa Samb//Caroline Filice Smith// Cherise Smith//Rebecca Solnit//Sop//Stephanie Springgay//Tentative Collective//Amanda Thomson// Sarah E. Truman

Walking

Whitechapel Gallery
London
The MIT Press
Cambridge, Massachusetts

Edited by Tom Jeffreys

WALKING

Documents of Contemporary Art

Co-published by Whitechapel Gallery
and the MIT Press

First published 2024
© 2024 Whitechapel Gallery Ventures Limited
All texts © the authors or the estates of the authors,
unless otherwise stated

All rights reserved. No part of this publication
may be reproduced, stored in a retrieval system
or transmitted in any form or by any means,
electronic, mechanical, photocopying or otherwise,
without the written permission of the publisher

ISBN 978-0-85488-316-5 (Whitechapel Gallery)
ISBN 978-0-85488-317-2 (Whitechapel Gallery
e-book)
ISBN 978-0-262-54758-1 (The MIT Press)
ISBN 978-0-262-37790-4 (The MIT Press retail
e-book)
ISBN 978-0-262-37791-1 (The MIT Press library
e-book)

A catalogue record for this book is available from
the British Library

Library of Congress Control Number: 2023949725

Whitechapel Gallery 10 9 8 7 6 5 4 3 2 1
The MIT Press 10 9 8 7 6 5 4 3 2 1

Commissioning Editor: Anthony Iles
Guest Editor: Tom Jeffreys
Design by SMITH
Gemma Gerhard, Justine Hucker,
Allon Kaye, Claudia Paladini
Printed and bound in Turkey

Cover: Jade Montserrat and Webb-Ellis, *Peat* (2015)
film still. Courtesy of the artists.

Whitechapel Gallery Ventures Limited
77–82 Whitechapel High Street
London E1 7QX
whitechapelgallery.org

Distributed to the book trade (UK and Europe only)
by Thames & Hudson
181a High Holborn
London, WC1V 7QX
+44 (0) 20 7845 5000
sales@thameshudson.co.uk

The MIT Press
Massachusetts Institute of Technology
Cambridge, MA 02142
mitpress.mit.edu

Documents of Contemporary Art

In recent decades, artists have progressively expanded the boundaries of art as they have sought to engage with an increasingly pluralistic environment. Teaching, curating and understanding of art and visual culture are likewise no longer grounded in traditional aesthetics but centred on significant ideas, topics and themes ranging from the everyday to the uncanny, the psychoanalytical to the political.

The Documents of Contemporary Art series emerges from this context. Each volume focuses on a specific subject or body of writing that has been of key influence in contemporary art internationally. Edited and introduced by a scholar, artist, critic or curator, each of these source books provides access to a plurality of voices and perspectives defining a significant theme or tendency.

For over a century the Whitechapel Gallery has offered a public platform for art and ideas. In the same spirit, each guest editor represents a distinct yet diverse approach – rather than one institutional position or school of thought – and has conceived each volume to address not only a professional audience but all interested readers.

Series Editor: Gilane Tawadros; Commissioning Editor: Anthony Iles; Editorial Advisory Board: Erika Balsom, Gabriela Bueno Gibbs, Sean Cubitt, Neil Cummings, Sven Spieker, Sofia Victorino

JAYWALKERS DISTURB THE PRODUCTION LINE, THE WORK OF THE LINE, THE ASSEMBLY LINE, THE FLOW LINE, BY DEMANDING INEQUALITY OF ACCESS FOR ALL.

Stefano Harney and Fred Moten, 'The Rebelator', extract from *All Incomplete*, 2021

INTRODUCTION//10

TO/TOWARDS//23
BACK AND FORTH//89
AROUND AND ABOUT//137
WITH//193

BIOGRAPHICAL NOTES//242
BIBLIOGRAPHY//244
INDEX//246
ACKNOWLEDGEMENTS//248

TO/TOWARDS
Sonia Overall précis, 2015//24
Dwayne Donald We Need a New Story: Walking and the wâhkôhtowin Imagination, 2021//25
Cherise Smith Moneta Sleet, Jr. as Active Participant: The Selma March and the Black Arts Movement, 2006//34
Tom Jeffreys *Bordered Miles*: In the Footsteps of Iman Tajik, 2021//43
Katherine Bailey Regina Galindo ¿Quien Puede Borrar Las Huellas? (Who Can Erase The Traces?), 2018//50
Antje von Graevenitz The Artist As a Pedestrian: The Work of Stanley Brouwn, 1977//53
Isobel Parker Philip Score For a Measured Walk, 2023//66
Kathleen Jamie A Lone Enraptured Male, 2008//72
Tanya Barson The Peripatetic School, 2011//80

BACK AND FORTH
Édouard Glissant The Black Beach, 1990//90
Rebecca Solnit The Treadmill, 2002//95
Stefano Harney and Fred Moten The Rebelator, 2021//100
Issa Samb The Walking Man, 2012//104
Elise Misao Hunchuck Trusting Movement 2023//107
Jacques Derrida And Say the Animal Responded? 2008//110
André Brasil The Tree of Forgetting, 2020//113
Carl Lavery Walking and Ruination, 2015//116
Roger Owen Go to google.com, 2011//120
Darby English Just above My Head, 2013//126
Camilla Nelson Epic, 2021//128
Amanda Thomson walkDrawings, 2022//133

AROUND AND ABOUT

Tehching Hsieh One Year Performance 1981–1982, 1981//138
Emily Hesse Looking and Walking, 2022//138
Caroline Filice Smith Briefly on Walking, 2012//140
Jane Rendell La Passante, 2010//144
Laura Grace Ford Spatial Disparities, 2005//148
Siddique Motala and Vivienne Bozalek Haunted Walks of District Six, 2021//152
Tentative Collective Political Walks: Karachi, 2017//160
Gabriella Nugent From Kinshasa to the Moon, 2021//167
JeeYeun Lee 100 Miles in Chicagoland, 2019//171
Annalee Davis This Ground Beneath My Feet: A Chorus of Bush in Rab Lands, 2016//179
Giordano Nanni Regularity Versus Irregularity, 2012//182
Sop The Den 2, 2020//187

WITH

Stephanie Springgay and Sarah E. Truman Queering the Trail, 2018//194
Sarah Jane Cervenak Jade Montserrat's *Peat*, 2019//200
Michael Marder Walking Among Plants, 2017//206
Myriam Lefkowitz In Conversation with Susan Gibb and Julie Pellegrin, 2019//210
Steve Graby Wandering Minds, 2011//215
Amanda Cachia Carmen Papalia's Prosthetic Extensions, 2015//225
Chus Martínez Ingo Niermann: The Reinvention of the Sock, 2018//227
Kate Fletcher Walking in Skirts, 2019//229
Steffani Jemison A Rock, A River, A Street, 2022//231
Jason Allen-Paisant On Blackness and Landscape, 2021//233
Annie Dillard Footprints, 2016//240

Introduction//Walking (Art) As Relational Paradox
Tom Jeffreys

You cannot walk away from politics. That is the starting point for this book: whenever and wherever somebody is walking, they are engaging with political questions, and the most privileged (those long championed in the art and literature of walking) are frequently the last to engage with what this really means.

In the literature of walking, there are often statements of the kind 'Walking is…'. Walking is free / healthy / slow / fundamental / powerful / transgressive etc.

The most precise of such statements are invariably contextualised. Be suspicious of those that are not. Which is to say that, in the most thoughtful writing, the role of the word 'is' is conditioned. It evades a universal conception of walking that could be essentialised. To define walking means to restrict what counts as walking and therefore who gets to be included in the art and literature of walking and who does not. Every definition participates in a process of exclusion and there has been far too much excluding already – especially where the three practices of art, walking and writing intersect. Ableism says: you cannot walk. Racism says: you cannot walk here. Patriarchy says: you must not walk like that. Capitalism says: no walking unless it generates profits for us. And to cap it all, the Western art world comes along to say: you may be walking, and you may have been walking for centuries, but it is not art because we say so and either we will appropriate the bits we currently find useful or we will ignore you completely. Each of these structures contributes to the exclusion of a specific configuration of intersecting 'you's. And if each of these exclusionary mechanisms is allowed to do its work, all that's left would be white men walking.

In this book, however, what walking is, does, means, and might one day be are not statements that have been fixed (how? by whom? with what authority?) but questions that remain open. This means that, when they do appear, statements of the kind 'Walking is…' are prefaced by some specific contextual information relating to who is doing the walking ('a Palestinian rambling group'; 'the Black body') or the situation in which the walking is taking place ('against Israeli state oppression'; 'on the treadmill').

As these conditioning phrases suggest, walking – as one mode of movement among others – involves bodies, place, and time. In chapter one, Dwayne Donald writes that '[w]alking is an intrinsically relational activity'. This is one of the few unconditioned statements of the kind 'Walking is…' included in this book and that is because it has to do with the very conditions of walking as a shifting

mode of relationality between bodies, place and time. In a sense, what Donald is saying is a paradox. Intrinsic properties are those that are innate, inherent, inseparable from the thing itself, which therefore remains whole and self-identical. But to be relational is to refer, reach out beyond the self, signify to and connect with an unmappable terrain of different actors. Therefore, to say that relationality is intrinsic is to say that the very notion of self is dependent on a world of others.

Could we make the case that this paradox lies at the heart of walking as an aesthetic practice? Artists operating with reference to traditions of dance and choreography tend to emphasise the moving body over the world in which it moves. Artists more interested in histories of place often focus on the details of an environment over the walking that bodies might (or might not) do there. Some artists feel walking as movement, as flow. Others are more interested in the traces that walking might leave behind. The artists doing the most thoughtful and important work are those that navigate between these two approaches. Or, to put it more accurately: these artists do not navigate between the two, as if they were separate poles awaiting acts of connection; rather, they embrace the always already entwined relationships between body and place, or between inside and outside, or between flow and trace, or between self and other. In short, we are not walled off from the world. All boundaries are porous. The world moves through us, every time we breathe, every time we walk.

Building on the efforts of many who have come before, this anthology foregrounds work that includes but is not limited to: walking with Black artists; Indigenous artists and artists of colour; working-class artists; LGBTQI+ artists; disabled artists; neurodiverse artists and many more who are frequently denied the right to take their places in public space – not only in the street (or the countryside) but also in art discourse.

This book is more than an exercise in widening representation, however important such work remains. Given the premise that all walking is political, priority has been given to art and writing that acknowledges these stakes. This acknowledging can manifest in multiple ways. For example, walking has long served important functions in activist traditions of direct action. In this book, the power of protest is generally emphasised over the non-committal critique of the flâneur, as famously theorised by Walter Benjamin. Anke Gleber, an important thinker on walking and modernism, cites the narrator of E.T.A. Hoffman's classic 1822 text of urban observation, *Des Vetters Eckfenster* ('My Cousin's Corner Window'), describing him as a 'narrating observer' who 'does not participate' in the situations described in the text.[1] Deborah L. Parsons has demonstrated how, as the nineteenth-century world observed by Hoffman collapsed, Benjamin's flâneur, always an ambivalent figure, retreated from

meaningful political critique to a 'detached and overlooking position above the city streets'.[2] This view from above is the view of authority: not only of the lone male wandering above the sea of fog with his back to Caspar David Friedrich, but also of the police, the drone and the algorithm. It is a view that features only rarely in this book. When it does occur, it is to critique its inevitably asymmetric power relations, or to think through what experiences continue to resist capture, especially in relation to technologies of communication and observation. Amanda Thomson's *walkDrawings*, made using GPS, are arguably one example. Another is Roger Owen's discussion of cattle paths visible via Google Earth. Both of these texts are included in chapter two. This book's cover, a drone shot of Jade Montserrat from the artist's 2015 film *Peat* (discussed in chapter four by Sarah Jane Cervenak) explicitly links the technological gaze to racist systems of surveillance and the hunt.

In contrast to the view from above are the views from within and alongside. In 1965, Civil Rights campaigners organised a series of protest marches from Selma, Alabama to Montgomery, the state capital. Their first march was halted after a violent attack by state troopers and racist paramilitary 'possemen' wielding batons and tear gas; the second march was called off following a federal court injunction. These two aborted marches demonstrate the stakes involved for racialised people simply to walk from one place to another, amid the ever-present threat of violence and legal suppression, and the two operating insidiously together to uphold white supremacy.

The third march went ahead and succeeded, not only in reaching its geographic destination but also in contributing to the passage of the Voting Rights Act later that same year. Photojournalist Moneta Sleet Jr. was there for the third march and his images helped to shape public perceptions of the event, its political significance and nonviolent nature. In chapter one, Cherise Smith's essay on Sleet emphasises the photographer's 'aesthetic, subjective, and activist vision'. Smith shows how Sleet embraced the ideas of the Black Arts Movement, that art should have a transformative function. While the flâneur traditionally self-identifies as an outsider (and even to choose to do so is itself often a privilege), Sleet Jr. made work for and from within a Black community. Like the marches themselves, his work contributes to wider directional movements of communal connection and emancipation.

In many contexts, walking continues to function as a way to assert presence in public space and public discourses. Recent examples include: a two-week freedom march by Muslim Uyghurs against China's ongoing genocide;[3] annual marches, smoking ceremonies and gatherings by Indigenous communities and anti-colonial allies against Australia's 'Invasion Day';[4] regular silent walks held by those still fighting for justice following the 2017 Grenfell Tower fire;[5]

marches, rallies and protests by millions across the world in solidarity with Ukraine;[6] and numerous walks and marches in response to the treatment of refugees by European governments.[7] In 2020, for example, Pankaj Tiwari and Abhishek Thapar undertook *The Art of Walking*, a 312-km durational performance walk from Amsterdam to the refugee camps in Calais, France.

A protest walk does not need to be long to resonate. For *Who Can Erase The Traces?* (2003), Regina José Galindo walked approximately 850 metres from the National Palace of Culture to the Constitutional Court in Guatemala City, leaving bloody footprints across the pavements in protest at the presidential candidacy of murderous former dictator Efraín Ríos Montt. Surprisingly, as Katherine Bailey discusses in chapter one of this book, Galindo's performance continued uninterrupted despite the presence of lines of police officers.

But the suppression of walking has taken many forms in different contexts. Analysing the violence that accompanied the colonisation of Australia and South Africa, historian Giordano Nanni charts the origins of the word 'walkabout', used by colonists to describe the movements of Aboriginal peoples. Unable or unwilling to understand nomadic ways of being that did not correspond to their own Christian-capitalist-settler world views, colonists were brutal in their repression of Indigenous peoples. And yet, as Nanni contends in chapter three, Aboriginal people continued to walk in order to attend community meetings, in accordance with the rhythms of hunter-gatherer existence, and as a way to resist the imposed spatio-temporal logics of colonial capitalism.

In a quite different context, Steve Graby, in chapter four, also explores both the emancipatory possibilities of walking, in this case by people deemed neurodivergent, and its repression by those who cannot understand alternative modes of relation. Graby argues against an official proposal to medicalise 'wandering behaviour' as a form of disease in people diagnosed with autism or other cognitive impairments. The proposal, backed by some medical professionals and 'cure'-oriented organisations, would pathologise walking while autistic, denying agency to those diagnosed with autism and transferring greater decision-making power to the medical industry. In resisting the proposal, and others like it, Graby draws upon the work of neurotypical walkers such as Guy Debord and Rebecca Solnit in order to situate autistic experience in relation to histories of walking theorised in art and literature.

This appeal to walking precedents demonstrates one of the ways that, instead of chronologies, this book walks in loops. When prominent figures in the history of walking do appear, it is when they have been adopted and reinterpreted in different contexts. The Situationist International (SI), for example, are not only cited by Graby; their work is also an influence upon the spectacular public performances of Kongo Astronauts in Kinshasa. As Gabriella Nugent argues in chapter three:

'Scholarship on the SI often overlooks the participation of activists beyond Europe.' Nugent's text conveys not only the political resonance of Kongo Astronauts' costumed public performances but also their playful sense of the absurd.

As Kongo Astronauts demonstrate in glorious style, walking can be a way to assert visibility, the right to be present and to take up space. Walking can also be a joyous coming together of groups and communities, an excuse to dress up, have fun, visit new places, explore familiar ones, and take pleasure in bodily movement. In other contexts, however, remaining invisible can be a privilege often denied to marginalised groups. This point has also been elaborated in response to the figure of the flâneur. As Kirsten Bartholomew Ortega points out:

> Benjamin's flâneur assumes complete invisibility and unlimited access in the city, a perspective that is undermined by racial, gender, and class differences in the post-WWII American city. It is unlikely that an upper-class, white dilettante is going to blend into the crowd of the South Side or provide an objective perspective of that community.[8]

Ortega's contention is that who you are conditions not only what you see, but where you can go and how you are seen. As a political practice, walking inevitably touches upon questions of access, public space, land ownership and use. Garnette Cadogan has also drawn upon the power dynamics involved in seeing and being seen to compare walking as a Black man in different urban contexts. Cadogan has a deep love of walking: for him, walking has served as a source of merriment, self-realisation and adventure. At first, Cadogan walked to escape patriarchal violence in the domestic sphere only to find differently mediated violences in the public sphere. He describes the specific strategies he has adopted to survive in these contexts: from faking madness while walking at night in Kingston, Jamaica, to dressing Ivy League style to signify student status to the police of New Orleans. 'I could be invisible in Jamaica in a way I can't be invisible in the United States', Cadogan writes. In the US, by contrast, he is regarded as 'alternately invisible and too prominent'.[9]

Drawing upon Ortega's work, Kaitlyn Greenidge has similarly written, 'The flâneur, the white male version at least, is not self-aware enough to realize that in his observations of the city, he may also be being observed back.'[10] In London, The Dazzle Club (artists Georgina Rowlands, Emily Roderick, Evie Price and Anna Hart) lead monthly silent walks with participants wearing CV Dazzle to draw attention to and resist the prevalence of facial recognition technology employed in one of the most heavily surveilled cities in the world.[11]

Such surveillance is supposed to keep people safe. To which, one must always ask: which people? Safe from whom? When Sarah Everard was kidnapped

and murdered by a police officer in London in 2021, the phrase 'she was just walking home' came to encapsulate the gendered violence of public space in the UK. Everard's murder and the Metropolitan police's aggressive response to a subsequent vigil informed widespread public opposition to the English government's Police, Crime, Sentencing and Courts Bill, which has criminalised protest and facilitated increased oppression of Traveller communities.

Patriarchy has long sought to confine women to the domestic sphere and exclude their participation in public life, which means that where women walk, how, when and with whom is often controlled and contested. In chapter three, Caroline Filice Smith describes the 'fear of being grabbed, followed, whistled at, hollered at, or attacked'. In the early literature of flâneurie, conditioned by a capitalist world view of exchange, the lone woman walking was often assumed to be involved in sex work. Also in chapter three, Jane Rendell discusses this gendering of public spaces via artist-publisher Sharon Kivland's critique of 'the conflation of the female shopper with the commodities she is purchasing'. Women artists and writers have long sought to expand the definition of the flâneur or, recognising the term's historical limitations, abandon it altogether in favour of making spaces for modes of women walking that owe nothing to that tradition.

In 2008, the UK Network of Sex Work Projects published a 60-page document containing safety advice for sex workers.[12] Under the heading 'Posture and Attitude' are several detailed suggestions:

> Be aware. Walk tall, act confident and be assertive.[…] Keep your head up and shoulders back, and take purposeful steps. Pay attention to what's happening around you. Adopt a confident look even if you feel nervous. Keep at least one arm free, and always be ready, mentally and physically, to protect yourself.

These guidelines indicate the state of heightened alertness that marginalised people such as sex workers are advised to maintain simply to stay safe from violence while walking – and working – in public. In this violent context, such work requires vigilance not only towards other people, trying to gauge their characters and likely behaviour, but also towards one's own bodily movements and how these form a language to be read or misread. What all this shows is that visibility, invisibility and hypervisibility are contextually dependent: they are also modulated through particular correlations of bodies, time and place.

As an action that occurs in time, walking may seem ephemeral. This means that our engagement with walking as aesthetic practice is often mediated through forms of documentation. This disconnect should prompt several questions. For example: who is the work's intended audience – those who join the artist on the walk, or those who encounter it in the gallery or publication?

What changes if the walk is virtual or fictional? How can we differentiate a walk that matters from art that matters? And do we even need to? For some artists, walking leads to writing, drawing, mapping, photography, sculpture, installation, film, digital and new media art and many other material outcomes. For a number of artists, the walk is the work.

In some art practices, walking occurs as a way to encounter, or re-encounter place. This might be an ethical response to concerns over mass tourism and carbon footprints. In which case, such walking might stay close to home and involve slowing down, paying attention, uncovering hidden stories, the granular realities of lived experience as a way of rubbing against the schematic abstractions of planning, management, map-making and theory. Rebecca Solnit has made the point that the specific invariably complicates the general.[13] Details, when you really pay attention, resist the drive towards abstraction. Materiality rubs theory the wrong way.

When walking does leave traces, these are not always easy to interpret. 3.75 million years ago, Annie Dillard tells us in chapter one, our ancestors left indentations in 'moist volcanic tuff' in Tanzania. In chapter two, Carl Lavery describes footprints as a kind of 'wreckage'. In more gnomic fashion, Jacques Derrida draws upon psychoanalysis to trouble old theoretical distinctions between human and animal that rest on the leaving of tracks and traces, their erasure or non-erasure, and the very question of subjectivity. Derrida writes:

> Traces erase (themselves), like everything else, but the structure of the trace is such that it cannot be in anyone's power to erase it and especially not to 'judge' its erasure, even less so by means of a constitutive power assured of being able to erase, performatively, what erases itself.

To think of the bloody footprints left across Guatemala City's pavements by Regina José Galindo while reading these lines from Derrida imbues the philosopher's occasionally opaque theorising with intense political immediacy. Judiciaries and constitutions, power and erasure – these are not abstractions but pressing political realities.

In each of the above examples, to leave a footprint is to activate a kind of iterative machinery, a technology of archiving. And as soon as there is reproduction, the pure singularity of the present event ruptures.

More questions then arise: what does this mean for the supposed primacy of the performance? And then: rather than simply secondary, or somehow parasitical upon the purity of the performed moment, might documentation, in the form of the trace, in fact be inherent to the very structure of movement itself?

Not all walks leave a trace, however, and not all traces can be collected, commodified or disseminated. While many prominent walking artists do have

productive relationships with commercial galleries, the more experimental, playful, and determinedly lo-fi approaches often operate in different ecosystems: affiliated with higher education institutions, funded through short-term research grants, and publishing zines or slim books through independent presses.

Some artists take up walking in response to economic realities. 'We wanted to do something that didn't need any permissions, didn't need any money', recalls Clare Qualmann on the early days of walk walk walk, a collective she co-founded with artists Gail Burton and Serena Korda.[14] Artist choreographer Mark Bleakley, however, has spoken of 'the economy of presence', a certain conception of value that creates an expectation for the artist to be there, always visible before the audience.[15]

Walking may often have low economic barriers to access, but Bleakley's observation highlights the limitations placed on certain performance practices. A painting can be shown anywhere in the world while the artist stays in the studio making more. But the dance or walking artist is often expected to be with (or part of) the work all the time. Artists such as Myriam Lefkowitz (in chapter four) and Alex Cecchetti navigate this complexity by training small teams to play the role of walking guides. But in both cases those who have been led by the artist rather than by a trained guide are somehow thought to have experienced the 'original' performance, even when we all know such a thing does not exist. Walking therefore has an ambivalent relationship with traditional art structures (museums and archives, biennials, the academy, the commercial sector). To what extent can walking be institutionalised or does it always overflow the limits of the institution?

Eschewing art-historical categorisation, this book adopts a loosely thematic structure. Each of the four sections takes advantage of the language of walking, which naturally slides from the literal to the metaphorical, and back again. Underlining an overall emphasis on the relational and the political, each is organised according to a direction of travel or a mode of walking. Within this structure, some texts form their own smaller groups: in chapter two, for example, texts by Elise Misao Hunchuk, Jacques Derrida, André Brasil and Carl Lavery share thoughts on archiving, forgetting and the materiality of memory. In chapter four, texts by Myriam Lefkowitz, Steffani Jemison, Carmen Papalia and Michael Marder are subtly linked by an attunement to touch.

The first section, TO/TOWARDS, focuses on linear or forward-looking walks, often with a specific destination or outcome, especially parades, protests and pilgrimages. As 1960s trail-blazer Stanley Brouwn says: 'It is not the past but the future which has the greatest influence on our ideas and actions.' Antje von Graevenitz's in-depth 1977 article on Brouwn's work is a key text in this anthology. In several cases, the destination is quite literal. Such walks include Sara

Morawetz's *étalon* (2018), which saw the artist walk 2,100 km from Dunkerque, France, to Barcelona, Spain, over 112 days in a critical revisiting of a scientific expedition carried out in 1792; or Iman Tajik's *Bordered Miles* (2021), a 26-mile day walk from the centre of Glasgow to Dungavel House Immigration Removal Centre. In other examples, the destination is not only a geographical location but also a desired future that the walk seeks to imagine or bring into being.

Where chapter one emphasises futurity, many of the texts in chapter two, BACK AND FORTH, look to the past, taking historic events or ideas as points of departure. The section opens with Édouard Glissant's story of a ghostly figure walking up and down the beach in opposition to the acceleration drive of modernity. Half way, the tale pivots into a parable, taking the man's walking as a metaphor for the economic and political prospects of Martinique. Rebecca Solnit's history of the treadmill – a less referenced section of her path-breaking book *Wanderlust* (2001) – also focuses on a repetitive mode of walking in a restricted area in order to trace connections between technologies of carceral punishment and the body as a terrain of self-improvement in the increasingly privatised spaces of modern capitalism. This section also emphasises repetition (which is always potentially ritualistic) and rhythm.

AROUND AND ABOUT offers a collection of exploratory or investigative walks without predetermined outcomes or endpoints. Several contributors walk in order to chart racist and colonial histories and their ongoing material legacies in contemporary built environments. In Chicago, JeeYeun Lee traces trails created by Indigenous peoples long before settlers arrived; in Karachi, Tentative Collective roam scrapyards, compiling lists of detritus; in Barbados, Annalee Davis walks to uncover the multiple pasts of the plantation on which she lives; and in Cape Town, Siddique Motala and Vivienne Bozalek employ 'counter-surveying' to understand the hauntings of District Six, a well-known site of apartheid forced removals. While some artists are concerned primarily with place, Emily Hesse walks in small circles inside a stable in order to engage in a fundamental rethinking of anthropocentric time. Materials become processes, nouns become verbs. Hesse's death in 2022 was a huge loss.

The final section, WITH, offers examples of walking as communal and collaborative. This section emphasises the importance of walking as co-production, as a route away from the alienated individual of the Modernist tradition and as a possible way forward at a time of ecological crisis. Several of the texts are attuned to the problematics of collaboration. Both Steffani Jemison and Myriam Lefkowitz emphasise bodily proximity through approaches to choreography. In Jemison's debut novella, primarily about the narrator's obsession with running, an unnamed philosopher recalls their early career as a dancer and, in particular, a collaborative artwork with a musician in which the

pair tie themselves together back-to-back and proceed to do everything together as an extended 'experiment in the plural body'. Stephanie Springgay and Sarah E. Truman quote Astrida Neimanis, who warns against sentimental idealisations of working together. 'Collaboration,' she writes, 'is sweaty work replete with tense negotiations.' Collaboration here is not limited to the human.

Preparing this book has coincided with the release in 2022 of two invaluable publications: *Going Out: Walking, Listening, Soundmaking* and *Walking from Scores*, both edited by Elena Biserna. The comprehensive brilliance of these books informed the shape of this anthology. There is limited attention paid here to listening or audio-led walks: readers interested in this are advised to read Biserna. Scores do feature, but less than they might have done: the poetry of Sonia Overall and the intentional statement made by Tehching Hsieh could both be read as scores of a sort. Hsieh's work is both the promise ('I shall stay OUTDOORS for one year never go inside') and its gruelling fulfilment. Stanley Brouwn's use of scores in the 1960s is worth reading in conjunction with Isobel Parker Philip's sensitive unpicking of the many meanings of the word itself, 'score'. But those interested in knowing more about walking scores should read Biserna.

One aim of this book is to map some of the terrain of walking in art today. With half a dozen exceptions, every text was first written after 2010. 'The experience and variety of walking practices have never been so broad, relevant or unpredictable,' write Helen Billinghurst, Claire Hind and Phil Smith.[16] This book does not claim to cover the earth, but there is a geographical spread of artists and writers, with contributions originating in or focusing upon walking-related questions beyond Europe and the US to include Australia, Barbados, Brazil, the Democratic Republic of Congo, Guatemala, Jamaica, Martinique, Pakistan, Senegal, South Africa, Syria and Ukraine. Nonetheless, like any map, the view is situated and partial, shaped as much by where we stand as by how we see. There are, inevitably, gaps.

To return to Dwayne Donald: could one say that, like walking, an anthology such as this one is also 'intrinsically relational'? A body made up of other bodies, produced entirely through multiple connections to external texts and art practices. If the slow process of editing is a kind of walking with or among, then maybe an anthology is a kind of footprint – a temporary material outcome of bodies moving together and apart. If this is a footprint of a sort, then who knows how long it might last, before it is walked over or washed away? As this introduction concludes, one walk is done. Many more now begin.

1 Anke Gleber, *The Art of Taking a Walk* (New York: Princeton University Press, 1999) 13.
2 Deborah L. Parsons, *Streetwalking the Metropolis* (New York and Oxford: Oxford University Press, 2000) 25.

3 Riya Baibhawi, 'Canada: Two-week-long "walking Protest" Organised Against China's Treatment Of Uighurs', *Republic World* (5 July 2021). Available at https://www.republicworld.com/world-news/rest-of-the-world-news/canada-two-week-long-walking-protest-organised-against-chinas-treatment-of-uighurs.html

4 Mostafa Rachwani, 'Invasion Day 2023: a guide to protest marches and events across Australia on 26 January', *The Guardian* (25 January 2023). Available at https://www.theguardian.com/australia-news/2023/jan/25/invasion-survival-day-guide-protest-events-marches-26-january-melbourne-sydney-brisbane-australia

5 See https://grenfellunited.org.uk

6 Alan Taylor, 'A Weekend of Global Protest Against the Invasion of Ukraine', *The Atlantic* (28 February 2022). Available at https://www.theatlantic.com/photo/2022/02/photos-weekend-global-protest-against-invasion-ukraine/622951/

7 See, for example, 'Hundreds of Migrants March in Serbia to Protest Closed EU Border', ABC News (4 October 2016). Available at https://abcnews.go.com/International/hundreds-migrants-march-serbia-protest-closed-eu-border/story?id=42555016; Amelia Gentleman, '"People felt threatened even by a puppet refugee": Little Amal's epic walk through love and fear', *The Guardian* (18 October 2021). Available at https://www.theguardian.com/stage/2021/oct/18/threatened-puppet-refugee-little-amals-epic-walk; and 'Thousands march against controversial immigration bill in France', France 24 (29 April 2023). Available at https://www.france24.com/en/europe/20230429-thousands-march-against-controversial-immigration-bill-in-paris.

8 Kirsten Bartholomew Ortega, 'The Black Flâneuse: Gwendolyn Brooks's *In the Mecca*', *Journal of Modern Literature* (Summer, 2007), vol. 4, no. 30, 139–55.

9 Garnette Cadogan, 'Walking While Black', *Freeman's: Arrival* (New York: Grove Atlantic, 2015) available at https://lithub.com/walking-while-black/

10 Kaitlyn Greenidge, 'Sex in the City: The Black Female Flaneur in Raven Leilani's *Luster*', *Virginia Quarterly Review*, University of Virginia, vol. 96, no. 2 (Summer, 2020) 210–214.

11 See The Dazzle Club, 'Dazzlegram' in Amy Gowen (ed.), *Rights of Way, the Body as Witness in Public Space* (Eindhoven: Onomatopee, 2021) 35–45.

12 UK NSWP, Keeping Safe: Safety Advice for Sex Workers in the UK (2008). Available at https://www.nswp.org/sites/default/files/Keeping%20Safe%20-%20Safety%20advice%20for%20sex%20workers%20in%20the%20UK.pdf

13 Rebeca Solnit, *Orwell's Roses* (London: Granta, 2022) 29.

14 Dee Heddon and Cathy Turner, 'Walking Women: Interviews with Artists on the Move', *Performance Research*, vol. 15, no. 4, 14–22.

15 Mark Bleakley, FELT symposium on dance in museums and galleries, Hunterian Art Gallery, Glasgow (26 June 2019).

16 Helen Billinghurst, Claire Hind and Phil Smith (eds.) *Walking Bodies* (Axminster: Triarchy Press, 2020).

The word wâhkôhtowin is ... a "bent-walking-over-the-land-reciprocity-movement-concept"

Dwayne Donald, 'We Need a New Story: Walking and the wâhkôhtowin Imagination', 2021

Walk very consciously in a certain direction for a few moments; simultaneously a certain number of microbes in the circle are moving in a certain number of directions.

Stanley Brouwn in Antje von Graevenitz, 'The Artist As a Pedestrian: The Work of Stanley Brouwn', 1977

TO/TOWARDS

Sonia Overall
précis//2015

It is simple and soon you will be running. But now
you must make those tentative trails, the one two one
and expect to trip.
This is just a beginning. First you must fall.

Once you have balance you may begin again. You are coltish, a stripling. You are a swaying sapling feeling to the tips of fine-fibred roots and pulling them free. The ground is uneven. The plane is littered with obstacles. You will learn to negotiate these.

Left. Right.

Left. Right. Find the rhythm. Grow taller. Take on speed.

Walk. Do this without thought, without effort. Walk as if your feet were lungs serving their unconscious purpose.

Walk holding hands. Walk on low brick walls and high grassy banks. Walk along the wet perilous perimeters of swimming pools. Walk on the gnarled foundations of Roman villas. Stub your toes on ancient hooks of flint.

Walk carrying lunchboxes in the shapes of animals. Walk carrying satchels containing Latin text books, plimsolls and unfinished homework in exercise books ruled with faint blue ink.

Walk carrying all of your worldly possessions in a bundle on a stick, a dog nipping at your heels, your clothes in rags, laughing.

Walk in parks. Walk on beaches. Walk beside busy roads and attempt to negotiate traffic. Walk in supermarket aisles steering trolleys, avoiding contact.

Walk for pleasure, slowly. Walk to clear your head. Walk to fill it. Walk in sunshine with head high, seeking birdsong in trees,

blinking in the light. Walk in rain under percussive umbrellas. Walk into high winds, gasping, shedding garments. Walk in sackcloth under raining blows, head bared, guilt-ridden.

Your soles thicken. Your legs fold like poorly-hinged gates. Your ankles soften with fluid. Your knees buckle. Take a seat. Allow your feet to rest on cushioned stools. Attach wheels to furniture, to stationary objects, to high-sided chairs. This is an ending: allow others to walk. Just watch.

Sonia Overall, 'précis', from *The Art of Walking* (Bristol: Shearsman Books, 2015) 7-8.

Dwayne Donald
We Need a New Story: Walking and the wâhkôhtowin Imagination//2021

[...] The ancient *nêhiyaw* (Cree) wisdom concept of *wâhkôhtowin* refers to enmeshment within kinship relations that connect all forms of life. When human beings undertake walking as a life practice, the *wâhkôhtowin* imagination can be activated, wherein the networks of human and more than human relations that enmesh us become vivified and apparent. From this confluence of walking and the *wâhkôhtowin* imagination emerges the possibility of a new story that can give good guidance on how to live life in accordance with kinship relationality.

I went on a walk in search of kinship relationality the day before the summer solstice of 2008. It was a personal pilgrimage, really – one that I had been imagining for several years. This walk felt like a pilgrimage to me because the walking was the enactment of multiple wisdom teachings shared with me over many years. These teachings came mostly in the form of stories that tell of places as living relatives, who offer wisdom on how to live a good life. I had learned how to approach such sacred places with reverence and to honour the presences that reside there. I participated in ceremonial practices that fed the presences at these sites and noticed how people were, in return, given sustenance back. Through such practices, I came to understand how *real people*[1] understand their own identities as intimately interconnected with these sacred places. The stories of such places slowly became a part of my own story.

I recounted some of these stories that day, while walking alone towards my destination, the Viking Ribstones. These buffalo stones were part of an extensive

network of sacred sites on the prairie landscape dedicated to the spirit of the buffalo and in honour of all that they provide for the people. I was told that the Ribstones site was originally comprised of a bull, a cow and a calf laying side by side on top of a prominent hill. Those buffalo became stones and the people began the practice of visiting the site to leave offerings and honour the spirit of the buffalo present at that place. Then, newcomers arrived, and the buffalo were removed from the landscape through systematic eradication. As a new way of living was imposed, the newcomers did not allow the people to visit this, and other, sacred sites anymore. Instead, the buffalo stones were neglected, vandalised and even removed by those who did not consider them sacred. The Viking Ribstones is one of the very few sites remaining on the prairies today that still has some buffalo stones in their original location.

This particular walk, then, was an intentional act of relational renewal. I walked to honour the spirit of the buffalo. I walked to step in the footprints of my ancestors and approach the site as they once did. However, attempting to renew these relations when so much has changed proved to be difficult. Instead of natural prairie, I walked on a gravel road. Instead of free-ranging herds of buffalo, I saw cattle behind barbed wire fences. Instead of the rich diversity of flora and fauna my ancestors knew, I saw monocrops, dugout sloughs and the occasional bird. As I walked along, I kept my eyes on the horizon in hope that I would recognise the prominent hill that the buffalo stones rest upon. However, buildings and trees, which were not part of the prairie landscape when my ancestors walked the land, often obscured my sightline. After about five hours of walking, I finally discerned the Ribstones' hill. I squeezed through the barbed wire and trespassed on private land to cross a meadow before climbing the hill where the buffalo stones rest. After making an offering, I stood up, slowly turned a full circle and surveyed the surrounding topography. I had visited this site several times before, but the act of walking to the site deepened my relationship to the place. I felt like the stones recognised me as a long-lost relative who had finally returned home.

While standing on the crest of that hill and surveying the landscape, I noticed that the relational psychosis[2] that troubles Indigenous-Canadian relations was on display all around me. Those buffalo stones are the tangible remnants of an ancient story of kinship relationality. Over thousands of years, the people lived in accordance with that ancient story and were gifted with ways to remind themselves of its teachings. These gifted practices, and their related wisdom teachings, are enmeshed within a kinship connectivity of original treaties between human beings and all other forms of life. The Viking Ribstones are an expression of these original treaty commitments to honour the generosity of the buffalo. When newcomers arrived, the story of ancient kinship relationality was

gradually replaced by the emerging story of a Canadian nation and nationality. The growth and development of the Canadian nation and nationality soon overtook other priorities, and newcomers began exploiting land and resources to build the economy. This narrative taught that the needs of human beings, in the form of the growth and development of the Canadian nation and nationality, must always supersede the needs of all other forms of life. This story of growth and development is commonly referred to as Progress.[3]

At the Ribstones site, there is a provocative juxtaposition of these two stories. The buffalo stones rest on a prominent hill surrounded by cultivated fields. You would not notice the stones there unless you went looking for them, as I did on that day. This tensioned juxtaposition poignantly characterises the pressing challenge faced by educators today. Most people now realise that the story of the Canadian nation and nationality that has been told in schools for many generations has brought benefits, but also has associated costs and consequences. Educational jurisdictions across Canada have slowly come to realise that the stories that have been told in Canadian schools have left out critical considerations, including the memories, experiences and foundational knowledges of Indigenous peoples. A pressing curricular and pedagogical challenge faced by educators in Canada today is how to facilitate the emergence of a new story that can repair inherited colonial divides and give good guidance on how to proceed differently. In my experience, the emergence of a new story can be facilitated through the life practice of walking.

Walking as Attuning to Life
I have been contemplating the intimate relationship between movement and thought for several decades now. My curiosity with this relationship arose from a self-study realisation that I have to move in order to think creatively. Now, when I am stuck on an idea or thought, or struggle with an important decision, I habitually go for a walk. When I am on the move, I find that the rhythmic sway puts me in a meditative flow that attunes me to the diverse life energies that surround me. My mind becomes animated with a dynamic flux of thoughts and ideas. It is common for me to burst in the door after returning home and rush to write down the thoughts and ideas that have come to me while I was on the move. I have learned that the clarity provided while walking will leave me once I settle into my office chair again.

Even though I have spent almost all of my life in schools, as either a student or an educator, the connections between knowing and moving have not been supported in my formal educational experience at any level. As Darling-Hammond (2010) notes, the culture of formal schooling is founded on a factory model designed to restrict the imagination of the students to predetermined and

standardised educational objectives.[4] In this model, the *citizen* – the intended target of curriculum initiatives and programmes of study – is expected to sit still and study as directed by the teacher. 'At school, the chair is one of the most common objects in the classroom and among the first words that a child learns to read and write.'[5] From this educational experience has emerged a cultural assumption that serious thinking can only take place when the thinker is seated and imbued with a 'sedentary perception of the world … unimpeded by any haptic or kinaesthetic sensation through the feet'.[6] This certainty that sitting is the habit of the educated and civilised has become so normalised that the word *pedestrian* can now be used to refer to something considered dull, tedious and commonplace.[7] Because walking, after the more primal needs, is one of the most fundamental drives of humans, it is strange to deny its role in our perception of the world.

Walking is an intrinsically relational activity that carefully attunes mind, body and spirit to surrounding life energies. 'Through our ambling bodies, we can discover an elemental relationship to the earth, a robust, even when culturally mediated, processual field of phenomena flowing beneath – but not only beneath – our fleeting feet.'[8] Attunement to these elemental relationships occurs when walking is enacted as a life practice through which the walker repeatedly recognises the self as intricately interwoven with the surroundings. By doing so, the walker 'does not so much add another figurative layer to the ground surface as weave another strand of movement *into* it'.[9] Conceptualising walking as 'dwelling-in-motion' supports the perception that strands of movement are interwoven with the living layers of growth, experience, memory and story that comprise the surface of the earth.[10] Ingold asserts that 'locomotion, not cognition, must be the starting point for the study of perceptual activity' and that walking is 'a form of circumambulatory knowing'.[11] By habitually walking around, humans are roused to perceive the world and know it in its fullness.

Indeed, it could be said that walking is a highly intelligent activity. This intelligence, however, is not located exclusively in the head but is distributed throughout the entire field of relations comprised by the presence of the human being in the inhabited world.[12]

As we walk, we simultaneously step into the organic flow of knowledge and knowing that generates attunement to relationality.

Walking and wâhkôhtowin

Forms of knowledge and knowing that are perceived as in motion and carefully attuned to relationality exist within many different Indigenous wisdom traditions. In *nêhiyawêwin* (the Cree language), a foundational wisdom concept that is central to *nêhiyaw* (Cree) worldview is *wâhkôhtowin*. Translated into

English, *wâhkôhtowin* is generally understood to refer to kinship and relationality. In a practical way, *wâhkôhtowin* describes ethical guidelines regarding how you are related to your kin and how to conduct yourself as a good relative. The guidelines teach how to relate to human relatives and address them in accordance with traditional kinship teachings. However, *wâhkôhtowin* also refers to more-than-human kinship relations. The *nêhiyaw* worldview emphasises honouring the ancient kinship and relationships that humans have with all other forms of life that comprise their traditional territories. This emphasis teaches human beings to understand themselves as fully enmeshed in networks of relationships that support and enable their life and living. Métis elder Maria Campbell eloquently addresses *wâhkôhtowin* inter-relationality:

> And our teachings taught us that all of creation is related and interconnected to all things within it.
> Wâhkôhtowin meant honouring and respecting those relationships. They are our stories, songs, ceremonies, and dances that taught us from birth to death our responsibilities and reciprocal obligations to each other. Human to human, human to plants, human to animals, to the water and especially to the earth. And in turn all of creation had responsibilities and reciprocal obligations to us.[13]

Thus, following the relational kinship wisdom of *wâhkôhtowin*, human beings are called to repeatedly acknowledge and honour the sun, the moon, the land, the wind, the water, the animals and the trees (just to name a few animate entities) as, quite literally, our kinship relations, because we carry parts of each of them inside our own bodies. Humans are fully reliant on these entities for survival, and so a wise person works to ensure that those more-than-human relatives are healthy and consistently honoured.

While I am truly inspired by this wisdom concept and its connections to the sacred teachings of my ancestors, I am absolutely stunned by the beautiful insights conveyed within the etymological roots of *wâhkôhtowin*. These etymologies were shared by *nêhiyaw* educator and *nêhiyawêwin* expert Rueben Quinn, and documented by Van Essen.[14] To summarise their findings, the word *wâhkôhtowin* is comprised of multiple morphemes brought together. The first one is 'wâki', which refers to something that is bent or curved. The second is 'pimohtê', which means to walk, but can be broken down to 'pim' (movement) and 'ohtê' (over land). Put together, then, 'pim' and 'ohtê' literally expresses walking as movement over land. Also included in *wâhkôhtowin* is 'ito', which connotes reciprocity. The ending 'win' is a nominaliser, which I understand to mean that a verb (movement) is converted into a concept (noun). So, when

the original morphemes are placed side by side – wâki + pimohtê + ito + win – what is expressed literally is a 'bent-walking-over-the-land-reciprocity-movement-concept'. Van Essen further shares the etymological insight on this concept of reciprocal bent-over walking by quoting *nêhiyaw* poet Louise Halfe: '*wâhkôhtowin* is our crooked good and in essence we walk this path in a crooked bent over manner holding hands with every stranger that we meet'.[15] Van Essen notes that Halfe's imagery here brings to mind the way bodies bend when we pick medicines from the earth, the way bodies bend when praying and braiding sweetgrass, or the way bodies bend when entering a sweat lodge, and how these ceremonies remind participants of (and help them to honour and understand) their relationships – *wâhkôhtowin*.[16]

It is important to recall that this imagery of crooked bending to honour life occurs while walking upon the earth. The act of walking activates the *wâhkôhtowin* imagination.

The Generation of a New Story

As an educator, curriculum scholar and human being, I derive much inspiration and meaning from the *wâhkôhtowin* imagination. However, I well understand that the field of education continues to be dominated by cultural assumptions that block meaningful and deep engagement with Indigenous understandings of knowledge and knowing. I understand these blockages as symptomatic of the perpetuation of colonial logics founded upon relationship denial. Such logics have grown out of the tremendous upheaval that occurred in Europe as a result of colonial processes. The flood of information about new people in new lands required new ways of making sense. Growing out of this colonial impetus was an educational imperative to 'construct an encyclopedic mastery of the globe', a model that would encompass European speculations on perceived new worlds, new peoples, new species and unfamiliar ways of knowing.[17] Notions of citizenship and the purposes of formal education were unified by the goal of coming to know the world according to this coloniser's model.[18]

Wynter has argued that the Columbian landfall on Turtle Island instigated a centuries-long hegemonic process wherein a universalised model of the human being was imposed on people around the world. Citing Foucault's 'figure of Man', and noting the epistemological complexes resulting from Enlightenment-based arrangements of knowledge and knowing, Wynter asserts that this particular advancement has served to 'absolutize the behavioural norms encoded in our present culture-specific conception of being human, allowing it to be posited as *if* it were the universal of the human species'.[19] Eventually, formal schooling became a primary means by which those with power could discipline the citizenry to conform to this model of the human being. As I see it, this has

resulted in the predominance of curricular and pedagogical approaches that perpetuate these universalised behavioural norms by persistently presenting knowledge and knowing in written, objectified, desacralised, deplacialised[20] and sedentary forms. As Lowe observes, the current moment is so replete with these universalised assumptions of human knowing and being that it has become very difficult to imagine other knowledge systems or ways of being.[21]

This struggle to imagine other knowledge systems, or ways of being human, is implicated in the deepest difficulties faced today in trying to live in less damaging, divisive and destructive ways. Over the years, I have learned that it is difficult to imagine other ways of doing things while sitting stationary at a desk. Even in formal educational settings, in which I have an opportunity to lead others to consider key insights from Indigenous wisdom traditions, there seems to be something very important missing when such engagements are required to conform to the colonial curricular and pedagogical approaches noted above. If we wish to take seriously the task of addressing the most troubling issues we face today, we must be willing to consider insights from knowledge systems that express alternative ways of being in the world.

An example of this dynamic comes from my experiences walking in the North Saskatchewan River Valley in Edmonton. Walking as an intentional life practice began for me after I listened to Blackfoot scholar Dr. Leroy Little Bear state that a human being experiences an identity problem when the land does not recognise them as a relative.[22] It became a personal life goal for me to be recognised as a relative of the place where my ancestral roots are quite deep. I began regularly walking alongside the North Saskatchewan River to facilitate this. As I walked, I began weaving together wisdom teachings, oral histories and written accounts until a unified story emerged that expressed how I understood myself in relation to the place I call home. Over many years of walking in this way as an intentional life practice, I noticed a shift in how I perceived the life around me. Now, I understand this personal transformational process as being gradually enlivened by the *wâhkôhtowin* imagination. As I walk, bent-over-holding-hands-in-reciprocity-with-all-my-relations, I am simultaneously imagining a new story to live by.

Since 2006, I have led students, teachers, university colleagues and other interested groups of people on walks beside the North Saskatchewan River, during which I share stories and insights that express the *wâhkôhtowin* imagination.[23] These walks have become very popular. This popularity is undoubtedly the result of heightened Canadian public interest and curiosity in Indigenous worldviews and ways. However, there is also an intangible explanation for its popularity. In terms of teaching and learning, these walks wake up something important inside of people that was put to sleep as they became

educated. By walking and listening, people begin to perceive the life around themselves differently. They feel enmeshed in relationships. This change in perception is not the result of anything special I do as their guide, rather, it arises from their willingness to be put in the flow of the traditional wisdom insight of the *wâhkôhtowin* imagination. They walk themselves into kinship relationality.

I have come to see this river valley walk as the most important contribution that I can make to the complex task of repairing Indigenous-Canadian relations and renewing them on more ethical terms. Indigenous-Canadian relations will not be repaired and renewed by an educational commitment to provide students with more information *about* Indigenous peoples. The holistic complexity of human perception is disregarded when teaching and learning is reduced to a simple telling of information *about* certain selected topics of interest. To make progress on these divisive issues, educators must be willing to experiment with curricular and pedagogical approaches that provoke their students to engage in such topics in qualitatively different ways. I am not suggesting that all our problems will be solved if everyone walks beside a river and allows themselves to be inspired by the *wâhkôhtowin* imagination. However, I do believe that walking is a fundamental way that human beings perceive the world and come to story their place in it. Wisdom teachings around the world make this connection consistently clear.[24] As I see it, teaching and learning theories that dominate formal education have left out this important insight. The intimate connections between movement and knowing need to be taken seriously if we wish to reconceptualise human life and living. Walking and the *wâhkôhtowin* imagination can help us re-story ourselves – individually and collectively – as real human beings bent-over-holding-hands-in-reciprocity-with-all-our-relations.

1 [Footnote 1 in source] In many of the different Indigenous languages of North America, including the Cree and Blackfoot languages, which I am most familiar with, the people consistently refer to themselves as the 'real people' or the 'true human beings'. While this could easily be interpreted as a sign that such people have a high opinion of themselves, I have been taught to understand this naming as declarative of the people's intentions to live humbly and in accordance with the laws of creation. In the languages and the cultural sensibilities connected to them, this is how real human beings are meant to live. For more on this see A.S. Gatschet, '"Real", "true", or "genuine"', in Indian Languages', *American Anthropologist*, vol. 1, no. 1 (1899) 155–61 and I. Praet, 'Humanity and Life as the Perpetual Maintenance of Specific Efforts: A Reappraisal of Animism' in Tim Ingold and Gisli Palsson (eds.), *Biosocial Be-comings: Integrating Social and Biological Anthropology* (New York: Cambridge University Press, 2013) 191–210.

2 [2] For many generations, Canadians have been taught – inside and outside of schools – to deny relationships with Indigenous peoples. The habitual disregard of Indigenous peoples stems from the colonial experience and is perpetuated in the present educational context as a curricular and

pedagogical logic of naturalised separation based on the assumption of stark, and ultimately irreconcilable, differences. I use the term 'psychosis' to draw attention to the ways in which the institutional and socio-cultural perpetuation of colonial logics has trained Canadians to disregard Indigenous peoples as fellow human beings. This disregard maintains unethical relationships and manifests as cognitive blockages (psychoses) that undermine the possibility for improved relations.

3 [3] I choose to capitalise this term to denote its mythological prominence within settler colonial societies such as Canada. This notion of Progress has grown out of the colonial experience and is predicated on the pursuit of unfettered economic growth and material prosperity, stemming from faith in market capitalism. For more on this see D. Donald, 'Homo Economicus and Forgetful Curriculum' in H. Tomlinson-Jahnke, S. Styres, S. Lille and D. Zinga (eds.), *Indigenous Education: New Directions in Theory and Practice* (Edmonton: University of Alberta Press, 2019) 103–25 and R.A. Nisbet, *History of the Idea of Progress* (New Brunswick: Transaction, 1980).

4 [4] See L. Darling-Hammond, 'Teaching and Educational Transformation' in A. Hargreaves, A. Lieberman, M. Fullan, and D. Hopkins (eds.), *Second International Handbook of Educational Change* (Dordrecht: Springer, 2010) 505–20. J.L. Kincheloe, 'Cultural Studies and Democratically Aware Teacher Education: Post-Fordism, Civics and the Worker-citizen', D.W. Hursh an E.W. Ross (eds.), *Democratic Social Education: Social Studies for Social Change* (New York: Falmer, 2000) 97–120, also provides a provocative explanation of Fordist production procedures with special emphasis on standardisation, compartmentalisation of tasks and static assembly lines. These Fordist innovations were conceptualised to modernise and optimise industrial production, and have had tremendous influence on industry around the world. In astonishing parallel, these industrial innovations have also had deep influence over the assumptions guiding teaching, teacher education and curriculum.

5 E. Tenner, 'How the Chair Conquered the World', *Wilson Quarterly*, vol. 21, no. 2 (1997) 64–70. http://archive.wilsonquarterly.com/essays/how-chair-conquered-world1997, p. 64.

6 Tim Ingold, 'Culture on the Ground: The World Perceived through the Feet', *Journal of Material Culture*, vol. 9, no. 3 (2004) 315–40, 323.

7 Ibid., 321.

8 D. Macauley, 'Walking the Elemental Earth: Phenomenological and Literary "Foot Notes"' in A.T. Tymieniecka (ed.), *Passions of the Earth in Human Existence, Creativity, and Literature*, 15–31. (Dordrecht: Springer, 2001) 15.

9 Tim Ingold, 'Footprints through the Weather-world: Walking, Breathing, Knowing. *Journal of the Royal Anthropological Institute*, no. 16 (2010) 121–39, 128 (emphasis in source).

10 M. Sheller and J. Urry, The New Mobilities Paradigm. *Environment and Planning A: Economy and Space*, vol. 38, no. 2 (2006) 207–26, 214.

11 Ingold, 'Culture on the Ground', op. cit., 331.

12 Ibid., 332.

13 Maria Campbell, 'We Need to Return to the Principles of Wahkotowin', *Eagle Feather News*, vol. 10, no. 11 (5 November 2007) 5.

14 A. Van Essen, 'Bending, Turning, and Growing: Cree Language, Laws, and Ceremony in Louise B. Halfe/Sky Dancer's The Crooked Good', *Studies in American Indian Literatures*, vol. 30, no. 1 (2018) 71–93.

15 Ibid., 86.
16 Ibid.
17 J. Willinsky, 'After 1492-1992: A Post-colonial Supplement for the Canadian Curriculum', *Journal of Curriculum Studies*, vol. 26, no. 6 (1994) 613-29.
18 James Morris Blaut, *The Colonizer's Model of the World: Geographical Diffusionism and Eurocentric History* (New York: Guilford, 1993).
19 Silvia Wynter, '1492: A New World View' in V. L. Hyatt and R. Nettleford (eds.), *Race, Discourse, and the Origin of the Americas: A New World View* (Washington: Smithsonian, 1995) 5-57, 42-3 (emphasis in source).
20 [5] Here, I am playing with a term introduced by Casey 'deplacialization', E. Casey, *The Fate of Place* (Berkeley: University of California Press, 1997) xii.
21 Lisa Lowe, *The Intimacies of Four Continents* (Durham: Duke University Press, 2015) 175.
22 C. Chambers, 'Where Are We? Finding Common Ground in a Curriculum of Place', *Journal of the Canadian Association for Curriculum Studies*, vol. 6, no. 2 (2008) 113-28, 123.
23 [6] A documentary film on this river valley walk titled *otenaw* can be accessed at https://vimeo.com/203909985
24 [7] For some examples of this, see Rebecca Solnit, *Wanderlust: A History of Walking* (London and New York: Penguin, 2001), Tim Ingold and Jo Lee Vergunst (eds.), *Ways of Walking: Ethnography and Practice on Foot* (London: Ashgate, 2008) and M. Somerville, L. Tobin, and J. Tobin, 'Walking contemporary Indigenous songlines as public pedagogies of country', *Journal of Public Pedagogies*, no. 4 (2019) 13-27.

Dwayne Donald, extract from 'We Need a New Story: Walking and the wâhkôhtowin Imagination', *Journal of the Canadian Association for Curriculum Studies*, vol. 18, no. 2 (2021) 53-62.

Cherise Smith
Moneta Sleet, Jr. as Active Participant: The Selma March and the Black Arts Movement//2006

Taken by Moneta Sleet, Jr. on 25 March, 1965, the image of Dr. and Mrs. King leading marchers in Montgonery, Alabama, on the cover of the May 1965 volume of *Ebony* documents the completion of the Selma to Montgomery March after two failed attempts.[1] At the front of the procession and the centre of the image, Martin Luther King, Jr. is pictured mid-stride and mid-song, flanked by Coretta Scott King to his left and Ralph Bunche, Under-Secretary to the United Nations, to his right. Looking determined, Rosa Parks, and Ralph and Juanita Abernathy are positioned to the right of Bunche.[2] Although each of the leaders is dressed

in a smart suit, their mud-covered casual shoes communicate the arduous fifty-four mile journey they have just completed. Sleet focused attention on King and company through the single point perspective created by the foreshortened asphalt in the foreground and the receding, directional lines formed by the buildings and signs along the street. With locked arms and hands, the leaders appear to be a single unit and larger than life in stature. The supporters in the background are out of focus and blurred, their expressionistic faces and diminished scale reading as a mass that extends backwards indefinitely.

As the cover image of the magazine, Sleet's photograph functioned as a symbol of the triumphant nature of the march, and, along with the superimposed, bold-faced and capitalised footer reading, '50,000 March on Montgomery', it announced the twenty-one-page photographic essay inside the volume.[3] Moreover, the choice of the preposition 'on', instead of 'in' or 'to', in the title is poignant and telling. It is a militant declaration: 50,000 supporters of the civil liberties of African Americans marched *on* Montgomery, the capital of Alabama which was understood by the magazine's readership to be 'the cradle of the Confederacy' and 'the land of the bomb and the bullet...where tiny children are not safe even when attending Sunday School.'[4] [...]

Sleet and *Ebony*

In 1955, when Sleet became a staff photographer for the large-format feature and news picture magazine *Ebony*, he had been a journalist for a number of years, honing his political affiliations and photo-documentary sensibilities while working for the black publications *Our World* and *Amsterdam News*. *Ebony*, the flagship of the Johnson Publishing Company magazines, was different, however, because of its large national distribution. *Ebony* featured articles – on world and national events, race relations and celebrities – that the editors deemed relevant and important to black Americans, and it continues to maintain a high circulation.[5] During the 1950s and 1960s, the magazine, along with its sister publications *Negro Digest* and *Jet,* played an important role in the Black Freedom struggle because it offered news and information at an affordable price and distributed it nationally. The regularly circulated publications encouraged a broader sense of community by providing updates on events that may have seemed distant or isolated to many African Americans.

The images of the Civil Rights Movement that Moneta Sleet, Jr. took for *Ebony* garnered support from its readers and helped mobilise them to act. For instance, when the magazine covered the Montgomery Bus Boycott in 1956, Sleet's photographs put faces to the names Rosa Parks and Martin Luther King, Jr. It was Sleet's pictures from the March on Washington DC (1963) that conveyed most effectively the historic nature of the event and record number of attendants.

Similarly, the images that Sleet took at Martin Luther King, Jr.'s funeral, in 1968, have reached the status of icon, burned into the collective memory of Americans. Sleet's advocate-style photography provided evidence and support and allowed readers to *see* themselves as participating in a greater national, and even international, process of liberation. Indeed, Sleet's photographs in *Ebony* articles dictated how African Americans understood the movement itself. [...]

In March of 1965, Sleet was sent, along with a staff writer and several photographers, to Alabama to cover the Selma voter registration drive and demonstration. Sleet and the rest of the Johnson Publishing Company team recorded various aspects of the event from walking demonstrators to the setting-up of campsites and all activities in between.[6] Authored by Simeon Booker and edited by Herb Nipson, the resultant article, '50,000 March on Montgomery', followed the sequence of the protest with pictures. The story was illustrated largely with Sleet's photographs, with forty-two of the ninety-five images taken by the photographer, demonstrating that the editorial staff considered his images appropriate to their vision. Rather than functioning in an exclusively news-providing capacity, the lavishly illustrated, twenty-one-page essay seems to have been conceived as a memorial in nature and function.

The sole article on the Selma March presented in *Ebony*, '50,000 March on Montgomery' was published one month after the successful completion of the demonstration. The editorial staff told the entire history of the voter registration drive, including the two failed attempts at marching. The logistics of the demonstration were described, including the weather conditions, the military presence, and overnight and meal accommodations. Protestors were portrayed as model American citizens who maintained their cleanliness, remained fashionable, and upheld sexual propriety. The economic, cultural, racial and religious diversity of the demonstrators was also emphasised.

Overall, the march was characterised as victorious, but *Ebony* represented its ideological platform as ambivalent, swinging between militant and conformist. The editorial staff made a deliberate decision, for instance, to acknowledge but not sensationalise the deaths related to the march. In that way, the magazine provided the appearance of calm in a time of growing unrest and discontent. However, it did not succumb to mainstream publications' – *Newsweek* and *Life*, for example – tendency to characterise all demonstrations as chaotic. Furthermore, the magazine, as represented by '50,000 March on Montgomery', subverted the status quo by presenting views of masses of people who would not tolerate legalised segregation and disenfranchisement.

In spite of Sleet's commitment to the Black Freedom struggle and the magazine, he had no say in which of his photographs were used in '50,000 March on Montgomery', nor in their manner of display. As a staff photographer

based in New York, Sleet was miles away from Johnson Publishing Company headquarters in Chicago and from influencing the design of the photographic essay. He could not change the fact that the editors employed a considerable amount of text, in the form of paragraphs and captions, which functioned to control the reading of the images. Sleet could not break rank with the editors, telling them that they sacrificed aesthetic concerns for narrative flow by choosing photographs that, for the most part, were easily understood and not formally compelling.

Sleet's Representation of the Selma March
Taken four years after the Selma March was completed, Sleet's well-known photograph, featuring Bernice King leaning into the lap of her mother at the memorial service of Martin Luther King, Jr., made Sleet the first African American man to win the coveted Pulitzer Prize in Feature Photography in 1969. The image is compelling because Sleet framed the Kings with a tight focus, leaving the other funeral attendants slightly blurred. The framing, combined with the right-angled point of the pew arm, make Bernice and Coretta Scott King the focal point. By placing the widow and child close to the picture plane, the photographer directs the viewer's attention, demanding empathy with the King family's grief.

Mistakenly, the image of the two Kings was sent out on the Associated Press wire, instead of being sent to the Johnson Publishing Company headquarters, landing it on the front page of national newspapers and qualifying it for the Pulitzer Prize.[7] The twist of fate that made the photograph eligible for the award led to another. Sleet's winning the Pulitzer Prize encouraged the St. Louis chapter of Alpha Kappa Alpha sorority to pressure the St. Louis Art Museum to mount an exhibit of the photographer's work in 1970. The resultant exhibition, *Moneta Sleet: Photographer,* afforded Sleet the unique opportunity to flex his artistic muscles and demonstrate his artistic vision, separate from Johnson Publishing Company and *Ebony* magazine. Sleet's selection of which Civil Rights Movement photographs to include in the St. Louis Art Museum exhibition begs to be studied through the lens of the Black Arts Movement.

When given the chance, Sleet revised the depiction of the demonstration by including images that he felt were both aesthetically and symbolically meaningful. On display from 15 May through 21 June, 1970, the exhibit, *Moneta Sleet: Photographer,* featured more than one hundred photographs that were eventually donated to the museum.[8] Of that number, eighteen were dedicated to the Selma March, though other subjects, including portraits of politicians and celebrities, street photography and African independence celebrations among others, were displayed. Sleet eliminated thirty-six images that appeared in

the *Ebony* article, '50,000 March on Montgomery'. In other words, Sleet chose only six out of the forty-two images published in the magazine to represent the Selma March in his mid-career retrospective. Clearly, his interpretation of the march differed dramatically from that of the magazine.

A significant expression of his artistic subjectivity, Sleet's mid-career retrospective allowed him to do what he normally could not: control the presentation of his work. Sleet acted as both featured artist and artistic director. He chose which of his photographs to display, managed the printing, and altered some of the images to ensure dramatic compositions. For example, though he shot the Selma March with both black-and-white and colour film, he decided that the prints should be black-and-white, the print type most commonly associated with 'art'. Modelling his presentation on earlier precedents, Sleet enlarged the majority of the prints to sizes that were more like the dimensions of paintings than photographs. [...]

His claim that 'the type of photography I do is one of advocacy' is also apparent in the exhibit.[9] In his close-up image of three protestors, for instance, Sleet portrayed a cross-section of the participants, emphasising the fact that civil rights supporters included people of different ethnicities and economic circumstances. On the right is a striking white woman whose dress and manicured appearance indicate some measure of wealth. A white man with styled goatee and tailored clothes appears in the top of the frame. Occupying the left of the composition is a black man wearing a misshapen felt hat and the dungaree overalls that came to be regarded as the unofficial uniform of civil rights workers. The swollen joints of his wrinkled hand identify him as a labourer or farmer. The triangular composition of this image encourages the viewer to move from subject to subject rather than settling at a single point. In contrast, this compelling photograph is lost in a sea of images in the *Ebony* photo-essay. Sleet's decision to enlarge the picture and allow it to stand on its own submerges the individual identities of these protestors in such a way that they become representative types, surrogates for the many others who participated in the demonstration.

A striking image of 'whiteface' in another work in this series presents a youth staring directly into the camera in an intense manner, while his companion looks back over his shoulder with a confrontational expression. Each of the young men wears heavy sunscreen with the word 'vote' inscribed onto their foreheads, signaling the major goal of the demonstration. The contrast between the white zinc oxide and the darkness of their skin makes the youth appear ghostly. This imaging of 'whiteface' dramatises the racial politics of the march.

The photographer's picture of marchers with United States and United Nations flags was also included in both the photographic essay and the

exhibition. The picture focuses on a middle-aged white woman walking with her right arm locked in the arm of a young African American man who carries the United States flag and wears a stern expression. Her left hand clutches the arm of another black youth, who carries the United Nations flag and holds his head low. A sense of motion is created by Sleet's use of a slow shutter speed, which freezes the marchers in the middle of their steps and blurs the asphalt beneath their feet. Symbolic in its depiction of forward motion, this image communicates the artist's interest in racial equality and demonstrates his awareness of the international implications of the freedom struggle.

Sleet's photograph of a demonstrator's calloused and bandaged feet stands as a testament to the physical rigour of the march and the determination of the marchers. The hand and feet in the outer edges of the picture frame, along with the vertical lines of the man's trousers, draw attention to the marcher who stands with his feet rolled outwards, as if his soles hurt. In the *Ebony* layout, the same photograph was confined to function as mere illustration, but in Sleet's exhibition, it can be appreciated for its abstraction, demonstrated in the pattern effect of the asphalt and printed fabric and in the play of light and dark.

Separated from the constrictions of the magazine, Sleet was better able to display the support and gratitude of local black Alabama citizens in three images instead of the one that appears in *Ebony*. He pictured an elderly man standing on the side of a road, welcoming marchers who walk past on the left. The man occupies the foreground, while the supporters form a diagonal line that extends deep into the right of the frame. Intended to convey a sense of motion, sequential images, such as these, were generally employed to display violence against blacks.[10] Sleet's suite of images, however, produces a resounding crescendo by showing the man first with one arm raised, then both, and finally clapping. [...]

Sleet's process of selecting images for the 1970 exhibition was conscious and deliberate, especially when viewed in the context of his commitment to the Black Freedom struggle. Though he considered himself a social documentarian and not an artist, the photographer created an aesthetic, subjective and activist vision of the protest.[11] Sleet's selection of Selma March photographs is characterised by equal parts of activism, celebration, aestheticism, heroism and the manifestation of an overt political affiliation with his blackness – attributes that were promoted by theoreticians of the black aesthetic.

The philosophy scaffolding the Black Arts Movement, the black aesthetic, was theorised as art by black people for black people; its function was to transform black audiences.[12] Occurring roughly from about 1960 to 1975, the Black Arts Movement, like the Harlem Renaissance, was a blossoming of art made by black people. Parallel to the social and cultural activism of Black Power, the Black Arts Movement is characterised by a nationalistic interest in blackness.

Larry Neal wrote that artists of the Black Arts Movement needed to 'speak to the spiritual and cultural needs of Black people.'[13] He explained that art and action are the same, saying, 'the Black Arts Movement believes that your ethics and your aesthetics are one.'[14] Other figures in the movement weighed in on the topic. Ron Karenga, the Black Arts activist and Kwanzaa founder, asserted that 'black art initiates, supports and promotes change.'[15] Cultural worker James Stewart claimed that 'the artist is a man in society, and his social attitudes are just as relevant to his art as his aesthetic position.'[16]

Moneta Sleet, Jr. was one of a large number of black visual artists working during this period. Though Sleet is not often recognised as a Black Arts Movement photographer, he was aware of both the notion of the black aesthetic and the nationalistic writings and attitudes of the movement, largely through the black press, particularly through the magazine *Negro Digest* (which was renamed *Black World* in 1970).[17] In the spirit of the Black Arts Movement, he, too, blended activism and aesthetics and sought to communicate on a mass scale to his audience.

Through his affiliation with *Ebony* and the Johnson Publishing Company, Sleet responded to the Black Arts Movement by tapping into mass distribution. As Houston Baker states in his introduction to the Black Arts Movement section of *The Norton Anthology of African American Literature*, 'the Black Arts Movement was, indisputably, committed to a goal of black mass communication.'[18] The magazine's circulation statistics demonstrate that his images enjoyed a large viewing audience. In fact, in 1965, the year of the Selma March, his photographs were seen by at least one million people. [...]

One of the more than one million viewers that Sleet's photographs reached was Reginald Gammon, African American artist and member of the New York City-based Spiral group. Indeed, Gammon was so moved by the work that he modelled an expressionistic painting after one of the photographer's pictures of a crowd at the March on Washington.[19] Painted in 1965, *Freedom, Now* is a close-up representation of a cross-section of the crowd: all feet, signs and disembodied faces. The grisaille painting references the original black and white of Sleet's photograph, but Gammon tweaked it. Like Andy Warhol, Roy Lichtenstein and other Pop artists of the period, Gammon took a piece of popular culture and abstracted it. Unlike his Pop counterparts who appropriated images from the popular media as a way to critique American consumer culture and divest it of meaning, however, Gammon appropriated Sleet's photograph in order to invest more meaning in it and encourage viewers to act. No longer read as individual identities, the abstracted faces become surrogates for the masses of people who demonstrated for their rights.

Because of his political affiliations and aesthetic choices, Sleet's Selma March photographs should not be classified as merely narrative or documentary

in nature. Formally compelling, the images communicate the essence of the event because they illustrate the commitment of both the supporters and the photographer to the cause of equality. They must be seen as an attempt, on the part of the photographer, to revise the manner of communication in which his photos were employed and to establish himself in the artistic arena. Sleet did nothing less than reassign his personal ideology to his own images. His primary goal was to depict the strength, courage and dignity of African American people. Sleet's photographs show that he was concerned with both creating the aesthetic value of the work and conveying his own emotional and spiritual response to the Selma March.

Moneta Sleet's representation of the Selma March stands in stark contrast to *Ebony*'s portrayal of the event. The ideological programme put forth in the photo-essay '50,000 March on Montgomery' is characterised by ambivalence. The magazine sought to instill in readers a conservative and patriotic ideology, while also encouraging readers not to be content with the racist status quo and to support the Civil Rights Movement. Sleet, however, was informed by the black aesthetic and, in the spirit of the Black Arts Movement, advocated spiritual strength, civil equality, cultural expression and independence for African Americans. He, like other artists, students and activists of the time, was aware of the fact that ideology was functional: he could use it, or have it used against him. Sleet seized it, attempting to secure a visual space for African Americans in which they would not be subjected to the dominant ideology.

1 The Johnson Publishing Company holds the copyright to the majority of images taken by Moneta Sleet, Jr., because he was a staff photographer. For this publication, I sought the right to reproduce eighteen photographs he took during the Selma March as well as several pages from *Ebony* magazine. Johnson Publishing Company denied permission. Due to those unfortunate circumstances, I refer readers to their book, *Special Moments in African–American History: 1955–1996. The Photographs of Moneta Sleet, Jr.* Ebony *Magazine's Pulitzer Prize Winner* (Chicago: Johnson Publishing Company, 1998).
2 Ralph Abernathy was a civil rights leader and aide to Martin Luther King, Jr.
3 Simeon Booker, '50,000 March on Montgomery,' *Ebony*, no. 20 (May 1965) 46–86.
4 The first quote refers to the fact that the South called itself 'the Confederacy' during the Civil War. The Confederate flag and the Confederacy remain symbols of Southern support of segregation, racism, and violence. Ibid., 85. The second refers, of course, to the tragic 1963 incident when four black girls were killed when a bomb exploded in their Birmingham, Alabama, church. 'Backstage,' *Ebony* no. 20 (May 1965) 22.
5 The Johnson Publishing Company began publishing *Ebony* in 1945. Like *Our World*, *Ebony* was modelled after *Life*. Like *Life*, *Ebony* is no longer published in large format. The dimensions of both magazines are now those of the standard sheet of paper, 8 x 11 inches.
6 [Footnote 9 in source] Interview with Moneta Sleet, Jr., 1992.

7 [10] Ibid.

8 [18] Sleet and the Johnson Publishing Company donated the prints to the St. Louis Art Museum in 1991.

9 [21] Sleet used the word 'advocacy' to describe the type of photography he practised. 'World of Photography,' Brockway Broadcasting Corporation (television series) (1986). The photographer was present at the independence celebrations of many newly liberated African nations, including Ghana (1957), Nigeria (1961), Kenya (1963), and South Africa (1994), among others.

10 [22] See 'Selma: Beatings Start the Savage Season,' *Life*, no. 58 (19 March 1965) 30–37.

11 [23] Interview with Moneta Sleet, Jr., 1992.

12 [32] See Addison Gayle, Jr., *The Black Aesthetic* (New York: Doubleday and Company, 1971).

13 [34] Larry Neal, 'The Black Arts Movement,' in *The Norton Anthology of African American Literature*, 1960.

14 [35] Ibid., 1962.

15 [36] Ron Karenga, 'On Black Art', *Black Theater*, no. 4 (1969) 9–10.

16 [37] James Stewart, 'The Development of the Black Revolutionary Artist,' in *Black Fire: An Anthology of Afro-American Writings*, eds. LeRoi Jones and Larry Neal (New York: William Morrow & Company, 1968) 9.

17 [38] Sleet had the opportunity to photograph fellow New Yorker Amiri Baraka (a.k.a. LeRoi Jones) on several occasions. In addition, the Johnson Publishing Company, for which Sleet worked, published the magazine *Negro Digest/Black World*, a major venue for Black Arts Movement texts. Because Sleet was a staff photographer for the Johnson Publishing Company, he most likely read *Negro Digest/Black World*. Therefore, he had to have been aware of Black Arts Movement ideology.

18 [40] Houston A. Baker, 'The Black Arts Movement,' in *The Norton Anthology of African American Literature*, op. cit., 1799.

19 [41] Sharon F. Patton, *African-American Art* (New York: Oxford University Press, 1998) 187, and conversation with the artist, March 2003.

Cherise Smith, extracts from 'Moneta Sleet, Jr. as Active Participant: The Selma March and the Black Arts Movement', in Lisa Gail Collins and Margo Natalie Crawford (eds.), *New Thoughts on the Black Arts Movement* (New Brunswick: Rutgers University Press, 2006) 210–226. Some footnotes omitted.

Tom Jeffreys
Bordered Miles: In the Footsteps of Iman Tajik//2021

Sometimes a sign can hide the very thing it's pointing at. On OS map 334, Dungavel House Immigration Removal Centre is visible amid coniferous forest as a cluster of beige buildings set back from the B743. 'Detention Centre', reads the text, in the same font and size used to denote small rural things like butts or cairns or sheepfolds. At the site itself, a white road sign marks the turning: 'Dungavel House IRC'; that unexplained acronym concealing far more than it wishes to reveal.

The difference in terminology between these two signs is subtly telling. The map denotes a place of detention; the road sign points to removal. One signifies movement, the other the prevention of movement. In both cases the signs also suggest a lack of agency: removal and detention being actions imposed without consent upon people or animals or things.

Movement as a fundamental right, and the state systems that prevent so many from being able to exercise that right, are key subjects in the work of Iman Tajik. In June 2021, Tajik led a marathon-length (26 miles), day-long group walk, entitled *Bordered Miles*, from the centre of Glasgow to Dungavel as part of Glasgow International.

The walk stretches across OS maps 342 and 334, beginning at George Square before heading through the Merchant City and out among residential sprawl, industrial estates and urban fringe, then through the fields and farmland surrounding Dungavel. Along the way, we talk about the walk itself but about many other things too. I don't know any of the other walkers, but a temporary community is quickly formed. I share in conversations about walking as an art practice or leisure pursuit or act of pilgrimage; about maps, especially the history of Ordnance Survey; about artists (Peter Doig, Edvard Munch); about David Graeber, bureaucracy, work and the state. I hear of the trauma of indefinite detention in which, with no known end in sight, time loses its markers and becomes unbearable.

Later I read Leah Cowan, who notes that 'Britain is the only country in Europe where you can be held in detention without knowledge of when you will be released or any limitation on how long you will be incarcerated.'[1] I wonder what that does to the marking of time, so central to life under capitalism that we can scarcely imagine a life without clocks.

On the walk I overhear a conversation:

'The driver was also at Dungavel.'
'How long was he there?'
'I didn't ask.'

With an hour to go, we stop at a gate by the side of a quiet country lane and wait in silence. Soon, a performance begins. Like many of Tajik's works, it consists of a series of simple gestures that resonate with complexity.

Iman lays out lines across the road in coloured tape. One by one, he kneels and loops tape in corresponding colours around our calves. I wonder if it is an act of care or a temporary branding. Each of us is marked differently in relation to the borders about to be crossed, but the nature of that relation remains unclear.

We read out short texts from workshops that Iman has carried out with communities in Glasgow and Huntly – mostly simple messages of love or hope, shock or solidarity. There is also a response from curator Natalie Nicolaides, in which she recounts reading Alexandra Hall's analysis of the 'thickened space', in which the state renders people 'abject... excludable', while sitting within the 'welcoming' interior of Glasgow's Mitchell Library.[2] One kind of state apparatus revealed inside another. Under neoliberalism, cuts to culture mean more money for incarceration.

As we stand together, I'm thinking about the multiplicity of accents in which the texts are read: Chinese, English, German, Russian, Scottish. I think about the car that approaches mid-performance and drives over the border lines *as if they were not there*. And I think about the swallows, hectic, flitting through the air just above us: As a migrating species, these swallows are a relevant distraction, so emblematic of freedom and joy. I think about the swallows on the cover of Harsha Walia's *Border and Rule*.[3] Nature is for movement.

Over the course of the performance, we stand as witnesses to the construction of the border, its multiple crossings, and in the end to its dismantling. It is shown to be flimsy, a temporary artefact of history, not natural, fixed or immutable. The border is a performative practice. It has a beginning and therefore, one day, an end.

For the next hour, at Iman's instigation, we walk in silence through a bucolic landscape, its beauty shaped by enclosure, agriculture, new technologies and changing labour patterns. Lush fields, tangled hedgerows, gnarled and ancient trees, verges dancing with cow parsley, hawthorn blossom blushing pink. Today all is stained or re-framed through the lens of detention, oppression, state violence. This place in the countryside is one of many where the border is enacted, a place where people are compelled to be because they are prevented from being.

Several weeks after the walk, Iman told me that during that final walking silence he felt a connection with other refugees, asylum seekers and migrants

who have made or tried to make a journey towards a better life, and with those thousands who have died en route. 'I see myself as one of them', he said, 'walking for a better life, a safe life.'

'I'm interested in ideas not stories', Iman says. Ironically perhaps, this emphasis can be understood in terms of Iman's own specific experiences and what it means to speak of them. The stakes are complex, and there is always a danger that, in telling your story as a refugee, it can be co-opted or weaponised. People are pressured into revisiting their trauma for the consumption of others. Tajik's response aims to resist this tendency and to speak beyond one set of experiences or identities. While Iman's time as detainee at Dungavel is significant in situating the work in the context of lived experience, he gives us no accounts of life inside or stories of his own journey as a refugee.

'As an artist and activist, it is my role to return there and draw attention to this place', he says of Dungavel. 'Now I have some kind of freedom and can point my finger at this place. I was there alone and now I come back with friends – it's a kind of revenge. I'm coming back with a different energy, a positive energy. As someone who's been in this place and knows many people who have been too, I know what happens there.'

In undertaking what is a long and tiring walk, there is a temptation to align oneself with the refugee experience. I must resist this temptation. We're often told about the importance of empathy for a more progressive, humane form of politics. As I write, an artist friend has shared a link arguing that empathy should be considered an aesthetic practice.[4] Walk a mile in another person's shoes, as the saying goes. But there are problems with this.

First is the ever-present danger of over-empathising and of writing myself, as a privileged white cis male, into or over the stories of those who have experienced real trauma at the hands of racialised border regimes. This overwriting is prevalent in sectors of the art world (and beyond) where in their eagerness to engage with work by marginalised artists, privileged writers/curators/critics/collectors cannot help but draw false parallels between their own globe-trotting lifestyles and the enforced and dangerous journeys of the migrant or refugee.

Secondly, empathy has its limits. For some, empathy relies upon some kind of common ground or shared experience/characteristic. An obvious danger is a politics based on proximity or similarity. Joanna Rajkowska's *Suiciders* effectively exploded the idea that empathy could really be any kind of basis for meaningful political action.[5] If even literally placing one's body in exactly the same position of another is not enough, then really it is never going to be possible to see the world through the eyes of another. What then? It is not only that empathy is always insufficient/impossible but that it relies upon the performance/

expression of essentialist differences in order for there to be a bridge for empathy to reach across. As Sara Ahmed argues, 'empathy sustains the very difference that it may seek to overcome'.

Thirdly, what is needed is not empathy (or not only empathy) but solidarity. It is through Harsha Walia that I encountered the above quotation from Ahmed. In *Border and Rule*, Walia argues that we should not rely on a (false) politics of (impossible) empathy. If what she terms liberal welcome culture, epitomised by Angela Merkel's response to the people fleeing war in Syria, is dependent on the good feeling of privileged Europeans, then it can always be reneged upon—and that leaves those deemed not local enough in a perpetual state of vulnerability to the whims of the privileged. We need only look to the Windrush scandal to see the disastrous consequences when a state first extends its 'welcome' and then changes its mind. As Walia writes:

> Most troubling about liberal welcome culture is the erasure of European complicity in creating displacement through colonial conquest, land theft, slavery, capitalist extraction, labour exploitation, and war profiteering. Refugees and migrants defying Fortress Europe do not require the variable empathy of Europeans; their movement is ultimately a form of decolonial reparation.

Eventually, up ahead, I catch a glimpse of Dungavel, its absurd fairytale turret just visible through evergreen trees. Built by the Dukes of Hamilton as a hunting lodge in the nineteenth century, the house was once surrounded by grouse moors. It was sold to the National Coal Board in 1947, then acquired by the government and converted into a prison. In 2001, Dungavel was reclassified as an immigration detention centre. At one time, it was run by private contractors G4S, then taken over by GEO Group. On a page of GEO's UK website, capacity at Dungavel is listed as 125.[6] On its US site it says 249.[7] All around, where grouse were once raised to be shot, aristocratic leisure has given way to commercial forestry.

Dungavel is just one node in a network that also includes Brook House, Colnbrook, Harmondsworth, Morton Hall, Tinsley House, Yarl's Wood and various other holding facilities, all under the control of the UK government in Westminster (rather than the Scottish government at Holyrood). 25,000 people are locked up without trial each year in these facilities at the cost, between 2013 and 2017, of £500 million.[8] As Harsha Walia argues, 'One of the sickest symptoms of neoliberal capitalist states is the subcontracting of incarceration to private companies.'[9]

This privatisation has been accompanied by a proliferation of border-policing techniques that extend well beyond the image of a singular line between nations: from the refugee camp at Calais to foreign aid agreements and the conversion of ordinary working people into border guards required to police,

surveille, refuse, and report. Priti Patel's advocacy for offshore detention follows Australia's opaque activities on Manus Island. As Walia puts it, 'The border is elastic, and the magical line can exist anywhere. Crossing the border does not end the struggle for undocumented people, because the border is mobile and can be enforced anywhere within the nation state.'[10]

At the entrance to the site is another sign. 'Welcome to Dungavel House Immigration Removal Centre', it reads, begging the question: who exactly is being 'welcomed' here? Who is this sign for? It bears the logo of GEO Group, the private contractors who profit from the detention of refugees and migrants. On Google Street View, you can still see the sign of the previous contractor: G4S. It points to the interchangeability of companies such as GEO Group, G4S, Serco and Mitie that run multiple arms of the globalised neoliberal state. The lie that governments and client journalists continue to peddle is that privatisation creates competition which in turn creates efficiency. In reality, many refugees are forced to waste their lives waiting for approval from a system that is grossly and willfully inefficient. 'In 1996', notes Shahram Khosravi, 'the average time of being a refugee was nine years. Today it is more than 20 years.'[11]

These interchangeable corporations function as hugely profitable buffers that enable governments to deny responsibility for their own incompetence/ atrocities and generate immense wealth for supporters and friends. The estimated net worth of George Zoley, GEO Group's founder and CEO, is at least $41.1 million.[12] During the last US election cycle, Zoley gave $514,800 to Trump's Republicans as well as $10,000 to Democrats, according to a report in the *Washington Post*. It states, 'According to the nonprofit Center for Responsive Politics, people and groups linked to GEO have given more than $1.7 million, mostly to Republicans.'[13]

As we walk up the access road, those who arrived by car wait to welcome us with cheers and applause. We've completed the walk. We are here, at last, in this half-hidden shadow place. But what does it mean – for us, for Iman, for those detained inside?

Midges surround us as Iman strides up the road, unfurls a flag, raises it to the sky. The gold and silver of the foil emergency blanket shimmers in the air, hangs, gusts a little. This flag has been a significant motif in Tajik's work for some time now, planted (as an act of triumph/revenge/arrival/solidarity?) in Scottish landscapes or hung to wave and rustle before a wind machine in the gallery at Stills, Edinburgh. As Iman himself has said:

> I want the flag to open up conversations about nationality and migration. I question nationality because of its association with borders. Borders divide; they are used as a tool for power and control, and can destroy freedom of

movement which is a basic human right. Freedom of movement exists but only for some people. It depends on your passport—if you are European or British you can travel easily. If you decide to go somewhere for work, for the weather, for love, you just go. So many freedoms. For other people, it is not the same.[14]

In the terminology of Vamık Volkan, a Turkish Cypriot psychiatrist known for his work in conflict resolution, the flag is a 'reservoir' of significance, a place where old meanings are preserved, around which communities converge or are forced to converge. Tajik leaves open what community his flag represents. As the climate crisis worsens, Iman notes, the numbers of refugees will increase. What if you were a refugee one day? Is this the flag you would rally around?

His flag is unusual. The colours and designs of most flags are usually chosen to symbolise some supposedly important aspect of a nation's history or geography such as green for fertility or red for blood. This flag is gold and silver. We might be tempted to speak about the construction of value under capitalism and about the extractive industries that have helped create conditions so dangerously intolerable that people have no choice but to flee. But Tajik's flag is, in fact, one of the emergency blankets which are often all that is given to refugees by way of shelter or 'welcome' . In a sense, we could think of Tajik's flag as an anti-flag. It is a material, not a representation. It is a thing with a function borrowed for a moment to serve as a flag for all those excluded by or opposed to the flags of nation states, armies, corporations.

At Dungavel, chanting erupts:

No borders! No nations!
Stop deportations!
Say it loud and say it clear!
Refugees are welcome here!

Iman tells me later that the chanting was partly planned in advance and partly a spontaneous act by the group. This feels important. As a communal walk, the work sets up a situation over which the artist's control is limited. Tajik does not tell us what to feel or think. But we feel throughout like a group. We/us not I/me. This speaks to an openness and generosity of spirit that infuses all of Tajik's work — a refusal to restrict how people engage, even when that leaves the work open to bad-faith responses by those who elect themselves to police who may walk in the Scottish landscape and what they may say and do here.

I hope that those inside Dungavel can hear us, that maybe it makes some small difference to know that not all people in Scotland share the voice of the state that claims to act in our name. We are implicated in the systems we

inhabit even as we oppose them. But people are fighting for change. Sophia Azeb expresses the importance of this kind of action better than I ever will:

[W]ith each grand, ebullient, tense, emotional meeting, we also open up the world a little for one another. We are able to prove to ourselves: we are not alone. We have come together here for you too.[15]

In lieu of a conclusion, here is Walia once more, whose every sentence is like Tajik's flag — a declaration to remember, a standard to rally around: 'A no borders politics... is a politics of refusal, a politics of revolution, and a politics of repair.'[16]

1 Leah Cowan, *Border Nation: A Story of Migration* (London: Pluto Press, 2021).
2 Alexandra Hall, *Border Watch* (London: Pluto, 2012).
3 Harsha Walia, *Border and Rule: Global Migration, Capitalism and the Rise of Racist Nationalism* (Chicago: Haymarket Books, 2021).
4 Susan Lanzoni, 'Empathy is, at heart, an aesthetic appreciation of the other', *Psyche* (10 August 2021) (https://psyche.co/ideas/empathy-is-at-heart-an-aesthetic-appreciation-of-the-other)
5 Joanna Rajkowska, *Suiciders* (2018) http://www.rajkowska.com/en/samobojczynie-2/
6 http://www.geogroup.co.uk/dungavel-house-irc
7 https://www.geogroup.com/FacilityDetail/FacilityID/88
8 *Border Nation: A Story of Migration*, op. cit.
9 *Border and Rule*, op. cit., 81.
10 Ibid.
11 Shahram Khosravi, 'Waiting Borders in Dictatorial and Bordering Regimes', *Funambulist* (Jul/Aug 2021).
12 https://gb.wallmine.com/people/34546/george-c-zoley
13 Nomaan Merchant, 'Private prison industry backs Trump, prepares if Biden wins', *Washington Post* (13 August 2020) https://www.washingtonpost.com/health/private-prison-industry-backs-trump-prepares-if-biden-wins/2020/08/13/a51c8f64-dd8a-11ea-b4f1-25b762cdbbf4_story.html
14 Sophie Suliman, 'Iman Tajik's "Bordered Miles"', *Bella Caledonia* (18 June 2021) https://bellacaledonia.org.uk/2021/06/18/iman-tajiks-bordered-miles/
15 Sophia Azeb, 'On Solidarity, In Solidarity', *Funambulist* (Jul/Aug 2021).
16 *Border and Rule*, op. cit., 214.

Tom Jeffreys, extract from 'Bordered Miles: In the Footsteps of Iman Tajik', *MAP Magazine* (2021). Available at https://mapmagazine.co.uk/bordered-miles-in-the-footsteps-of-iman-tajik

Katherine Bailey
Regina Galindo ¿Quien Puede Borrar Las Huellas? (Who Can Erase The Traces?)//2018

[...] Regina Galindo is a Guatemalan born performance artist who lives and works in Guatemala. Her work centres on the [country's history of] armed conflict: through the often shocking forms that this work takes, Galindo strives to have the violence of the past recognised and to evoke a response from her viewers. There are very clear elements of contest within her work: in *Tierra* for example, she stood naked in a field while an earth-moving machine destroyed the ground around her, to reflect the incidents in the conflict in which innocent citizens were murdered and their bodies buried in a mass grave. Her most well-known piece of work, however, and a piece in which this idea of contest is especially prevalent, is her performance *¿Quien Puede Borrar Las Huellas? (Who Can Erase The Traces?)*.

In 2003 it was announced that Efraín Ríos Montt had unanimously been selected as the presidential candidate for the Guatemalan Republican Front (FRG); this was despite the constitutional ruling that former dictators may not run for presidency. However, many Guatemalans did not meet Ríos Montt's presidential campaign with enthusiasm, with crowds even booing and jeering him when he turned up to vote at a school in Guatemala City.[1] Regina Galindo was living in Guatemala City at the time of this announcement. She stated in an interview conducted in 2006:

> I cried out, I kicked and stomped my feet, I cursed the system that rules us. How was it possible that a character as dark as this would have such power with which to bend everything to his will?[2]

It was this anger, and a desire to challenge what she considered to be a dangerous and corrupt decision, which led her to create the piece *¿Quien Puede Borrar Las Huellas?* As with the demonstrations, the violence of the past and the situation in the present are linked within Galindo's performance: both inspired the piece to be created. This performance entailed Galindo dipping her feet into a basin of human blood, and then walking the route from the Constitutional Court to the National Palace, leaving a trail of bloody footprints behind her.

When Galindo and I discussed the creation of *¿Quien Puede Borrar Las Huellas?* I asked her what she had been hoping to evoke with these footprints, what they represented. She told me that the footprints she created were 'in

memory of all the victims of genocide in Guatemala': they served as a literal reminder to all who saw them of the blood that had been spilt.[3] 'In this work, the line between Galindo's body as object and subject was so subtle that the blood covering her feet appeared to be her own; she embodied the war's victims, taking their blood as hers.'[4] For the disappeared, such an expression of the violence that was endured prevents their absence from being overlooked: Galindo wanted to remind people of the past through a physical statement.

The performance of this piece took around forty-five minutes. Galindo had the performance filmed, and later, curator Rosina Cazali circulated images of her performing with a text speaking out against Ríos Montt's presidential candidacy.[5] It is not known how long the footprints themselves lasted, but Galindo's focus was the performance itself and the message this sent rather than its longevity. Similar to Hernandez-Salazar's *Street Angels*, the original performance of this piece and its results were not intended to be permanent: it was created in order to communicate a key idea that rested, in part, on the location it was in. Although the piece was disruptive, while creating the footprints Galindo reported that no one interacted with her or questioned what she was doing. Even when she arrived at the National Palace and was faced with a line of police officers that were guarding its entrance, there was still no reaction.

She made two final footprints side by side at the main door and left the bowl of blood next to them. Galindo described that she felt 'eyes looking back at [her]' but that 'nobody followed me, nobody said anything.'[6] One might have expected her performance to cause more of a reaction in those who saw it, but given the concentration that Galindo performed with and the unusual nature of her act, onlookers were not encouraged to ask her questions; and although the police officers were positioned in front of the National Palace, Galindo made no attempt to threaten or damage the Palace itself or the people around it, so they may have been unsure about how to respond to such a performance, especially as they were being filmed.

What identifies Galindo's piece as an open and disruptive form of contest against the State, is not only the extremely provocative material that she used (although Galindo used human blood in her performance, the appearance of any substance that looked like blood would have arguably had the same impact) but also her use of space. The bloody footprints led directly to the Palace, and therefore to Ríos Montt, creating a powerful link between him and his actions during the civil war, and the blood of the footprints. Even if an individual were not familiar with the circumstances under which Galindo performed this piece, there can only be negative connotations drawn from witnessing bloody footprints leading up to the steps of the Palace. That the residents of Guatemala City would have been more than aware of the announcement that the former

dictator was planning to run for president makes the piece more effective, as the link is made between the route Ríos Montt would take if his bid was successful, and the violence he inflicted on Guatemala the last time he was in power.

As an act of defiance and opposition to the State, Galindo drew attention to the past that the government, and especially Ríos Montt, were hoping would remain ignored. She successfully made visible the 'stains of [Ríos Montt's] military actions upon the nation, kept out of view or washed away in collective memory'.[7] The disappeared and all the victims of violence were given a physical, tangible presence within the streets of Guatemala City. In doing this, she also openly contested the presentation of Ríos Montt as an honourable Statesman who was suitable to become president; similar to *Street Angels, ¿Quien Peude Borrar Las Huellas?* drew attention, and made visible, the perpetrators of past violence.

By reaching out and drawing on the past, Galindo presented an image of the danger such a presidency could bring in the future. 'Memory's recovery is, fundamentally, about power', and this is an idea that is clear to see in Galindo's performance piece.[8] She was recovering the past, Guatemala's violent past and Ríos Montt's role within this, in order to affect the process [of] power. By challenging the presentation that he gave of himself, Galindo was trying to take control over the past, away from former regime members, in order to influence the present and show people the crimes, deaths, and disappearances that Ríos Montt was truly responsible for. [...]

1 Tim Weiner, 'Guatemalan Voters Reject a Former Dictator', *The New York Times* (November 2003), http://www.nytimes.com/2003/11/10/world/guatemalan-voters-reject-a-former-dictator.html
2 Francisco Goldman, 'Regina José Galindo', *BOMB*, http://bombmagazine.org/article/2780/regina-jos-galindo
3 Interview with Regina José Galindo, 11/02/2015, by Katherine Bailey.
4 Guggenheim Collection, 'Regina José Galindo', https://www.guggenheim.org/artwork/artist/regina-jose-galindo
5 Francisco Goldman, 'Regina José Galindo', *BOMB*, http://bombmagazine.org/article/2780/regina-jos-galindo
6 Ibid.
7 Ara H. Merjian, 'Regina José Galindo: Piel de Gallina', *Frieze*, http://www.frieze.com/shows/review/regina-jose-galindo-piel-de-gallina/
8 Kirsten Weld, *Paper Cadavers: The Archives of Dictatorship in Guatemala* (Durham: Duke University Press, 2014) 19.

Katherine Bailey, extract from '"So That All Shall Know": Memorialising Guatemala's Disappeared' (University of Lancaster, PhD thesis, 2018) 155–61.

# Antje von Graevenitz
The Artist As a Pedestrian: The Work of Stanley Brouwn//1977

A walk usually has a destination, unless one decides to drift aimlessly. Little attention is paid to the actual steps; it all seems to happen automatically unless one is teetering on a mountain ridge, or negotiating a bog or muddy patch, or is afraid of crabs or snakes, or is exercising the muscles of the feet, or improving one's gait, or one's feet ache at each step. There are many ways of becoming aware of movements which one normally takes for granted, like the ones involved in walking.

During the past sixteen years the artist Stanley Brouwn has been placing this type of locomotion in different contexts, but always in formative ones, meaning that his intention is to refer to the fact that one 'forms' as one goes. One either changes one's environment visibly by changing one's position, or one changes one's ideas by imagining a particular walk. Both the actual steps and the imagined ones influence our relation to space and time – they 'form' it. Brouwn's maxim and motto for the first half of his total output is a summary of all the advice given to him by pedestrians whenever he asked them the way: *This way Brouwn.*

> Brouwn is standing somewhere in the world. He asks a random passer-by to show him on paper how to get another place in town. The next passer-by tells him the way. The 24th, the 2,000th, the 11,000th passer-by tells Brouwn the way. This way Brouwn. Every day, Brouwn makes people discover the streets they use. A farewell to the city, to the world, before taking the big jump into space, before discovering space. It is not the past but the future which has the greatest influence on our ideas and actions.

These words of Stanley Brouwn's are from an article which appeared in 1965 in Jürgen Becker's and Wolf Vostell's documentation under the title *Happenings, Fluxus, Pop Art, Nouveau Réalisme*.[1]

Brouwn's article fitted into this artistic development in several ways: it described an 'action' which did not take place in traditional cultural institutions but on the streets, requiring the 'creative' cooperation of anonymous pedestrians and assuming its form chiefly from the idea that the pedestrian must imagine the way from A to B and project it in his own words or by scribbling something on the piece of paper Brouwn held out to him.

Then you turn right, and then you go straight on. Then you go straight on. And then you turn right at that corner there. And then you turn right straight over the bridge. And you go straight on for a while. And then you get to the Jodenbreestraat, and you cross that. And then you come to the Hoogstraat, and you go straight up the Hoogstraat, across the Dam to the Post Office. Then you turn left into the Raadhuisstraat and you keep going straight on and then you cross some canals ...

Participation, imagination and finally the description of space and time in a summarised form (words or scrawls) – these were the new bywords for modern art in the nineteen sixties and seventies. And since Stanley Brouwn's contribution is not limited to a single work but consists of his entire output – apart from his first experiments which were scarcely exhibited at all – from 1960 up to the present, his work would indeed appear to be exemplary of the intentions and realisations of that period.

Stanley Brouwn was born in 1935 in Paramaribo, the capital of the former Dutch colony Surinam, and has been living since 1957 in Amsterdam, where he soon made contact with people like Armando, a member of the group of Dutch artists who at first worked 'informally', joining in 1960 under the name 'Nul' the European 'Zero' movement. Armando had tried to get Brouwn into the group, but in vain, despite the members' approval of Brouwn's work. This tells us something about their common aims: their rejection of a visible, personal signature of the artist, and their bias towards reality, which in art was to assume a 'new reality'. As early as the end of the 1950s, Brouwn was working on plastic constructions which embodied this principle: first in rough wood sculptures from which iron rods protruded, then in transparent polythene bags filled with all kinds of 'rubbish' and dangling from the ceiling. The work of art no longer illustrated anything on its surface but ingested the things it showed, which thus became identical with their image. Formulated briefly, this was their 'new reality'. It is chiefly French artists such as Arman and Yves Klein who became well-known in this development: 'nouveau réalisme' was founded in 1960 in Klein's house in Paris. Today hardly anybody realises that the movement was not restricted to Paris. Even before Arman emptied his waste-paper baskets into perspex boxes and dubbed them works of art, Brouwn had filled his art bags. However, they were aware of one another; Brouwn visited Arman in Nice. None of these early works seem to have survived: Brouwn destroyed them.

Still, this early work ought not to be quite forgotten, for what Brouwn subsequently regarded as his first work exhibits distinct links with the beginnings. This time the artist did not even make them himself. He laid sheets of paper down in the street and a random pedestrian or cyclist unwittingly

created a work of art. He became Brouwn's partner in creation. The dusty traces of shoes or wheels indicate an action; they halt time. It is a new process compared with the method of preserving painting actions with paint and brush (action painting), or by means of rain dripping onto a blue-painted canvas so as to record natural processes (Yves Klein's *Cosmogonies*). The shoe-prints had a ready-made character, just like the things in Brouwn's polythene bags; they were made in connection with the idea of a 'new reality'. These shoe-traces pointed the way to ideas and aspects which Brouwn pursued at various levels. There is therefore little sense in making chronological acquaintance with his work; it is better to deal with its various aspects. Large sections of his work can be summarised, for instance, under the heading of participation. This term covers one of the focal demands of the art of the 1960s.

Participation
The anonymous pedestrian proved to be a participator in the genesis of a work of art without being particularly active. He did not do anything special, he just walked on. This kind of participation changed when Brouwn selected a pedestrian at random and asked him to draw the way to a particular place on a piece of paper. The only thing the pedestrian had in mind was to do Brouwn a favour, but what he was in fact doing was giving shape to his ideas and projecting them onto paper: unskilled drawings consisting of loops, lines, circles, dots, arrows, crosses and street-names. The well-meant scrawls have a very personal effect, but they nonetheless express a way of thinking which anyone might have. Brouwn then added his motto to the projection: 'This way Brouwn'.

One of the inexorable consequences is that blank sheets of paper also counted as works of art. They, too, expressed a thought process: Brouwn had asked somebody the way to a place he had already reached: no way Brouwn.

These *This way Brouwns* resulted in a series of rules for making a work of art. Sometimes Brouwn 'played' along, but he usually opted for the role of the person who had made the rules and let the others play, as in the case of the *This way Brouwns*. This is what things were all about for the generation of artists at the beginning of the sixties: to activate the spectator.

Everyone who comes across a happening joins in, wrote Jean Jacques Lebel in his essay on happenings,[2]

> there is no longer any audience, actors, exhibitionists, spectators; everyone can alter his behaviour as he pleases. Each individual is turned over to his limits and transformations. No longer is he reduced to nothing, as in the theatre. There are no longer any 'functions of the audience', and no animals behind bars as at the zoo. No stage, no poetry, no applause.

The term 'happening' was at that time usually interchangeable with that of Fluxus, meaning volatile, flowing actions. Lebel made one mistake though; the participant had a function which is in no way different from that of the traditional spectator: he was supposed to be able to abstract and recognise the model character of the things he had experienced, to think about what he had helped to bring about. And, as we see today, there was indeed something resembling 'applause': for the person who had developed the idea of the game, in this case for Stanley Brouwn.

Tomas Schmit, a German Fluxus artist, made the following statement about Stanley Brouwn in the Aachen publication *Prisma 5* in July 1964: 'Stanley Brouwn is the only person to have made real actions.'[3] This verdict was based on Schmit's definition of an 'action', which he held to be an anonymous walk in which the observer, if present, is involved, totally unprepared.

Later, Brouwn himself explained to an interviewer: [4]

It is the search for the awareness we have of wide space, and the discovery of the city before we discover space. With these events I am trying to make something of what is going on have an effect on the spectators in terms of an action.

For a while things did not get any further than plans, but in 1964 in the Patio gallery in Neuisenburg there was an 'art-happening' in which Brouwn pulled a polythene bag over his head and sat down on a chair which he had placed on a pedestal in a corner of the gallery.[5] Again, as one could see, there was a distinct connection with his earlier sculptures, in the context of a 'new reality'. It is not known how visitors to the gallery reacted to this provocation.

During the 'Bloomsday 64' exhibition at the Dorothea Loehr gallery in Frankfurt in 1964 spectators threw banana peel at a girl lying on a bed. She then ironed the peel smooth at the same time reading aloud statistics of flies in various countries. While this was going on, Brouwn was driving around the streets of Frankfurt with 24-foot lengths of wooden planks on the roof of his car. From time to time he would swat at imaginary flies through the window.[6]

Perhaps the planks on his car were a reference to his early sculptural experiments with wood and iron rods, but what is more crucial for the development of his work if the imagination of a particular quantity, in this case the number of flies, and the aspect of simultaneous events. Both aspects keep on recurring later.

This fly-happening resembles another rule which, more strongly than before, is applied to the idea of an almost inconceivably great quantity:[7]

Brouwn Toy 4000 A.D.
(contents: a thousand billion toys)

INCREASE THE MICROBES AND VIRUSES IN THIS CIRCLE
5,000,000 times

O

GIVE THEM TO YOUR CHILDREN TO PLAY WITH
(do not use the BROUWNtoy before 4000 A.D.)

In that same year (1964) Brouwn formulated the participation role even more plainly than in the Bloomsday happening, this time for visitors to a Berlin gallery. He asked the guests at the opening in the Réne Block gallery to tell him the way through the streets of Berlin over a walkie-talkie. Once more the projection of the idea of space and time was involved, just as in the *This way Brouwns*, but the crucial difference was that these participants already knew that they were being involved in a work of art, this time in one which they had to create in their own minds. Brouwn, marching according to their instructions, was merely the 'projection surface'. He was a substitute for the paper on which the pedestrians once made their drawings.

The game can be reversed: Brouwn approaches a passer-by and immediately starts telling him how to get to another place in town. This way public. The reversal corresponds to the traditional relationship between the artist and his public, in which the artist always knew the way. It is not known whether Brouwn ever really turned the tables in this way, but in any case, 'no this way Brouwn without Brouwn?'[8] applies in both examples.

What was (and is) more important than the artist's authoritarian action towards the spectator was the creative collaboration of any participant whose action and/or imaginative powers are supposed to complete the work. For example, in 1969 Brouwn asked visitors to the Art & Project gallery to send him telegrams telling him what their respective ways from their homes to the gallery looked like. In 1971 he distributed little round self-adhesive labels to visitors in the Modern Art Agency gallery) at Naples. They could note down every change of direction on the labels on their way home. A year previously he had sent visiting cards to people asking them to send him maps of their home-towns. He distributed cards in galleries on which this request was printed:

> send me a poste-restante letter. send the letter to a city of your choice. any city on earth is o.k. write me (see address) to which city you sent the poste-restante letter.

Finally he sent his requests from a Danish beach in bottles. The only reply came from a man who lived on a lonely island with someone else. All these projects are based on the conviction that creativity, in terms of formative work, is

latent in everybody, the artist merely having to entice it out and guide it. The happening, the Fluxus movement, and kinetic objects of the sixties as well, were on the side of this ideology. Like Brouwn, most artists have turned away from the participation idea, which acquired a different emphasis, becoming orientated towards the spectator's active imaginative capacity, This meant that the spectator was no longer expected to abstract an action by means of his descriptions or scrawls, but the other way round: that the participant was to use his imagination to convert the abstraction back into action, for example the abstract projection of a stretch of road or a direction.

Stretches of Road
In a early 'work concept' of 1962, Brouwn had already proposed on a typed card

> a way across a field on exactly the same straight line from a to b: every day, a whole year long.

In this way a footpath would be made. The English artist Richard Long did this in Wuppertal for the collectors Mr. and Mrs Braun – in 1969 – in a flowering meadow which he then declared to be a sculpture. What Brouwn meant and means, however; was not an executed sculpture but the imagined forms: the printed one and the one in his imagination. There are astonishing parallels here between semiology and the plastic arts. It is not necessary for Brouwn's work that his concept be carried out; things are different in the case of the American artist Bruce Naumann, who in 1968 walked around in a square for a long time until it actually became visible. The aim is not the introspection of one's body with reference to space, not the body as material for a sculpture, but the forms of projection and their formation in the mind.

For example, in 1971 Brouwn set up a monitor in his Amsterdam gallery which showed a view of the opposite side-street. It was easier to dissociate oneself mentally from the model-like character of the stretch of road covered by each pedestrian on the screen than out on the street in real life.

The text under the monitor read:

> Walk from point a to point b.

For the *This way Brouwns* the following already applied:

> if I make a 'this way Brouwn' from a certain route, I think out this route with the help of the very simplest thing we have: the power of movement, movement as a source of our experience which can barely be reduced.[9]

The decisive aspect of this context is that Brouwn never leaves his spectator alone to wander around, meditating at will on an imaginary stretch of road. He marks the way with points. The concrete, 'scientific' aspect of his work is important to him. Or he supplies information as to the direction, potential starting points, the number of steps needed, the distance, scale or time required. He deals with direction in an entire series of works.

Direction
In 1970, using a wooden frame suspended from the ceiling of his Amsterdam gallery, Brouwn diverted the spectators away from the object in a different direction towards quite different forms that were not present.

A notice read: 'If you go in this direction, you will be walking in the same direction as x pedestrians on the Dam Square of Amsterdam at this very moment. A little path in a corner of the garden also indicated a certain direction. In that same year, astonished readers of What's On In Amsterdam read on the title page and inside the booklet[10] that if they went straight up the Kinkerstraat they would arrive in La Paz. Brouwn's exhibition at the Schiedam Stedelijk Museum[11] offered visitors similar journeys: white lines on the floor pointed the way to all sorts of cities in all directions of the compass. The catalogue suggested:

Walk	95 m	towards	La Paz
"	1 m	"	Rangoon
"	776 m	"	Havana
"	18 m	"	Helsinki
"	3 m	"	Georgetown
"	19 m	"	Seoul
"	65 m	"	Washington
"	2 m	"	Warsaw
"	74 m	"	Dakar
"	118 m	"	Khartoum
"	6 m	"	Tokyo
"	181 m	"	Dublin
"	233 m	"	Peking
"	16 m	"	New Delhi
"	4 m	"	Madrid
"	21 m	"	Montevideo
"	319 m	"	Berne
"	41 m	"	Brazzaville
"	20 m	"	Ottawa
"	8 m	"	Moscow
"	5 m	"	Guatamala

A text Brouwn had written six years previously reads almost like a statement on this:

> The Armada of streets, squares, alleys etc. is sinking increasingly deeper into a network of 'this way Brouwns'. All directions are being taken away from it. They no longer lead anywhere. They are trapped, caught in my work. I am the only way, the only direction. I have become direction.'[12]

Texts, markings, and photographs too can 'set imagination going', to coin a phrase. For instance, a photograph can help form an idea of a particular direction. Brouwn travelled to Tatwan in Turkey and aimed his camera along diverging railway lines ...[13]

Imagination is always concerned only with what is possible, e.g. with future actions. Brouwn clarified potential as an element of his art by referring to potential 'this way Brouwns'.

POTENTIAL STARTING POINTS

Any city on earth: a little piece of the earth's surface is crisscrossed by potential 'this way Brouwns'. The streets, alleys and squares (the brain of the universe) crisscross our brain. Every point is a trap. The way can begin anywhere. There is no way out. The ways smash us,

explained Brouwn in 1964.[14]

Potential starting points can be anywhere as long as there is a chance of being able to walk at all and to run away. In the Kargadoor youth centre in Delft in 1969, Brouwn indicated on a TV screen with a light-arrow where he suspected starting points to be. At the time films on space travel and a football match were being shown. That same year a photographic certificate was on sale at his one-man show in his Amsterdam gallery, showing a square section of the street in front of the gallery: a potential starting-point for a conscious departure from the gallery. In our society we usually let computers decide all potential matters. Although Brouwn does not permit this, he did formulate 101 questions for the computer on 101 pages of a book, rounding them off to the nearest number in the title: '100 this way Brouwn problems for computer IBM 360 model 95' (Köln, New York). Problem 101 is: 'show Brouwn the way from each point on a circle with x as centre and a radius of 100 angström to all other points.'[15]

A *This way Brouwns* can begin anywhere – anywhere there can be:

POTENTIAL PLACES

Stanley Brouwn's list of exhibitions begins in 1960 with an invitation card to an exhibition of all the shoe-shops in Amsterdam. If we relate this invitation to a broad context in art, we could classify it as Dada, new realism, the happening, Fluxus, pop art and – since it is merely text with a formal idea – even as conceptual art. Brouwn has both feet firmly in the middle of the general reform of concepts in art. However, such categories do not bring us very far, although a discussion on the qualification of classification into styles would be most interesting in the case of Stanley Brouwn. Not because it would be easier to understand his work, but because it would be easier to disentangle the definitions of art movements. Such a discussion would however take us beyond the scope of this article.

A little later, Brouwn started his *This way Brouwns*, and wrote about them:

A 'this way Brouwn' is a portrait of a tiny bit of earth. Fixed by the memory of the city: the pedestrian.[16]

An early statement, already plainly showing that even then Brouwn was primarily concerned with ways of imagining things. He soon proceeded actually to collecting pieces of earth. Somewhere in a city he would buy a square yard of land, or let someone give it to him as a gift.

Things should not be taken too literally, however. Perhaps they are registered in the land registry office, perhaps not, but why bother about trifles when imagination is involved? Brouwn called this project *Mother Earth*, of which after all he does own a few scraps: one square yard in Driebergen, Holland, another bit on a farmyard in Denmark (for which he paid ten Danish crowns), another somewhere in France, one on a farm near New York (price one dollar and a bottle of Dutch gin) and other square-yard sites in Japan, Belgium, Sweden and even in the ocean.'[17]

This makes Brouwn a world mini-landowner – ownership for the imagination. The sites are not fenced in but, wherever possible, their boundaries are marked by posts. From each piece of land, Brouwn can refer to others, can at all times evoke the shape of a particular place in space, and so can his 'spectators'.

Besides the distance, direction and possible starting points or places, intersections of two imaginary stretches of road can also indicate a fixed form for the imagination:

Crossings

In his Amsterdam one-man show in 1969, a little notice in the front window referred to a short post in the front garden: it was supposed to be the intersection of X and Y streets in an imaginary city. Such a link between object

and illusion is typical of abstract art in the 20th century: Kandinsky referred in his paintings to tensions and dissonances of a musical or psychic character, Mondrian referred in his pictures composed of lines and planes to a spiritual harmony, [Kazimir] Malevich with a black square on a white background to 'Nothing' and 'Something', and [Constantin] Brâncuşi with a pillar of serial rhombuses to the infinity of time and space. The conceptual art of the early-1960s also belongs, in accordance with its nature, to abstract art, but the visual projections have been transformed in the meantime: Stanley Brouwn requested visitors to his 1970 exhibition in Mönchengladbach (Germany) to cross intentionally the cosmic rays in the rooms of the museum. Compared with the illusion of something imaginary, everything that is present is likewise concrete, regardless of whether a picture of geometric shapes, of figurative objects or a text consisting of comprehensible terms is involved. Perhaps the most important and primarily concrete unit for an imaginary journey is the step, because we relate it to concrete physical experience. By means of steps we experience changing space and time in ourselves.

Steps
'I count my steps in the context of a particular project', Brouwn explained to a fellow-walker,[18] 'and I count my steps in countries, cities and villages where I have never been ...' What everyone finds quite commonplace becomes special when the number is stated. Brouwn works as a kind of catalyst. The way he counts his steps is expressed in very different forms. In 1972, for example, he printed on a card: '18,947 steps, the number of steps counted in one day.'[19]

The reader can convert the number in his mind back into a chain of steps. Steps or numbers are the serial elements in Brouwn's work, just as others make use of circles or squares. The precise number of steps is not always stated. The spectator is supposed to imagine the potential number. It has even been put on exhibition: in 1971 in Frangoise Lambert's gallery in Milan: *My Steps in Milan*, and shortly afterwards in the MTL gallery in Brussels: *My Steps in Brussels*.

At the 1972 Documenta 5 in Kassel, Brouwn showed for the first time grey filing cabinets, each filled with a certain number of white cards. One of the cabinets contained 1,000 cards, the construction of a walk consisting of 3,000 steps, the length of the strides being between 840 and 890 millimetres. What could be seen were the definitely sobering filing cabinets. However, on leafing through the cards, the spectator embarked on a foot-journey in his mind through an undefined space with a predetermined number of steps.

Once, in front of 1,000,000 spectators, Brouwn concentrated on just one step. For a series of artists' films entitled *Identifications* produced by the television gallery of Gerry Schum and transmitted on Baden-Baden 1 in 1970 and later in the Netherlands,[20] Brouwn filmed the view from the square in front of the Hotel

Americain in Amsterdam towards the theatre of that city, the Stadsschouwburg, holding the camera quite still. Then the picture wobbled. Brouwn had taken a step forwards. The picture had come one step closer to the viewer.

Indications as to time, space and quantity are units of measurement for Brouwn's work on paper and in our imagination. Both comparisons are valid. A straight line on paper can mean the projection of several steps on top of one another, in the mind the compressed form is converted back into action. A little strip of paper on the table is then the standard for a much larger step, and three similar drawings each with ten vertical lines one centimetre apart become 'dissimilar' because of Brouwn's captions: under two of them he writes 2m and under the third 1m. The observer may decide which of the two forms he wants to keep to. Other examples of deformation can be seen in two works from 1974: Brouwn drew lines forming borders on three sheets of paper, each line denoting the length of a step. When the pictures are hung close together, a continuous movement can be imagined. The border-line indicates this movement. As soon as the border-lines in a second work are one metre long, they no longer refer to steps but to the ideal measurement of distances. They need no longer represent a continuous movement. When the pictures are hung in a disconnected fashion, the measurement indication and the form in which they now hang deforms an originally conceived idea into another one,

At a first glance, then, Brouwn's work appears to be very concrete, even self-evident.

Only at a second glance does it become clear that he relativates concepts and representations, ironifies them and thus deforms them.

An artist who, like Brouwn, decides to accept the collaboration of anonymous 'creators' and not that of trained apprentices as did earlier masters in their studios, must take chance into the bargain.

Chance and Randomness

His *This way Brouwns* were not the first impulse towards 'laissez-faire'. The Dutch writer K. Schippers owns an early Brouwn from before 1960: a duster divided into sections.[21] Brouwn placed price labels in each section. What other meaning could these labels have than that the dust should gradually 'form' a different picture in each section? It was not the first time that an artist had worked with dust. Marcel Duchamp 'painted' the funnel of his *Large Glass* (1923) with dust instead of paint, but Duchamp did not emphasise the random character of settling dust as conceptually as Brouwn did.

Brouwn realised later on that the size of his steps was also a random quantity. Of course he could make an effort to keep them of as equal length as possible, but that would result in boringly similar forms.

In 1972 he published a book called *Construction* in which he noted the extremely varying size of his steps: 857mm 877mm etc.[22] Each page of the book looks like a different serial picture made of rows and columns of step-lengths. Just as the 'homogenous' surface of the picture summarises steps that were once continuously executed on the pages of a book, time is similarly compressed: in one instant one can see what actually happened successively in time.

Time-Moments

The duration of the creation of a 'this way Brouwn' is precisely limited, in contrast to what was previously generally done in art. There is no adjusting, no measuring, no rounding-off or embellishment of the result. The time Brouwn really needs to walk from A to B is compressed in the explanation-time of the passer-by in the street.[23]

Brouwn defines this explanation-time more closely: 'At the moment of explanation the situation is still in the future.' 'He' (the pedestrian, author's remark) 'makes a jump in time and space.'[24]

Years later Brouwn added two more time themes to that of compressed time with which he had been occupied earlier. He applied them particularly in works executed after 1969:

Simultaneity and Infinity

In *Bulletin* 11 of the Art & Project gallery he advised the reader: 'walk very consciously in a certain direction for a few moments, and simultaneously an infinite number of living creatures in the universe are moving in an infinite number of directions.'[25] At the Dusseldorf exhibition 'Prospect 69' Brouwn showed circles, providing them with printed captions such as:

Walk very consciously in a certain direction for a few moments; simultaneously a certain number of microbes in the circle are moving in a certain number of directions.

Later, in 1974 for the first time, he no longer regarded infinity as a number, but as an infinite distance in space and time. One of his card-concepts read:

a: distance 1: ∞; b: 1m 1:1°/a distance defined as (a) distance 1: ∞ and (b) 1m 1:1°.[26]

Brouwn 'simultaneously' compares what is ordered with what is unimaginable, and consequently what is not ordered, what is actual, with what is imaginary. This

comparison results in a relativation or even deformation of possible individual positions. The scope is wide: the extremes meet in Brouwn's work, the least valid and the infinite. All references are nonetheless logical and very easy to understand, because they are interdependent. 'It is not impossible', Stanley Brouwn wrote for the television announcer's introduction to his film *A Step*, 'it is even very probable that I shall be able to summarise all the projects I shall ever carry out in my life under one title, which would be: "We Walk on the Planet Earth"'.

1 Jürgen Becker and Wolf Vostell (eds.), *Happenings, Fluxus, Pop Art, Nouveau Réalisme. Eine Dokumentation* (Reinbeck bei Hamburg: Rowohlt, 1965) 154. Also in: Hugo Claus, Ivo Michaels, Harry Mulisch and Simon Vinkenoog (eds.), *Manifesten en Manifestaties 1916–1966, Randstad*, no. 11–12 (Amsterdam: Amsterdam Bezige Bij, 1966) 166.

2 Ibid., 12–13.

3 J. Bernlef, K. Schippers, *Een Cheque voor de Tandarts* (Amsterdam: Querido, 1967).

4 *De Tijd* (30 June 1969).

5 *Happenings*, op. cit.

6 *Een Cheque voor de Tandarts*, op. cit., 171.

7 *Happenings*, op. cit., 153.

8 Ibid., 156, cf. *NRC Handelsblad* (13 March 1971).

9 *De Tijd* (30 June 1969).

10 *Weekprogramma Amsterdam* no. 16, 3–13 December 1970.

11 Catalogue Stanley Brouwn, Stedelijk Museum Schiedam, 14 February–16 March 1970.

12 Stanley Brouwn, *This Way Brouwn: Zeichnungen 25-2-61 26-2-1961*, (ed.) Gebrüder König (Köln and New York: Verlag Gebr. König 1961).

13 Several works from this series exist: for example, Brouwn filmed the diverging railway lines from the train and later projected this film from a Volkswagen bus in motion onto the streets of Munich. His film remained as a document. At an exhibition in the Aktionsraum I in Munich there was a book entitled *Stanley Brouwn: x - Tatwan* (München: Aktionsraum I, 1970).

14 *Een Cheque voor de Tandarts*, op. cit., 174.

15 [Editors' note: a measure of displacement equal to 0.0000000001 metre (10^{-10} m). It is sometimes used to express wavelength s of visible light, ultraviolet (UV) light, X rays, and gamma rays. https://www.britannica.com/science/angstrom]

16 [Footnote 15 in source] *Een Cheque voor de Tandarts*, op. cit., 175.

17 [16] *Haagse Post* (10 September 1969).

18 [17] *NRC Handelsblad* (13 March 1971).

19 [18] *Stanley Brouwn* (exh. cat.) (Eindhoven: Van Abbe Museum, 1976).

20 [19] The film was remade with the title *A Step* for the Foundation Openbaar Kunstbezit (February 1971, 15th year). Before it was broadcast, the announcer explained that at the same moment that the step was being broadcast, Stanley Brouwn would repeat the step live at the same time, the same place and in the same direction.

21 [20] *Algemeen Handelsblad* (11 October 1969).
22 [21] *Stanley Brouwn, Construction* (Amsterdam: Art & Project, 1972).
23 [22] *Een Cheque voor de Tandarts*, op. cit., 173.
24 [23] Ibid., 174.
25 [24] *Stanley Brouwn: Bulletin 11* (exh. cat.) (Amsterdam: Galerie Art & Project, 1969) 30 September–12 October 1969.
26 [25] *Stanley Brouwn* (exh. cat.) (Eindhoven: Van Abbe Museum, 1976) no. 108. It is interesting in this context to note that in 1970 Stanley Brouwn proposed a plan for an eternal film to one of the organisers of the 'Sonsbeek 71' exhibition, Frans Haks. The camera was to film events in a street without a break, 'from day to day. from year to year etc.' This film should only be shown to one spectator, and was supposed to make the room in which it was shown into an environment in which the film was to be projected from the ceiling onto the floor. The spectator would not have to watch the film continuously, but it would be crucial for him to regard the filmed street-situation for his own. Brouwn even went so far as to suggest that his spectator be 'exhibited' while watching the film.

Antje von Graevenitz, '"We Walk on the Planet Earth" The Artist As a Pedestrian: The Work of Stanley Brouwn', *Dutch Art + Architecture Today*, no. 1 (June 1977).

Isobel Parker Philip
Score For a Measured Walk//2023

Beset by Relentless Administration

Etched into a slab of marble in the wall beneath the arcade at 36 Rue de Vaugirard in Paris is the last remaining original reference metre. The slab sits slightly proud of the wall and is capped by ornamental edging. Beneath the inscription 'MÈTRE', two horizontal lines have been gouged into the marble, book-ended by protruding pieces of metal. Small incisions subdivide the horizontal band into ten sections, and within those subdivisions, on the right, are further subdivisions of ten, indicating the length of a centimetre. To the left of the slab, slightly above its datum, is a plaque with the heading 'MÈTRE ÉTALON'. *Étalon* roughly translates as the 'standard of measure', while the word 'metre' itself is derived from the Greek term for measure. The measure of a measure. The authority.

This metre was installed along with 15 others between 1796 and 1797 after the Académie des Sciences had proposed this new system of measurement in March 1791. Placed on busy streets, these public metres set the new benchmark for quantifying length. They were intended to be checked against and replicated in order to collectivise an understanding of distance. They were a civic offering

designed to codify a sense of space.

In pre-revolutionary France, before the introduction of the metre, it is thought that around 250,000 different weights and measures were in concurrent use, causing certain frictions among those trying to buy and sell and commission goods. The metre was meant to instill order.

Those pre-metric measuring systems, some of which remain in use today, were often based on readily quantifiable references. A 'yard' is etymologically related to branches, twigs and rods, a 'furlong' to the distance that an ox could plough without a rest, while a 'foot' is self-explanatory; an anatomical allusion but also an enduring example of encoded bias, in which the 'norm' is presumed to be able, adult and male. The metre had loftier aims. It was to be one ten-millionth of the circumferential distance from the Earth's pole to its equator, calculated against the measurement of a ten-degree segment of the meridian of France. A reference point, unlike an arm's length, that is literally beyond our reach.

The metric mandate was one of King Louis XVI's final decrees before the revolution. Napoleon then embraced the endeavour. 'Conquests come and go, but this work will endure.'[1] It was bigger than revolution.

And yet, the metre on the wall in Paris, this measure of a measure, was, merely – technically – provisional. It was selected from a set of prefabricated lengths as the one that most closely matched the measurements taken during the expedition to measure the meridian, a pursuit helmed by two French astronomers, Jean Baptiste Joseph Delambre and Pierre François André Méchain under the direction of the Académie des Sciences. The phrase 'most closely' sits at odds with the sense of exacting finitude the *mètre étalon* conjures, undermining the notion of an 'objective standard'.

There is a subtle poetry in the idea of a provisional metre. In the idea of the 'almost exact'. It is a poetry that Australian artist Sara Morawetz is attuned to as a practitioner with a long-standing interest in the tensions that bind the social and the scientific. It is a poetry Morawetz amplified in her epic performance work *étalon* (2018) which retraced the steps of Delambre and Méchain's journey, or as much of it as possible. While Delambre and Méchain travelled via carriage, Morawetz went on foot.

[This is the work]

Across 112 days, Morawetz walked 2108.7 km. As she walked, she saw the seasons change from summer into autumn. She saw the subtle shifts in the landscape between the north and the south of France, and on into Spain. Delambre and Méchain had support teams while Morawetz carried all her provisions on her back, relying on the towns she passed through for food

and shelter. Her path, at points, dovetailed with established walking tracks, frequented by day trekkers, and with those taken by pilgrims. But at other times, her route encountered roads that were never intended to be navigated on foot.

These small steps amassed

Well before she set out on 25 June 2018 from Dunkerque, 226 years after Delambre and Méchain, Morawetz took her first step. In 2016, she wrote:

> Score for a measured walk
> Walk the meridian arc from Dunkerque to Barcelona
> retracing the steps taken by Méchain and Delambre
> to define a metre. Based on your own measurements
> recalibrate the metric system creating a 'metre'
> of your own making.

Morawetz didn't write a script, or a scheme, or a timeline or a plan of action. She wrote a 'score'. A score is many things. It is a tally of points within a game. It is a fine, straight line incised into a surface. And it is a form of music or dance notation.

A score, in performative contexts, is a set of directives for a sequence of actions such that they can be re-performed. A piece of music or a dance that is performed only once is simply an improvisation. If it is to be performed again, it needs to be translated into communicable instructions. But no performance is ever identical. A score offers an approximation, but there is always room for the variability of interpretation. Much like a provisional metre.

> The bind of actions within actions.
> You cannot rest – you cannot stop.

Morawetz's walk was already a re-performance. An echo, but not a faithful 're-enactment', of Delambre and Méchain's expedition. Hers had its own tempo and its own rhythm, one foot after the other, a heavy pack thudding against the lower back. A metre, after all, is another name for a rhythmic pattern. Morawetz was mapping in more ways than one.

> I've brought you
> along for the process
> of building
> The messy and imperfect act
> of assuming form.

Unlike Delambre and Méchain, who only attempted half the journey each, Morawetz travelled from point to point, end to end. The intent wasn't oppositional. She had companions, but they walked alongside, not towards her. They were, almost exclusively, women. This was a deliberate choice, an acknowledgement of how women have been excised from scientific histories. Too emotional for objective reasoning. *Étalon*, after all, is another name for a stallion.

Across the journey, 12 women joined Morawetz for different week-long legs of the journey,[2] as well as her husband and collaborator, mathematician Darren Engwirda, who accompanied her on the first week and helped devised a system to measure the size of the Earth from which her new metre measurement could be extrapolated.[3] Others participated remotely. Morawetz chronicled the journey in real time on the project website and Instagram and at two stages of the walk she sent email dispatches with fragments of prose composed en route. In the emails, these episodic observations were laid out as an uninterrupted list, each entry numbered, like an inventory of introspection.

Beyond the performance of the walk itself – a performance only witnessed in person (and in part) by a few people – the artwork is constituted by the accrual of information. And indeed, as with many performances, that is what endures. The text fragments that appeared in the emails were converted to small text cards, post-performance, so they could be displayed for exhibition. As transcriptions of the physical impact and felt reality of the journey, these texts constitute a performance archive.[4]

An accumulation of emotion. / Thin skin rubbed raw.

The texts have a very different cadence to the 'score' Morawetz penned pre-performance. They feel immediate and urgent, not precise and 'measured'. And yet, they also form a kind of notation. A record of an action such that it can be re-accessed and experienced. They are another kind of score.

[You must measure and be measured]

The word 'score' derives from the Old Norse *skor* which refers to a mark or an incision in rock, possibly to keep a numerical record – of a flock of sheep, say. A *skor* is a self-contained dataset, a mode of measurement.

Morawetz's own record keeping was comprehensive. In addition to the text fragments compiled on scraps of paper or drafted as text messages, she sent field reports to the Musée des Arts et Métiers in Paris each day. These daily dispatches

outlined the temperature, humidity, distance travelled, cumulative distance, provisional metre length from the daily measurement and other observations. The other kind of data the walk yielded was not as readily contained. The throb in the legs, the aching back, the 'accumulation of emotion'. All this feels very close to the surface when Morawetz describes the experience, almost five years on.[5]

When you score a piece of paper or a piece of wood or a slab of stone you aren't meant to cut all the way through. You're just meant to pierce it, leaving a mark but not breaking the form. Like the line that demarcates the metre, with its notched subdivisions, on the slab of marble in Paris. Morawetz's own body was marked, was scored, by the walk. She wasn't just recording the metre's measurements; she was recording what the metre felt like.

This is it.

This is what it feels like.

In spite of the fact that the meridian on which the metre is based is longitudinal, running from North to South, the metre itself is often represented as a horizontal bar – or at least that's how it's defined on the streets of Paris. This might be a matter of ease and access, but it also aligns neatly with how many people are taught to see and experience space. Space as the distance laid out before us, on a horizontal plane.

Time spent trying to reach the horizon

There is here a widespread assumption that humans experience space as horizontality. That while we may engage with ideas of verticality, when we look at a map or fly in a plane or ascend a great height, the way we cognitively inhabit space – the way we perceive it – prioritises the lateral span. When we get to the top of a mountain, we reach a lookout. But this is not true of all cultures. Single point perspective is a Western construct that disavows alternative views. The ascendancy of the horizontal vantage point is intimately embroiled in ideas of control and possession. The subject is centred; the landscape laid out before them; the King surveys his territory.

The invention of the metre is part of this story. Its adoption beyond the borders of France was enabled by, and enmeshed in, colonisation. The metre was a tool used to exert influence over how people experience space at a granular level.

The end was always an abstraction.
A flat thing — no more than a surface.

During our call, Morawetz quotes American critic John M. Culkin: 'We shape our tools, and thereafter our tools shape us.'

The lateral span – the ongoing horizontality – is what Morawetz wrestled with each day. What she pushed through, and into and towards. On her march, the metre's connection to control was keenly felt.

The forces and constraints in constant motion.

The uncontrollable — the elemental —
the emotional.

The work is all of these things for you ...
[and for me also]

What was her horizon? Her hypothesis?

Morawetz's metre was more accurate than the one determined by Delambre and Méchain, whose measurements, it would later be revealed, were compromised from the beginning. The discrepancies in the data are thought to have sent Méchain mad.[6] Morawetz's attempt was, then, an unmitigated success. But that wasn't really the point.

It is the subtlest shift in perception:
what if you get there after all?

The standard length of the metre is no longer calculated against the circumference of the earth. Instead, it's determined according to the speed of light and the length of a second. It has crossed disciplines; a measurement of space now based on a temporal marker. The literal length proved to be too variable, too risky, for the measure of a measure. Of course it did; it implicated the body.

Morawetz reoriented the narrative by bringing the body back in. Hers was a methodology of repeat and return that didn't just allow for variability, but welcomed it. Experiment and experience are, after all, sibling terms. Science has a hard time reconciling the body and its vulnerabilities, its accumulation of emotion, within the framework of objective fact. But, as Morawetz reminds us, the two are often embroiled and intertwined. They score one another. We shape our tools, and thereafter our tools shape us.

My body knew even if my mind did not.

1 Ken Alder, *The Measure of All Things: The Seven-Year Odyssey and Hidden Error that Transformed the World* (New York: Free Press, Simon & Schuster, 2003) 3.
2 Morawetz's walking companions were: Boni Cairncross, Alex Pedley, Kath Fries, Laura Hindmarsh, Lucy Parakhina, Magali Duzant, Connie Anthes, Chantel Meng, Sharne Wolff, Stephanie Brotchie, Angela Lopes, along with Darren Engwirda.
3 This system differed from Delambre and Méchain's approach which relied on triangulated measurements made accumulatively during the journey.
4 The indented, italicised texts that appear intermittently throughout this essay are taken from Morwawetz's emails and the associated text cards.
5 Conversation with the artist, June 2023.
6 For a detailed account of Delambre and Méchain's expedition, see Alder, 2003.

Isobel Parker Philip, 'Score For a Measured Walk', a new text written for this book, 2023.

Kathleen Jamie
A Lone Enraptured Male//2008

A situation has arisen on Ben Nevis. I don't mean a rescue, although as it happens the RAF and mountain rescue teams are bringing down a man and two boys who, the report says, 'didn't read the weather forecast'. The situation I have in mind has also arisen on Snowdon and Scafell, and it concerns the dead. Apparently, the biggest hills are covered in so many memorials – plaques and little cairns – that it's becoming an issue. These are not memorials to people killed on the hills necessarily, though there are those too, but to those who felt some affiliation with the outdoors. Furthermore, so many people's ashes are being scattered on the summits that it's changing the chemical balance of the soil, fertilising it with phosphorus and calcium, to the detriment of rare alpine plants.

 A delicate issue. The John Muir Trust and the other owners of the land around Ben Nevis have constructed a 'Memorial Site for Contemplation' at the foot of the mountain, and are removing the memorials from the open hill. As for ashes, well, the Nevis Partnership says: try throwing them into the air on a windy day, or into a corrie so they disperse more widely, or under a tree on the lower slopes.

 I should imagine that people who want to scatter someone's ashes on a mountain, or leave a memorial there, do so because they consider a 'Memorial Site for Contemplation' municipal and tame. It's just what they'd be seeking to avoid. And the problem with the plaques? They're being removed because

they are 'intrusive'. One person's loving memorial, however discreet, is another person's intrusion. What it intrudes on is the other person's sense of 'the wild'.

The John Muir Trust, which has now bought eight estates in Scotland, has a remit to 'protect wild land'. By 'wild', I think is meant openness, expansiveness, that sense of land, as Willa Cather wrote, which is 'nothing but land: not a country at all, but the material out of which countries are made'. But does this 'material' exist any longer? Is there any 'wild land' in this congested country, if it's on the scale of landscape and requires protection or, worse, 'management'? The various quangos, charities and interest groups (the John Muir Trust, the RSPB, Scottish Natural Heritage, the National Trust, Natural England, all that kind of thing) are forever managing and intervening. Many of their interventions are designed to undo or ameliorate previous interventions: to remove footpaths, say, or dismantle cairns or plant forests or reintroduce species now locally extinct. (I think 'nature', 'natural' and 'wild' are almost synonymous here, though 'wild' ups the rhetorical ante. A dandelion poking up between paving slabs is natural and wild – and cheeky and subversive – but it doesn't carry that special wide-eyed sense of 'wild'. In the wild, size matters, or so it seems.)

It would be too easy to scorn this notion of the wild as precious and romanticised. In big landscapes, to see wildness might require a suspension of disbelief, like at the theatre. But, I admit, only those of us privileged to get there can bore on about how unwild the wild places are. Last year I took *The Wild Places* with me to St Kilda and to Mingulay. Both islands are now uninhabited and St Kilda is, of course, an icon of remoteness. But I never read a line, even when it rained. I was with friends and we were too busy. There were too many birds and basking sharks to watch, too many ruins to explore and projects to help with, too much conversation, too many general comings and goings, boats and helicopters. It's different in winter, but St Kilda is busier on a summer's day than many mainland places, what with the radar base and the cruise liners.

There's nothing wild in this country: every square inch of it is 'owned', much has seen centuries of bitter dispute; the whole landscape is man-made, deforested, drained, burned for grouse moor, long cleared of its peasants or abandoned by them. It's turned into prairie, or designated by this or that acronym; it's subject to planning regulations and management plans. It's shot over by royalty, flown over by the RAF, or trampled underfoot in the wind-farm gold-rush. Of course there are animals and birds, which look wild and free, but you may be sure they've been counted, ringed maybe, even radio-tagged, and all for good scientific reasons. And if we do find a Wild Place, we can prance about there knowing that no bears or wolves will appear over the bluff, because we disposed of the top predators centuries ago, and if we do come unstuck there's a fair chance that, like the man on Ben Nevis, we'll get a mobile signal, and be rescued.

Wild is a word like 'soul'. Such a thing may not exist, but we want it, and we know what we mean when we talk about it. And yes, we're drifting here towards the religious. When we want to scatter someone's ashes in a wild place, we know the kind of place we're looking for. Further: we know what the wild is because we're making small acts of reparation towards it. It's noble to reintroduce species once persecuted into extinction, albeit as part of a management plan. Once reintroduced, though, they might show signs of being a bit self-willed: white-tailed eagles have an eight-foot wingspan. Recently, one took a flight round the Asda car park in Dunfermline. People were so alarmed they called the police.

If there's a breath of wild at Asda, in the furthest flung places you might find sweet and poignant domesticity. On the beautiful, stormy, truly remote island of North Rona, forty miles north of Lewis, everyone died: there had been a community there for a thousand years, but all at once they died, possibly of starvation, possibly of smallpox, which was the scourge of the islands. But that was in the 17th century. No one has really lived there since. What remains on that tiny outpost catches at your heart: ruined homes, field systems, an ancient graveyard and a saint's cell. Conversely, wild places can be surprisingly close. Willa Cather's land was Nebraska: she had the settler's sense of a country yet to be begun. In the UK, empty land could be material we're finished with. My own forebears were coalminers. A couple of years ago I went to visit the settlement where they spent a long century, several generations of them, high on the Ayrshire moors. What astonished me was not the open-cast mines – there were those as well, great gouges in the earth – but the beauty of the place. Miles of sunlit moor, a huge sky, distant hills, marsh harriers, lapwings, everything. The settlement of five hundred people had been squalid, despite the women's constant toil, and now it has been wiped, as they say, from the face of the earth, and the land restored.

Wild and not-wild is a false distinction, in this ancient, contested country. The contests are far from over. When the wild is protected by management, or re-created by the removal of traces of human history, you have to ask, who are these managers? Why do conservationists favour this species over that? Whose traces are considered worth saving, whose fit only to be bulldozed? If the landscape is apparently empty, was it ever thus? There is more to the history of Irish and Scottish emptiness than the piteous romance of the Clearances or the Famine. And if we read about 'nature' or wild places, it pays to wonder, who's telling me this, who's manipulating my responses, who's doing the mediating?

Still, there are empty places, hill and moor and island out there, where, if you're minded, you can meet no one else for a while, see nothing 'intrusive' and have all the challenging, solipsistic experiences you please. As more land

is wrested from private ownership, more people can have more solipsistic experiences more often, if that's what they want. But it's only recently that we, with our (almost) guaranteed food supplies, motor engines, vaccines and antibiotics, have begun to make our peace with these wild places, and to seek recreation in land which was once out to kill us, where we can be reassured, in some way, by something we fancy is bigger-than-us, and which, unlike the Christian god, is indifferent to our antics.

So there are theatrically empty places, let's call them 'wild' for short, but they're also contested, politicised, occasionally dangerous, peopled by ghosts – miners' wives or the wandering monks who capture Robert Macfarlane's imagination in the opening pages of his book. Our push and shove with the land is far from over; in fact you might consider the whole present consumerist extravaganza to be rage against the land, the ties that bind.

All of this is preliminary to the admission of a huge and unpleasant prejudice, and here it is: when a bright, healthy and highly educated young man jumps on the sleeper train and heads this way, with the declared intention of seeking 'wild places', my first reaction is to groan. It brings out in me a horrible mix of class, gender and ethnic tension. What's that coming over the hill? A white, middle-class Englishman! A Lone Enraptured Male! From Cambridge! Here to boldly go, 'discovering', then quelling our harsh and lovely and sometimes difficult land with his civilised lyrical words. When he compounds this by declaring that 'to reach a wild place was, for me, to step outside human history,' I'm not just groaning but banging my head on the table.

Is this fair? Well, no, of course not. The 'outside human history' bit was just an opening gambit – or a brave admission – and he will graciously recant in due course. But there is a lot of boldly going. Mostly alone, occasionally in the company of his friend and mentor the late Roger Deakin, Macfarlane made a series of highly researched journeys into the British and Irish landscape seeking those places 'not on the road map', seeking the 'glimmerings of a wild consciousness'. These places range from the summit of Ben Hope in Sutherland, to the Cuillin of Skye, to Glencoe, to the Burren in the West of Ireland, to the sunken lanes of Dorset and the Essex salt marshes. It's an exciting and liberating variety of terrain, the trips are well planned and thought through, an awesome amount of reading has been done. Everyone will find somewhere they haven't been. I was intrigued by the Holloways, the old sunken lanes of Dorset, and by the beaches of Suffolk, because they're faraway places to me; now I feel I know secrets about them. The book is organised in a refreshing way, which accentuates and almost deifies the land-types: moor, ridge, cape, salt marsh, beechwood etc.

Very fit, a highly competent mountaineer who certainly reads the weather forecasts, Macfarlane participates in these places by swimming, climbing,

skulking under hedges, walking by day and night, in sunshine and snow. He sleeps outdoors wherever possible, on hilltops and tors and sand dunes. It's dashing stuff – he admits to a liking for John Buchan.

Energetic and keen, his imaginative attachment is to the benign fugitive, and to the lone male. The book opens with a consideration of the early Christian saints who went off to islands in search of some spiritual resource. They were not the first to venture to these remote places, far from it. For thousands of years Mesolithic groups, extended families probably, came and went with the seasons, then Neolithic farmers, and so on. The early Christian monks would have been the first literate people in this country and the first we know of to seek out remote places qua remote for some spiritual quest. Literature began with them, and a tradition developed which has persisted ever since and remains largely uninterrogated: the association of literature, remoteness, wildness and spiritually uplifted men. It must be connected with the elevated tone characteristic of so much nature writing.

Here is Macfarlane swimming at Ynys Enlli, off Wales.

I dived in. Blue Shock. The cold running into me like a dye. I surfaced, gasping, and began to swim towards the cliffs at the eastern side of the bay. I could feel the insistent draw of the current, sliding me out to the west, back toward Enlli. I swam at a diagonal to it, to keep my course.

Nearing the cliffs, I moved through different ribbons and bands of temperature, warm, then suddenly cold again. A large lustrous wave surged me between two big rocks, and as I put a hand out to stop myself from being barged against them, I felt barnacles tear at my fingers.

I swam to the biggest of the caves...

And here – I open the book almost at random – in the Black Wood of Rannoch in Perthshire:

I wandered in the wood all that day, tacking back and forth, following rides, moving through its dozens of covert worlds: its dense and almost lightless thickets, its corridors and passageways, its sudden glades and clearings. I leapt streams, passed over sponge-bogs of sodden peat, soft cushions of haircap mosses. There were big standing groves of green juniper, alders, rowans and the odd dark cherry. The pines, with their reptilian bark, gave off a spicy resinous smell, and their branches wore green and silver lichens of fantastical shapes: antlers, shells, seaweeds, bones, rags. Between the trees grew heather and bracken. I climbed a whippy rowan, scattering its orange berries in all directions, and a tall old birch that shivered under my weight near its summit.

At Blakeney Point in Suffolk, where he has slept on a sand dune:

> In the long silky dawn light, I crunched back over the rinsed shingle, calling out good morning greetings to the seals, who followed me cheerfully in the shallows . . . I passed two dead crabs, lying on their backs, claws locked behind their heads, pale stomachs presented to the dawn, like a couple of early sunbathers.

Such lovely honeyed prose. Macfarlane is delightful literary company, polite, earnest, erudite and wide-ranging in his interests. It's rather wonderful – like an enchantment on the land. In place after place, the length and breadth of the country, there is 'wildness'. There are no meetings, no encounters with intrusive folk. It is all truly empty, secret and luscious. From Sutherland to the Burren, even to Dorset and Essex, the book reveals a sense of beguiling solitude. There are no other voices, no Welsh or Irish or differently accented English. It has to be thus, of course, because if we start blethering to the locals the conceit of empty 'wild' will be lost. So there has to be silence, an avoidance of voices other than the author's, just wind in the trees, or waves, the cry of the curlew.

The danger of this writing style is that there will be an awful lot of 'I'. If there is a lot of 'I' (and there is, in *The Wild Places*) then it won't be the wild places we behold, but the author. We see him swimming, climbing, looking, feeling, hearing, responding, being sensitive, and because almost no one else speaks, this begins to feel like an appropriation, as if the land has been taken from us and offered back, in a different language and tone and attitude. Because it's land we're talking about, this leads to an unfortunate sense that we're in the company, however engaging, of another 'owner', or if not an owner, certainly a single mediator.

'My sleepings-out, in cups and dips of rock and earth and snow; this was the habit of the hare. But the pull to the high ground, to the summits and ridges, to look down upon the land, this was in mimicry of the hawk.' The author is everywhere, north, south, east and west. High and low. He is both hawk and hare. Is this a problem? Is it not just in the nature of books, of prose especially? I heard a woman on the radio discussing *The Wild Places* and she actually said: 'Oh, he's so brave, I couldn't possibly do that.' What's being reduced is not the health and variety of the landscape, but the variety of our engagement, our way of seeing, our languages. There are lots of people, many of them women, who live in, or spend long seasons in places like Cape Wrath, St Kilda, Mingulay, thinking about the wild, studying its ways. Interesting people, with new ideas. It's a pity we meet none of them.

Class comes in here. For a long time, the wild land was a working place, whether you were a hunter-gatherer, a crofter, a miner. But now it seems it is

being claimed by the educated middle classes on spiritual quests. The land is empty and the saints come marching in.

Having been in North Wales, Skye, Rannoch Moor, the Black Wood, Cape Wrath and Ben Hope, we're halfway through the book before we are taken to the Burren in the West of Ireland. The epiphany comes on the limestone pavements there. Before this it's all been big lumps of land, big enough to hike or swim or climb through. But here is Macfarlane in the company of Roger Deakin, with the two of them lying on the ground gazing into a fissure or crack in the flat limestone called a 'gryke':

> We lay belly down on the limestone and peered over its edge. And found ourselves looking into a jungle. Tiny groves of ferns, mosses and flowers were there in the crevasse – hundreds of plants . . . thriving in the shelter of the gryke: cranesbills, plantains, avens, ferns, many more I could not identify . . . This, Roger suddenly said as we lay there looking down into it, is a wild place. It is as beautiful and complex, perhaps more so, than any glen or bay or peak. Miniature, yes, but fabulously wild.

This is a lovely moment, I want to say a poet's moment, the going down, deeper and still. The revelation comes that a wild place is not necessarily landscape-sized, and not necessarily an adventure playground. A wild place can also be mouse or beetle-landscape sized, and everywhere, and near at hand.

This alerts Macfarlane to what he's decent enough to call his 'myopia'. He discovers that, in pursuit of the wild, he's been looking too much into the apparently empty distance. Wildness can be small, and is maybe better described as a process than a place. This provokes a rethink about his earlier definitions, and he realises that the notion that there was something, especially in Scotland and Wales, which was wild because 'outside human history' was 'nonsensical' and 'improper'. With the new understanding that wildness can be close by and tiny, it's time to head for home, and to discover eventually what he'll come to call 'English wildness', which will be 'something continually at work in the world, something tumultuous, green, joyous'.

The Wild Places will be much loved because, for all its wildness, it's a deeply conservative book, and very English, in the long tradition of English settledness, whose pantheon includes Samuel Palmer and Edward Thomas, Wordsworth and Clare. It's not what you'd call wild-minded. It's a book about books: as much about the literature and reception of wild places as about the places themselves. To create texture and interest and avoid a constant look-at-me-swimming, it is full of digressions, explorations and asides which hugely enrich its texture. We learn about the Clearances and the Famine, of course, but also about the

Chideock martyrs, the natural history of hares, cartography and glaciers, among much else. It is sensitive, courteous and above all comforting.

Why comforting? And why English? Because its shape, the wide arc north, west, south and east into the 'wild places' and then home, is a warm and familiar one, the shape of an embrace. Adventures, then home for tea. The strikes into Scotland or Ireland or Wales are just that – strikes, then retreats. Cambridge is still the centre of the world: we started there and will end there, albeit up a tree. It's also politically comforting, for landowners: there will be no revolution. Macfarlane speaks of gravesites like Maes Howe and Sutton Hoo as 'uplifting'. 'The exhilaration you feel has something to do with the innocence of the assumptions embodied in such a gravesite.' I'm afraid my hackles are rising again. Innocence? Sutton Hoo? Maes Howe? Thousands of years separate the two, but both speak of power and elitism, surely. These aren't wee plaques on a mountainside. Contemporary power structures and land issues are not mentioned either. It's reassuring, but the effect of ignoring all this is to put the wild places outside history again. There is even political reassurance to be had in the idea that there is an entity called 'Britain and Ireland'. The concerned folk who join the Campaign to Protect Rural England will be glad to know that there is much wildness even in England's green-and-pleasant. Not only wildness, but superior southern wildness: lying in a sunny Dorset field Macfarlane visited his new, post-gryke understanding and 'again I felt a sense of wildness as process . . . This was a wildness quite different from the sterile winter asperities of Ben Hope, and perhaps, I thought for the first time, more powerful too.' Ach weel.

Waiting to be discovered is a wildness which is smaller, darker, more complex and interesting, not a place to stride over but a force requiring constant negotiation. A lifelong negotiation at that: to give birth is to be in a wild place, so is to struggle with pneumonia. If you can look down a gryke, you can look down a microscope, and marvel at the wildness of the processes of our own bodies, the wildness of disease. There is Ben Nevis, there is smallpox. One wild worth protecting, one worth eradicating. And in the end, we won't have to go out to find the wild, because the wild will come for us. Then, I guess, someone will scatter our ashes on a mountaintop, and someone else will complain.

Kathleen Jamie, 'A Lone Enraptured Male', *London Review of Books*, vol. 30, no. 5 (6 March 2008) 25-7. Available at https://www.lrb.co.uk/the-paper/v30/n05/kathleen-jamie/a-lone-enraptured-male

Tanya Barson
The Peripatetic School//2011

We are living in a period in which globalisation impacts on every facet of daily life, and our relationship with the natural world is reaching a point of acute crisis. Contemporary artists who wish to address related concerns such as the environment, mechanisms of state power, rapid and unrestricted urbanisation, technological expansion, architecture, notions of history and modernity (and the ruin of the latter), mobility and migration, education, and the role of political activism, are not only revisiting modes of action such as walking and other forms of travel, but are also utilising landscape as a means of thinking about America. While walking locates man within the landscape, it is more than merely a means of traversing space; it is also a cultural act, an aesthetic gesture, a means of protest and a source of knowledge, and therefore of power or dominion. [...]

The relationship between exploration and enquiry or, more simply, between walking and reflection, has a lineage that dates back to the school of philosophy founded by Aristotle in ancient Greece, whose teachings were rooted in empirical observation and knowledge drawn from experience. The term 'peripatetic' is derived from the ancient Greek term meaning 'of walking' or 'given to walking about', and is used to mean itinerant, wandering, meandering or, more generally, going from place to place. While it is said that the Aristotelian school was named after the *peripatoi* (colonnades) of the Lyceum, it is also claimed that it was because of Aristotle's habit of walking while lecturing. This school, therefore, made an explicit connection between thinking and walking, as well as establishing the use of the word 'peripatetic' to describe itinerant teachers. In her book *Wanderlust: A History of Walking* (2000), Rebecca Solnit describes how the process of pursuing the connections between walking and thinking back to the ancients provided more than a mere 'coincidence of architecture and language' but enabled figures of the European Enlightenment who 'strove to consecrate walking by tracing it to Greece' to make the activity a 'conscious cultural act rather than a means to an end'.[1] Thus Rousseau's *Confessions* (1782), in which he describes his long, thought-filled walks to visit the encyclopaedist Denis Diderot in prison stands at the beginning of such a history and 'laid the groundwork for the ideological edifice within which walking itself would be enshrined.[2] This manner of conceptualising walking, and the tradition it established, was exported to the New World through the figure of the traveller artist, many of whom initially came from Europe, although it was

through the separation from European colonial domination – with the formation of a newly independent 'America' – that it came to play a role in defining a postcolonial identity.[3]

Beginning in the eighteenth century, the tradition of scientifically driven traveller artists in the Americas drew on the Enlightenment: 'the influence on the artistic climate most widespread and most profoundly felt was unquestionably direct observation, experiment and rational analysis as the new basis of reality, brought into being by the European Enlightenment.'[4] The earliest manifestations bracket the era of independence, and resulted in extraordinarily extensive pictorial records of topography, flora and fauna, peoples, customs and costumes, societies and architecture: for example the work of physician and horticulturalist José Celestino Mutis, who began a 33-year-long botanical expedition in New Granada in 1784 which produced over 5,000 drawn studies,[5] or German explorer-artist Count Alexander von Humboldt, who conducted an expedition to Central and South America from 1799 to 1804 with French botanist Aimé Bonpland, or Jean-Baptiste Debret who 'like a latter-day Diderot [...] depicted visually the economic, architectural, ceremonial and ethnic aspects of life in the settled parts of Brazil as well as the nearer wilderness of its interior,' from 1816 to 1824.[6] It was Humboldt's protégé Johann Moritz Rugendas, however, who, between 1821 and 1847, travelled furthest and produced the most extensive body of work. Such projects attempted an encyclopaedic knowledge of the world, captured largely through meticulous drawings, and brought the Enlightenment's scopophilia and quest for absolute knowledge to the Americas.[7] Each of these attempts at a totalising gaze, albeit achieving an unprecedented level of visual accuracy or delivering new facts and sights, failed to capture the vastness and entirety of their subject and often instead produced or perpetuated clichés of distance/remoteness, scale, exoticism and abundance, just as Simon Bolivar (1783-1830), through his dream of pan-American union, failed ultimately to unite the lands that were being traversed and catalogued.[8]

In the twentieth century, those who inherited an adherence to a 'rational' analysis of the environment also became, in the Americas in particular, its most effective saboteurs. Le Corbusier, who had epitomised the modernist blending of the Cartesian with the mechanistic, encountering Brazil for the first time in 1929 was prompted to develop his 'law of meandering', which he recorded on a sheet of curvilinear sketches. As Lisette Lagnado states, 'his confrontation with the voluptuous landscape marked a turning point for the town planner as well as the land that embraced his ideas. It represented a drift from the supremacy of the straight line and a derivation along the curves of the Brazilian hills and bays.'[9] As a result, Le Corbusier's aesthetic changed to incorporate a new organicism

and he developed an urbanism that was at once more sensitive and expressive. Similarly, the anthropofagist architect and artist Flavio de Carvalho applied the notion of scientific experimentation 'as an artistic procedure' to an avant-garde and highly provocative version of street action or expedition which he recorded in series of surreal and expressionistic drawings. *Experiencia No. 2* (1931), for instance, investigated the behaviour of crowds, and saw him walking against the flow of a Corpus Christi procession. Subverting Eurocentric cartographic norms, Joaquín Torres-Garcia's inverted drawing of a map of the southern continent first appeared in *Circulo y cuadrado* in May 1936 alongside his own article on Andean Pre-Columbian art; he repeated the motif in 1943. Following his return to Uruguay in 1934, Torres-Garcia had declared 'the South is our North' thereby defining his strategic shift in orientation in developing an abstract-constructive modernism that was linked to the existing geometric abstractions of Latin American cultures in a resurgence of avant-garde indigenism.[10] In literature, it was the lengths to which many of the traveller artists, cartographers and scientists had gone in the preceding centuries, and the extent to which the continent had been explored, examined, mapped and drawn, that led Jorge Luis Borges in 1946 to create a subversive parody of cartography, and by extension scientific rationalism, by imagining a map of ultimate accuracy yet lack of utility: 'the Cartographer's Guild struck a Map of the Empire whose size was that of the Empire, and which coincided point for point with it. The following Generations, who were not so fond of the study of Cartography as their Forebears had been, saw that that vast Map was useless'.[11] Such a perfect simulacrum satirises and undermines the tradition that binds map-making to military and colonial ambition, and thus to the creation of empires.

A generation later, in the context of increased repression in Argentina that would lead to dictatorship, the misshapen maps of conceptualist Horacio Zabala were a clear testament of the political conflict within the nation. In a sequence of pencil drawings of maps of the southern cone titled *The distortions are proportional to the tensions* (1974) he introduced voids, fissures and fragmentation where Argentina should otherwise have been located. Also created in a context of escalating political authoritarianism, Cildo Meireles examined the abstractions that occur in science and mapmaking, and the conceptual relationship between man and territory which defines country or state, in works such as *Physical Art* (1969), a series of drawings for largely unrealised actions, and *Geographical Mutations* (1969), where earth from either side of an internal border is contained in adjacent spaces in a leather case, while *Southern Cross* (1969–70) used scale to demonstrate the symbolic reduction and denigration of indigenous culture and cosmogony by the dominant culture.

Like Cildo Meireles, Francis Alÿs and Carlos Garaicoa have also had recourse to evoke and examine geography, exemplifying what has been called a geopoetics. The work of these artists explores issues of mobility in relation to contested territories and border zones, migration, land rights and deterritorialisation, and the consequences of utopias (whether political or architectural). Alÿs' *When Faith Moves Mountains (2002)*, an action to shift a sand dune on the outskirts of Lima where many internally displaced people now live in 'informal settlements', was made in response to the situation of social degradation, authoritarianism and internal violence in Peru under the Fugimori dictatorship. The action, which is registered in part through numerous drawings, involved 500 volunteers who walked while shovelling, and can be seen as an 'allegory of a circular politics of promise, bureaucratic organisation, disproportionate efforts, eventual underachievement, new promise, new effort and so on'.[12] Garaicoa's work encapsulates the paradox between so-called 'formal' and 'informal' living, and the material manifestation of the failures of utopian schemes, in images that contrast architectural ambition and projected futures with those of collapse, decay and ruin. As Iván de la Nuez points out, 'he establishes a contrast between the "no such place" of our projects and the places that really exist, the ruins of those projects'.[13]

The link between 'scientific' accuracy and the mechanisms of power was highlighted by the French theorist Paul Virilio: 'the same preoccupation with an ever-more complete unveiling of the world lives on in the geographical politics of armies'.[14] Such an approach prefigures the recourse, once again, to absolutes, in the character of technological mapping (and warfare) in the twenty-first century. While the Enlightenment mapping of the Americas saw it itemised and classified for European minds and ownership, and was followed by a long history of postcolonial imperialist intervention and incursion, this has shifted, with the advent of globalisation, into a more subtle but still aggressive era of political and economic interference, which has been made more difficult to counter owing to its global, rather than national, character. This has involved the collusion of internal governments with global multinationals and has established critical contrasts in terms of wealth, access to education and land ownership. In this era of globalisation, mobility has also become an issue: movement has become easier for the wealthy and those from Europe and the US, but increasingly restricted for any others, since, as Jean Fisher points out, 'the North has reserved the right to human movement while imposing limitations on the South's ability to travel, the justifications being the fear of illegal immigration or, more recently, 'terrorist' infiltration.[15] Nevertheless, despite the real difficulties imposed on movement, particularly across national borders, migration and other forms of transnational exchange has taken place

and produced important changes in terms of spatial relationships and their impact on identity, as Stefano Varese highlights:

> The last five decades of Pax Americana in the Americas have witnessed a process of social and spatial restructuring, expressing itself in the transformation of old cultural and national loyalties into new trans-ethnic, transnational, and multidimensional identities. The growing phenomenon of an Indian diaspora in Latin America and beyond that transcends national borders is questioning conventional ideas and practices of nationalism, citizenship and territoriality.[16]

In recent years, the general trends of globalisation and capitalism have been countered through political activism and in particular the indigenous movement that is critically concerned with issues of autonomy, land rights, cultural patrimony, language and education.[17] In *The Pedagogy of the Oppressed* (1968) the radical anti-colonial educationalist Paulo Friere, viewing learning as a critical tool of emancipation, had already declared that 'no pedagogy which is truly liberating can remain distant from the oppressed by treating them as unfortunates and by presenting for their emulation models from among the oppressors'.[18] His final and unfinished book addressed a nascent field of 'ecopedagogy', which many of his followers have since developed. It is not surprising, then, that his work has been adopted within the indigenous movement, particularly given its concern with education and environmental issues.[19] [...]

In his work, André Komatsu explores the ways in which we negotiate urban space and the power structures embodied by the built environment. His work brings a somewhat absurdist sensibility and wry humour to bear on our everyday experience of cities, in particular in relation to the arbitrary, often surreal and chaotic environment of a megalopolis such as São Paulo. It also questions how we situate ourselves in relation to that environment, its fabric and to others we encounter within it, examining our reaction to our surroundings, the territorial boundaries imposed upon us, and our strategies of transformation and survival. Komatsu takes inspiration from his own perambulations through the city, and his personal reactions, observations and frustrations. In one work, a performative video entitled *West or Until Where the Sun Can Reach* (2006), he sets himself the simple task of following a compass westwards; inevitably obstacles arise, but he persists in his attempts to overcome both physical and socially established limits, demonstrating lack of access to territory, therefore highlighting structures of ownership and exclusion, and the language of isolation and protection that defines the

built environment. In particular, he emphasises the constant flux within such a large city, the incessant building and demolition that he describes as 'the wreckage that reconstructs itself, the destruction that transforms'.[20] Although Komatsu makes work in a number of media, drawing is a constant, often made on eccentric supports, reclaimed surfaces or found objects. His drawings range from fragmentary urban scenes on pieces of masonry or other detritus, such as *Landscape* (2005), a partial image of an apartment block, to watercolours of shadows cast by buildings and street furniture, images of improvisatory or bizarre situations he encounters while walking around the city and representations of the aftermath of street violence and its material impact. Three entropic drawings feature ambiguous urban sites that could be under construction or demolition. Additionally, a diptych on plasterboard from the series 'Imaginary Fields' (2011) bears footprints, scuffs and sgraffito marks (a scratched graffiti), while *Blank* (2011) is a sculptural project that registers indexically the action and imprint of walking. [...]

1 [Footnote 4 in source] Rebecca Solnit, *Wanderlust: A History of Walking* (London and New York: Verso, 2001) 14.
2 [5] Ibid., 17.
3 [6] Both the concepts of America and Latin America have been widely explored, contested and addressed as constructs tied to the history of European colonialism: 'The moment I hear anyone propose to speak – or to act – on behalf of Latin America alarm bells go off in my head and, if possible, I run for cover [...] one does not need to be on guard against the demonstrable fact that what we construe as Latin America, in any of its guises, has persisted in a language of euphemisms and a pretended unity that have often done little more than reproduce colonial gestures.' Ivan de la Nuez, 'The Stain of the Territory', *Radar Model Kits: Aspects of Contemporary Latin American Culture*, no. 0 (2010) 57–8.
4 [7] Stanton L Catlin, 'Traveller-Reporter Artists and the Empirical Tradition in Post-Independence Latin American Art, in Dawn Ades, *Art in Latin America: The Modern Era 1820 –1980* (New Haven and London: Yale University Press, 1989) 42.
5 [8] José Celestino Mutis y Bossio's *Expedicion Botanica del Nuevo Reyno de Granada*, which became known as the Expedicion Mutisiana, was given a royal charter in 1784. New Granada was one of four Spanish territories or viceroyalties and encompassed present day Colombia and parts of Venezuela and Ecuador. His findings were published as *Flora de la Real Expedicion Botanica del Nuevo Reyno de Granada*. See ibid., 43–5.
6 [10] Published as *Voyage pittoresque et historique au Brésil* (1834-39); see ibid., 48.
7 [11] While the term scopophilia – literally a love of looking – is associated with Freud's ideas about voyeurism and sexuality, it has also been used to describe a Kantian gaze that is driven by the quest of the Enlightenment for total knowledge and additionally is connected with the process of 'othering' in terms of race and culture.

8 [12] Set against this Eurocentric history of walking and its cultural significance is another, more longstanding, one. In pre-Columbian South America, the Inca road system was the most extensive and advanced of its time. It was used almost exclusively by people walking, and was a system of communication, a network for commerce and exchange, a source of stability, a sign of Imperial authority and a method of marking boundaries or borders. Overlaying this road system was a symbolic structure of mapping the landscape: a system of astrologically defined and mathematically precise conceptual straight lines (known as *ceques*) that emanated from Cusco through the Incan Empire and guided the designation of locations *huacas*, often large carved rocks or pyramids, that are simultaneously shrines embodied deities and maps. Hence, 'America' had already been systematically 'mapped' pre-Conquest – spatially, politically and spiritually. The continent already had a long history of cartophilia and of 'drawing' and walking lines through the landscape.

9 [13] Lisette Lagnado, 'Shifts in the Derive: Experiences, Journeys, Morphologies', in Lagnado (ed.), *Drifts and Derivations: Experiences, Journeys and Morphologies* (Madrid: Museo Nacional Centro de Arte Reina Sofia, 2010) 66.

10 [14] Indigenism refers to the positive promotion of native or indigenous culture, values and history, in art, literature, archaeology, education and politics. In art history, it forms a movement that is defined ideologically, rather than stylistically, in various countries, although particularly Mexico and Peru, in the 1920s and 1930s.

11 [15] Jorge Luis Borges, 'On Exactitude in Science', in *The Aleph* (London: Penguin Books, 2000) 181.

12 [18] Mark Godfrey, 'Politics/Poetics: The Work of Francis Alÿs', in Mark Godfrey, Klaus Biesenbach and Kerryn Greenberg (eds.), *Francis Alÿs: A Story of Deception* (London: Tate, 2010) 19.

13 [19] Nuez, op. cit., 62.

14 [20] Paul Virilio, *Bunker Archaeology* (New York: Princeton Architectural Press, 1994) 17. One of the clearest examples of this is the original Ordnance Survey, the first of which was conducted in 1791, when the British government directed its Board of Ordnance – the early equivalent of the Ministry of Defence – to survey the south coast of England to aid its defence from invasion. It was the first time that every part of Britain was mapped in detail. The Ordnance Survey continues to be the source of official maps of Britain.

15 [21] Jean Fisher, 'Neither North Nor South', in Cuauhtémoc Medina (ed.), *South, South, South, South... VII Simposio Internacional de Teoria Sobre Arte Contemporaneo* (Mexico City: Patronato de Arte Contemporaneo, 2010) 22.

16 [22] Stefano Varese, 'Indigenous Peoples Contesting State Nationalism and Corporate Globalism', in Lois Meyer and Benjamin Maldonado Alvarado (eds.), *New World of Indigenous Resistance: Noam Chomsky and Voices from North, South and Central America* (San Francisco: City Lights Books, 2010) 259.

17 [23] Jean Fisher, citing Emir Sader, has pointed out that if 'Latin American countries were used as laboratories for testing the neoliberal economic model (Chile, Bolivia), they have also been amongst the first to reject it (Venezuela, Ecuador and Bolivia).' Fisher, in *South, South, South, South*, op. cit., 23.

18 [24] Paulo Freire, *The Pedagogy of the Oppressed* (New York: Continuum, 1970) 54.

19 [25] The Mexican city of Oaxaca has been an important centre for this movement. For three decades, the teachers' union has used the tactic of striking and camping out in the streets during

negotiations with the local government. In 2006, just such a teacher-led protest ended in a much broader uprising and violent clashes with federal police. More clashes took place in early 2011.

20 [36] Artist's statement, unpublished PDF, Galeria Vermelho, Sao Paulo, undated, unpaginated.

Tanya Barson, extracts from 'The Peripatetic School', in *The Peripatetic School: Itinerant Drawings from Latin America* (London: Ridinghouse, 2011) 13–17, 20. Some footnotes edited.

THE COUNTRY WALK *has been* A CRUCIAL SCENE *for* BRITISH ARTISTS *working through the* ANXIETIES *besetting individual expression in a culture every bit as* ADDLED BY TRADITIONALISM *as* ANIMATED BY IT.

BACK AND FORTH

Édouard Glissant
The Black Beach//1990

The beach at Le Diamant on the southern coast of Martinique has a subterranean, cyclical life. During the rainy season, *hivernage*,[1] it shrinks to a corridor of black sand that you would almost think had come from the slopes above, where Mont Pelée branches out into foliage of quelled lava. As if the sea kept alive some underground intercourse with the volcano's hidden fire. And I imagine those murky layers undulating along the sea floor, bringing to our airy regions a convoy of this substance of night and impassive ashes ripened by the harshness of the north.

Then the beach is whipped by a wind not felt on the body; it is a secret wind. High waves come in, lifting close to the shore, they form less than ten metres out, the green of *campêche* trees, and in this short distance they unleash their countless galaxies. Branches of manchineel and seagrape lie about in havoc, writing in the more peaceful sunlight a memoir of the night sea's work. Brown seaweed piled there by the invisible assault buries the line between sand and soil. Uprooted coconut palms have tumbled sideways like stricken bodies. Along their trail, all the way to the rocky mound marking the distant Morne Larcher, one can sense the power of a hurricane one knows will come.

Just as one knows that in *carême*, the dry season, this chaotic grandeur will be carried off, made evanescent by the return of white sand and slack seas. The edge of the sea thus represents the alternation (but one that is illegible) between order and chaos. The established municipalities do their best to manage this constant movement between threatening excess and dreamy fragility.

The movement of the beach, this rhythmic rhetoric of a shore, do not seem to me gratuitous. They weave a circularity that draws me in.

This is where I first saw a ghostly young man go by; his tireless wandering traced a frontier between the land and water as invisible as floodtide at night. I'm not sure what he was called, because he no longer answered to any given name. One morning he started walking and began to pace up and down the shore. He refused to speak and no longer admitted the possibility of any language. His mother became desperate; his friends tried in vain to break down the barrier of total silence. He didn't get angry; he didn't smile; he would move vaguely when a car missed him by a hair or threatened to knock him down. He walked, pulling the belt of his pants up around his waist and wrapping it tighter as his body grew thinner and thinner. It doesn't feel right to have to represent someone so rigorously adrift, so I won't try to describe him. What I would like

to show is the nature of this speechlessness. All the languages of the world had come to die here in the quiet, tortured rejection of what was going on all around him in this country: another constant downward drift yet one performed with an anxious satisfaction; the obtrusive sounds of an excitement that is not sure of itself, the pursuit of a happiness that is limited to shaky privileges, the imperceptible numbing effect of quarrels taken to represent a major battle. All this he rejected, casting us out to the edges of his silence.

I made an attempt to communicate with this absence. I respected his stubborn silence, but (frustrated by my inability to make myself 'understood' or accepted) wanted nonetheless to establish some system of relation with this walker that was not based on words. Since he went back and forth with the regularity of a metronome in front of the little garden between our house and the beach, one day I called him silently. I didn't exactly know what sign to make – it had to be something neither affected or condescending but also not critical or distant. That time he didn't answer; but the second or third time around (since without being insistent I was insisting) he replied with a sign that was minute, at least to my eyes; for this gesture was perhaps the utmost he was capable of expressing: 'I understand what you are attempting to undertake. You are trying to find out why I walk like this – not-here. I accept your trying. But look around and see if it's worth explaining. Are you, yourself, worth my explaining this to you? So, let's leave it at that. We have gone as far as we can together.' I was inordinately proud to have gotten this answer.

It was really a minute, imperceptible signal, sort of seesawing his barely lifted hand, and it became (because I adopted it as well) our sign of complicity. It seemed to me that we were perfecting this sign language, adding shades of all the possible meanings that chanced along. So until my departure we shared scraps of the language of gesture that Jean-Jacques Rousseau claimed preceded all spoken language.

I thought of the people struggling within this speck of the world against silence and obliteration. And of how they – in the obstinacy of their venture – have consented to being reduced to sectarianism, stereotyped discourse, zeal, to convoy definitive truths, the appetite for power. And also of what Alain Gontrand has described so well as 'our masquerades of temperament.' I thought about those people throughout the rest of the world (and the rest, moreover, is what is on the move) who have not had the opportunity to take refuge, as this walker has, in absence – having been forced out by raw poverty, extortion, famines, or massacres. It is paradoxical that so many acts of violence everywhere produce language at its most rudimentary, if not the extinction of words. Is there no valid language for Chaos? Or does Chaos only produce a sort of language that reduces and annihilates? Does its echo recede into a sabir of sabirs at the level of a roar?[2]

The beach, however, has confirmed its volcanic nature. The water now runs along the sea wall of rocks heaped there, a souvenir of former hurricane damage, Beulah or David. The black sand glistens under the foam like peeling skin. The shoreline is cornered, up among coconut palms that now stand in the sea, hailing with their foliage – so perfectly suited – the energy of the deep. We gauge the more and more drastic shrinkage as the winter season strengthens. Then, abruptly, at least for those of us attentive to such changes, the water subsides, daily creating a wider and wider grayish strip. Don't get the idea that this is a tide. But, still, it is on the ebb! The beach, as it broadens, is the precursor of a future *carême*.

It seemed to me that the silent walker accelerated the rhythm of his walks. And that exhilaration also infected the surrounding country. At all costs we wanted to imitate the motion we felt everywhere else, by synthesising, agitating; and speeding everything up (noise, speech, things to eat and drink, *zouc*[3], automobiles). Forgetting ourselves any way possible in any kind of speed.

Then, in this circularity I haunt, I turned my efforts toward seeing the beach's backwash into the nearby eddying void as the equivalent of the circling of this man completely withdrawn into his motor forces; tried to relate them, and myself as well, to this rhythm of the world that we consent to without being able to measure or control its course. I thought how everywhere, and in how many different modes, it is the same necessity to fit into the chaotic drive of totality that is at work, despite being subjected to the exaltations or numbing effects of specific existences. I thought about these modes that are just so many commonplaces: the fear, the wasting away, the tortured extinction, the obstinate means of resistance, the naive belief, the famines that go unmentioned, the trepidation, the stubborn determination to learn, the imprisonments, the hopeless struggles, the withdrawal and isolation; the arrogant powers, the blind wealth, the maintenance of the status quo, the numbness, the hidden ideologies, the flaunted ideologies, the crime, the whole mess, the ways of being racist, the slums, the sophisticated techniques, the simple games, the subtle games, the desertions and betrayals, the unshrinking lives, the schools that work, the schools in ruin, the power plots, the prizes for excellence, the children they shoot, the computers, the classrooms with neither paper nor pencils, the exacerbated starvation, the tracking of quarry, the strokes of luck, the ghettos, the assimilations, the immigrations, the Earth's illnesses, the religions, the mind's illnesses, the musics of passion, the rages of what we so simply call libido, the pleasures of our urges and athletic pleasures, and so many other infinite variations of life and death. That these commonplaces, whose quantities are both countless and precise, in fact produced this Roar; in which we could still hear intoned every language in the

world. Chaos has no language but gives rise to quantifiable myriads of them. We puzzle out the cycle of their confluences, the tempo of their momentums, the similarities of their diversions.

The beach now undergoes tempestuous change. The sand is the colour of confusion, neither dull nor bright, and yet it suits the quality of the atmosphere and wind. The sea is unseasonably foamy: one feels that it will soon subdue the attacks on shoaling rocks. It is haloed by flickering surfaces. As if this reality (the sand, the sea trees, the volcano's conductive water) organised its economy according to a cyclical plan, buttressed by disorder. Those fantastic projects set up every two years or so to save the country crossed my mind: every one of them determined by notions of subjection and inevitably destroyed, swallowed up by personal profit. I wondered whether, in little countries such as ours ('I believe in the future of little countries'), economic prospects (their inspiration) ought not to be more like the beach at Le Diamant: cyclical, changeable, mutating, running through an economy of disorder whose detail would be meticulously calculated but whose comprehensive view would change rapidly depending on different circumstances.

When, in fact, we list unmethodically some of the realms demonstrating every level of economic development in a country like this – the infrastructure and its maintenance, the terms of investment, the budget of the state (what state?), professional training, the search for prospects, energy sources (what sources?), unemployment, the will to create, Social Security coverage, taxes, union dialogue, the internal market, import-export, capital accumulation, the division of the national product (of what nation?) – every single one is in crisis, nonexistent, or impossible; not one has summoned its inspiration from independent political power; furthermore, all are products of structural disorder inherited from colonisation, which no adjustment of parity (between the former colony and the former home country) and, moreover, no planning of an ideological order could ever remedy.

That is what we have to shake off. To return to the sources of our cultures and the mobility of their relational content, in order to have a better appreciation of this disorder and to modulate every action according to it. To adapt action to the various possibilities in turn: to the subsistence economy as it existed on the Plantation fringes; to a market economy as the contemporary world imposes it upon us; to a regional economy, in order to reunite with the reality of our Caribbean surroundings; and to a controlled economy whose forms have been suggested by what we have learned from the sciences.

To forsake the single perspective of an economy whose central mechanism is maximum subsidisation, that has to be obtained at the whim of an other. Obsession with these subsidies year after year clots thought, paralyses initiative,

and tends to distribute the manna to the most exuberant, neglecting perhaps those who are the most effective.

An economy of disorder, which, I now recall, Marc Guillaume had turned into a completely different theory *(Éloge du désordre,* Gallimard, 1978), but perhaps it is one that would be akin to what Samir Amin said about autocentric economies. Madness! was my first thought. Then – madness! – they jeer. But this is madness made up of considerable possibilities of reflection for experts in the matter.

Here acceleration becomes the most important virtue. Not the deliberately forgetful haste prevailing everywhere but an intense acuteness of thought, quick to change its heading. The capability of varying speed and direction at any moment, without, however, changing its nature, its intention, or its will, might be perhaps the optimal principle for such an economic system. Course changes would be dependent on a harsh analysis of reality. As for steadfastness of intention and will, this we would forge as we come to know our cultures.

This acceleration and speed race across the Earth. 'And yet, it does turn!' Galileo's aside did not simply determine a new order in our knowledge of the stars; it prophesied the circularity of languages, the convergent speed of cultures, the autonomy (in relation to any dogma) of the resultant energy.

But, while I was wandering like this, a silence as dizzying as speed and disorder gradually rose from the uproar of the sea.

The voiceless man who walks keeps on carting his black sand from a distant volcano known only to himself, to the beaches he pretends to share with us. How can he run faster when he is growing so desperately thin? One of us whispers: 'He goes faster and faster because if he stops, if he slows down – he will fall.'

We are not going any faster, we are all hurtling onward for fear of falling.

1 [Editors' note: in the Glossary to *Poetics of Relation* translator Betsy Wing defines *carême*: 'The dry season. Martinique has two seasons: the rainy season, *hivernage*, and the dry, *carême*.']
2 [Editors' note: across *Poetics of Relation*, Glissant uses 'sabir' pejoratively to mean a 'contact language' or *lingua franca*, such as the Anglo-American language, that resists poetry. He writes: 'falsely convenient vehicular sabirs must be relentlessly refuted'. 120.]
3 [Editors' note: the Glossary to *Poetics of Relation* defines, *zouc*: 'Martinican dance music.']

Édouard Glissant, 'The Black Beach', in *Poetics of Relation* (1990), trans. Betsy Wing (Michigan: University of Michigan Press, 1997) 121–7.

Rebecca Solnit
The Treadmill//2002

The suburb rationalised and isolated family life as the factory did manufacturing work, and the gym rationalises and isolates not merely exercise but nowadays even each muscle group, the heart rate, the 'burn zone' of most inefficient calorie use. Somehow all this history comes back to the era of the industrial revolution in England. 'The Tread-Mill', writes James Hardie in his little book of 1823 on the subject, 'was, in the year 1818, invented by Mr. William Cubitt, of Ipswich, and erected in the House of Correction at Brixton, near London'. The original treadmill was a large wheel with sprockets that served as steps that several prisoners trod for set periods. It was meant to rationalise prisoners' psyches, but it was already an exercise machine. Their bodily exertion was sometimes used to power grain mills or other machinery, but it was the exertion, not the production, that was the point of the treadmill. 'It is its monotonous steadiness and not its severity, which constitutes its terror, and frequently breaks down the obstinate spirit', Hardie wrote of the treadmill's effect in the American prison he oversaw. He added, however, that 'the opinions of the medical officers in attendance at the various prisons, concur in declaring that the general health of the prisoners has, in no degree suffered injury, but that, on the contrary, the labour has, in this respect, been productive of considerable benefit'. His own prison of Bellevue on New York's East River included 81 male and 101 female vagrants, as well as 109 male and 37 female convicts, and 14 female 'maniacs'. Vagrancy – wandering without apparent resources or purpose – was and sometimes still is a crime, and doing time on the treadmill was perfect punishment for it.

Repetitive labour has been punitive since the gods of Greek myth sentenced Sisyphus – who had, Robert Graves tells us, 'always lived by robbery and often murdered unsuspecting travellers' – to his famous fate of pushing a boulder uphill. 'As soon as he has almost reached the summit, he is forced back by the weight of the shameless stone, which bounces to the very bottom once more; where he wearily retrieves it and must begin all over again, though sweat bathes his limbs.' It is hard to say if Sisyphus is the first weight lifter or the first treadmiller, but easy to recognise the ancient attitude to repetitive bodily exertion without practical results. Throughout most of human history and outside the first world nowadays, food has been relatively scarce and physical exertion abundant; only when the status of these two things is reversed does 'exercise' make sense. Though physical training was part of ancient Greek citizens'

education, it had social and cultural dimensions missing from modern workouts and Sisyphean punishments, and while walking as exercise had long been an aristocratic activity, industrial workers' enthusiasm for hiking, particularly in Britain, Austria, and Germany, suggests that it was far more than a way to make the blood circulate or calories burn. Under the heading 'Alienation', Eduardo Galeano wrote a brief essay about fishermen in a remote village of the Dominican Republic puzzling over an advertisement for a rowing machine not very long ago. 'Indoors? They use it indoors? Without water? They row without water? And without fish? And without the sun? And without the sky?' they exclaimed, telling the resident alien who has shown them the picture that they like everything about their work but the rowing. When he explained that the machine was for exercise, they said 'Ah. And exercise – what's that?' Suntans famously became status symbols when most of the poor had moved indoors from the farm to the factory, so that browned skin indicated leisure time rather than work time. That muscles have become status symbols signifies that most jobs no longer call upon bodily strength: like tans, they are an aesthetic of the obsolete.

The gym is the interior space that compensates for the disappearance of outside and a stopgap measure in the erosion of bodies. The gym is a factory for the production of muscles or of fitness, and most of them look like factories: the stark industrial space, the gleam of metal machines, the isolated figures each absorbed in his or her own repetitive task (and like muscles, factory aesthetics may evoke nostalgia). The industrial revolution institutionalised and fragmented labour; the gym is now doing the same thing, often in the same place, for leisure. Some gyms actually are born-again industrial sites. The Chelsea Piers in Manhattan were built in the first decade of this century for ocean liners – for the work of longshoremen, stevedores, and clerks, and for the travel of emigrants and elites. They now house a sports centre with indoor track, weight machines, pool, climbing gym, and most peculiarly, a four-story golf driving range, destinations in themselves rather than points of arrival and departure. An elevator takes golfers to their stalls, where all the gestures of golf – walking, carrying, gazing, situating, removing, communicating, retrieving or following the ball – have vanished with the landscape of the golf course. Nothing remains but the single arc of a drive: four tiers of solitary stationary figures making the same gesture, the sharp sound of balls being hit, the dull thud of their landing, and the miniaturised armoured-car vehicles that go through the green artificial-grass war zone to scoop up the balls and feed them into the mechanism that automatically pops up another ball as each one is hit. Britain has specialised in the conversion of industrial sites into climbing gyms. Among them are a former electrical substation in London, the Warehouse on Gloucester's Severn River waterfront, the Forge in Sheffield on one side of the

Peak District, an early factory in downtown Birmingham, and, according to a surveyor friend, a 'six-story former cotton mill near Leeds' I couldn't locate (not to mention a desanctified church in Bristol). It was in some of these buildings that the industrial revolution was born, with the Manchester and Leeds textile mills, Sheffield's iron- and steelworks, the innumerable manufactories of 'the workshop of the world' that Birmingham once was. Climbing gyms are likewise established in converted industrial buildings in the United States, or at least in those cities old enough to have once had industrial-revolution architecture. In those buildings abandoned because goods are now made elsewhere and First World work grows ever more cerebral, people now go for recreation, reversing the inclinations of their factory-worker predecessors to go out – to the outskirts of town or at least out-of-doors – in their free time. (In defence of climbing gyms, it should be said they allow people to polish skills and, during foul weather, to stay fit; for some the gym has only augmented the opportunities, not replaced the mountain, though for others the unpredictabilities and splendours of real rock have become dispensable, annoying or unknown.)

And whereas the industrial revolution's bodies had to adapt to the machines, with terrible consequences of pain, injury, and deformity, exercise machines are adapted to the body. [Karl] Marx said history happens the first time as tragedy, the second as farce; bodily labour here happens the first time around as productive labour and the second as leisuretime consumption. The deepest sign of transformation is not merely that this activity is no longer productive, that the straining of the arms no longer moves wood or pumps water. It is that the straining of the muscles can require a gym membership, workout gear, special equipment, trainers and instructors, a whole panoply of accompanying expenditures, in this industry of consumption, and the resulting muscles may not be useful or used for any practical purpose. 'Efficiency' in exercise means that consumption of calories takes place at the maximum rate, exactly the opposite of what workers aim for, and while exertion for work is about how the body shapes the world, exertion for exercise is about how the body shapes the body. I do not mean to denigrate the users of gyms – I have sometimes been one myself – only to remark on their strangeness. In a world where manual labour has disappeared, the gym is among the most available and efficient compensations. Yet there is something perplexing about this semipublic performance. I used to try to imagine, as I worked out on one or another weight machine, that this motion was rowing, this one pumping water, this one lifting bales or sacks. The everyday acts of the farm had been reprised as empty gestures, for there was no water to pump, no buckets to lift. I am not nostalgic for peasant or farmworker life, but I cannot avoid being struck by how odd it is that we reprise those gestures for other reasons. What exactly is the nature of

the transformation in which machines now pump our water but we go to other machines to engage in the act of pumping, not for the sake of water but for the sake of our bodies, bodies theoretically liberated by machine technology? Has something been lost when the relationship between our muscles and our world vanishes, when the water is managed by one machine and the muscles by another in two unconnected processes?

The body that used to have the status of a work animal now has the status of a pet: it does not provide real transport, as a horse might have; instead, the body is exercised as one might walk a dog. Thus the body, a recreational rather than utilitarian entity, doesn't work, but works out. The barbell is only abstracted and quantified materiality to shift around – what used to be a sack of onions or a barrel of beer is now a metal ingot – and the weight machine makes simpler the act of resisting gravity in various directions for the sake of health, beauty, and relaxation. The most perverse of all the devices in the gym is the treadmill (and its steeper cousin, the Stairmaster). Perverse, because I can understand simulating farm labour, since the activities of rural life are not often available – but simulating walking suggests that space itself has disappeared. That is, the weights simulate the objects of work, but the treadmill and Stairmaster simulate the surfaces on which walking takes place. That bodily labour, real or simulated, should be dull and repetitive is one thing; that the multifaceted experience of moving through the world should be made so is another. I remember evenings strolling by Manhattan's many glass-walled second-floor gyms full of rows of treadmillers looking as though they were trying to leap through the glass to their destruction, saved only by the Sisyphean contraption that keeps them from going anywhere at all – though probably they didn't see the plummet before them, only their own reflection in the glass.

I went out the other day, a gloriously sunny winter afternoon, to visit a home-exercise equipment store and en route walked by the University of San Francisco gym, where treadmillers were likewise at work in the plate-glass windows, most of them reading the newspaper (three blocks from Golden Gate Park, where other people were running and cycling, while tourists and Eastern European émigrés were walking). The muscular young man in the store told me that people buy home treadmills because they allow them to exercise after work when it might be too dark for them to go out safely, to exercise in private where the neighbours will not see them sweating, to keep an eye on the kids, and to use their scarce time most efficiently, and because it is a low-impact activity good for people with running injuries. I have a friend who uses a treadmill when it's painfully cold outside in Chicago, and another who uses a no-impact machine whose footpads rise and fall with her steps because she has an injured hamstring (injured by driving cars designed for larger people, not by running).

But a third friend's father lives two miles from a very attractive Florida beach, she tells me, full of low-impact sand, but he will not walk there and uses a home treadmill instead.

The treadmill is a corollary to the suburb and the autotropolis: a device with which to go nowhere in places where there is now nowhere to go. Or no desire to go: the treadmill also accommodates the automobilised and suburbanised mind more comfortable in climate-controlled indoor space than outdoors, more comfortable with quantifiable and clearly defined activity than with the seamless engagement of mind, body, and terrain to be found walking out-of-doors. The treadmill seems to be one of many devices that accommodate a retreat from the world, and I fear that such accommodation disinclines people to participate in making that world habitable or to participate in it at all. It too could be called Calvinist technology, in that it provides accurate numerical assessments of the speed, 'distance' covered, and even heart rate, and it eliminates the unpredictable and unforeseeable from the routine – no encounters with acquaintances or strangers, no sudden revelatory sights around a bend. On the treadmill, walking is no longer contemplating, courting, or exploring. Walking is the alternate movement of the lower limbs. Unlike the prison treadmills, of the 1820s, the modern treadmill does not produce mechanical power but consumes it. The new treadmills have two-horsepower engines. Once, a person might have hitched two horses to a carriage to go out into the world without walking; now she might plug in a two-horsepower motor to walk without going out into the world. Somewhere unseen but wired to the home is a whole electrical infrastructure of power generation and distribution transforming the landscape and ecology of the world – a network of electrical cables, metres, workers, of coal mines or oil wells feeding power plants or of hydropower dams on rivers. Somewhere else is a factory making treadmills, though factory work is a minority experience in the United States nowadays. So the treadmill requires far more economic and ecological interconnection than does taking a walk, but it makes far fewer experiential connections. Most treadmillers read or otherwise distract themselves. *Prevention* magazine recommends watching TV while treadmilling and gives instructions on how treadmill users can adapt their routines to walking about outside when spring comes (with the implication that the treadmill, not the walk, is the primary experience). *The New York Times* reports that people have begun taking treadmill classes, like the stationary bicycling classes that have become so popular, to mitigate the loneliness of the long-distance treadmiller. For like factory labour, treadmill time is dull – it was the monotony that was supposed to reform prisoners. Among the features of the Precor Cardiologic Treadmill, says its glossy brochure, are

'5 programmed courses' that 'vary in distance, time and incline. The Interactive Weight Loss course maintains your heart rate within your optimum weight loss zone by adjusting workload', while 'custom courses allow you to easily create and store personalised programs of up to 8 miles, with variations as small as 1/10th mile increments.' It's the custom courses that most amaze me; users can create an itinerary like a walking tour over varied terrain, only the terrain is a revolving rubber belt on a platform about six feet long. Long ago when railroads began to erode the experience of space, journeys began to be spoken of in terms of time rather than distance (and a modern Angeleno will say that Beverly Hills is twenty minutes from Hollywood rather than so many miles). The treadmill completes this transformation by allowing travel to be measured entirely by time, bodily exertion, and mechanical motion. Space – as landscape, terrain, spectacle, experience – has vanished.

Rebecca Solnit, extract from *Wanderlust: A History of Walking* (London and New York: Verso, 2001) 260–6.

Stefano Harney and Fred Moten
The Rebelator//2021

In *Upon Westminster Bridge*, Mikey Smith is jaywalking through the language.[1] It's 1982, the beginning of logistical capitalism. The assembly line is snaking out of the factory and into his mouth. And he cyaan believe it. He won't believe it. He won't go to work. He comes from the property. He's been there before. He's come to undo. He's moved to dissemble. The gathering in his mouth is out of line.

With the rise of logistical capitalism, it is not the product that is never finished but the production line, and not the production line, but its improvement. In logistical capitalism it is the continuous improvement of the production line that never finishes, that's never done, that's undone continuously. The sociologists caught a glimpse of this line and thought that they were seeing networks. The political scientist called this line globalisation. The business professors named it and priced it as business process re-engineering. Mikey knew better.

Mikey veers back across the street to where Louise Bennett sits, talking about how she inspired him. We can see her in a clip, wronging rights with her words, advocate of an undone language open to respecting what you like, and liking what you respect. Now her words are everywhere, like whispers from a cotton

tree, and they have to be. And logistics, which is to say access, is everywhere – again, because it wants to be.

But not just logistics; and not just any kind of access. The capitalist science of logistics can be represented by a simple formula: movement + access. But logistical capitalism subjects that formula to the algorithm: total movement + total access. Logistical capitalism seeks total access to your language, total translation, total transparency, total value from your words. And then it seeks more. At Queen Mary, University of London, before the counterinsurgency, we called this postcolonial capitalism. How does it feel to be a problem in someone else's supply chain? What else is a colonial regime but the imposition of psychopathic protocols of total access to bodies and land in the service of what today is called supply-chain management? The problem of the twenty-first century is the problem of the colour line of assembly.

This logistical capitalism, this postcolonial capitalism, uses the stored, stolen, historical value of words to press its point. But Mikey would not speak that way. He saw what was coming by misremembering what had come to pass. Mikey jay-walked through his audience as they listened the wrong way across his words. Mikey put his hands up to fight one night and surrendered to us. He fought, and by fighting surrendered to, what M. Jacqui Alexander called our 'collectivized self-possession,' to our hapticality, which is at the same time our collectivised dispossession.[2] Because a rebelator defends our partiality, our incompleteness, our hands dispossessed to hold one another up in the battle of Zion. Mikey was a rebelator in the battle of Zion. Mikey the Rebelator sabotaging a line of words(worth).

Mikey is talking to C.L.R. James on a bed in Brixton in South London, in an unsettled room, Linton Kwesi Johnson standing to the side. You have to move across the language because the language moves the line through you. The line moves now, the assembly line, the flow line, the high line, and that means you. You're moving to work like you always did but now you're working as you're moving, too. James is telling them he used to love Wordsworth and still does, but it was only when he got back to the Caribbean that he realised what was missing in that poetry because something else in that poetry was everywhere. James is talking about language as domination; Mikey is already having to deal with language as forced improvement in production, on the new and improved line, where the Man gives orders to His men. Mikey's working on an old new open secret logisticality, born in the hold, held together in loss and in being lost, and James is giving him some uncoordinates, a sea captain like Ranjit's father, high on the land now, low, shipped, stranded on a bed in Brixton, in an unsettled room. Mikey's not working on improving the English language. He's working on disproving it.

Mikey Smith deregulates the Queen's English in 'Mi Cyaan Believe It' and he's not worried about being incomplete. He's jaywalking through the Queen's English, instituting a sound system to which her standard submits, right across down there so. He's walking across to it right now, on the gully side. Mikey the rebelator. He says that those have 'been restless a full time, dem go get some rest.' But there's no rest with access; access troubles the unrest it came to steal, and still. This is the early moment of logistical capitalism, with James on the bed aged from industrial capitalism, and all that settler capitalism sedimented underneath them in London in the hard-red earth. In an unsettled room they institute. They're the offline institute of the new line, the new poetics of the anti-line, the antillean, multi-matrilinear dispersion of drum and bass and grain against the grain of organised saying, catching logistics in logisticality's crosstown traffic, in crosstown traffic's constant violation of the crosswalk, the sanctioned intersection, the settled, hegemonic term. Mikey's more and less than perpendicular swerve cyaan believe that managed disturbance and keeps on fucking it up as a field of hypermusical staying, crossed between crossing and forgetting, contradicting and misremembering, revealing and rebelling, refusing to believe. Look the wrong way before you cross. Move the wrong way when you cross. That's how we semble.

When we move we move to access, which is to say we assemble and disassemble anew. And in logistical capitalism the assembly line moves with us by moving through us, accessing us to move and moving us to access. We can't deny access, because access is how we roll, and roll on, in and as our undercommon affectability, as Silva might say.[3] But we make access burn and we love that, the line undone in the undoing of every single product, our renewed assembly in the general disassembly, our dissed assembly offline on the line, strayed staying, stranded beneath the strand, at rest only in unrest, making all the wrong moves, because our doing and undoing ain't the same as theirs. They know, sometimes better than we do, that to move wrong, or not to move, is now no longer just an obstruction to logistics or an obstacle to progress. To move wrong or not to move is sabotage. It is an attack on the assembly line, a subversion of logistical capitalism. To move wrong is to deny access to capital by staying in the general access that capital desires and devours and denies. To move wrong, to move nought, is to have our own thing of not having, of handing and being handed; it is our continuous breaking up – before, and against that, we were told – of our continuous get together. But with the critical infrastructure that is the new line, and with the resilient response that protects it, the jaywalker becomes no longer just a rube in the way of logistics, a country bukee in traffic, but a saboteur, a terrorist, a demon. Jaywalkers do not sabotage by exodus or occupation as once a maroon, or a striking miner, or a ghost dancer may have. Jaywalkers disturb

the production line, the work of the line, the assembly line, the flow line, by demanding inequality of access for all. When the line don't stop to let you catch your breath, jaywalkers stand around and say this stops today. Jaywalking is dissed assembly for itself. Such sabotage is punishable by death. It's hard to know what we institute when we don't institute but we do know what it feels like.

Total value and its violence not only never went away, but as Silva says, they are the foundation of the present as time, the condition of time, of the world as a time-space logic founded on the first horrible logistics of sale, the first mass movement of total access.[4] Now continuous improvement drives us toward total value, makes all work incomplete, makes us move to produce, compels us to get online. We are liberated from work in order to work more, to work harder. We are violently invited to exercise our right to connect, our right to free speech, our right to choose, our right to evaluate, our right to right individuality in order that we may improve the production line running through our liberal dreams. Freedom through work was never the slave's cry but we hear it all around us today. Continuous improvement is the metric and metronomic metre of uplift. Those who won't improve, those who won't collectivise and individuate with the correct neurotic correctness, those who do the same thing again, those who revise, those who tell the joke you've heard and cook the food you've had and take the walk you've walked, those who plan to stay and keep on moving, those who keep on moving wrong – those are the ones who hold everybody back, fucking up the production line that's supposed to improve us all. They like being incomplete. They like being incomplete and incompleting one another. Their incompleteness is said to be a dependency, a bad habit. They're said to be partial, patchy, sketchy. They lack coordinates. They're collectively uncoordinated in total rhythm. They're in(self)sufficient.

Paolo Friere thought our incompleteness is what gave us hope.[5] It is our incompleteness that inclines us toward one another. For Friere, the more we think of ourselves as complete, finished, whole, individual, the more we cannot love or be loved. Is it too much to put this the other way around? To say, by way of Friere, that love is the undercommon self-defence of being-incomplete? This seems important now when our incompleteness is something we are invited and then compelled to address and improve, when we are told to be impatient with it, and embarrassed by it. We need to be intact. We're told to raise our buzz because we're all fucked up. But in our defence, we love that we are complete only in a plained incompletion, which they would have undone, finished, owned, and sent on down the line. We do mind working because we do mind dying.

1 [Footnote 16 in source] Anthony Wall, *Upon Westminster Bridge*, BBC Television, 1982. See https://youtu.be/NE3kVwyY2WU

2 [17] M. Jacqui Alexander, *Pedagogies of Crossing: Meditations of Feminism, Sexual Politics, Memory, and the Sacred* (Durham: Duke University Press, 2005) 328.
3 [18] See Denise Ferreira da Silva, 'No-Bodies: Law, Raciality and Violence,' *Griffith Law Review*, vol. 18, no. 2, 2009, 214.
4 [19] Nahum Dimitri Chandler, *Toward an African Future – of The Limit of the World* (Living Commons Collective, 2013) 81.
5 [20] Paolo Freire, *Pedagogy of Freedom: Ethics, Democracy, and Civic Courage*, trans. Patrick Clarke (Oxford: Rowman & Littlefield, 1998) 58.

Stefano Harney and Fred Moten, 'The Rebelator', extract from *All Incomplete* (Colchester, New York and Port Watson: Minor Compositions, 2021) 38–42.

Issa Samb
The Walking Man//2012

[…] *The Walking Man* by N'dary Lô, this sculpture, a third of whose face is lit up by the rising sun reflected off a blue pane of glass, represents a (double) man who walks. He is young. He is naked. He is young. His arms are raised. He is no longer a child. A man of about fifty years. An adult. His head straight. The left face (rising side). The right face (setting side). The left foot slightly behind. The right foot in front – vertically. This movement expresses both the ease of a man walking, and the other foot on the ground at rest, sure of itself, which gives the centre image a kind of suspended flight, a particular elegance. The other no longer walks. He must be pushed to question, not his personal identity, but rather to move him about, help him to define his role, which is to resemble me (which is to be here and there). A fragment of me and the reflections of a few silhouettes. Other mirrors of displacement of another uncommon person. But this assumes that he is in my place to describe the character I am. I am not him. He doesn't know it. He doesn't know that I am a mentally exceptional man who knows the difference between two letters. I am very different and my thinking is very different. When the sun disappears between three landscapes – a total displacement, a rotation, and the tabby cat moves about and stops, listens to the bird who sings, watches the grasshoppers' and crickets' movements, perks up its ears, gets up, walks to the gate, stops, sniffs the lemon, looks at the sky, there go the birds passing by, ah, lies down, bites its tail in the middle of the path. A leaf falls. The cat miaows. It is not him, it's the other. He goes away, he goes away, he goes away. He goes out. A total displacement. A rotation. Those movements

can never be explained. They are different from the semblance and the similarity of movement. Disaster. That which exists for you is the movement of ideas. For me the movement of everything that lives and the most interesting feelings. As for what energy remains to us, it is necessary to study what the rules are based upon – displace them. DISPLACE THE LINES. Then study, no find how, by what reason, what imperceptible placement, displacement, replacement, to be in the fall's axis. I believe that this would be our participation in the September rain. I would place seeds that like water on green leaves, which I would place in fertile areas between two roots. Count seven times the displacement of the warm-blooded animal before laying the knife down on the seeds. Beforehand charge with real power the knots. We begin the test. Take any object, the one you want. Put it yourself on the table and wait. Move it about. Don't open your mouth! Move about slowly and wait to be connected beyond words that are inaudible to impatient people. Observe these characters. They have spent months in the dust. All that holds me back, still attaches me passionately to poetry, is this brilliant means of correcting feelings and instants. When in their falling like stars, ideas break up on the horizon, is this not a sign that art still has, more or less vigorously, some necessity?

Beneath the rain, characters with their assegai and spears have rediscovered an amazing vitality. Like all the other pieces here, they serve as an instrument when we try to modify the flow of our thoughts or the improbable moments of our meditations. On this subject, what one would not know how to say, better to hush it up!

Word? Word! Word?

[....] The sea maps out oils that shimmer and waters on the tiles. Don't walk there. Change direction. Avoid the holes. Get used to the night. Among the ruins, walk without destroying yourself. Get used to the dust of building sites and to floods, to smoke, to the rust of cars. But nothing will be similar. From whom I would receive the strength to reach beyond the desert? An intact code all villous with baobab, jujube, silk cotton fibres and totally fresh seaweed, barely created bamboos. To hear with them the voices given back to the sea and perhaps to at last see sparkle above the reefs gravitations impervious to the winds and seisms that fracture edifices, statues and monuments. The other man. A man from the past beneath the acacia. Like each dawn before the wind, the leaves roll on the machine, beneath the reactors, the generators, the shadows, the footsteps ...

Something tries to break apart. Something in this city which constantly defies the atom. But how to pass beneath the wave? How to pray (and what prayer), to whom, for whom, for what? No prayer distances from the waves the man who knew not how to open himself up to the world once again. The Earth. In the middle of the fire, the metamorphosis of waters with a light where, in a circle, leaves like

loosened knots displace and replace themselves. Then the crackling of silk cotton tree seeds and the kapok fleeing the wind withdraws by ruse on the wall, settles at the edge of the thorn bushes. The cocks in the silk cotton bark burn to a cinder. After the leaves, the branches fall and break the roof, the shelves and books. The rain falls. The books rot. My heart is heavy. Beneath the rain, like a tree I resisted the storm, death, its cost, creation. In garages, attics, bric-à-brac traders, museums, stores, roads, forests, oceans, wrecks, in birds' nests we always find some things. The open sky, the rain – and I standing, by dint of practical exercise. We believe to have invented it. The image. That is what invention is; it is a thing, something that appears to you and makes you believe that you invented it. It lies. It's a lie that you foresee. Rather live one's moments than collapse, weeping on letters. No, above all not this particular Thursday! The night surprised me, I admit it. September surprised me. The 26th, that particular evening, that particular night surprised me in the walk alongside Sénégal River. It was 6 o'clock, 7 o'clock. Perhaps. I don't know what I must do. I hadn't checked my notebook or the hotel, 'the residence' attendant. He sleeps. Who'd dream of sleeping in such circumstances? I thought a lot during this period (27 September, 2002, is a Friday), about the other, about the walk. I let a few minutes pass by. It wasn't so that I could move about and think. Nor was it to tear out a few plants in this language of barbarity. Here the stone has begun to put down roots in the stone. It was as though I were forced to be interested in the kitten vaguely caught in the net (in the Guet Ndar fishmermen's cemetery), as though it wanted to attract my attention to a point of balance. I moved, like I felt I saw it do, toward the silk cotton tree, but I found no meaning to this. The kitten looked at me. Even though, at the end of a certain amount of time, I had to face the facts ... The other was found there, well and truly in the field of my attention. There was something there – the other. I didn't find it immediately. I moved to the back of the studio and there I had a kind of foreboding. Of what? I don't know. The kitten looked at me. It rushed forward toward the other as though to grab him. It came back to me with the weaver's shuttlecock, which had been put on the altar. The day? The hour? I can't respond. The cost? Without wanting to conceal myself, I cannot respond. The time was real and I wasn't dreaming. To be pursued. I believe that we could probably be enriched ...

The sanctuary is not damaged, seems like stone. It strikes whoever comes near the altar where love lies and which holds the reins of your heart. He who holds the reins of your heart must decipher the truth in the fertile details of the acacia's white flowers.

 Words, words, words.

Issa Samb, extracts from *100 Notes – 100 Thoughts*, no. 95 (Kassel: dOCUMENTA 13 and Hatje Cantze, 2012) 18–19, 32–3. Available at http://bettinafuncke.com/100Notes/095_Samb.pdf

Elise Misao Hunchuck
Trusting Movement//2023

It began with walks through fields and meadows. It began with a stick planted into a small hill. It began with the trust placed in the others who had come before, their collective steps wearing away a path to be followed through the seasons, through the grass and the soil and the snow and the mud. It began with a series of subtle, repeated gestures, sometimes done without thinking, that would leave small traces here and there throughout her life.

'It' is the artistic practice of Anna Zvyagintseva. Though her formal artistic training took place at the HAOMA, National Academy of Fine Arts and Architecture, department of painting in Kyiv, Ukraine, her transmedia practice is one of careful observation, registering both memories and the elusive, almost intangible moments she encounters along the way.

For a time, Zvyagintseva lived in the city centre of Kyiv while her studio was in a so-called 'dormitary district' full of large houses, roads, and pedestrian pathways. While walking home from her studio, she noticed that people were often ignoring established routes and paths, making their own way through the city, sometimes leaving traces and sometimes not. When we walk in the paths made distinctly by the feet of others, Zvyagintseva proposes that we trust the movement of those people who walked before us. In *Paths* (2013), Zvyagintseva enacted and documented the physical manipulation of sites by others, as they made and left distinct trails through grass, snow, and slush to make their own routes, sometimes shortening their way and sometimes not. She began to see these paths everywhere: the film and the ink on paper drawings trace out the marked sites that turn out not to be straight lines and, often, not direct at all. The resulting series consists of forty-nine ink drawings filling forty-nine A5-sized sheets of paper, an assembly of small line figures that show us the breaks and meanders of Anna's trust, each drawing recording somewhat interrupted lines of walking on paths that Zvyagintseva followed. Every one of these paths is an intervention into the real space of the world: material – dirt, grass, snow – is moved, and the site is reconstructed, even if only temporarily. And each of these interventions is a response to cues and factors that are sometimes obvious and sometimes not.

In 2016, before the pandemic and the escalation of the ongoing Russo-Ukrainian war,[1] Anna Zvyagintseva's grandfather, the painter Rostislav Zvyagintsev, passed away. During one of the pandemic lockdowns, Anna found herself going through the notebooks and sketches of his archive. Between pages,

she found a torn piece of paper. On it, she found a poetic phrase from Dmytro Pavlychko's Дзвенить у зорях небо чисте (*The Stars Shine in The Clear Sky*), written in Ukrainian:

> Неначе дерево безлисте стоїть моя душа в полях.
> *Like a tree without leaves, my soul stands in fields.*

The pencilled scrawl, left by a stranger's hands moving blackened carbon tightly held between pressed wood, was a surprise to her. Rostislav, like many Ukrainians who lived most – if not all – of their lives under Soviet and imperial rule, was a Russian speaker. The history of Russia's suppression of the Ukrainian language is a long one, becoming especially pronounced from the nineteenth century onward. And while it is true that in the Soviet Union, there was no state language, measures taken to suppress the Ukrainian language and culture came in more insidious, indirect forms – for example, in the Executed Renaissance, the purging of a generation of Ukrainian poets, writers, and artists throughout the 1920s and '30s. That this scrap of writing was written in Ukrainian reminds us that in many cultures, we find one of the most powerful sites of resistance in poetry, and in Pavlychko's poems in particular, which were often shared as songs and played by the Ukrainian Radio Symphony Orchestra. and that resistance can take many forms. Policies prohibiting the use of the Ukrainian language in different historical periods mean that today even ethnic Ukrainians often do not speak Ukrainian. We see this changing in real time as the war in Ukraine continues.

When she was a young girl, Zvyagintseva and her grandfather would go for long walks through the meadows near their summer house in the village of Reshutsk.[2] Every time they walked together, he would find a sturdy willow branch and, using a pocket knife, would whittle it down to the right height (her height), and off they would go through fields of wildflowers or tall grasses or sometimes both.

There are around thirty species of willow (*Salix*, or in Ukrainian, *verba*) to be found throughout Ukraine 'where they grow along riverbanks and canal banks, road ditches, and dam slopes.'[3] It is said that the willow came to Ukraine from China in the form of woven baskets holding purchased goods. Once emptied of their wares, the baskets would be discarded, sometimes carelessly. We know now that a willow tree, even if cut and woven, can maintain its hydrophilic tendencies. It desires water, and once it finds it, it will propagate, the tendrils of roots emerging from its cut edges, finding more moisture, and, eventually, soil in which to hold itself upright. Once rooted, willows grow rapidly; the indolebutyric acid found in their growing tips spurs them to add mass and leaves. Zvyagintseva herself remembers a fence made of willow branches, for

which one was able to find enough water to grow back into a tree: *A stick without leaves becomes a tree.*

Just before the escalation of the war, in November 2021, Zvyagintseva made her way to Maastricht, where she continued to develop her art practice, expanding in new directions[4]. She created powerful responses to the war with experimental textiles and sunflower seeds in *Sustainable costume for an invader* (2022), to her own fears and displacement in the stark series of *drawings from the diary* (2022), and to the loss of her grandfather with the culmination of *To plant a stick* (2019–2022).

Since then, Zvyagintseva has occupied different places within the expanded field of sculpture, as theorised by Rosalind Krauss. For *To plant a stick*, Zvyagintseva found a sturdy willow branch and, using a pocketknife, whittled it down to become a walking stick. *A stick was once a branch on a tree.* And in her temporary walking fields of Maastricht, in the softly rolling meadow of grasses and flowers, she took her walking stick and pierced the ground with it. Using a Tachihara 8 by 10 inch analogue camera, she took a black and white photo of her sculpture: *a tree without leaves is standing in the field.*

In the summer of 2023, Zvyagintseva tells me via a video call that, 'In my first solo show, I came to trust my own movement', referring to the aptly named exhibition, *Trusting Movement*, held at the Shcherbenko Art Centre in Kyiv (2013). In the online archive of the exhibition, we see a show full of gestures, of feet making paths (*Paths*), of small hand movements captured in sculptural discards (*Sculptures of my father*, 2013). But in *To plant a stick*, we meet an artist who is now working to expand the expanded field, who trusts not only her own movement but also trusts when to be still, and when to trust us to trust her.

1 The Russo-Ukrainian war began on 20 February 2014 when Russia invaded and subsequently annexed the Crimean Peninsula from Ukraine. On 24 February 2022, Russia launched a full-scale invasion of Ukraine. Since then, tens of thousands have been reported killed on both sides, with Russian troops committing widely documented war crimes. By June 2022, an estimated eight million Ukrainians have been internally displaced and just over eight million have fled the country. It is Europe's largest refugee crisis since the second World War.

2 Near the city of Rivne in the Rivnenska region.

3 *Encyclopedia of Ukraine*, vol. 5 (1993), available at https://www.encyclopediaofukraine.com/display.asp?linkpath=pages%5CW%5CI%5CWillow.htm

4 Zvyagintseva returned to live in Kyiv in summer 2023.

Elise Misao Hunchuck, 'Trusting Movement', a new text written for this book, 2023.

Jacques Derrida
And Say the Animal Responded?//2008

[...] [Jacques] Lacan cannot deny that the animal takes the other into account. His article 'On a Question Preliminary to Any Possible Treatment of Psychosis' (1957-8) contains a remark headed in that direction, which I would have liked to insert into this network in a careful and patient manner: putting it at the same time in tension, if not in contradiction, with Lacan's discourse on the imaginary capture of the animal (thereby deprived of the other, in sum), and in harmony with the discourse on pathology, evil, lack, or defect that marks the relation to the other as such in the human, but which is already announced in the animal:

> To take up Charcot's formula, which so delighted. Freud, 'this does not prevent [the Other] from existing' in his place O.
> For if he is taken away, man can no longer even sustain himself in the position of Narcissus. As if by elastic, the *anima* springs back on to the *animus* and the *animus* on to the animal, which between S and o sustains with its *Umwelt* 'external relations' noticeably closer than ours, without, moreover, one being able to say that its relation with the Other is negligible, but only that it does not appear otherwise than in the sporadic sketches of neurosis. (*Ecrits*, 195, translation modified)

In other words, the animal resembles the human and enters into relation with the Other (in a more feeble manner, and by reason of a more 'restricted' adaptation to the milieu, hence, as we were saying earlier, more 'fixed', better 'wired') only to the extent of its sickness, of a neurotic defect that brings it closer to man, to man as failure [*défaut*] of the premature and still insufficiently determined animal. If there were a continuity between animal and human orders, as between animal psychology and human psychology, it would follow this line of evil, of fault and defect. Lacan, moreover, has claimed, in his own defence, not to hold to a discontinuity between the two psychologies (animal and human), *at least as psychologies:* 'May this digression at least counteract the misunderstanding that we could have provided the occasion for in the eyes of some, those who impute to us the doctrine of a discontinuity between animal psychology and human psychology that is far from being what we think.'[1]

What does that mean? That the radical discontinuity between animal and human, the absolute and indivisible discontinuity that he, however, confirms

and compounds, no longer derives from the psychological as such, from *anima* and *psyche*, but instead from the appearance of a different order.

Yet an analogous (I don't say 'identical') conceptual undecidability comes to trouble the opposition, which is so decisive for Lacan, between leaving tracks [*tracer*] and covering one's tracks [*effacer ses traces*]. The animal can trace, inscribe, or leave a track or trace, but Lacan adds, it does not 'cover up its tracks, which would be tantamount to making itself the subject of the signifier.' But there again, supposing one can trust the distinction, Lacan doesn't justify, either by means of testimony or by some ethological knowledge, this affirmation that 'the animal', as he calls it, the animal *in general* does not cover its tracks. Apart from the fact that, as I have tried to show elsewhere (and this is why so long ago I substituted the concept of trace for that of signifier), the structure of the trace presupposes that *to trace* amounts to *erasing a trace* (always present-absent) as much as to imprinting it, all sorts of sometimes ritual animal practices – for example, in burial and mourning – associate the experience of the trace with that of the erasure of the trace. A pretence, moreover, even a simple pretence, consists in rendering a sensible trace illegible or imperceptible. How can it be denied that the simple substitution of one trace for another, the marking of their diacritical difference in the most elementary inscription, which Lacan concedes to the animal, involves erasure as much as the imprint? It is as difficult to assign a frontier between pretence and pretence of pretence, to have an indivisible line pass through the middle of a feigned feint, as it is to situate one between inscription and erasure of the trace.

But let us take this further and pose a type of question that I would have wished, had I the time, to pose generally. It is *not just* a matter of asking whether one has the right to refuse the animal such and such a power (speech, reason, experience of death, mourning, culture, institutions, technics, clothing, lying, pretence of pretence, covering of tracks, gift, laughter, crying, respect, etc. – the list is necessarily without limit, and the most powerful philosophical tradition in which *we* live has refused the 'animal' *all of that*). It *also* means asking whether what calls itself human has the right rigorously to attribute to man, which means therefore to attribute to himself, what he refuses the animal, and whether he can ever possess the *pure, rigorous, indivisible* concept, as such, of that attribution. Thus, were we even to suppose – something I am not ready to concede – that the 'animal' was incapable of covering its tracks, by what right could one concede that power to the human, to the 'subject of the signifier'? Especially from a psychoanalytic point of view? Granted, every human can, within the space of doxic phenomenality, have the *consciousness* of covering its tracks. But who could ever judge the effectivity of such a gesture? Is it necessary to recall that every erased trace, in consciousness, can leave a trace of its erasure

whose symptom (individual or social, historical, political, etc.) will always be capable of ensuring its return? And is it necessary, above all, to remind a psychoanalyst of that? And to recall that every reference to the capacity to erase the trace speaks the language of the conscious, even imaginary ego? (One can sense all the virtual consequences crowding in here on behalf of the question that is our subject, namely, autobiography.)

All this will not amount to saying (something I have developed at length elsewhere) that the trace cannot be erased. On the contrary. It is inherent to a trace that it is always being erased and always capable of being erased [*Il appartient à une trace de toujours s'effacer et de toujours pouvoir s'effacer*]. But the fact that it *is* erased [*qu'elle s'efface*] that it can always *be* erased or erase *itself*, and this from the first instant of its inscription, through and beyond any repression, does not mean that someone, God, human, or animal, can be its master subject and possess the power to erase *it*. On the contrary. In this regard the human no more has the *power* to cover its tracks than does the so-called 'animal'. *Radically* to erase its traces, that is to say, by the same token *radically* to destroy, deny, put to death, even put itself to death.

But let us especially not conclude, therefore, that the traces of the one and of the others are ineffaceable, or that death and destruction are impossible. Traces erase (themselves), like everything else, but the structure of the trace is such that it cannot be in anyone's *power* to erase *it* and especially not to 'judge' its erasure, even less so by means of a constitutive power assured of being able to erase, performatively, what erases itself. The distinction might appear subtle and fragile, but its subtle fragility affects all the solid oppositions that we are in the process of tracking down [*dé-pister*], beginning with that between symbolic and imaginary, which underwrites, finally, this whole anthropocentric reinstitution of the superiority of the human order over the animal order, of the law over the living, etc., wherever such a subtle form of phallogocentrism seems, in its way, to testify to the panic Freud spoke of: the wounded reaction not to humanity's *first* trauma, the Copernican (the earth revolves around the sun), nor its *third* trauma, the Freudian (the decentering of consciousness under the gaze of the unconscious), but rather to its *second* trauma, the Darwinian. [...]

1 [Footnote 20 in source] Jacques Lacan, 'Situation de la psychanalyse et formation du psychanalyste en 1956', *Écrits* (French) 484.

Jacques Derrida, extract from 'And Say the Animal Responded?' (2008), *The Animal That Therefore I Am*, trans. David Wills (New York: Fordham University Press, 2008) 134–6. Originally published in French as *L'animal que donc je suis* (Paris: Éditions Galilée, 2008).

André Brasil
The Tree of Forgetting//2020

[I]n *Árvore do Esquecimento* (*L'arbre d'oublier*, 2013), Paulo Nazareth walks, circulates the tree in an apparently calm square of Uidá, in Benin. He does it, however, backwards.

Nazareth's performance is performed for the first time in the city that was sadly marked by having housed one of Africa's main slave trading ports. A square, the statue of the infamous Chacha, Francisco Félix de Souza, an influential slave trader in West Africa, and a tree covered in flags: alone, apparently without any audience, Paulo Nazareth circles the tree with 437 reverse turns.[1] The artist's action makes reference to the so-called Tree of Oblivion, the Baobab around which enslaved people were forced to go around (9 times for men and 7 for women), which would make them forget their past, their name, their family and their land before embarking towards forced exile.

If the turns around the tree were intended to produce the forgetfulness of the individual and collective past – as if that forgetfulness could, in the form of a blank slate, found the future of slavery in another country – now, in the performance of Paulo Nazareth, it deals with undoing the rite, demanding that we remember both the black ancestry and the oppressive and violent gesture that its erasure aimed to produce. Reverse turn that asks us *not to forget oblivion*: to un-forget; to remember the oblivion to which were forced the kidnapped blacks; to remember, finally, that the work of forgetting – a deliberate erasure – remains operating in the present.

A moment in the *Árvore do Esquecimento* draws our attention: near the number 133, a woman, whose presence partially out of frame was unnoticed, moves and sits. The artist now has the company of someone who watches the performance. The woman assumes the position of spectator, perhaps the only one.[2] The same performance was repeated by Paulo Nazareth in other places: in Belo Horizonte, in front of Cine Brasil; in Maputo, in front of Cine África; and again in Belo Horizonte, around a yellow Ipê tree. With each new performance, the refusal to forget is reiterated, addressing this to the present, as if each tree planted in the centre of a city updated the possibility of this reverse 'forgetting' gesture. [...]

Body-walker, Reverse Time
In *Walking in an Exaggerated Manner Around the Perimeter of a Square* (1967), Bruce Nauman walks exaggerating his movements on the lines of a square, inside his studio. Recorded on a 16mm camera, the walk moves forward,

backwards and, occasionally, duplicates itself in the mirror located discreetly at the back of the room.

Both performances, Nauman's and Nazareth's, repeat the gesture of exhaustively going around a shape, in the first case, a square in a closed space; in the second, a circle around the tree, in an open space. Despite the initial similarity, both performances have very different results and addresses. Nauman seems to be interested in the movement itself, the exaggerated gesture, the sway that disconcerts the square. Although the artist is at the centre of the scene, it does not seem fair, in the case of this performance by Nauman, Rosalind Krauss' [1976] critique of the video performances produced in the 1960s: that they would compose a sort of *aesthetic of the narcissism* that would make the environment and the self-centred exposure of the self coincide.[3] *Walking in an Exaggerated Manner* shows itself, mainly, as a criticism to the disciplining of the body, the submission of gestures to normative parameters. In Foucauldian terms, exaggerating bodily manners would therefore be a criticism of bodily exercise as a disciplinary strategy, leading the body to experiment with gestures that normative standards reject.[4]

It could retain, however, a specific aspect of Krauss' critique, which would be valid here: in these performances, she writes, the 'self' is exposed as if it had no past, without any connection with objects that are external to it. Perhaps there is an important difference between the performance of Nauman and that of Paulo Nazareth who, instead of the closed space of a studio, walks around the tree in the square of Uidá. Nauman's performance is built in the present – the theatrical body transgressing the normative – and it is the present that it aims; that of Paulo Nazareth rather turns to the past (which here is less biopolitical than necropolitical). Counter-spell rite (disenchantment), its time is reversed: it reverses the erasure of memory that the rite around the Tree of Oblivion was intended to produce; it reverses the oblivion of this gesture of erasure, as if it needed to be constantly reminded to be fought. In this sense, when turning to a past practice, performance intervenes in the present (without losing its connection with history): it aims at the erasures that continue to operate and that sustain contemporary racism. It is not by chance that the artist performs in urban centres, as in summoning, in the present of cities – in Africa and Brazil – the gesture of un-forgetting. Resuming the past thus seeks to undo (as if rewinding) one of its events – the rite in the Tree of Oblivion, an emblem of the slave trade violence. However, for the task to be successful, it is necessary to remember, actively and constantly, the persistence of this violence in the present.

It would also be necessary to place *L'arbre d'oublier* in the broader set of Paulo Nazareth's work: there is an aspect there that is suggested by the appearance of the woman, a solitary spectator, to carelessly follow the performance.

Wanderings and performances are a way to intervene in current issues related to racism and, in the same gesture, to form precarious alliances with others, whose life is constantly threatened by stigma and social exclusion. A kind of community of the margin and exile finds, in residual images (a video, a photo, a handwritten poster, a pamphlet) its mode of exposure. Walks, performances and fortuitous encounters produce records, scattered vestiges that exhibit 'a fragile materiality, weak as a residue, disposable and forgettable as the stories of the people the artist found along the paths of America' and, now, through Africa's paths. Paulo Nazareth meets subjects from this peripheral community – which does not respect borders – and, at the same time, shelters it in his own body.

Árvore do Esquecimento participates in the *Cadernos de África project*, which aims, in the artist's words, 'to know what there is of my house in Africa' and 'to know what there is of Africa in my house'[5]. To this end, he visits African cities, again assuming his role as a collector (of objects and images) open to the encounters he has with marginalised subjects, holders of experiences, stories and knowledge as diverse as they are invisible. The turn, the return and the resuming are not gestures of identity fixation, producing rather alliance and exchange, explaining affinities between blacks, indigenous people, caboclos, migrants, exiles and nomads in a community that is constituted by the separation and updating, in the present, the affinities of an 'insurgent mythical time'.[6] The counter-spell rite – walking backwards around the tree – is less an identity return to the past than a 'decolonial turn'[7] (or counter-colonial), which produces a reverse time to that of violence and erasure (of memory and knowledge). The result of this reversal is the reactivation – through materials and precarious encounters backed by the daily struggle and the 'insurgency' – of ancestral alliances.

Part of his travels – work in progress – the films produced by Nazareth are also what allows the rite to circulate beyond the present of performance. If it acts in the present to 'undo' an ancestral rite through the film, it continues to act in the future (in other presents, in other contexts): the 437 turns become infinite and, in front of each spectator, the reverse gesture is virtually redone endlessly.

1 [Footnote 5 in source] Asked via Whatsapp about this number, Paulo Nazareth says that it is 'a cabalistic... prime number... for me something like the infinite and at the same time the incomplete...' [...] '4 + 3 + 7 = 14 1 + 4 = 5 5 = the number of fingers we have in our hands ... principle of Mayan mathematics'.

2 Renata Marquez, 'Experiência estética e regimes de sensibilidade: parlatórios para dissensos territoriais', *Devires*, vol. 13, no. 1 (January/June 2016) 148–63, 159.

3 [Editors' note: Rosalind Krauss, 'Video: The Aesthetics of Narcissism', *October*, no. 1 (1976) 50–64.]

4 [17] Not for nothing, the performance was remade in a prison cell in Nottingham as part of the Impossible Prison exhibition in 2008.

5 [18] M.A. Melendi, 'Folhas ao vento – Paulo Nazareth, Notícias de América, 2012' in E.L. Cornelsen, E.A. Vieira and G.L. Quijada (eds.), *Em torno da imagem e da memória* (Rio de Janeiro: Jaguatirica, 2016) 165–78. Blog of the project 'Cadernos de África', available at https://bit.ly/34r4Tb5
6 L. Oliveira, 'Sobre Che Cherera de Paulo Nazareth: uma conversa no tempo mítico'. *Lindonéia*, Belo Horizonte, no. 3 (2014) 90–9.
7 [19] I freely call upon the concept Santiago Castro-Gomez and Ramón Grosfoguel (eds.), *El giro decolonial Reflexiones para una diversidad epistémica más allá del capitalismo global* (Bogotá: Siglo del Hombre Editores; 2007).

André Brasil, extract from 'Crossroads, Walkers, Apprentices', *Significação*, São Paulo, vol. 47, no. 53 (January–June 2020) 21–47.

Carl Lavery
Walking and Ruination//2015

[T]here is no simple method for walking or indeed for describing a walk. Like a performance score, a walk is an open-ended phenomenon, no one knows in advance what will present itself or who you might meet. The meaning is in the doing, properly performative then, which is to say, self-generating, contingent, improvisatory, light-footed and rooted in the everyday. It is also unexpected. On the route of my daily walk along the Forth and Clyde canal in Glasgow, I am sometimes astonished as I watch brown bottles of empty Buckfast Tonic Wine gleam in the water, to see a huge. looming brutalist tower-block rise up and attack the corner of my eyeball. To walk is to montage, to assemble difference, to exist as a kind of mad, avant-garde camera eye, the socket discombobulating. rendered insane by vision itself.

There is also a high possibility of failure: that the performance of the score or walk (or both, if that is the instruction) might not amount to much. A favourite building might have been destroyed, a path re-routed, a neighbourhood gentrified, perhaps even, as has happened in Wales, a village flooded or requisitioned by the state. We are in Proustian territory here, but with a difference – minor key Proust. This is not the famous Proust of the madeleine, the Marcel who is able through the sensory play of the *mémoire involuntaire* to recover, like Henri Bergson, lost time *(le temps perdu)* in the present. Rather this is the Proust of failure, the absurd Proust, the one for whom lost time is wasted time, impossible, irrecoverable, out of reach. Consider, for instance, the tragicomic potential of the passage below:

And so it is with our own past. It is a labour in vain to attempt to recapture it all: all the efforts of our intellect must prove futile. The past is hidden somewhere outside the realm, beyond the reach of intellect, in some material object (in the sensation which that material object will give us) of which we have no inkling. And it depends on chance whether or not we have come upon this object before we ourselves must die.[1]

What I love about this writing, and this is certainly what also seduces me in Robert Walser's horrific and shocking short story 'The Walk' (1917), is the idea of chance, the sense in which there is no guarantee that we will ever keep our appointment with the past, that it all might have happened without us. Perhaps it's me, but I find great consolation in the image of someone walking past, blithely and without noticing, the redemptive object that will allow access to one's secret life.

Some of my friends, including my colleague Dee Heddon and Wrights & Sites, like to walk in groups, I, on the other hand, always prefer to walk alone. Though fully aware that my gender and 'able-bodiedness' assign me special privilege, I walk in order to think, to engage in a kind of embodied writing, to let an idea, like a landscape, unfold. I have always found that difficult to do in company. There is nothing exclusive or regulatory in this strategy. Other users will doubtless have different ideas and practices of engagement.

Much has been written about the intimate, perhaps even symbiotic relationship that exists between walking and thinking. One thinks here, of course, of Immanuel Kant heading out for his daily constitutional through the streets and fields of Konigsberg as he composed his tripartite series of *Critiques* between 1780 and 1790; or of Walter Benjamin, in the 1930s separated from his son and always on the verge of homelessness, pacing through the I and II Arrondissements in Paris on the lookout for remnants – 'fossils' he called them – of the arcades or 'dream palaces' that were so popular in this area of the city in the nineteenth century. Likewise, Friedrich Nietzsche cautioned, in typically melodramatic fashion, that he never trusted a thought that came to him while indoors; and more recently, Rebecca Solnit, in her study *Wanderlust: A Short History of Walking* (2000), has argued that 3 mph is the classic pace for thinking.

With her invitation to write this [text], Claire Hind sent this citation from Eric Anthamatten's 'Philosophy begins with Wander':

Philosophy begins with wonder *(thanmazein)*. To riff with a homophone 'Philosophy begins with Wander'. It is precisely the wandering that facilitates the wondering, and the philosopher wonders while he wanders. The structure of thought is not a straight line, but a wandering, an ambling, a meandering, a walkabout. The dialectic zings, zags, not aimlessly, but less

characterised by a straight line than a squiggle that goes this way, then that, moves forward, then turns back on itself. Philosophy is just this movement.[2]

In two articles, 'Mourning Walk and Pedestrian Performance: History, Aesthetics and Ethics' (2009) and 'Pas de Deux' (with Nicolas Whybrow), I tried to advance my own theory for this mysterious connection between walking and philosophy by drawing, first, on ideas of cinema, and second, on the technical vocabulary of versification that creates a distinct analogy between the beat of a line and the beat of a foot.[3] Increasingly, however, I am minded to think of the relationship between walking and thinking (and I use that word to encompass making), in terms of a creative process of ruination, which troubles normative notions of the archive. It is surely no coincidence that in French, the word for step or pace *(un pas)* has a negative sense when used in syntactical construction such as 'Je ne vois pas' or 'Je ne suis pas'. In this example of what linguists call 'sentential negation', the step *(le pas)* is something that erases what came before it, making the past dissolve in the dust, wiping away, we might say, all traces of self-presence. This negative, essentially forward-looking significance of walking, is seen, too, in the French self-reflexive verb *se promener,* which translates, literally as 'to take oneself for a walk'. The prefix of *se promener,* in this instance, rooted, as it is, in the Latin *pro* (to go forth), assigns an essentially projective significance to walking, as if everything you are, and ever were, was somehow always being placed in crisis. The negativity of the step *(le pas)* moving relentlessly into the future, is willing to wager on loss, and to accept that nothing can be predicted in advance.

How different such a process of negation is from the current obsession with archiving, which as Jacques Derrida has suggested in *Mal d'archive: une impression freudienne (Archive Fever: A Freudian Impression)* is a kind of 'infinity of evil'.[4] Unlike the score or the walk, the archive, as Derrida explains it, always tries to impose an order, to invest in an act of authentic conservation, in which the past will somehow be able to transcend the vagaries, fictions and fragilities of memory. Whereas the archive, in its most normative form, seeks to control the past by fixing it in a prosthetic of sorts (a tablet, page, floppy disk, or electronic cloud), walking, when conceived as an act of necessary negation, reduces the past to ashes, to cinders. So that while the trace of my footprint might remain, my other foot is always rising into the air, willing to move on, to become something different, something new. At the very end of *Archive Fever,* Derrida, while sitting on the slopes of Mount Vesuvius, makes this statement:

> [O]f the secret itself, there can be no archive, by definition. The secret is the very ash of the archive, the place where it no longer even makes sense to say

'the very ash' *(la cendre meme)* or 'right on the ash' *(a meme la cendre)*. There is no sense in searching for the secret of what anyone may have known.[5]

Inevitably, perhaps, in light what I have been arguing, I cannot help but see walking (again) as a kind of secret. Of course the trace or impress of the foot remains, but what can we say of the living, singular person who makes those marks with a step *(un pas)* which is always a negation? Instead of approaching this negation as a melancholic reminder of what was, characterised by an impossible drive to make the secret speak – the logic of the archive as a logic of historical truth, in other words – I wonder if it might make more sense to celebrate walking as an act of perpetual and incessant ruination, an instance of a secret that refuses, stubbornly, to reveal itself? Faced with this secret, the one who remains, be that a reader or maker of performance, is constrained to respond to the footprint in a different way, to use the secret not as a sign of truth, but as a catalyst of/for imagining, a type of speculation, then, that avoids the mistake of Orpheus. Here the point is not to look back to the past but to keep one's eye firmly on what is ahead, in affirming, that is, the future, which is tantamount to affirming the impersonal flux and flow of a time that we can never inhabit fully or know.

To turn from philosophy to performance practice, such an affirmation is consonant with the logic of the score, those '25 Instructions for Performances in Cities' that I proposed a decade or so ago.[6] To perform a score is not to perform in the name of truth, as if one were somehow concerned with idealising a perfect, self-contained actualisation of the original instruction; rather, it is to affirm the necessity of betrayal and the ineluctable reality of failure. In this way, through the necessary ruination of the instruction, the performed score, like the walk, is a guardian of the secret. It realises that the footprints it leaves are a kind of wreckage, an act of creative destruction that has the generosity to foreclose in advance its own will to truth, to temper its own archive fever, and to leave a space for ghosts of the future to come, those spectres who are always still to arrive but yet are strangely already here.

1 Marcel Proust, *Remembrance of Things Past, vol 1*, trans C.K. Scott Moncrieff and Terence Kilmartin (London: Penguin, 1984).
2 Eric Anthamatten, 'Philosophy begins with Wander', *Nomadic Sojourns*, vol. 1, no. 1 (2012) 13.
3 Carl Lavery, '*Mourning Walk* and Pedestrian Performance: History, Aesthetics and Ethics' in Roberta Mock (ed.), 'Walking, Writing and Performance: Autobiographical Texts by Deirdre Heddon, Carl Lavery and Phil Smith', *Intellect*, 2009) 41–56 and Carl Lavery and Nicolas Whybrow, 'Pas de Deux', *Research*: 'On Foot', vol. 17, no. 2 (2012) 1–11. See also John Hall, 'Foot, Mouth and Ear: Some Thoughts on Prosody and Performance', *Performance Research*: 'On Foot', vol. 17, no. 2 (2012) 36–41.

4 Jacques Derrida, *Archive Fever: A Freudian Impression*, trans. Eric Prenowitz (Chicago: University of Chicago Press, 1998) 20-1.
5 Ibid., 100.
6 Carl Lavery, '25 Instructions for Performance in Cities', *Studies in Theatre and Performance*, vol. 25, no. 3 (2005) 229-38.

Carl Lavery, extract from 'Walking and Ruination', in Clare Qualmann and Claire Hind (eds.), *Ways to Wander* (Axminster: Triarchy Press, 2015) 9-14.

Roger Owen
Go to google.com//2011

Go to google.com; click on maps; find Western Europe, then the UK. In the mid-western extremity of the UK, zoom in to find Wales; in the south-west of Wales, zoom in to find the town of Cardigan, up on the western coast to the north of Haverfordwest and Carmarthen. Zoom in again (probably more than once) to follow the A487 road north-eastwards past Penparc and Tremain to Blaenannerch.

Zoom in. OK.

By now, you should be viewing at 500 metres above the surface, with the village of Blaenannerch towards the centre of your screen (a little lower than centre would be best). The long straight strip that you can see is the runway of a former RAF base now known as West Wales Airport; the road which runs past it in a broad arc – the B4333 – runs down towards the seaside village of Aberporth (if you're in the mood for an excursion, follow the road down there and see people sunning themselves on the beach by Ffordd yr Odyn. The tide's out. It's a nice day. Good. Now come back to Blaenannerch, the rest of us are waiting). After the airport, there's a roundabout, keep on along the B4333, past the buildings, then you see the road bends to the left, up to a junction? OK. Now. Don't follow the B4333 down to Aberporth (again); this time, follow the straight unmarked road which leads ahead – north-west, toward the top left of your screen.

Got it? OK, good.

Now, stop looking at the roads, look at the fields next to the road. To your right (north-east) there's a patchwork of light-coloured fields, some light brown, some lain with white-coloured strips, and some light green. Follow the three nearest to the road: the tip of the third points to a road junction. Across the road from that third field (to the south-west), a sharp line of three more white-

120//BACK AND FORTH

stripped fields meets a patch of smaller green ones. This is the western boundary line. Zoom in. Looking at those green fields, you should be able to see that they're grouped together into the broadly triangular shape of a spearhead (the single light brown next to the road, the one shaped like the Cyrillic 'Я', marks the eastern boundary, along with the three rectangular fields to its south).

Congratulations, you've arrived. That spearhead of fourteen fields is – or was – Maesglas, the farm where I grew up.

I hope you've found it. It might not be that easy, since the specific colourings of the terrain as represented on the Google® map may have changed by now, but try to use the instructions as well as you can. If you're using any other mapping site (such as Bing®), it might not be quite as easy because the colours of the fields are different and the road layout doesn't look the same. Actually, comparing the two tells you something about the way in which agricultural land changes its appearance and use over relatively short periods of time, and also about the process of producing these kinds of online maps. To the casual user, the maps produce a powerful illusion, that of a continuously spreading, faithful portrayal of the condition of the earth's surface as seen through a clear sky; a miraculous, eternal moment showing the whole terrain, from individual fields and buildings to a whole country, or indeed the whole world (somewhere, you and I are on there).

But these maps, like all others, aren't concerned with producing a truthful representation of the experience of living on the surface, but rather with helping us to regard the land as navigable. That promise of navigability might lead the reader to ignore the fact that this kind of map, at a large scale, is fundamentally distorted; like every other map, it has to deal with the problem of projection, but the Google® map also has to deal with the fact that it is composed of a massive digitised patchwork of images, a huge cut-and-paste job which is adjusted in order to produce the most affordable and amenable view of the land surface. Particularly in rural and less populated areas, the workings and imperfections in the patchwork can be evident.

So much for the large scale. My concern in this essay is with the small scale. Here, also, the Google® map has to deal with other possible distortions of the cartographic ideal: in this case, events. Close up (at about 50 metres or less), you can see the surface of the earth is in a state of flux; disturbed by the weather – by tidal and seasonal patterns of change – and by human agency – building, demolition, transport, the movement and gathering of people, and farming. Of course, the images had to be photographed at some point in time, and so the specifics of those moments, their particular non-generality, leak out: the map records not only points in space but also specific moments in time.

For example, the markings and colouration of the land provides very clear evidence of the specific conditions on the ground at the time of the map's

production. Look at the fields surrounding Maesglas, at about 200 metres up: you will see some, bare of grass, which have ploughed and sown; some where crops are already providing a dense green coverage; and others where they are being 'forced' through the early stages of their growth under strips of polythene; some which have been either partly or fully mown for hay or silage; and some which have been left for grazing by cattle or sheep.

These fields will change their colouration from year to year (hence the difference between the Google® and Bing® images, and the possible inconsistencies between the images on the Google® map described above and that which you might see now – if Google® even still exists by the time you read this). But they will also, obviously, look different at different times of the year: the grass which is mown for hay or silage will re-grow, turning pale green fields dark; the crops sown in the fields, along with the trees and hedgerows, will grow, possibly flowering into vivid colours, like the yellow of rapeseed or gorse; and open grassland may become parched and brown in high summer. Given these adjustments in colour and function, it isn't difficult to place the Google® image as having been taken in late May-early June, while the hawthorn bush is still in white flower.

Other leakages into the temporal purity of the map include occasional sightings of sheep or cattle grazing (or dawdling near the sheds at Plas Newydd, to the north-east of Maesglas: they might have just come out after milking); and of people at work on the land – within a couple of screens' radius of Maesglas (at 200 metres), you can see tractors mowing, raking cut grass into rows, and baling either silage or early hay. And the beaches along the coast are comfortably populated.

Everywhere, there is evidence of the human attempt to organise the land in order to extract as much from it as may be economically viable. Most obviously, the map shows the seemingly random division of farmland into small units with asymmetrical field boundaries. But, once again, these boundaries may be read as traces not only of spatial division but also of historical time. The asymmetricality of these boundaries is a major feature of the Welsh landscape, and derives partly from the undulating topography of the land but also partly from historical and commercially-driven change – some farms have expanded, others remained small; those that have stayed small may have retained smaller fields whilst the larger farms have pulled hedges down in order to facilitate the use of heavier machinery. If you look closely at some of the larger fields, you can make out traces of some boundary lines in the soil where hedges have been removed. You can also see evidence of (relatively) recent diversification into leisure activity – the conversion of farmland into caravan parks, a go karting track, a wildlife park, the building of new houses and estates.

And so, the map operates as a document of space and time. Importantly also, it is a document of culture. This part of south-west Wales is a relative stronghold for the Welsh language, a fact which is reflected in the Welsh place names all around (Aberporth, 'estuary-port'; Parcllyn, 'field pool'; Penparc, 'field top'; Tremain, 'stone homestead', etc.). Moreover, there are, as you might expect, dozens of idiomatic expressions for an individual's relationship with their own area which do not appear on the map, which, though they might be translatable, remain highly specific: for example, *y filltir sgwar* ('the square mile'), *y fro* ('the locale'), *y gymdogaeth* ('the neighbourly community'), and so on.

Farming has been an important locus for specific terminology and discourse in Welsh. The practices of farming, being daily, physically immediate and relatively widespread (although varied according to terrain, crop and type of livestock) have tended to create the kind of specialisation and density of usage which any language needs in order to become embedded within a local culture. Of course, as farming becomes a more diverse and technologically driven (and often solitary) practice, the need for so many people, sharing the same labour and thus the same specialised language, diminishes. Similarly, as fewer people rely directly on agriculture for a living, and as tourism grows as an economic sector, the emphasis on a language which describes the experience of working the land decreases, while a language which describes the land via the experience of spectatorship increases.

I'd like to use two Welsh terms to expand on this, and also to describe the effect of looking at the Google® map. 'Landscape' in Welsh may be rendered either as *tirwedd* or *tirlun*. These two words are often treated as interchangeable, but are significantly different in terms of their derivation: the first, *tirwedd*, is literally translated as 'land-feature' or 'land-face'; whilst the second, *tirlun*, translates as 'land-picture' or 'land-scene'. The first, I would argue, is distinctly tactile, and connected with the physical experience of the land; while the second is concerned with the act of representation and spectatorship. The descent to earth from space, which we undertook in order to find the Maesglas on the Google® map, as well as the angle and distance from which it is viewed, plays with the distinction between these two terms.

As we descend from high altitude (at about 2,000 kilometres to start with), we are presented first of all with a *tirlun*, a conventional picture of landmasses bounded by sea; as we descend, this broader sense of perspective is lost, and we are made increasingly aware of objects or labels which suggest ways of traversing the surface, and of preferred locations on that surface, all of which begins to seduce us with the promise of a relationship with the land as *tirwedd*. 'Come closer,' the map seems to say, 'you'll be able to touch, to smell the surface.' This seduction seems to be at the point of fulfilment at one kilometre, when a

new, and final, level of exposure is revealed. Here, the more detailed features of the land are shown, the true scale of the roads in relation to the fields, and the vast diversity of the human taskscape – both industrial and domestic. And yet, the promise of some kind of sensual interaction with the land is delayed. The promise of *tirwedd* comes to nothing and you are left with *tirlun*, the land fetishised, where gazing stands in for touching.

We ought to know better, really. As we fell out of the sky with Google®, we succumbed to the comforting lie that everything we see down on the surface is recognisable in human terms. Of course the land bears the marks of human activity almost everywhere we look. But not all the lines on the map have been made by humans. There are other traces, visible from the air even at one kilometre. Across the fields of Maesglas, and on other fields too, you can see paths cut into the soil by cows, visible in at least half the fields. The daily activity of cows moving from field to field leaves a trail line across the ground. The trail shows how they choose to move: in a single file, moving largely in straight lines which snake gently around the contour lines of the fields. The flatter the field, the straighter the line. In my experience (I lived permanently at Maesglas until the age of eighteen), the trail they left across the fields marked their migration from their chosen pasture ground to the farmyard and cowshed where they were milked twice a day. As they trudged their way along in single file, their hooves scuffed and wore the line into the ground, denuding it of grass. The dense clay of the soil, once exposed to the sun and rain, waxed and waned from grey mud to a white dusty concrete. And so, four times a day, to and from the yard for milking, some thirty cows (along with heifers and steers) wore the line into the ground. By the end of summer, the line was a shallow trough, a light brown indentation against the surprisingly deep green of the pasture after the adle – the regrowth – of August.

It is rather ironic that the Google® map, this latest human hyper tool of navigation, reveals occasional traces on the land which are essentially alien. I hesitate to argue that the cow-lines are evidence of 'nature' in action – dairy cows are products of industrial selection, and on negotiating a specifically-designed landscape comprised of fields, hedges and gates. By this reckoning, the mark which they leave on the ground is largely determined by human activity and order, which then effectively 'contracts' the drawing of the line to the cows. But even so, they choose to walk the line even when not driven by humans. The trails which they leave across the land suggest a level of organisation amongst them as a herd, a hierarchy which inclined some to lead and others to follow, and a preference for habit. It is ultimately their line, not ours.

This may be why their tracks across the fields carried a particular significance for me as I grew up at Maesglas. In fetching the cows for milking in

summer, and in walking down through the fields to check on them and count them at dusk, I would follow their tracks. Sometimes, as in thick fog, it was the only way of seeing which way to go; but, largely, it too was a matter of habit, or of a desire to use, to claim and ritualise something which had been created by an agency which was not human. In that sense, the cows' path was a proper 'land-feature', produced by an intelligence which (for all we know) did not and does not comprehend *tirlun*, the land as objectified by visual representation. Its presence on the great *tirlun* of the Google® map, then, provides a brief moment of relief from our eroticised consumption of the landscape. This is *tirwedd* par excellence, an object formed by an impression of the land as tactile experience; since no amount of gazing at the cow-line will give the viewer even the myth of access to the imagination which scuffed it into the ground.

Afterword

The time of year represented in the maps is now far more like high summer than late spring (and the images are somewhat the poorer for it).

The references to milking cows seen by Plas Newydd no longer apply. Since the publication of the original essay, many farms have sold their dairy herds, keeping beef cattle or sheep instead, or diversifying into other fields entirely. Many of the farmsteads do not possess much of the land which surround them, and are noted as the locations of new small businesses, many focusing on wellbeing, tourism and leisure.

Since 2011, the number of cattle grazing up on the fields of Maesglas has decreased substantially, and so the lines marked by the passage of cattle across the land have disappeared. It is now more commonly grazed by sheep, which do not leave the same lines at all. However where cows are visible on the map, you can still observe the lines drawn by this single file marching across the fields from gate to gate, or up towards feeding troughs.

Roger Owen, 'Go to google.com', in Wapke Feenstra and Antje Schiffers (eds.), *Images of Farming* (Heijningen: Jap Sam Books, 2011) updated by the author and with a new afterword for this book, 2023.

Darby English
Just above My Head//2013

Just above My Head, a black-and-white film by the British artist Steve McQueen, is a nine-minute-and-thirty-five-second document of the artist out for a walk in the English countryside.[1] Agitated camera movement tells of an uneven terrain clearly lacking the fluency of a sidewalk or roadway. McQueen created the film by holding at arm's length a 16mm camera pointed at himself. Always exhibited in a continuous loop, the film opens with a view of the artist from below, against a stippled expanse of clouds. He stands still briefly before commencing his stroll. The unorthodox camera work abbreviates McQueen's figure: he never occupies more than the bottom third of the screen or an even smaller fraction of its width. For nearly ten minutes, his part-figure bobs shakily along, above and below the frame's edge, at points seeming to descend into the floor beneath our feet.[2] Sometimes, McQueen passes under a copse of leafy trees; at all others, seeing only the sky above him, we note the absence of any architectural array. A cryptic naturalism – contorted perspective, cloud forms rendered in grainy grisaille – locates McQueen's action squarely in the rural landscape. This much is utterly familiar: a British artist films himself undertaking the perambulatory ritual that for two long centuries has been emblematic of his country's visual and literary arts.

The raw material of tradition is in some way reworked and realigned. Yet this fact is not registered in the literature on the artist, which, moreover, routinely places him on the 'street'. A rich bevy of contextual support surrounds this assumption: the film's story began in London; the scenography of McQueen's early works is predominantly urban, and his characters are mostly black. His emergence into prominence coincided with the zenith, in the mid-1990s, of the politics of difference that would significantly alter the public profiles of museums, galleries, and schools in major metropolitan centres. This context and reception lend the work a generous share of its historical texture.

Eventually, though, the course of this work's interpretation, so marked by its time, must open itself to a longer view of its historical character and form, and to the ways in which the artist has responded to tradition. McQueen's action clearly attends the development of a plot, and a plot requires a stage, a space wherein to develop, and time to unfold.[3] That plot is provided not only by late dramas of identity politics but also by a long-standing British literary and pictorial convention. However unforeseeably, *Just above My Head* restages the intellectual's occupation of the rural English landscape as a starting ground for subjective expression. Since the beginning of the nineteenth century, the country

walk has been a crucial scene for British artists working through the anxieties besetting individual expression in a culture every bit as addled by traditionalism as animated by it. The idiom proves expansive enough to gather the wildly divergent aesthetic sensibilities of, say, Samuel Taylor Coleridge and Richard Long, into a fraught proximity. This symbolic process, and the imagined displacement from the vicissitudes of metropolis it generally entails, are not so easily bracketed. The specificity and power of McQueen's appropriation do not illustrate formalised pieties about postcolonial social relations (as dramatised, say, by symbolically reclaiming land rights withheld), but instead frustrate the supposition that McQueen would, or could, illustrate them at all.

Readings of the film urge vigilant attention to the artist's restive confinement to the lower margin of the screen, where, try as he might to close the gap between himself and us, his effort is continually thwarted. But the spatiality immanent within the film's subject matter is too vivid to permit us to confine our attention to the edge. The film gives a great deal else to see, if not exactly to look at. McQueen's prospect, what his outlook encompasses, remains his business. The inverted, mobile camera provides a decisive transposition: the practice of attentive looking, which discussions of such art invariably ascribe to a hyperembodied viewer, here shifts onto McQueen himself. The restless frame suggests a concerted labour to establish an image in which McQueen is an incidental rather than a determining force. The film's generally solitary affect makes it all the more redolent of the peculiar tradition it awkwardly extends. The most appropriate term for the condition it represents is privacy. Recall that for Wordsworth, too, in his poem of 1804 'I Wandered Lonely as a Cloud', the salient encounter was not with the well-known 'crowd of daffodils' that bursts forth in the poem's opening stanza.[4] By the lyric's end, we find the narrator's attention shifted from this sweet scene to its afterimage in a subsequent reverie, which is to say, to the impression it left on his mind. Wordsworth's narrator finally locates 'solitude's bliss' in the very separateness between a concretely picturesque view and the 'flash upon that inward eye' that returns it to the viewer, only now as a uniquely bracing but utterly private image.

What the viewer sees in this film's halting but deeply affecting articulations of McQueen's location is an individual's curious, shifting, and nontransparent relation with one of his culture's most enduring representational systems. By withholding rather than sharing the view, the film reframes the artistic gesture of the country walk without domesticating it in a pat statement about belonging. *Just above My Head*, in fact, resists making the kind of depersonalising pronouncement about cultural location that was virtually a precondition of professional visibility for minority artists in 1996. In this way, it is a work of art completely of its time, only not compliantly so: it insisted on the sacredness of the individual, her or

his body and experience, at a moment when it was preferable to project them as metaphors for an entire social condition. What called forth McQueen's artistry was not the concreteness of outward events but the private self's outlook on them, and the space needed to elaborate one. These themes he pursued enthusiastically, even at the risk of distorting the tempestuous realities of race and racial conflict in contemporary England. This, finally, is the more credible marker of his difference.

1 McQueen disclosed his location to me as 'somewhere in Devon,' personal correspondence with the author, 26 November, 2012.
2 McQueen's preferred display apparatus places the viewer in a standing position before a screen that terminates in the gallery floor.
3 See John Dewey, 'Having an Experience' (1934) in *Art as Experience* (New York: Penguin Books, 2005) 43.
4 See William Wordsworth, 'I Wandered Lonely as a Cloud', in *William Wordsworth: The Poems*, (ed.) John O. Hayden, vol. 1 (New Haven: Yale University Press, 1977) 619–20.

Darby English, 'Just above My Head', *The Art Bulletin*, vol. 95, no. 3 (September 2013) 362–4.

Camilla Nelson
Epic//2021

Let's get one thing straight. I am embarassed not embarassed to be writing this word work weft of man woman child as if it were something worth worrying about. As if it were a Bayeux epic for the masses rather than the jottling weave of my own rambling mind. But if his words are worth the time, money and space then why the hell aren't mine? Sad sack Penelope they call me. Beautiful. Rich. Intelligent. Odd sock, Circe. Witch, weaving spells. Medusa. Monstrous ugly. Thread-dancing, Ariadne. Condemned as side shows for men that stop along their way. Working our lines in their shadow. Not any more.

Mere Downs To Maiden Bradley
Wednesday 15th May 2019

I find myself composing as I walk. I'm not so sure of
 A crow cawks above me and the wind plays shoals of fish through grey ploughed fields. Heat haze ripples the green. A choking gulp distinguishes the rasp of the pheasant from the panting of a worn out dog. I find

myself thinking of The hawthorn is powder perfect. The rape is neon yellow. Colours change. Flax blue? Apple blossom over. Lilac turning. Horse chestnuts' proud white flame. Pheasant starting to sound like a dog again.

I am walking far today. Maybe 15 miles. Making the most of the sun while we have it. And when I go out to say goodnight to the jungle of my garden. I think of under the same sky. I know that writing is often, of necessity, intense and lonely. And if it is, I'm thinking

maroon-topped grasses stalking-green periwinkle blue white eyes

 insect buzz of birds struggling sound of a man running invisible shout

I'm only part way to the ridge but I know there won't be any sheltered place to sit for a good while once I'm there, & I remembered what else about Ulysses. And realised that even though I mocked a Greek hero (the mockery still stands), *Ulysses* is one of my favourites. Joyce's version. Stephen

 [crow cawks – or is it a raven? sonorous warmth]

was a long-standing literary crush – with his romantic pretensions, unexamined egotism & difficulties with sex. I'd hate him in real life because he is a self-important navel-gazing chauvinist. But Joyce gives him beautiful words .
As a convent-bound teenager, I wanted my thoughts to sound as beautiful and interesting as his. Sad state of affairs.
 But who wants to be Wendy when you can be Peter Pan? And I never liked Bloom. His middle-aged pot belly & slightly disgusting seriousness never appealed. He was just a bit dribbly. Always belching and muttering.

 It depends which habit I'm trying to break:
 holding out for the unavailable slamming doors shut faster and harder
 . I'm looking for a way to transform . I'm not sure what that is in this context. Perhaps
 out of one dynamic into another.

Nelson//Epic//129

Anyway

I'd better get on. Who wants to sit at home and spin when you can be out walking? Is there room for us both to be the hero of this piece?

– – – – – – – – – – – – – – – –

I've crested the ridge & find myself writing again. I'm making good time, looking across the hill I will be walking in the other direction very soon.

I wonder if Dissembling the self
 A self that remembers a past that was a future before it was present. Predicated on falling apart – re-membering – and perhaps this is
 Perhaps my voice How to make space for the other without being overwhelmed . How to accept the other into the space of yourself without feeling squashed or invaded. How to remember your self with so much otherness passing through. I think I am writing to I recognise my intention to bury in landscape in order to . Romantic. With all the criticism that accompanies it. To form an intense bond of being with . Of course, intentions and realisations are entirely different avoid the trap of othered reflection but perhaps this is what we do all the time? Perceiving othered in our perception How the world offers alterity, loss, expansion in becoming other through absorption it becomes other in us.

There is a bird warbling in the grasses and the sound of someone mowing growls between these hills.

– – – – – – – – – – – – – – – –

I've crossed to the other side, , to look back at the path upon which I was just walking. Dante. Frost. bald moon congratulates me from sky. I am prone to hurting myself in the slamming.
 put my heart on hold listen to the other side. Have they gone? Does anyone want to be let in? Are they there ? But I don't want to
 Not silence or passionate proximity. Something more

– – – – – – – – – – – – – – – –

130//BACK AND FORTH

All these miles of mulling over what to say. Of talking to a ghost. Who is this shell that speaks in echo ? cocooning absence? I have almost walked myself out. I choose fleshy walls over absence.
 Break the glass. Summon I don't want this

--- --- --- --- --- --- --- --- ---

Penelope

And here I am, condemned to darn and weave a life while he's off word working and drinking his way into old age and blindness. I'm trying to make a fabric for us all to fit but he keeps stealing my punctuation. Leave. Leave and come with me, he says. I will provide... Nothing. Nothing.

A Cambridge professor once came up to me at a wedding and told me how proud I should be to support such a genius. Wasn't I lucky to be lit up by his shadow? Not on your fucking life. What about my fire? Where's the space and time for my words when I'm not washing and bathing, wiping mouths and arses, soothing scraped knees, offering solace and breaking up fights? Finding money for food, clothes and worrying, worrying. Watching the clock and wondering if he'll be back. On time or ever. Drunk. With money or without. Fuck that shit. He should be so lucky to have me weaving this web for him. I'm the dark night to his fucking star. I am the air you breathe. The page on which you're writing. Fuck him and fuck you too, I should have said. But I just cried. Furious angry tears. And he thought I was mad.

[...] --- --- --- --- --- --- --- --- ---
I'm just –

I'm just –

a granite stone outcrop

hard chalk

)) [in] ([out])) [in] ([out]
)) [in] ([out])) [in] ([out]
)) [in] ([out])) [in] ([out]etc.

stone table top park bench Mere footpath
Mid Wilts Way will I be –
view old one day?

\-\-\-\-\-\-\-\-\-\-\-\-\-\-\-\-

birds answer anyhow	before	answer
shout	caw	caw
there it is	bike whirr	meurgh
baby bleat	"Mummy"	"Mummy"
they are all gone under the hill		crying
make it your own this time	clouds pass	crying
[…]		

\-\-\-\-\-\-\-\-\-\-\-\-\-\-\-\-

 heart-ease & walk a bit

 pink-soled confession

\-\-\-\-\-\-\-\-\-\-\-\-\-\-\-\-

 you don't own me

you don't own any of these islands to invite or not to invite that

is the question not yours to ask you don't own me

you don't own any of this walking writing mineshaft of

caw caw caw

we were here be –

caw caw caw

be – fore be – fore you

we were here

we were here
 wind
bird everything

Camilla Nelson, extract from *EPIC* (Cornwall: Guillemot Press, 2021) 1, 5-8, 11, 20.

Amanda Thomson
walkDrawings//2022

For years now I have been making *walkDrawings* – where I record the walks and routes I take using a handheld GPS. They're mainly around Abernethy, though I have walks from all kinds of places, including repeated ones around St Ninian's Isle on Shetland.

They started as part of the process of making *dead amongst the living* – the artwork I created about dead trees. I needed to find a way to retrace my steps and return to the snags I was looking for.[1] They were often difficult to find a second, third, fourth time, as I wasn't looking for them in any systematic way, as I might if doing it 'properly', using transects as an ecologist would. In looking for these snags, it was easy to get lost or disoriented and, even in such a small area, to forget where one tree was in relation to another. Sometimes, depending on the light, they seemed so obvious; at other times they disappeared completely. On a dreich day, it was impossible, from amongst the trees, to say where the north or the south was. After a while, I started using a GPS to map these walks – setting off from the house where I was staying and creating waypoints where I'd found the trees and mapping where I walked. These drawings show my leavings and returns back to the house, and the same and different paths I would walk depending on what I saw and what I would aim for.

At one point I placed 10cm² steel plates at the north side of each snag I found – around thirty in all. I'd partially coated each with an acid-resistant (and so water-resistant) ground, leaving a circle of exposed metal in the middle. I wanted to gather some sense of place, some weathering, some physical evidence of time passing. I left them exposed to the elements for two months so the moisture would rust the metal that remained exposed. When I retrieved the plates, they were marked where rain, snow, frost, damp or dew had touched the metal.

Later, I did the same with bigger steel plates (36cm²), asking a friend to leave each plate in the forest for a month at a time, over the space of a year. Each month's plate was slightly different; some were more rusted from months that had had more rain or had been damper or dewier. Some had echoes of where birch leaves or pine needles had fallen and lain on the plates. May's plate was stained blue where pollen had interacted with moisture and the metal. The plates became compelling objects in themselves, as well as the matrix for the prints I made running them through the etching press, where the rust marks transferred onto paper.

When I started volunteering with the Royal Society for the Protection of Birds (RSPB) on the Abernethy reserve, walking with rangers, foresters and ecologists as they were doing their work, I used my GPS to map these walks too. They showed not just where we'd been, but how particular activities dictated how we moved through and across the land.

I liked the traces, their marks, how they worked like a pencil line on a page. Paul Klee's observation that 'drawing is taking a line for a walk' and Richard Long's work *A Line Made by Walking* – where he walked back and forth in a straight line across a piece of grass until it was worn with the indentation of his repeated steps – writ large. I started to remove the maps and contours to be left just with the lines.

We were often involved in the maintenance of the reserve. Sometimes we walked erratically along paths and tracks, moving from one side to the other clearing any trees within two metres to ensure that the paths would remain free of fallen branches, should there be a heavy snowfall.

I once followed an ecologist who was counting the regeneration of Scots pines. This involved walking transects: straight lines plotted across the landscape at equal distances apart that allow representative estimates of, in this case, Scots pine regeneration. In the drawing made, I can see the lines of each transect walked: parallel, equally spaced, east to west. I can see the curve of the track we walked up to get to the start of the survey transects, the straight lines walked, and how we got back to the car. I can also see where, boots off, we took a detour in order to cross a river at a narrower point to get to another, longer transect. A record of a day's walking doesn't reveal the labour, the conversations, changes in weather and changes in light, what was learnt and what was seen, nor the *hillworn-ness* at the end of the day. It doesn't tell us that we finished and walked back to the car in near darkness, and what it felt like to not quite know where I was, almost, until the car came into view.

The straightness of line belies the lay of the land, and I remember how, for each of these long transects, we walked in silence and in single file, noting any new growth, gauging the age of each young tree. The world became smaller and more immediate, to the line and footfall of the person in front, with a need for constant attention to the detail of what one was looking for. With that concentration other elements of place faded into the background. Only at the end of each transect did we stop and look up, at which point the whole of the place would come into view again.

I turned my first few *walkDrawings* into etchings, and they became delicate lines in white ink on a beautiful grey 250g mould-made printmaking paper called Somerset Newsprint. I used a photopolymer plate – a technique that combines the essence of etching but uses light rather than acid to 'etch' a light-

sensitive plate, creating a deep incision so the ink pushed into it forms a ridged surface on the paper when the plate with paper is run through the press.

The results are delicate, minimal imprints of thin lines on paper, lines that lose their meaning in terms of time and place, even memory, but gain something else, and the lines are thicker with repeated visits and time spent, and thin when only passing through.

1 [Editors' note: a snag is a standing dead tree, often missing many of its branches. As they decay, snags provide valuable multispecies habitats. Earlier in *belonging*, Thomson writes: '[A snag] can be something that catches our attention, emotionally resonates, arrests and holds us [...] I think of snags as hooks on which we can hang past experiences [...]' (p.4).]

Amanda Thomson, extracts from *belonging: natural histories of place, identity and home* (Edinburgh: Canongate Books Ltd, 2022) 35–40. Reproduced with permission of the Licensor through PLSclear.

DUSTY MAZES

OF LOSS

AND PARANOIA

SPATIAL

DISPARITIES / WALKWAYS

GHOSTING THE

DEAD DOCKS.

Laura Grace Ford, extract from *Savage Messiah*, no.1, 2005

AROUND AND ABOUT

Tehching Hsieh
One Year Performance 1981–1982//1981

September 26, 1981

STATEMENT

I, Tehching Hsieh, plan to do a one year performance piece.

I shall stay OUTDOORS for one year, never go inside.

I shall not go in to a building, subway, train, car, airplane, ship, cave, tent.

I shall have a sleeping bag.

The performance shall begin on September 26, 1981 at 2 P.M. and continue until September 26, 1982 at 2 P.M.

Tehching Hsieh

New York City

Tehching Hsieh, 'One Year Performance 1981–1982'. Statement © 1982 Tehching Hsieh (New York City). Courtesy of the artist.

Emily Hesse
Looking and Walking//2022

Inside the stable. It is cool here. Sandstone time is holding the still coldness of earth time. The floor is large cut sandstone blocks. I am walking in slow circles, each circle not quite the same. The stone time shows traces of animal time, weathered and softer than when they were cut and laid. The edges have been rounded. Bent under foot, their particle grains dislodged into water time, then dust time, and back to ground time.

Everything that is in the process of standing is breaking down. The slow almost invisible processes of decomposition time. I also feel this in human time, it is felt in my age. The ache of wrist time as it pushes lead into paper time, formerly tree time.

Walk circles. Edge into corners.

Large, smaller. I walk. When a mark on the stone interior catches my attention, I break the circle to be drawn into stone time. Observe. Draw. Return to circle.

Walking the stone time. I am interrupted by cow time, brought in on wind time. I leave the circle to observe the heifer's jostling calves. They are waiting for Hobo. He is an enormous figure in cow time. The muscular structure of the bull is all power. Almost steroid driven. His size makes his time slow. Hobo time is much slower than heifer or calf time.

A heart. A hole. A letter. A crack. The stone filled hole. The earth full crack.

Years of excrement. The straw filled crack. Cut, marked, smooth. Pockmarked concrete in places. There were once stalls here. Enclosed animal time. Probably wooden. Tree time. The holes in stone time indicate three stalls either side. The stone has split around the wood time it once held.

Cow time draws nearer. Chewing cud. Pull grass from ground time, teeth, breath. Swallow time flies in and out.

There are stones in the stable wall from elsewhere. Notches cut in or out. Square holes. Rectangular slit windows. Two doors directly opposite each other. A thoroughfare, in another human's time. Perhaps a walkway. This area is known for Norse farmsteads, where the trackways once ran through the home.

What is this, what is that?

Nettle time creeps under door time, pushing its way into wood time. The worm time was once in the beams above. Knots in this time, whorls in things. Light time from sun time alters my vision. Outside the door, heat time is lazing somewhere over the beck water. Fly time dashes and sits in and out of wood time and wall time.

The outer walls speak of an older stone time. The stone is rough hewn and undressed. Below lies earth time, inside this chthonic time.

My fingers have grown cold. Stone time has entered my body, numbing my fingertips in human time. I clasp and unclasp my hands to warm them, acknowledging but attempting to rid myself of stone time. Swallow time returns to nest time on wood time, supporting stable time.

I hear the nest full of tiny voices.

Life time.

Emily Hesse, 'Looking and Walking' from *Matters of Being* (Saltburn-by-the-Sea: TE ME NO Press, 2022) 49–51.

Caroline Filice Smith
Briefly on Walking//2012

> Even tonight and I need to take a walk and clear
> my head about this poem about why I can't
> go out without changing my clothes my shoes
> my body posture my gender identity my age
> my status as a woman alone in the evening/
> alone on the streets/alone not being the point/
> the point being that I can't do what I want
> to do with my own body because I am the wrong
> sex the wrong age the wrong skin and
> suppose it was not here in the city but down on the beach/
> or far into the woods and I wanted to go
> there by myself thinking about God/or thinking
> about children or thinking about the world/all of it
> disclosed by the stars and the silence:
> I could not go and I could not think and I could not
> stay there
> alone
> as I need to be
> alone because I can't do what I want to do with my own
> body and
> who in the hell set things up
> like this...[1]

As a practising architect and a woman (a fairly genderqueer one at that), the realities of how architecture manifests and reinforces dominant social and political power structures (on my body) is inescapable. And while it is fairly easy to find communities of people who would like to talk about the relationships between capitalism/colonialism/imperialism and architecture, it becomes much more difficult when the subject of gender, class, and race are brought into the discussion. Issues which are conveniently considered 'special interest' despite the fact that these issues affect a majority of the population... though because of the social/educational 'cost' of becoming an architect, constitutes not much of the population actively designing buildings. And so it is also inevitable that as a woman, 'my issues' will be regarded as secondary and more possibly, selfish to bring up, when compared to the 'larger' demons of things like unregulated capitalist development.

Which of course, is a topic which consistently comes up in all activist circles (see: any article on Occupy and the issues of class, gender, race within the movement).

A few months ago I moved from Los Angeles, where I was involved in the Occupy movement, to Shanghai. Obviously moving from a city where you have spent the last several months facing more and more visible political/physical oppression to a city where political dissidents are kept fairly invisible involved not only a political shock to the system but also a good amount of political concession. And then, on a particularly warm day in May, I wore a skirt; and I walked two blocks; and.... nothing. It was at the moment I realised Shanghai had given me something I had never expected to have. I, for the first time in 25 years of living, could walk down a street without (too much) fear of being: grabbed, followed, whistled at, hollered at, or attacked. I, for the first time in my life had the opportunity, to potentially have ownership over my own body while also existing in 'public'.

And so we get statements like these:

> Architects are called upon to develop urban and architectural forms that are congenial to contemporary economic and political life. They are neither legitimized, nor competent to argue for a different politics or to 'disagree with the consensus of global politics' (as David Gloster suggests).[2]

This statement has already been thoroughly spoken about [...] Not only is it a highly privileged position, it is also a completely binary one. The idea that changes in social/political policy alone can 'fix' the deep rooted and systematic oppression of marginalised people that has rooted itself into all parts of social/political life, is a farce at best. And attempting to pinpoint the cause or conversely the 'fix' to one thing denies entire histories of oppression. As a woman working in a profession in which I am often reminded of how much my body does not belong to me; from the constant use of female models as props in renders, the idea that the 'correct' height for all objects is always the average euro-male height, to the development in countries where my 'body' is simply not welcome in most public places; this statement can be easily distilled to: 'sit down, and shut up' or 'if you don't like it, then get out'. Pretty much the same privileged bull' that all marginalised people have been told forever.

> 'There are some areas where, in the nature of our society, personal experience is impossible for the male architect, and feedback from the public unlikely,' 'I have become convinced that the architect's lack of personal experience and involvement in what he is planning constitutes a real problem here—the more so since I imagine he is unaware of it'.[3]

The simple fact is that I am able to speak about the city, I am even 'qualified' to design cities, but I am not able to 'be' in a city (or really any place for that matter). Navigating the city, much like navigating a building, for a non-normalised body (which is most), involves a constant negotiation of shifting boundaries, where the psychological becomes physical. Where the leers, stares, hollers, and leans are so incessant that you can actually feel the space around you contract as you approach every new potential danger; and every trip involves constant weighing of the risks. The worth of running through 'occupied territories' rather than staying home or going miles out of your way. As designers we often speak about the 'grid' or infrastructural patterns of the city; punctuated by architectural 'moments'. When in reality, the endless grid does not exist outside of google street view, or maybe a car. For the streets which do exist in my mental map of available routes, every intersection, every alley, every stairway, entrance, wall, corner, stop-sign, elevator, plaza, stoop, park and bench becomes a moment of potential violence. Every route I take is a careful equation of time-of-day, weather, clothing, shoes, weight of bag, hairstyle, time of year, and amount of harassment I feel I can manage through at that moment. Always knowing, should anything ever happen to me, my 'body' will be to blame. This sometimes means the path from point A to point B becomes 3 miles longer, or ceases to exist at all.

This is the disconnect, the realisation that there is a vast difference between the way we think about architecture/city and the way architecture is lived. That the intersection is not JUST an intersection, that a glass staircase is not just a design detail (no skirts allowed!) and that a bathroom without hooks is a reminder that although I am expected to carry all this stuff with me, so that my body may continue to remain 'appropriate', no one cares if I have a place to put it while I.... And at that moment you are reminded of exactly where your body stands on the list of check boxes.

What does an architect who is accountable to the bottom of the barrel, who can give an account of what that rock and hard place space of choosing feels like, what does that architect imagine and build?[4]

And so I will end with a brief introduction to June Jordan's project for Harlem (with Buckminster Fuller), entitled 'Skyrise for Harlem'. I have chosen this project, not because it is in any way a water-tight fix to the problems of 'urban renewal' it was attempting to address, but because it addressed social and architectural issues from a place of action instead of projection, a place of personal experience rather than paternalistic hand-me-downs, and from a place of lived personal/social struggle; bottom-up in its truest sense. This is not to say that an architect can not help a community which they are not a part of, but that no matter how many 'monoliths for the people' we draw, they will always fail if designed from a

place fundamentally lacking in understanding the extent of the cultural/political/ and social issues/violence at hand.

> Imagine...how home is impossible when whether you have water depends not on whether you go pump some, but on whether you can convince an absentee landlord to imagine you as human.[5]

June Jordan and Buckminster Fuller's plan for Harlem, addressed three major issues: First: through the replacement of the existing grid with 'psychologically generative' curvilinear streets they addressed the pattern of the intersection as a pattern of inevitability: an inevitability of violence. When the rhythm of intersection after intersection, embeds within itself the knowledge that every ¼ mile will bring a new 'psychological crucifixion' then there becomes no chance for life outside of struggle. Second: the project proposes highrises be built above, but connected to, existing housing. When the construction is completed, the old housing is removed, releasing ground to be used as community gardens, playgrounds, etc...thus addressing the problem that 'urban renewal' usually just means urban removal; and Third: the emphasis on creating spaces of personal 'production' to address the lack of social and political control the residents of Harlem had over their own neighbourhood.

> As the plane tilted into the hills of Laconia, New Hampshire, I could see no one, but there was no tangible obstacle to the imagining of how this land, these contours of growth and rise and seasonal definition could nurture and extend human life. There was no obvious site that might be cleared for housing. No particular grove nor patch visually loomed as more habitable, more humanly yielding than another And yet I surmised no menace of elements inimical to life in that topography. It seemed that any stretch, that every slope, provided living possibilities.... By contrast, any view of Harlem will likely indicate the presence of human life – people whose surroundings suggest that survival is a mysterious and even pointless phenomenon. On the streets of Harlem, sources of sustenance are difficult to discover and, indeed , sources of power for control and change are remote... Keeping warm is a matter of locating the absentee landlord rather than an independent expedition to gather wood for a fire. This relates to our design for participation by Harlem residents in the birth of their new reality. I would think that this new reality of Harlem should immediately reassure its residents that control of the quality of survival is possible and that every life is valuable...[6]

...but let this be unmistakable this poem
is not consent I do not consent
to my mother to my father to the teachers to
the F.B.I. to South Africa to Bedford-Stuy
to Park Avenue to American Airlines to the hardon
idlers on the corners to the sneaky creeps in cars
I am not wrong: Wrong is not my name
My name is my own my own my own
and I can't tell you who the hell set things up like this
but I can tell you that from now on my resistance
my simple and daily and nightly self-determination
may very well cost you your life.[7]

1 [Footnote 1 in source] June Jordan, 'Poem About My Rights' in *Directed By Desire: The Collected Poems of June Jordan* (Port Townsend, WA: Copper Canyon Press, 2005).
2 [2] Patrik Schumacher, 'Schumacher Slams British Architectural Education', *The Architectural Review*, no. 31 (January 2012).
3 [3] Denise Scott Brown, 'Planning the Powder Room', *Having Words* (Architectural Association, 2009).
4 [4] Alexis P. Gumbs, 'June Jordan and a Black Feminist Poetics of Architecture' *Plurale Tantum* (21 March 2010) (http://pluraletantum.com/2012/03/21/june-jordan-and-a-black-feminist-poetics-of-architecture-site-1/).
5 [Also numbered 4 in source] Ibid.
6 [5] June Jordan, 'A Letter to R. Buckminster Fuller (1969), *Civil Wars* (New York: Touchstone, 1995).
7 [Also numbered 1 in source] 'Poem About My Rights'.

Caroline Filice Smith, 'Briefly on Walking', in *The Funambulist Papers* (New York: The Funambulist and Punctum Books, 2013) 32–6.

Jane Rendell
La Passante//2010

Sharon Kivland's *Le Bonheur des Femmes (The Scent of a Woman)* (2000)[1] consists of twenty-four photographs hung low on the gallery wall. Above them float the names of various famous perfumes: Allure, Fantasme, Knowing, Fragile, Dazzling and Sublime. The images all show women's feet and legs clad in black from the knees down. This is apparent. But another similarity is not. All the photographs were taken in the same kind of place – at the perfume counters of various

shopping venues in Paris: *La Samaritaine, Galeries Lafayette, Au Printemps* and *Bazaar de L'Hotel de Ville*.

Kivland's images are caught up in a rhetoric of movement. At the moment these women are at rest, pausing; their feet are in touch with the ground, just. But it is inevitable that soon they will move on. This is not the first time moving women passing between one place and another have been present in Kivland's work. They are blurred, caught in motion in black and white in *Les Passages Couverts* (1998), and in colour in *Mes Péripatéticiennes* (1999), both series of photographs which capture women moving through the passages of Paris.

In Kivland's installation *La Valeur d'Échange*, two images face one another: one of the Paris Stock Market, the other of the Passage des Variétés.[2] Here the artists' door leads into the passage from the Theatre of Variétés where Emile Zola set Nana's 'triumph'.[3] Phrases from Zola's *Nana* (1880) describing her sensual form are written delicately across translucent pages, luscious like skin, interleaved with collaged paintings of nineteenth-century women, perhaps courtesans, in Kivland and Jeannie Lucas, *Parisiennes*.[4]

Moving urban women are also referred to in Kivland's *La Passante* (London, 1995), an artist's book that consists of proper nouns – London streets with women's names. The title of this work brings to mind Charles Baudelaire's sonnet 'A une passante' in *Fleurs du mal* (1857), referred to by Benjamin in his discussion of the poet's fascination with the urban crowd and with love 'at last sight'.[5] Like *Parisiennes*, Kivland's *La Passante* is dedicated to Jeanne Duval, Baudelaire's mistress. On the inner flap reads the following phrase:

> Walter Benjamin notes of Baudelaire that the street is always his arena for amorous encounter, never the closed house, the 'maison de passe'. The streetwalker doesn't walk far, she inscribes her position on a short and wellworn route, easily recognised or remembered. The streets, one might say, are named for her...

Kivland has been exploring the gendering of urban passage, particularly in Paris, in her work for a number of years. My own research into sites of consumption, display and exchange in early nineteenth-century London brought me into contact with similar spaces and figures: arcades and streets, ramblers and cyprians (the English equivalent of the French courtesan), with Benjamin, Freud, Luce Irigaray and Karl Marx, as well as with a complex set of thematics concerning the commercial activity of shopping, the conflation of the female shopper with the commodities she is purchasing, the exchange and use-value of femininity, and choreographies of looking and moving in public city spaces.[6]

Benjamin's *Passagen-Werk* is populated by a series of 'figures', both real-life and operational as dialectical images.[7] Haussmann, for example, builds the 'new phantasmagoria', Grandville represents it critically, Fourier's fantasies are 'wish-images, anticipations of the future expressed as dream symbols' and Baudelaire's images are 'ruins, failed material expressed as allegorical images'. Likewise, all the other more conceptual characters – the collector, ragpicker, detective, flâneur and gambler – are men, with a single exception, the female prostitute.[8] As seller and commodity in one, the prostitute occupies a pivotal position in Benjamin's thinking: she is an allegory of modernity – part of the 'oldest profession' and as new as a fleeting commodity.[9]

In Kivland's *La Passanta* (1996) five copper plates are engraved with the names of women written phonetically. The words ask to be spoken; they wish to be shaped by the mouth in order to be understood. Articulated verbally, they 'turn out to be street names in the former prostitution quarter of Rome'.[10] Kivland's artist's book, *La Forme-Valeur/The Value-Form*, constructs a two-way passage at the intersection of two tongues. One text can be read forward in French and the other backward in English. Both are written in search of 'a woman speaking' in Marx's *Capital*.[11]

In his materialist analysis of the commodity, Marx makes a distinction between exchange and use value. The use value of a commodity, he argues, is determined by physical properties, whereas when goods are produced for exchange in the market they are seen not only as articles of utility but as inherently valuable objects with special mystical properties.[12] In making a distinction between the natural and exchangeable values of commodities, Marx uses the body of a woman as an exemplar of exchange.[13] Quoting from a satirical poem, 'Dit du Lendit', by the medieval French poet Guillot de Paris, Marx describes 'femmes folles de leur corps', or wanton women, as one of the commodities to be found at a fair.[14]

Irigaray's 'Women on the Market' reworks the Marxist analysis of commodities as the elementary form of capitalist wealth to show the ways in which women are the commodities of patriarchal exchange – the objects of physical and metaphorical exchange among men.[15] Like the commodity in Marxist analysis, the female body as a commodity is divided into two irreconcilable categories – women are utilitarian objects and bearers of value; they have use and exchange value, natural and social value. Irigaray outlines women's three positions in the patriarchal symbolic order as the mother who represents pure use value, the virgin who represents pure exchange value, and the prostitute who represents 'usage that is exchanged'.[16]

As well as providing a feminist critique of women's existing position in patriarchy, Irigaray's writing suggests an alternative and celebratory way of viewing female movement, from a position of feminine subjectivity, considered in terms of the 'angel'. For Irigaray, it is in order to deny the angel, or women's

nomadic status, that men have confined women as and in the symbolic spaces of patriarchal law and language. Irigaray's angel cannot be represented within these structures since she rethinks their very spatial and temporal mode of organisation. Like the passage, which combines real space and dream, and facilitates movement from one place to another, the angel is both transformational and transitional. She circulates as a mediator, an alternative to the phallus, who rather than cutting through, goes between and bridges.[17]

To be 'at' the perfume counter is to anticipate the application of a certain scent. This is magical space, a place of enchantment where the air is dense with possibilities, played out again and again at the very point at which the scents are allowed to breath, to escape into the air. The placing of the names of perfumes – all words which suggest desire, intoxication and altered states – hovering just above the images of the grounded feet points 'to' the gap between who we are and who we might become.

1 [Footnote 108 in source] See the artist's book: Sharon Kivland, *Le Bonheur des Femmes (The Scent of a Woman)* (Trézélan: Filigranes Editions, 2002). See also Sharon Kivland, *Flair* (London: domoBaal Editions, 2004). For a longer discussion of this work see Jane Rendell, 'The Scent of a Woman: Between Flesh and Breath', *Portfolio*, vol. 31 (2000) 18–22.

2 [109] Sharon Kivland, *La Valeur d'Échange* (Centre d'Art Contemporain de Rueil-Malmaison, 1999), n.p.

3 [110] Jean-Marc Huitorel, 'Proper Nouns', trans. Stephen Wright, in Sharon Kivland, *La Valeur d'Échange* (Centre d'Art Contemporain de Rueil-Malmaison, 1999), n.p. See Emile Zola, *Nana* (1880), trans. George Holden (Harmondsworth: Penguin, 1972).

4 [111] Sharon Kivland and Jeannie Lucas, *Parisiennes*, (ed.) Jean-Pierre Faur (Paris: Impression sur les Presses de Suisse Imprimerie, 2004).

5 [112] Walter Benjamin, 'The Paris of the Second Empire in Baudelaire' (1938) trans. Harry Zohn, Benjamin, *Charles Baudelaire*, 9–101, 44–5.

6 [113] See for example Jane Rendell, '"Industrious Females" and "Professional Beauties", or, Fine Articles for Sale in the Burlington Arcade', in Iain Borden, Joe Kerr, Alicia Pivaro and Jane Rendell (eds.), *Strangely Familiar: Narratives of Architecture in the City* (London: Routledge, 1995) 32–6; Jane Rendell, 'Subjective Space: An Architectural History of the Burlington Arcade', Duncan McCorquodale, Katerina Ruedi and Sarah Wigglesworth (eds.), *Desiring Practices* (London: Black Dog Publishing, 1996) 216–33; and Jane Rendell, 'Thresholds, Passages and Surfaces: Touching, Passing and Seeing in the Burlington Arcade', in Alex Coles (ed.), *The Optics of Walter Benjamin* (London: Black Dog Publishing, 1999) 168–91.

7 [114] See for example Benjamin, 'Materials for the Exposé of 1935', especially 909–16.

8 [115] 'Paris: the Capital of the Nineteenth Century' (1935), trans. Quintin Hoare, in Walter Benjamin, *Charles Baudelaire: A Lyric Poet in the Era of High Capitalism (1935–1939)*, trans. Harry Zohn (London: Verso, 1997) 155–76.

9 [116] Ibid., 171.

10 [117] Huitorel, 'Proper Nouns', n.p.
11 [118] Sharon Kivland, *La Forme-Valeur/The Value-Form* (London: domoBaal Editions, 2006).
12 [119] Karl Marx, *Capital: The Process of Production of Capital* (Harmondsworth: Penguin, 1976) 132.
13 [120] Ibid., 138.
14 [121] Ibid., 178, n.1.
15 [122] Luce Irigaray, 'Women on the Market', *This Sex Which Is Not One* (1977), trans. Catherine Porter with Carolyn Burke (Ithaca: Cornell University Press, 1985) 170-91, 172, 176 and 185-7.
16 [123] Ibid., 186. It is interesting to note that in the eighteenth and early nineteenth centuries, the word 'commodity' was used to refer to a woman's sex, and the term a 'public commodity' described a prostitute. See Francis Grose, *A Classical Dictionary* (London: S. Hooper, 1788) n.p., and Pierce Egan, Grose's *Classical Dictionary of the Vulgar Tongue* (London: Sherwood, Neely and Jones, 1823) n.p.
17 [124] Luce Irigaray, 'Sexual Difference' (1984), *An Ethics of Sexual Difference* (1984), trans. Carolyn Burke and Gillian C. Gill (Ithaca and London: Cornell University Press and Continuum, 1993) 5-19, 15.

Jane Rendell, 'La Passante', in *Site-Writing: The Architecture of Art Criticism* (London and New York: I.B. Tauris, 2010) 179-83. © I.B. Tauris, an imprint of Bloomsbury Publishing Plc.

Laura Grace Ford
Spatial Disparities//2005

Walkways,
dusty mazes of loss and paranoia.
The Island. Leaching into silt lagoons, seeping and shifting.
E14.
The Samuda Estate.
Kelson House. Fugitives hidden in upper chambers. spatial disparities walkways ghosting the dead docks.
After Broadwater the abolition of walkways intensifies. 1985 riots. Tottenham. Battle of Beanfield. Wapping and Warrington. Networks of connecting corridors with their potential for attack and surveillance. Elevated pavements feared by authorities, projectiles hurled, debris shattered on concrete floors.
Residues of contempt for 60s estates, blocking of access, gates and barriers... police hatred, malarial swamp of souped up monkeys, criminal sub class.
We stand on a nameless beach, waiting for revenge. A flight of ceremonial steps leads to the foyer of Kelson House. Ghosts of miners, printers, travellers, seething hatred of Thatcher. Sultry July night. Wapping Highway. 1986. Drawn by the lantern glow of that rose interior, cigarette smoke, glazed tiles, burnt sienna.

Circle a gated enclave, a confusion of padlocks and blank windows. Infantile 80s pastiche, grotesqueries of riverside developments.. across the water the skulking Dome.

Find traces of anti LDDC graff.

Bricks thrown at TNT lorries.

NO ONE LIKES US WE DON'T CARE

Canary wharf, arrogant totem. That and a cluster of cap doffing comforters. You look away and it's like mushrooms in a field, they're suddenly there, springing up from nothing.

Masonic henge conjuring medieval Italy. Height and prestige, riches stashed on the top floor. Enclosed courtyards.

Proto gated communities.

Canary wharf PLC, jealous controllers. No development allowed higher than Tower One.

Canary Wharf symbolised a failure of 80s values, Olympia and York, receivership and swathes of redundant computer terminals. Now Blair takes Thatcher's project onto new and more audacious levels.

Anxiety levels high already before 9-11. There were checkpoints here already. IRA had a go. Twice. The Tower and the South Quay. 1996, ring of steel around the complex, 100 million pounds worth of damage.

Canary Wharf is built on Poplar Gut, it all sinks back to the marshes.

Punk rock blaring from Reef House on the Samuda estate. Cockney Rejects, window rattling volume. Sitting down to smoke amidst the detritus of a light blocked living room.

Solstice skag bonanza.

Round the headland, looping now, blocks emerging from woodland, hazy in violet light. Filtered through an amethyst lens, Maze Hill and Greenwich shimmering across the river.

Grand vistas unfolding. Greenwich Hospital. Palace of Placentia.

Balmy summer night. Drinking in a beer garden beneath St Alfege's, lilac shadows, orange street glow. Honeysuckle, jasmine and rose.

Fire of London.

Spiral Tribe, early 90s, reaching transcendental states with sleep deprivation, repetitive beats and ketamine. Mudchute. The Omphalos. That party by the dog food factory in Canning Town, under the pyramid strobe of Canary Wharf. Old Bill sealing the Island. Boots and batons. Smashing faces, blacking eyes.

Occult geometry and architectural control. A commission set up to designate

new churches. Wren and Hawksmoor. Naval College and churches aligned.

The line cuts through subatomic research at Queen Mary's College and the experimental malice of Throbbing Gristle in Martello street.

Island closed.

Pass the river portal, a silverfish edifice that tugs you shivering under the murky Thames – Ferry House pub.

An explosion of expletives. Dark beer stains cigarette smoke unfurling, This is ENGLAND. Nexus of empire. Bacchinelean revel, blood spattered walls and smashed glass. [...]

Millwall Park. WE HATE HUMANS! The Den not here now, shoved down Bermondsey, but the anger and hate remains, spat into the fabric like fossilised webs.

Adrenalin, sharp intoxication, vodka and coke. Wapping gentrification / industrial struggle, explosions of Class hate. Millwall crews rampaging, constructions of menace steel fencing, video cameras and barbed wire.

Isle of Dogs delivers conflict, we will not leave this Island!. 'Hitler couldn't get me out of Poplar,' incentive schemes won't work...

14 grand and a transfer to a Northern sink estate.

Got to be joking.

Heaps of bricks and stones.

NO MORE NEW HOMES FOR THE RICH!!!

THE SAMUDA ESTATE, Wood Henge an emblem of no future, of biodegradable sinking into the dirt. 1985, solstice exclusion zones, tactics from Orgreave shift to Wiltshire. Police road blocks, fractured skulls and vehicles destroyed.

YUPPIES OUT!!!

What they want for the Island is one big gated community, iris scanning and ID cards to get in. You can't even walk down the Thames without yuppie flats bundling out onto the landings.

PRIVATE PROPERTY KEEP OUT.

Cubitt Town. Eerie drum and bass emanating from an estate built in 1936.

Photek, 'Hidden Camera'.

Canary Wharf, ghoulish needle, Thatcher's Britain, gleaming obelisks overseeing dilapidated streets.

Rigging and spars, landbridges and dungeons.

A confusion of space.

Daniel Asher Alexander and the jails of Dartmoor and Maidstone. Money

and power, the air thick with a heady confection of cinnamon, tobacco and rotting wood.

De Quincey. Warm opiates. Verlaine and Rimbaud intoxicated by glyphs.

Dizziness, inner ear malfunction, swaying like I'm out at sea. Drawn in chamber after chamber, worlds and vistas unfolding like a computer game. Staggering through, level after level, clambering on with no thought to what lies above or below. I am drawn by curiosity and desire, to play the game for the sake of playing.

No 777 Commercial road. Masonic planning. Limehouse. Pale authority of St Anne's, chalky pyramids replicating in the shadows.

Sacrifice. The Accursed share. Back the Bid. Social cleansing.

The Star of the East. Ghosts of opium dens. Pennyfields, the Chinese quarter, Fan-Tan and Pak a Pu gambling shops, men with Mandarin moustaches marking ledgers with camel hair brushes.

Pogrommed out... burnt out of area in a vortex of moral panic and fear of the white slave trade.

The last small streets to escape the Blitz and the wreckers ball become fragments hidden in a maze of LCC blocks. East India Dock road dark dilapidation blackened nets. Amoy Place corrugated alley of breezeblocks and bins. Cherry blossom and low rise maisonettes in Ming street.

And now the regeneration projects of Sylhet are where dreams of the future are being made. Turmeric and cumin scent the air.

Backwards and forwards, other realms, a psychotic envelope of human suffering and desire. Shadows green under orange street lamps, the phosphorescent aura of a spectral tower.

Post apocalyptic phantoms of stadia, overgrown velodromes, the dome laid to waste under a convolvulus matrix. London 2013. Apotheosis of Thatcher's project, neoliberal expansion, exurbia and the Thames Gateway. Hazily estuarial, new towns not yet named, the reaches of Thurrock become an invocation of America with Drive thru Macdonalds luminous clowns and an Ikea.

Blue eyes steely, a constructivist angle and a motorway bridge set scene for encounters, bouts of malice and ultra violence. My skin is bruised, purple and yellow, livid tattoos. He lurches out of the Spar on Manchester road, post brawl tremor. Once he was part of the Treatment, now he's on largactil and only comes out once a day to buy tomato soup.

Laura Grace Ford, extract from *Savage Messiah*, no. 1 (self-published zine) (2005) reprinted in Laura Grace Ford, *Savage Messiah* (London: Verso, 2011) 7–15.

Siddique Motala and Vivienne Bozalek
Haunted Walks of District Six//2021

Being the most famous site of apartheid forced removals, District Six is a mythical place, almost a non-place. For many years, it has been a striking memorial to the vicious apartheid system, because it consisted of open, unused land close to the city centre of Cape Town. In 1966, District Six was declared a Whites-only area, and by the early 1980s, more than sixty thousand people were forcibly removed to far-flung suburbs and townships (some would later become notorious ghettos) on the outskirts of Cape Town. Their houses, shops, markets, cinemas, and all other buildings in the District were destroyed by apartheid bulldozers. Only a few buildings and rubble remained. Today, much of District Six is still barren rubble, but it is changing. After years of contestation and politicking, the post-apartheid government's land reform policy is resulting in some of the old residents of District Six (or their descendants) being returned to newly built accommodation. When we speak to people in Cape Town about District Six, many have a connection to it – usually, it is a place that a family member was (removed) from. It is not a neutral space – as a haunted and contested space, it is intensely affective. [...]

A Cartography of the Walks of District Six
One afternoon 15 years ago, Siddique left his office at CPUT and was walking back to his car when a haunting happened. He stopped, looked up at Table Mountain, and realised that he was walking on the land of District Six. The questions that immediately came to mind were as follows: what was here before? Exactly here – where I am standing right now? He then realised that he could answer the questions by using the techniques and technologies that he taught.

The essence of cartography was sought by Western academics in the 1960s and 1970s, and they focused on 'the flow of data from the world through the map to the user'[1] as if the underlying world is an unambiguous, single, discrete entity. This is the underlying premise of surveying. There is a stable ground 'out there', an inert backdrop against which we go about our everyday lives, that can be measured by surveying and represented cartographically.

A diffractive reading helps us to understand how the practice of surveying/mapping gets co-constituted with the creation of the world. What gets mapped, therefore what gets surveyed, is dependent on specific (ostensibly scientific) factors such as accuracy and scale. There is a Cartesian cut being enacted – the surveyor-as-subject surveys the land-as-object and then represents it on a map

through the act of mapping. Western culture has a deeply entrenched faith in representationalism. [Karen] Barad (2007) points out that

> the asymmetrical faith we place in our access to representations over things is a historically and culturally contingent belief that is part of Western philosophy's legacy and not a logical necessity; that is, it is simply a Cartesian habit of mind. It takes a healthy scepticism toward Cartesian doubt to be able to see an alternative.[2]

As an alternative, a posthumanist ontology challenges the land-as-backdrop view, and recognises that specific procedures, methods of observation and practices produce the world. Thrift (2008) reminds us that non-representational theory is about performance, practice, and movement, as opposed to representation.[3] This shift from representation to performance requires a disidentification from White, Western, rationalist, humanist, and anthropocentric hierarchies, all of which are strongly enforced in the geomatics knowledge base.

Geomatics is overwhelmingly focused on technical issues, and geomatics practitioners often believe that they are observers who are largely disconnected from political issues. However, surveyors do not stand at a distance and represent something 'out there'; rather, surveyors are part of the materiality of the world that is being surveyed. Surveyors and their maps played a role in the destruction of District Six, as did architects, planners, engineers, and politicians. J.B. Harley points out that what is shown on the map is not a representation of a pre-existing world, but it helps to construct the world. According to Harley, 'maps represent the world through a veil of ideology, are fraught with internal tensions, provide classic examples of power-knowledge, and are always caught up in wider political contexts'.[4] [...]

In 2019, Vivienne suggested that Siddique take a group of conference attendees for a walk of District Six. The conference theme was related to hauntology, memory, and nostalgia. We decided to combine old and new maps of District Six, and to take people on a route that went past some sites that still exist and others that don't physically exist but remain as hauntings. The addition of old maps and photographs to the walks produced counter-cartographic experiences that were deeply affective.

Counter-Surveying Diffracted
The introduction of walking and storytelling into the sedimented engineering education curriculum provided us with inspiration and opportunity for deterritorialisation. In particular, we are interested in the potential of subverting

traditional practices of surveying, mapping, and archiving to embrace a counter-orientation. Our practices are micro-instances of activism that open up creative possibilities. This is especially important in engineering education, which is grounded in positivist and quantitative logic. In addition, the engineering education assemblage in South Africa is shot through with power relations that are situated at a unique intersection of race, place, and inequality.

Focusing on individual stories and their entanglements counters the erasure of the complexities of lives. This erasure was due partly to the fact that the destruction wreaked on District Six was massive, and the sheer number of stories of dispossession paradoxically renders individuals invisible. As [Katherine] McKittrick notes, it is crucial to pay attention to 'past erasure and objectification of subaltern subjectivities, stories, and lands'.[5] We are similarly observing the anonymisation of victims of the Covid-19 pandemic, because individual stories get buried among a deluge of bad news. As [Kakali] Bhattacharya (2019) suggests, communal healing should be a priority as we traverse multiple worlds, whether they be academia or the physical space of Cape Town.[6] We wish to work with a sensibility that does justice to dispossessed people's stories, that respects their knowledge, and decentres colonial knowledge agendas. By working with micro-instances of activism, we are advocating for a practice that is similar to the practice of 'autonomous mapping' that was proposed by the Counter Cartographies Collective et al., who describe it as 'a mapping of and for political change without the aim of becoming a singular, dominating (cartographic) power'.[7]

Counter-surveying is an exercise in disidentification from the colonial surveyor or the purely technical surveyor (which, as we have noted, is a myth). Counter-surveying utilises traditional surveying techniques, but has some fundamental differences, thus allowing it to have the 'counter-' prefix. Traditional surveying practice in South Africa manifests in different forms, but the most common types of surveying done by surveyors are cadastral surveying and engineering surveying. Cadastral surveyors are deeply implicated in the system of land ownership, with its problematic colonial and capitalist underpinnings. Despite the conscious efforts by the ANC-led government in post-apartheid land reform, most of the race-based spatial boundaries still exist in South African cities and towns. Land reform initiatives are failing, and the reasons are multiple. These include a lack of political will by the government, seemingly contradictory viewpoints enshrined in the Constitution, cumbersome legal processes, and, more generally, the neoliberal economic environment.[8] Usually, engineering surveyors produce topographic maps that are used to plan a structure, mark out its location on the ground, and monitor the construction.

Both cadastral and engineering surveying are done within rigid legislative frameworks, and ultimately serve to propagate the status quo. Springgay and Truman problematise the detached theorisation of the racialisation of space and remind us that traditional surveying and mapping could normalise the erasure of Black subjects.[9] In counter-surveying, the physical demarcation of a site is done temporarily, and is done mainly for the benefit of dispossessed or disenfranchised people. By focusing on the Other, we are subverting traditional humanist power relations.

A diffractive reading of the practices of counter-surveying, counter-archiving, and counter-mapping shows resonances and dissonances between them. For Springgay, Truman, and Maclean,

> Counter-archiving and anarchiving practices are political, resistant, and collective. They disrupt conventional narratives and histories and seek ways to engage with matter not typically found in official archives and the affective experiences and lived histories of human and more-than human bodies.[10]

Counter-surveying is done in the same vein as counter-archiving, with a view to affirmative horizons of hope. We are less interested in the documentation of past events, and more on processes, micro-political acts, and becomings.[11] An important aspect of counter-surveying is the use of counter-mapping techniques.

The term 'counter-mapping' was first used by Nancy Peluso (1995) to describe mapping work that challenges maps made by government and corporate authorities. Counter-mapping is political and seeks to reveal the hegemonic politics in such maps.[12] Our counter-surveying practice takes seriously the scientific method of geomatics, but applies it in new ways that challenge the silencing and erasure typically associated with traditional maps. By showing the locations of Rose-Anne and Joe's ancestral homes over the current landscape, we are challenging their erasure. [...]

A dissonance between counter-archiving, counter-cartography, and counter-surveying is that counter-surveying focuses less on permanence – it is more of an ephemeral process that requires an embodied immersion. The process of walking is thus crucial to counter-surveying, and the end result of a counter-survey may be no physical artefacts at all. The traces are affective and could lead to new sensibilities and encourage new forms of activism and pedagogy. This is unlike counter-cartography, which relies on the production of a map. However, there is much overlap between the practices, and we utilise the Deleuzian logic of 'and... and... and...' to conceptualise this new practice.[13]

Contrary to the traditional geomatics conception, surveying and mapping can also be viewed as performances. The voice of humanism is privileged in

the traditional geomatics conception of the world. The figure of the surveyor evolved out of a contingent array of historical processes. This figure is humanist and subtly anthropocentric.[14] The cartographic record of colonies such as South Africa shows us that surveyors/cartographers, through their maps, helped to create the myths of empire. Harley notes that '[s]urveyors marched alongside soldiers, initially mapping for reconnaissance, then for general information, and eventually as a tool of pacification, civilisation, and exploitation in the defined colonies'.[15] Furthermore, colonial maps simultaneously contained and produced colonial subjects. There is a genealogical connection between war, colonisation, cartography, and control. Garuba sums it up succinctly: 'The surveillance and control of land, body and subject was the object of colonial geographies and, in securing this objective, the map as text, as model, as document and as claim was central to its project'.[16]

Harley notes that maps can speak volumes by their silence. Like feminist philosophers, he points out that silencing is an important aspect to note, so as to learn about the Other. Urban maps, for example, are not at the human scale and do not contain information about the quality of human life – The differential between the quality of White life and the life of Others in South Africa is stark. There is a qualitative shortcoming of maps to describe the human experience. Furthermore, mapping as we know it follows the Western paradigm of placing boundaries around 'resources'. These resources also included Indigenous people, who were viewed as raw material to be exploited.[17] [...]

The Walk With Rose-Anne

Rose-Anne's mother lived at 7 De Villiers Street until the house was demolished in 1968 and they were forcibly removed to various neighbourhoods across Cape Town. Rose-Anne grew up in Belhar, a designated Coloured group area approximately 20 km away from District Six. The house was a large double-story semi-detached dwelling that was bordered by De Villiers Street in the front. Rose-Anne's mother and her eight siblings were born and grew up here. The pain of being forced to leave this special place and cosmopolitan community is still felt by many, and both Rose-Anne's mother and Joe's grandfather attest to this. Rose-Anne's mother feels tired of telling one-sided stories of District Six that focus on the forced removals only. While this was an important event, and one that invariably brings forth pain, Rose-Anne points out that this erases the complexity of life as a District Sixer, and casts ex-residents as victims only. Both Rose-Anne's mother and Joe's grandfather chose not to be present at the demarcation of their childhood homes. Memories are written into the world, and as we have noted elsewhere, the 'ghosts which linger in District Six exert an impact on everyday life of those who traverse this territory in the centre of Cape

Town, impacting the taken-for-granted realities of the past, present and future of the city'.[18]

Using counter-surveying, Siddique calculated the location of the ghost house and placed poles to mark the locations of the corner beacons temporarily. The house was walked through and after a discussion, the poles removed. This experience had a profound effect on Rose-Anne, and she cried when she saw the poles that marked out the location of her mother's house.

After the demolitions, some schools, churches, and mosques were perversely left behind – Although they were bricks and mortar, they were differently marked and survived. These surviving buildings played an important role in the lives of the Black bodies who were removed from District Six. We see in Rose-Anne's story that long after all the other buildings were gone, her family returned to their church in District Six. Rose-Anne came to school in District Six, even though she lived in Belhar, some 20 km away. Schools and churches are the ghostly remnants of District Six and exert an attraction on residents. The binary concept of here–there is troubled by Rose-Anne. As she walked over the ghost of the house, she alluded to the complexity of multilocality:

When we talk about being in *this* place; the wind blows to us in Belhar (where we lived). So when I'm walking here, I'm walking in Belhar, I'm walking in Kensington, I'm walking in Fairways[19] where my family had to go to. I'm here but I'm walking into Greenmarket Square and the racism that we experienced,[20] and the joy that was here.

In District Six, the schools that are still operating today have an excellent reputation and a proud anti-apartheid heritage. Many people at Vivienne's institution, which is a historically Black university, who occupy or have occupied leadership positions had attended one of these schools. The schools have maintained their intellectual rigour, and produced some of the leading political, artistic, and scientific minds in South Africa. [...]

Although the destruction of District Six emerged out of colonial logic – the valuable African land was claimed by the powerful White government and the residents were forcibly removed – it did not necessarily aid nor guarantee settler futurity in the immediate aftermath. Seen from the point of view of the colonised, the destruction is an ongoing act of violence that continues to tear communities apart and keep people away. Yet District Six was also seen by many White South Africans as salted earth, a contentious place that was haunted with pain and conflict, so the replacement of Black bodies by White bodies never happened on a scale that was originally envisaged. Instead, Cape Technikon, a White higher education institution which later became CPUT, was

built as an after-thought. Even though the process of land reform is moving slowly, what continues in District Six is an ongoing emplacement of settler futurity and anthropocentrism, premised on the logics of the market. We walked over the rubble of houses, and we know that a new generation of District Sixers will settle here. Will District Six once again become the cosmopolitan and progressive place that it once was, a place that embodied the positivity of difference? We hope so, yet our walk is foreboding. This beautiful piece of land, situated between the ancient mountain and the ocean, is valuable because of its location. It has always been haunted by the ghosts of many – the ancient Khoi; the colonising Dutch and British; the working-class and enslaved settlers from India, Indonesia, Malaysia, Madagascar, and East Africa; the imported flora (some still stand defiant); the critically endangered endemic plants and animals of the shrinking biodiverse Cape Floral Region; and the people who were forced away from here.

1 M.H. Edney, Cartography Without "progress": Reinterpreting the Nature and Historical Development of Map Making in M. Dodge (ed.), *Classics in Cartography: Reflections on Influential Articles from Cartographica* (Chichester: Wiley-Blackwell, 2011) 305–29, 308.
2 Karen Barad, *Meeting the Universe Halfway: Quantum Physics and the Entanglement of Matter and Meaning* (Durham NC: Duke University Press, 2007) 49.
3 Nigel Thrift, *Non-representational Theory: Space/Politics/Affect* (London: Routledge, 2008).
4 J.B. Harley, 'Cartography, Ethics and Social Theory', *Cartographica*, vol. 27, no. 2, 1–23 (1990) 1.
5 Katherine McKittrick, *Demonic grounds: Black women and Cartographies of Struggle* (Minneapolis: University of Minnesota Press, 2006) x.
6 Kakali Bhattacharya, '(Un)Settling Imagined Lands: A Par/ Des(i) Approach to De/colonizing Methodologies', in P. Leavy (ed.), *The Oxford Handbook of Methods for Public Scholarship* (Oxford: Oxford University Press, 2019) 175–208.
7 Counter Cartographies Collective, C. Dalton and L. Mason-Deese, 'Counter (Mapping) Actions: Mapping as Militant Research', *ACME*, vol. 11, no. 3 (2012) 439–46, 440.
8 L. Ntsebeza, 'The Land Question: Exploring Obstacles to Land Redistribution in South Africa', in I. Shapiro & K. Tebeau (eds.), *After Apartheid: Reinventing South Africa* (Charlottesville: University of Virginia Press, 2011) 294–308.
9 S. Springgay and S. Truman, *Walking Methodologies in a More-than-human World: Walkinglab* (London and New York: Routledge, 2018).
10 S. Springgay, A. Truman and S. MacLean, 'Socially Engaged Art, Experimental Pedagogies, and Anarchiving as Research-creation', *Qualitative Inquiry*, vol. 26, no. 7 (2019) 897–907, 2.
11 E. Manning, *For a Pragmatics of the Useless* (Durham: Duke University Press, 2020) and Brian Massumi, 'Working Principles' in A. Murphie (ed.), *The Go-to How to Book of Anarchiving: Senselab and the Distributing the Insensible Event* (Montréal: Concordia University, 2016) 6–9.
12 R. Rundstrom, 'Counter-mapping' in A. Kobayashi (ed.), *International Encyclopedia of Human*

Geography (Amsterdam: Elsevier, 2009) 314–18.

13 Gilles Deleuze and Claire Parnet, trans. H. Tomlinson and B. Habberjam, *Dialogues* (London and New York: Athlone Press, 1987).

14 S. Motala, 'The Two Cartographies: A Posthuman-ist Approach to Geomatics Education' in R. Dolphijn and R. Braidotti (eds.), *Deleuze and Guattari and Fascism* (Edinburgh: Edinburgh University Press, 2022).

15 J.B. Harley, 'Maps, Knowledge, and Power' in G. Henderson and M. Waterstone (eds.), *Geographic Thought: A Praxis Perspective* (London and New York: Routledge, 2009) 129–48, 132.

16 H. Garuba, 'Mapping the land/body/subject: Colonial and Postcolonial Geographies in African Narrative', *Alternation*, vol. 9, no. 1 (2002) 87–116, 87.

17 Achille Mbembe, *On the Postcolony* (Berkeley: University of California Press, 2001).

18 M. Zembylas, V. Bozalek and S. Motala, 'A Pedagogy of Hauntology: Decolonizing the curriculum with GIS', *Capacious Journal for Emerging Affect Enquiry*, vol. 1, no. 5, 26–48, 27.

19 [Footnote 2 in source] Belhar, Kensington and Fairways are residential areas to which people classified as Coloured under apartheid legislation were forcibly removed.

20 [3] When the Methodist Church in District Six (Rose-Anne's church) was turned into the District Six Museum in 1988, a decision was made to amalgamate with the Central Methodist Church, a mainly White church in Greenmarket Square nearby. Rose-Anne described the significance of walking from the Methodist Church, which contained a lively, cosmopolitan congregation that vehemently opposed apartheid, to the Central Methodist Church, where she experienced racism.

Siddique Motala and Vivienne Bozalek, extract from 'Haunted Walks of District Six: Propositions for Counter-Surveying', *Qualitative Inquiry,* vol. 28, no. 2 (2022) 244–53.

Tentative Collective
Political Walks: Karachi//2017

Shershah Scrap Yards. 2017

There is a sludge
beneath the earth
moving with cohesive force;
gaining momentum
with the burial of
discarded fragments.
It moves to find its way,
to finds its place
to find its meaning.
How long will it remain there
discarded and hidden
under the ground
underground
beneath the grating hatchways
beneath the many decks?

There, on the fringes of the city
within its landfills
inside metallic scrapyards
are collections of discarded things
gathered in unlikely lists
There are pieces of Karachi
telling stories of a city;
of many cities within cities-
as they press against its walls.
There is an acid fracture
an air drill
an annular blowout
an artificial lift
an automatic slip
a bailing
a belly buster
a bit

a blind ram
a block
a blooey line
a blowout
a bore hole
a bullet perforator
a casing
a cathead
a catline
a cementing
a chain drive
a choke
a christmas tree
a completion rig

What will happen when
100,000 cubic metres of sludge
slides down a hill,
gathering dust
and rock
unidentified objects
and bodies,
towards you?
Towards all
that you have collected
and built
into a semblance of some sort;
a semblance
of something you call home.
There is a deadline
a derrick
a drill collar
a drill pipe
a drill stem
a driller

a finger
a fish
a foaming agent
a geronimo
a guy line
a hoist
a hook
a jacknife mast
a kelly
a kick
a pipe ram
a rathole
a reeve
a rig
a shale shaker
a shear ram
a sheave
a slurry
a sour gas
a spinning cathead
a stab
a stabbing board
a swab
a swivel
a whipstock
a wildcat
There are houses on the move
houses on the run.
They lift themselves up and glide
effortlessly on land and over water
avoiding moments of impending loss
to enter places full of promise.
Sometimes they are seen
hovering over ground
and over the seas
where they gaze, they float, they climb,
and they finally descend-
to rest the weight of their loads.
Lest, upon a strike
they scatter into fragments

There are Kings Lavish
Apartments
King's Garden
King's Luxury Homes
King's Dream Villas
King's Hill View
King's Excellency
King's Galaxy
King's Skyline
King's Cottages
King's Classic
King's Luxury Apartments
Offering all the amenities and
facilities of modern living.
Blue Bell Residency
Chapal Skymark
Diamond Tower
Gulf Towers
La Grande by Al Ghafoor
Marwa Palace
Metro Twin Tower
Omega Heights
Pyramid Residency
Royal Luxuria
Seven Wonders City
Breathtaking lifestyles to the
common people.
Shumail Heights
The Arkadians
The Orchid
Tricon Tower
Bahria Sports City Karachi
Bahria Farmhouses Karachi
Bahria Golf City Karachi
Bahria Homes Karachi
Bahria Apartments
Bahria Heights
Bahria Town Karachi
(Overseas Block)
Bahria Hoshang Pearl Karachi

Bahria Opal 225 Karachi
Bahria Diamond Bar City on Kutta Island
Enchants residents by the grace and
amazing acrobats
of Dolphins in an
interactive show.
DHA City Karachi
DHA Oasis
DHA Creek City
DHA Creek Vista
A gated community monitored by DHA professional vigilant staff.
Karachi Waterfront Sugarland City
Navy Housing Scheme
Fazaia Housing
Defence Regency
Emaar Crescent Bay
Emaar Pearl Towers
Emaar Reef Towers
Emaar Coral Towers
Emaar Canyon Views
Emaar Prados Villas
Emaar Alma
Emaar Mirador Villas
Life, the way you
have always wanted

There are Xtreme Bars G-500W
Deformed Bars G-60
Billet
Sarriya
Sand Chenab
Sand Ravi
Silica Sand
Bajri Margalla
Bajar Dina
Natural
Portland
PVC
Clinker

Blast Furnace
Rapid Hardening
OPC 42.5
Quick Setting
Coloured
Sulphate Resisting
White Portland
High Alumina
Block
Plain
Reinforced
Prestressed
Reinforced Brick
Fiber Reinforced
Lime
Polymer
Sulpher Infiltrated
High Early Strength
Water proof
Common burnt
Sand Lime
Engineered
Lucky
Dewan
Attock
Bestway
Dadabhoy
Pakistan Slag
Javedan
Al-Abbas
Zeal Pak
Pioneer

There is CORE
(Client Oriented Real Estate)
Dream Ambassador (Pvt) LTD
UR Property
Z.S Associates
Universal Property Network
Rayyan Real Investment

Rajput Enterprises
Athar Associates
Icon Real Estate
Al Rafay Associates
New Rockwell Associates
Zakria Real Estate & Marketing
Estate Bank Property Advisor
Karachi Real Estate
Sona Properties
Buy N Sell Realty
Takaful Estate
Kazmi Associates
Home Land Enterprises
Kainat Associates
Hallmark Estate
Tabani Real Estate
Munawar Estate & Builders
Land Masters Real Estate
Real Investment Consultants
Luxury Properties
The Estate Arts
Infinity Properties
Geo Real Estate
Aslam Brothers & Sons
Abuzar Estate
Splendour Homes
Al Hafiz Estate
Online Enterprises
Wasif Associates
786 Estate
Advance Properties
Sunset Properties
Pardesi Real Estate
Al Tawakkal Enterprises
Khurram Enterprises
DR. Estate
Defence 4 U Estate
Jinnah Estate
Tricon Associate
Shaheen Builders & Marketing

Falak Enterprises
United Country Real Estate
Hi-Land Estate
Sky Line Real Estate
Syed Zada Enterprises
Makaan Realtors
Arafat Estate And Marketing
Best Property Solution
Al Wahid Associates
Sahara Properties
Harem Construction Co
Lakyari Estate
Universal Estate & Builders
Sheikh Estate Dot Com
Shah Global Enterprises
VIP Estate
There is a Platinum Estate Agency
and Shackles Enterprises

There is iron scrap
and niggar scrap
and ms melted
and chaddors
and bundles
and local bundles
and niggar bundles
and light bundles
and beerh
and loha
and silver
and steel
and cast steel
and cast iron
and gunehgaar loha
and gunehgaar steel
and parchoon
and goolli
and bhangaar
and aaru

and chikni mitti
and SS (16-4) solah chaar grade
and SS 118 aikso athara grade
and SS Indian grade
and garrari
and chotta makkah
and rassa
and light scrap
and dharra
and purchoon
and ship plates
and 7up plates
and chira plates
and gates
There is red sludge
unidentified object 8
Chinese Baijui Liquor
offbrand smart phones
bubble blowing wands
plastic molded items
unidentified object 43
window grills
900 Fushan I keyboards
63 unpaired shoes
pvc ceiling tiles
embossed stationery
unidentified object 208
58 bodies
33 buildings
14 factories
2 office buildings
1 cafeteria
3 dormitories
13 sheds
100,000 square metres
special economic zone
151 rescue cranes
There are white flowers on debris
no exact number available as yet

There are scraps of broken,
fragmented
and used metals from the
freighter ship 'Elizabeth II'.
They are making their way up
north
from the shipbreaking yard at
Gadani
to build a city
to build many new cities.
Cities like forts
forts that fortify themselves
against all the residue
they have rendered waste
around them.
There are paranoid walls of
paranoid cities
which extend to great heights
in their wish to not confront
excesses of their own.
There are excesses
excesses that flow, heap,
gather, collect, stack, assemble,
bundle,
pile, jam, clog, rise, tower, and
spill beyond each gate
beyond each encircling
boundary.
There are

grated hatchways

breast hooks
boom jaws
burden boards
sculling notches
rudder gudgeons
rising ribs
(hanging) knees

two and two.
right leg of one
left leg of other
right hand of one
left hand of other
legs in legs
hands in hands
There is the world in your palm
connecting people
with fingerprint scanner
OmniVision:
daily, weekly, monthly, 45 days, & yearly
a bold statement
with smart pause control
infinity touch
world's slimmest
snapdragon.
Billowing from a star
a million years ago,
there is scatter
of decaying shrapnel.
It accumulates,
building a mass,
bundling together
interstellar sand
from nebula in curved space.
The sound of its arrival
registers on the crust of the earth.
On the Congo craton there are
rare earth minerals
dug out of igneous rock
embedded in the myriad layers of time.
Columbite-tantalite, Tantalum, Coltan;
more valuable than gold-
mined with bare hands
and bare skin.
Smuggled to
special economic zones.
Dullblack
lustrous grey-
ever increasing in value
reduced in size,
smelted to powders and tubes
capacitors and circuitboards.
Encased in glossy armatures,
and rose gold rectangles.
And there are million dollar
ad campaigns,

I'm Jacqueline Fernandes
I Noir, do you?

There is a dust rising
and it gradually
takes the ground away
a grain at a time.
It rises a grain at a time.
A grain at a time a cluster forms.
Brewing a storm within a cloud.

There is a cloud.
It stretches for rows
upon rows
upon rows,
and columns
upon columns
upon columns.
Like cities within cities
upon cities
and beyond cities.
Drenched with ambition
it does not know how to float.
All that it has accumulated
weighs it down,
chains it down.
Like decks upon decks
upon decks
upon decks
upon decks

There is a dust rising
from the polished surface
of a stainless silver rectangle
from the grated hatchways.
There is a dust rising from the sludge
beneath the earth.
It billows, escaping metallic bonds
stretching out onto the decks
into the space between bodies.
And as you breathe it in,
with every breath,
it brings you closer to the ground;
making you more like itself
more indium
more silicon
more yttrium
more lanthanum
more neodymium
more gadolinium
more praseodymium
more terbium
more europium
more dysprosium
more lithium
more magnesium
more tantalum
more antimony
more gallium
more arsenic
more copper
more iron
more lead.

Tentative Collective, 'Political Walks: Karachi', *The Funambulist*, no. 11 (May 2017).

Gabriella Nugent
From Kinshasa to the Moon//2021

In September 2013, a series of verbal accounts emerged in Kinshasa of an astronaut walking the streets of the city in a silver spacesuit constructed from discarded junk and electronic debris spray-painted silver and gold.[1] First sighted in Lingwala, a neighbourhood near the city centre, the astronaut, it is alleged, subsequently travelled through the streets of Kindele; Kimbanseke, where the prophet Simon Kimbangu had lived; Ngwaka, one of the city's toughest areas; Matonge, the site of the historic boxing event 'Rumble in the Jungle' graced by Muhammad Ali and George Foreman in 1974, and finally Massina, also known as the People's Republic of China. This apparition was in fact a performance by Kongo Astronauts, an artist collective established in 2013. [...]

Although their performances are designed for the streets and audiences of Kinshasa, the collective are simultaneously vested in the transmission and retransmission of their work through photographs, short films and collaborations. Shot by [Eléonore] Hellio, [one of the collective's co-founders], their ongoing series of short films is entitled *Postcolonial Dilemna*, while, more recently, they have started to produce their own photographic series, such as *Capital SCrashed.exe* (2021). Musicians offer one avenue of collaboration for the collective. In 2014, their image appeared in the music video for Kinshasa-based band Mbongwana Star's 'Malukayi', travelling through the layered cityscape of Kinshasa. In 2015, they collaborated with the Belgian rapper of Congolese origin, Baloji (cousin to the artist Sammy Baloji) in the music video for 'Capture' where two astronauts search a warehouse for the toppled statue of Henry Morton Stanley, the explorer who had spent 1879–84 assisting King Leopold II claim a large area of the Congo. They collaborated again with Baloji in 2019 for the short film, *Zombies*, that was written, directed and produced by him.

The body of work created by Kongo Astronauts is grounded in Kinshasa, a megacity with an estimated population of fifteen million, and, although the Congo has immense natural resources, its citizens have limited access to basic commodities such as electricity and running water. The inhabitants of Kinshasa have become adept at navigating the vertigoes of an informal economy based on recycling. This same ethos shapes the spacesuits worn by the collective. Mineral extractions from Katanga endure as the bedrock through which contemporary digital technologies are created. Cobalt and coltan are shipped to China where they enter the production of electronic devices that are subsequently distributed and sold around the world. Finally, the objects themselves travel back to the

Congo and other African countries as e-waste. It is cheaper for the West to export these discarded electronic devices than to recycle them, and they end up in Kinshasa's markets and scrap heaps. The collective construct their spacesuits from this e-waste, studded with discarded wires, circuit boards and smartphone parts. Like the spacesuits themselves, the collective's artwork connects stories and scales that are most often kept separate.

Urban Landings and Postcolonial Dilemmas
Kongo Astronauts was established by Eléonore Hellio and Michel Ekeba, but the team varies from between two and seven members. On the collective's website, Hellio writes that she 'expands KA's fields of action through importable connections. Interspace and species communications, paranormal phenomena, dilettante cybernetics, cognitive dissent that shapes her video practice'.[2] Meanwhile, Ekeba 'embodies KA through an action that proceeds from states of consciousness, from urban *dérives* to collisions'.[3] He creates 'the spacesuits with old electronic circuits loaded with cobalt, copper and coltan, putting them into action, crossing the city, its streets, its roundabouts'.[4] Hellio and Ekeba are joined by Bebson Elemba, a 'composer, inventor of instruments, performer and instigator,' and Danniel Toya, a builder of robots, who contributes to their films.[5] On occasion, Hellio and Ekeba, the two 'co-pilots', are accompanied by other passengers, such as Amourabinto Lukoji, Chara Kalej, Cedrick Tamasala, Céline Banza and Rachel Nyangombe.

The performances staged by the collective are rarely announced, and they produce a sense of surprise amongst onlookers who witness them, giving this strange aberration a double take. Dressed in a gold or silver spacesuit, with a matching helmet and boots, Ekeba wanders from one district to another in the Kinshasa megalopolis, appearing in bars, sometimes helping a passer-by cross the street or change a tyre. He often counters accepted ways of occupying the city as demarcated by its layout, eschewing sidewalks to tread along the centre of a throughfare with cars on either side. Ekeba's intentions are opaque, and it is up to the spectators to deduce what they want to take from the collective's costumes and performances.

[T]he collective is concerned with the urban *dérive*, a tactic developed by mid-twentieth century avant-garde collectives, the Lettrist International (LI) and subsequently the Situationist International (SI). In the three-channel digital video installation, *One.Two.Three* (2015) the Belgian artist Vincent Meessen explored the connections between the SI and the Congo. The SI developed a sustained interest in the Congo when the country started to appear in global press coverage in 1960.[6] Meessen's *One.Two.Three* centres around a protest song written by the Congolese Situationist Joseph M'Belolo Ya M'Piku in May

1968 that was discovered by the artist in the archives of the Belgian Situationist Raoul Vaneigem.[7] Scholarship on the SI often overlooks the participation of activists beyond Europe.[8] Working with M'Belolo and young singers in Kinshasa, Meessen developed a version of the song that was subsequently videoed in the Kinshasa club Un Deux Trois, the same space where OK Jazz orchestra led by Franco Luambo had played in the 1960s. Kongo Astronauts' engagement with the city speaks to an analogous set of concerns to the ones that were developed by the Paris-based collective the LI, the group that preceded the SI, in the 1950s. These strategies offer a paradigm through which to consider the activities of Kongo Astronauts.

One of the concerns central to the LI and subsequently the SI was that of 'psychogeography' as in an exploration of everyday city environments that emphasised a sense of playfulness. Developed by the theorist and filmmaker, Guy Debord, in 1955, the term encouraged an alternative engagement with architecture and city space.[9] Central to Debord's thinking was a 1952 study by French sociologist Paul-Henry Chombart de Lauwe, which observed that 'an urban neighbourhood is determined not only by geographical and economic factors, but also by the image that its inhabitants and those of other neighbourhoods have of it'.[10] In order to illustrate 'the narrowness of the real Paris in which each individual lives... within a geographical area whose radius is extremely small', Chombart de Lauwe diagrammed the activities of a student living in the sixteenth arrondissement over the course of a year.[11] Her itinerary delineated a small triangle from which she rarely ever deviated. Debord extensively discussed and reprinted Chombart de Lauwe's diagram, commenting on the lack of variety and suggesting that occupants of the city were trapped in their own arrondissements, overlooking otherness and actuality, even when it is in close proximity. The circuits of everyday life discouraged exploration and enquiry and constructed obstacles. As Debord wrote:

> Others unthinkingly followed the paths learned once and for all, toward their work and their home, toward their predictable future. For them duty had already become a habit, and habit a duty. They did not see the insufficiency of their city. They thought natural the insufficiency of their life.[12]

In contrast, the strategy of the *dérive* proposed to venture through new urban environments, complicating the way in which arrondissements were conceived and allowing for an alternative experience of the city: 'We wanted to get out of this conditioning, in search of different uses of the urban landscape, of new passions'.[13] In a *dérive*, the participants were expected to explore the streets, observing the way in which their emotions changed according

to the environment. Releasing 'themselves to the solicitations of the site', the wanderers on the *dérive* escaped the totalisations of the eye and overdetermined constructions of space.[14] The city and its arrondissements were conceived as social constructions through which the *dérive* operates and simultaneously disrupts.

[...] Kongo Astronauts engage the absurd: their events centre around an astronaut who is earthbound. However, the alien-like silver cosmonaut compels viewers to see Kinshasa and the surrounding environment with fresh eyes, as if they were looking at outer space. In doing so [...], the collective challenges stereotypical and preconceived conceptions of the city, as well as cliched assumptions that circumscribe various geographies and events. [...] The collective captures a sentiment of optimism associated with the end of colonialism, the Space Age and the Internet, all of which purported a more equal and shared world, and yet Kongo Astronauts simultaneously suggest its downfall through e-waste and the global corporations that pillage the country's mineral resources. Ultimately, [...] the abstract entity of the Internet and global appetites for digital consumption are given physical shape through an astronaut dressed in a costume constructed from e-waste that walks the streets of Kinshasa.

1 My reconstruction of these events is indebted to Dominique Malaquais' account of Kongo Astronauts. See Malaquais, 'Postcolonial Dilemma: Parts I–III', *Ellipses Journal of Creative Research*, http://www.ellipses.org.za/project/postcolonial-dilemma-parts-i-iii/.

2 [Footnote 21 in source] These quotes are taken from the collective's website. 'élargit les champs d'action de KA au moyen d'improbables branchements. Communications inter-espaces et espèces, phénomènes paranormaux, cybernétique dilettante, dissidence cognitive forgent sa pratique de la video' (original).

3 [22] '...incarne KA via une action qui procède d'états modifiés de conscience, de dérives urbaines, de télescopages' (original).

4 [23] 'Il fabrique des combinaisons spatiales avec de vieux circuits électroniques chargés de cobalt, de cuivre et de coltan, les met en action, traversant la ville, ses rues, ses rond-points' (original).

5 [24] '...compositeur, inventeur d'instruments, performeur, incitateur' (original).

6 [25] In a letter dated 24 July 1960 and addressed to André Frankin, Guy Debord expressed his concern for the Congo: 'Are we going towards colonial recapture, that is, a new Korean War?'. Debord, who predicted Lumumba's assassination, also wrote in the letter: 'What has been happening in the Congo in the past 12 days will have to be studied for a long time and in all aspects, and seems to me to be an essential experimentation of the revolutionary conditions of the third world'. See Debord, *Correspondance, tome 1: juin 1957–âout 1960* (Paris: Fayaed, 1999) 356–7. In an unsigned article entitled 'Géopolitique de l'hibernation', the author, probably Debord, described the Congolese people's reaction in 1960 as a total refusal of the colonial rationality and a 'most dignified continuation of Dadaism'. He called Lumumba a poet who hijacked the language of the master to transform the world. See

'Géopolitique de l'hibernation', *Internationale Situationiste*, no. 7 (April 1962) 3–10.

7 [26] On the interactions between Congolese exchange students in Paris and members of the SI, see Pedro Monaville, *Students of the World* (Durham, NC: Duke University Press, 2013) 222–7.

8 [27] Monaville, op. cit., 220–21. Andrew Hussey, one of Debord's biographers, notes the Situationists' interest in the Congo, but only parenthetically as a near incongruity, and describes the Congo as one of the 'most far-flung and unlikely parts of the world'. See Hussey, *The Game of War: The Life and Death of Guy Debord* (London: Jonathan Cape, 2001) 180.

9 [28] Ken Knabb (ed. and trans.), *Situationist International Anthology* (Berkeley: Bureau of Public Secrets, 1981) 1–8.

10 [29] Paul Henry Chombart de Lauwe, 'Paris et l'agglomération parisienne' (1952), *Paris: essais de sociologie, 1952–1964* (Paris: Éditions ouvrières, 1965) 19–101.

11 [30] Tom McDonough (ed. and trans.), *The Situationists and the City* (London: Verso, 2009) 78.

12 [31] Ibid., 88.

13 [32] Ibid.

14 [33] Ibid., 78.

Gabriella Nugent, extracts from *Colonial Legacies: Contemporary Lens-Based Art and the Democratic Republic of Congo* (Leuven: Leuven University Press, 2021) 119–21, 124–6, 150.

JeeYeun Lee
100 Miles in Chicagoland//2019

Walk One: Vincennes Trail, 2 October, 2019

I'm standing at Michigan and Wacker on the southwest corner of DuSable Bridge in downtown Chicago. I'm chilled and awkward, trying to act like it's normal to wear this Korean dress and pose for pictures early in the morning. Commuters around me rush to work, heads down, coffee in hand. I'm in front of a tall relief sculpture that depicts a white man wielding a sword to protect white women and children from Native men with tomahawks and arrows. It memorialises an event in 1812 that the carved inscription describes as a brutal massacre, whose white victims 'will be cherished as martyrs in our early history.'

This place is the heart of settler Chicago's story. The footprint of Fort Dearborn, created to protect American trade, marks the sidewalk on the south side of the Chicago River. The bust of Jean Baptiste Point DuSable, recognised as the first non-Native settler of this region, graces the sidewalk on the other side. And the location itself, where the river meets Lake Michigan, is what made this region irresistible to European settlers – the magical link between the Great

Lakes and the Mississippi River. Now the centre of Chicago tourism, this spot is where visitors crowd onto boats for river tours of Chicago's famed architecture.

It's the perfect starting point for my project to track settler colonialism in today's environment. For five Wednesdays in October 2019, I begin here and walk for twenty miles. Each week, I head in a different direction, on diagonal roads originally forged by Native people. The board game Settlers of Catan has colonisation right – you have to build a road before you can build a settlement. The irony is that early settlers used roads forged by Native people. In *An Indigenous Peoples' History of the United States*, Roxanne Dunbar-Ortiz quotes David Wade Chambers: 'early Native American trails and roads ... were not just paths in the woods following along animal tracks used mainly for hunting. Neither [were they] routes that nomadic peoples followed during seasonal migrations. Rather they constituted an extensive system of roadways that spanned the Americas.' Settlers took those roads and paved them; now they are our highways. Indigenous civilisation undergirds today's infrastructure.

It's still dark outside when I start my first walk. The streetlights are on, shining orange through the damp and drizzly mist. I head south on Michigan Avenue, starting down the Native route renamed by settlers as the Vincennes Trail. The path used to hug the shore of Lake Michigan, which now lies a few blocks east due to generations of landfill. In 1914, the Pokagon Band of Potawatomi Indians sued the city of Chicago for that landfill. They had been among the signers of the Treaty of 1833, which designated the eastern boundary of land cessions as Lake Michigan. But the city had since created land beyond the shore, acres of landfill that we know today as Streeterville, Grant Park, Soldier Field, and other valuable lakefront property. The Potawatomi argued for return of this unceded territory, or payment for its purchase. The Supreme Court ruled against the tribe, saying that they had abandoned their right of occupancy: 'for more than half a century no pretence of such occupancy has been made by the tribe.' An odd and impossible argument, since that land had been underwater in 1833, and the treaty had required the Potawatomi to leave.

Native peoples were forced to cede their lands around what is now Chicago in a series of six treaties from 1795 to 1833. Villages of Potawatomi people had dotted the region, where they lived with Ojibwe and Odawa kin. Menominee, Ho-Chunk, Sauk, and Meskwaki peoples had also lived in the area, and before that the Miami and Illinois confederations.

I don't like occupying other peoples' lands. Coming from a place that was colonised in the last century, I am acutely aware of the injustice. The least I can do is witness the present-day occupation of the land where I now live. I walk to witness how the logic of taking has wreaked elimination, containment, and dispossession upon peoples seen as less than human. I wear a traditional Korean

dress made in denim, an embodiment of slavery and settler colonialism in its cotton and indigo materiality. I walk through the landscape as an immigrant, settler, 'American' and Korean female.

On Martin Luther King Drive at 24th Place, a sign announces the entrance to the historic Bronzeville neighbourhood. Just beyond is the Monument to the Great Northern Migration by Alison Saar, one of the few public art works in Chicago made by a Black woman. From 1915 to 1970, the number of African Americans in Chicago grew from 15,000 to one million, less than 2% to one-third of the whole city. Drawn by networks of family and friends, recruited by factories that needed labour, descendants of kidnapped and enslaved Africans thronged to the big city, only to be confined to the 'Black Belt'. But the numbers of newcomers quickly stretched the limits of their containment. As St. Clair Drake and Horace R. Cayton asked in their iconic *Black Metropolis*: 'Where would the black masses, still bearing the mark of the plantation upon them, find a place to live?'

Where indeed? Vicious policies forced African Americans into patterns of hyper-segregation and impoverishment that still exist today. Restrictive covenants, redlining, urban renewal, public housing, redevelopment, and organised violence and harassment by white people – all the mechanisms possible have been and are still being used here in Chicago to confine movement and deny dignity. It's evident all around me as I walk through the South Side. [...]

It's drizzling again as I cross State and 51st. The mist blurs the air above the empty fields where the Robert Taylor Homes once stretched for blocks. Completed in 1962, the infamous public housing project housed 27,000 people at its height, 20,000 of them children. The development was demolished in 2007, its existence and its ending both evidence of what Saidiya Hartman calls the 'brutal disposability and precarity of black life' ('On Working with Archives', interview in *The Creative Independent*). Ironically, the project was named after Robert Taylor, the first African American chair of the Chicago Housing Authority board, who quit his position when City Council opposed scattered-site public housing in order to preserve racial segregation in the city. Today, only a fraction of the housing rebuilt on the demolition site is affordable for low-income families, despite the promises of the Chicago Housing Authority. In a capitalist logic where land only has value in its use, the emptiness of these lots proclaims the disposable value of the people who used to live here. [...]

Walk Two: Barry Point Trail, 9 October, 2019
It's warm today, the sky intensely blue and clear. I've left downtown's skyscrapers far behind when I reach North Lawndale. Decades of systemic disinvestment show in the boarded-up buildings and cracked sidewalks around

me. This neighbourhood is featured by Ta-Nehisi Coates in his seminal 2014 article 'The Case for Reparations', where he talks about the plunder of Black bodies, Black labour, and Black families as the foundation for white democracy. He features stories of Black North Lawndale residents about their experiences of segregation and redlining, and how they organised the Contract Buyers League to fight discriminatory real estate practices. In the essay he goes on to compare slave ownership to home ownership: equally aspirational in its time, equally unthinkable then to envision ending it. 'Imagine what would happen if a president today came out in favor of taking all American homes from their owners', he writes; 'the reaction might well be violent.' As I leave this neighbourhood, I wonder: how did we start thinking that ownership of anything was a right? How do we dispossess the American dream, predicated on land as property instead of something we are part of, connected to, related to? How do we unhitch our aspirations from their origins in violence?

Transportation is a big theme today. I'm in the suburb of Cicero now, and for blocks and blocks I walk past the Cicero Intermodal Terminal for BNSF, the largest freight railroad company in North America. Containers get moved between trains, ships, and trucks here, conveniently located near the railroad tracks, the I-55 highway, and the Chicago Sanitary and Ship Canal. A quick internet search brings up a 2014 EPA report on this terminal's high levels of diesel pollution, which waft over its surrounding residential areas, right where I'm walking. Exposure to diesel exhaust has been linked to asthma, cancer, heart attacks, brain damage, and premature death. Of the 340,000 people who live within a half mile of an intermodal terminal in the Chicago region, more than 80% are Latinx or African American. Environmental justice activists call these areas 'sacrifice zones'.

[...] I've switched over to Plainfield Road now, and the sun is still beating down when I pass by the entrance to a subdivision in suburban Western Springs. A plaque on a boulder sitting among landscaped flowers reads: 'Last Camp Site of the POTAWATOMIE INDIANS in Cook County 1835; Erected by LaGrange Illinois Chapter Daughters of the American Revolution MAY 15th 1930.' According to the Western Springs Historical Society, the last Potawatomi people to leave Chicago by the terms of the 1833 treaty departed in fall 1835. The group of about 70 people slept that first night of travel here. It was a farm then, belonging to Joseph Vial, a settler who came from New York and bought 170 acres right after the land was taken through the treaty. Vial paid the US government $1.25 per acre, the equivalent of $33 today. A sign above the subdivision walls advertises that 'Timber Trails' is still building and selling new homes. They are priced in the $600,000s. Land was taken, people displaced, and resources extracted in order to make this placid suburban scene possible. All

through these walks this question persists in my mind: How do we see what has deliberately and violently been made unseen?

Walk Three: Lake Street Trail, 16 October, 2019

[…] Lake Street itself runs under the tracks of the 'L' train. First built in 1892, the system of elevated tracks was mostly retained by Chicago even after other cities replaced them with subways. So now the trains clatter above me for the first few miles of my walk. The periodic passing of trains punctuates the feeling of desolation around me. On either side of the elevated tracks are empty lots and vacant industrial buildings. Research confirms what I see: Industry has been leaving the West Side of Chicago for decades, going to the suburbs where land is still plentiful and cheap, and municipal governments desperate for jobs offer taxpayer-funded incentives. The result? Less than 15% of manufacturing jobs remain in the city from fifty years ago. The unemployment rate for African Americans in the city, many of whom used to work in the manufacturing sector, is now twice the regional average, which might explain why they're leaving. Since 2010, one out of four African Americans in Chicago, once the largest racial group in the city, have left for the suburbs or gone out of the state altogether in a reverse migration to places like Atlanta and Houston. Who will we become without our Black neighbours? What happens when it's our turn to get eaten up by capitalism?

Running parallel a few blocks south of my route is I-290, known as the Eisenhower Expressway. I hate this perpetually congested highway, and so I feel superior today, as if my walking is faster than driving on that damned road. Built in stages during the 1950s, it was part of a new superhighway system intended to relieve traffic but conveniently deployed to eliminate 'blight', code word for working-class neighbourhoods and communities of colour. Highways take up enormous parcels of land: construction of the Eisenhower displaced about 13,000 people and 400 businesses. Early in the day I walked through the Near West Side; almost 40% African American in the 1950s, the neighbourhood was decimated by the highway. I cross the border now into the suburb of Oak Park, whose more affluent residents were able to stop the highway's proposed cloverleaf ramps and got centre-lane ramps instead, which take less land. […]

Walk Four: Elston Road Trail, 23 October, 2019

[…] I head northwest from downtown, through a part of Chicago where white people live. Construction is clearly the day's theme: the neighbourhood is booming with new office buildings, condos, and street improvements. I pass the outer edge of Lincoln Yards, a new $6 billion project subsidised in part by $1.3 billion from the city. In exchange for what? Protestors question whether

the development will create affordable housing or simply perpetuate racial segregation. A 2019 Urban Institute report says majority-white neighbourhood in Chicago receive 4.6 times more in home mortgages, small business loans, and commercial real estate investment than majority-Black neighbourhoods, and 2.6 times more than majority-Latino neighbourhoods. I can see that money today, in these improved streets and brand-new buildings, just as I witnessed the lack of it on my previous walks, in neighbourhoods deteriorating from lack of investment. [...]

It's sunny again today, with the light reflecting green off the trees by this stretch of sidewalk. I've reached the edge of the city, where the forest preserve, a golf course, a nearby road, and the entire neighbourhood are named after Sauganash, also known as Billy Caldwell. Born to a Mohawk mother and English father, he came to Chicago in the late 1700s and married into the Potawatomi tribe. For his role in negotiating the Treaty of Prairie du Chien in 1829, Caldwell received 1,600 acres of land. He started selling it off a few years later, and then was forced west with other Potawatomi after the 1833 Treaty. Almost forty years later, a man came forward as Caldwell's son to ask about the land. The Bureau of Indian Affairs told him that a portion of the plot, 160 acres, had been sold without permission of the U.S. president, a condition regularly built into treaties ostensibly to protect Native people. The land remained unrecovered, and it was sold to the Cook County Forest Preserve in 1917 and 1922. Technically, Caldwell's descendants might still be able to make a claim to this piece of land.

Stories like this lay bare for me the colonised status of this land, pulling the fact of occupation into the present day. I grew up in Illinois, a state that lacks a single federally recognised tribe. Like so many non-Natives here, I'm not used to the idea of Native people actually living on their ancestral land. I end the day at the corner of Milwaukee and Lake in suburban Glenview, in a shopping mall that has several Korean stores and restaurants. My people make a living here, on other peoples' land.

Walk Five: Green Bay Trail, 30 October, 2019
It's my final walk. It's drizzling again, a freezing rain. I head north across the DuSable Bridge, past the bust of Jean Baptiste Point DuSable. Every Chicago schoolchild knows him: the founder of modern Chicago, its first immigrant, a visionary and entrepreneur. Of African descent, he was born in Haiti or Canada, and came to the Chicago area as a fur trader. He married a Potawatomi woman named Kitihawa, established an extensive farm and trading post here on the north bank of the Chicago River, then sold it all and moved away in 1800. The farm was later bought by John Kinzie, a leading figure in early settler Chicago. For many years, African Americans protested the city's lack of official recognition

of DuSable, while Kinzie, a white man, is commemorated in many Chicago sites. Even the bust was a private donation by a Haitian American. In 2010, ninety years after this bridge was built, it was renamed after DuSable as a result of these protests, and in June 2021, Chicago's City Council voted to rename Lake Shore Drive after him too. Even that necessitated a compromise: instead of replacing the previous name, more words got added, creating the unwieldy moniker 'Jean Baptiste Point DuSable Lake Shore Drive'.

As uncertain as the facts are about DuSable, almost nothing is known about Kitihawa, his wife, even though it's likely that her family networks enabled his success as a trader. Searching in the archives while preparing for this walk, I looked in vain for information about Kitihawa. How did she grow up, what kind of person was she, what did she think about or like to do? If the archives don't tell us, will a monument or renaming do the trick? When we add a bust of DuSable on the Magnificent Mile, or perhaps erect a statue of Kitihawa, what are we celebrating? What do we proclaim when we celebrate the founding of anything on this continent, and does it mean something different if those people are Black and Native?

Those are the questions that swirl in my mind as I walk north along the Magnificent Mile, home to upscale shopping and the world's largest Starbucks. This stretch of Michigan Avenue, its iconic status boosted by city financing and a strategic marketing campaign, didn't become a shopping mecca until the 1950s. As restrictive covenants were outlawed, African Americans started to move out of the Black Belt into other parts of the South and West side. Rather than serve their new Black customers, retailers abandoned those neighbourhoods, and African Americans, with few neighbourhood options, began shopping on State Street, which was then downtown's main retail strip. In a domino chain of retail white flight, State Street's higher-priced retailers pulled up their stakes and moved to Michigan Avenue. Thus, the Magnificent Mile was born. Racism's distaste of proximity to Black bodies extends even to shopping.

Not far past the Magnificent Mile, I turn onto Clark Street and come to a high-rise housing complex, the result of 1960s urban renewal. My cousin used to live here, and I once dated someone who lived here. The neighbourhood was home to Chicago's first large Puerto Rican community, who called it 'La Clark'. As working-class people of colour started moving closer to the tony Gold Coast district, the city decided that this land was blighted. It demolished the entire neighbourhood and financed a $6.4 million housing complex for middle and upper-income professionals. From 1950 to 1966, Chicago displaced over 80,000 people through urban renewal projects, the most per capita in the nation. Forced to move out to Lincoln Park and Humboldt Park, Puerto Rican youth fought back, forming the Young Lords Party and a national movement for self-determination.

No marker, no monument alerts pedestrians to this history. It requires organised resistance to even document stories of resistance.

The sleet keeps coming down. I'm looking for a place to get dry when I reach Wrigley Field. Looking at the country's second-oldest ballpark, I don't think about baseball history or the Cubs, but about Carol Warrington. In 1970, this Menominee mother of six lived behind Wrigley Field in an apartment with steadily worsening conditions. After two months of withholding rent in protest, she was evicted. Native organisers rallied around her eviction and camped outside the apartment building for three months to protest substandard housing for Native Americans. Led by Mike Chosa (Ojibway), this group became the Chicago Indian Village and went on to stage encampments around the Chicago region for the next two years, occupying buildings and federal properties to bring attention to housing needs for Native Americans.

Most Native people living in Chicago at the time had come as a result of the federal Bureau of Indian Affairs relocation programme in the 1950s, part of its termination policy designed to assimilate Native people as well as end federal recognition for tribes. When I delved deeper, I discovered the BIA commissioner championing this effort had previously headed the War Relocation Authority, the agency in charge of imprisoning Japanese Americans in internment camps. Incarceration, assimilation, removal: sometimes the connections are right there, you don't even have to stretch to make them. [...]

I'm done, at the end of my final walk. I just walked through Winnetka, the second-richest town in the state. Now I'm at the corner of Green Bay and County Line Road in Glencoe, the richest place in Illinois, tenth richest in the U.S., with an average household income of $340,000. These suburbs are 90% white. In 2013, white families had thirteen times the amount of wealth as Black families, a wealth gap, often attributed to the ongoing legacy of slavery, that Ta-Nehisi Coates defines as theft. For most families, of any colour, wealth is acquired through owning property, specifically a home. It is the American Dream. Walking through these neighbourhoods where the median value of homes is over $1 million, I am in someone's dream come true. Whose dream? Whose wealth? [...]

JeeYeun Lee, extract from '100 Miles in Chicagoland' (2019), in Ann de Forest (ed.), *Ways of Walking* (Philadelphia: New Door Books, 2022) 61–80. This essay is based on Instagram posts that the author made during her walks.

Annalee Davis
This Ground Beneath My Feet: A Chorus of Bush in Rab Lands//2016

iii.
The cartographer says
 no –
what I do is science. I show
the earth as it is, without bias.
I never fall in love. I never get involved
with the muddy affairs of land.
Too much passion unsteadies the hand.
I aim to show the full
of a place in just a glance.

xiii.
You see, the rastaman
has always felt uneasy
in the glistening white splendour
of Great Houses; uneasy
with the way others
seem easy inside them,
their eyes that smoothly scan the green canefields
like sonnets,
as if they'd found
a measure of peace
in the brutal
architecture of history.
– Kei Miller, *The Cartographer Tries To Map a Way to Zion*

The plantation sits deep inside of me.

Many mornings and afternoons, I walk the fields of Walkers Dairy, formerly Walkers Plantation, formerly Willoughby's Plantation, circa 1660.

I am getting to learn their names:
Big Mansion
Small Mansion

Upper Garden
Lower Garden
Upper New Ground
Lower New Ground
Upper Orchard
Lower Orchard
Rab Land
Moor Door
King Line
Upper Gittens
Lower Gittens
Pilgrim
Squire
Hill Field
Upper Stone Wall
Lower Stone Wall
Two Acre
Stable Field
Girls School
Holy Field

While walking these fields I consider the historical complexities of what lies beneath the soil, a virtual slaughterhouse. Walking across this landscape and poring over family archives disrupts the notion of a single history with one set of coordinates articulating the plantation as the sole (colonial) instrument. Rather, it becomes a kind of base line, which other notes exist in concert with. The audacity to compose other arrangements, to strike new chords, allows for alternate utterances to take place, and for different understandings to unfold across these grassy grounds.

 This small island has been the one and only home of my family since 1648 when a man by the name of Leonard Dowden (b. 1628) arrived from Somerset, England and acquired a small parcel of land in the northernmost parish of St. Lucy. Fourteen generations ago, this relative eked out a living as a 'freeman', so called because he owned less than ten acres of land. Other relatives became planters, while some were indentured labourers or small merchants.

 Nine years after Dowden's arrival, in 1657, another Englishman, Richard Ligon[1] wrote what he called 'A True and Exact History of the Island of Barbados':

> Illustrated with a mapp of the island, as also the principall trees and plants there, set forth in their due proportions and shapes, drawne out by their

severall and respective scales. Together with the ingenio that makes the sugar, with the plots of the severall houses, roomes, and other places, that are used in the whole process of sugar-making; viz. the grinding-room, the boyling-room, the filling-room, the curing-house, still-house, and furnaces; all cut in copper.[2]

While Ligon considered that the history he wrote was true and exact, when I examine wills and testaments, look at maps, search for boundaries and probe for truth, I find that nothing is exact. Where did Ligon find these due proportions and respective scales?

Several years ago, I found hundreds of 1970s plantation ledger pages in a dilapidated building on the plantation where I grew up. It was the office where Mr. Rudd, and before him, Mr. Whitehead, worked as bookkeepers for the sugar estate. In these ledgers are the familiar names of those who worked in the fields along with an array of numbers that inhabit these hundreds of fragile papers, logging how many tonnes of cane were harvested, what rent was paid by those living in the tenantry, etc. I bring the pages to the studio and begin to draw an inexact series of lines. First one line, another line, then; many more lines across the unremembered palimpsests.

So many different worlds co-existed on these fields which I continue to walk, to query, unravel and dislocate. In addition to the many wild plants that hijack my path, I find red shards made from local clay along with imported ceramic remains creeping out from underneath the now bovine-trodden grassy fields. These fragments have been on this land for more than two hundred years.

I walk the fields in early mornings or late afternoons. They seem to have a voice and are speaking back. What once were acres of uninterrupted, well ordered *Saccharum officinarum* are now a disarray of red-tipped grasses, Elder Bush, Wild Plumbago, River Tamarind, Ink Vine, Jack Lantern, Clammy Cherry, Broad Path, Cerasee Bush and many other wild plants forcing themselves up through this ground beneath my feet.

My wanderings are interrupted by this continual emergence of wild flora, ceramic and clay remains. They challenge the monoculture that was so orderly and so traumatically inscribed into the soil with borders that neatly defined where one field ends and the other begins.

Upper Gittens. Lower Gittens. Holy Field. Rab Land. My father, born on this land, remembers finding clay pipes in the fields. He lives on King Field.

I have gotten involved with the muddy affairs of this land. I have fallen in love with these fields and this is an attempt to reckon with history and place; blood and race; privilege and the power to do something with it. […]

1 Richard Ligon was an upper class Englishman, Royalist and naturalist who came to Barbados in 1647 where he would have been considered a freeman. He returned to England in 1650 and wrote *The True and Exact History of the Island of Barbadoes* which was first published in 1657.
2 Richard Ligon, *The True and Exact History of the Island of Barbadoes* (1657) edited and annotated by J. Edward Hutson (St. Michael, Barbados: Barbados National Trust, 2000).

Annalee Davis, extract from *This Ground Beneath My Feet: A Chorus of Bush in Rab Lands* (Austin, Texas: Warfield Center, 2016) online catalogue (https://rablands.annaleedavis.com/).

Giordano Nanni
Regularity Versus Irregularity//2012

Maureen Perkins notes that the term 'walkabout' entered Australian colonial discourse around 1828, and soon became a common expression for describing the perceived irregularity inherent in Aboriginal life.[1] Aboriginal people who moved about land without the purpose of seeking employment elsewhere, or who left their work outside of the approved periods of leave, were commonly said to have gone 'walkabout' – a term which implied the perceived extraneousness of Aboriginal life, evoking images of a culture that was guided by 'another' calendar, or by no calendar at all. To 'wander' (from the Germanic, *wend* – 'to turn') connoted the idea of non-linear movement; of aimlessness and lack of direction. Migrant workers could move from place to place without raising suspicion because they did so according to the calendars and seasons of approved forms of labour and industry. But Aboriginal people and 'vagrants' were said to 'wander' about the country, since their movements were not guided by an accepted source of temporal authority. The term 'walkabout' is indeed 'a reminder', Perkins notes, 'that at the very heart of representations of indigenous people as timeless is a deep abhorrence within western European culture to the practice of nomadism'.[2] As such, it echoed similar prejudices towards nomadic populations in other colonial spaces, as well as the fears and suspicions which were generally felt in Europe toward gypsies, vagrants and other itinerants.

The use of time-conscious attributes such as 'wandering' and 'irregular' to describe Aboriginal peoples' movements reveal the deep-seated aversion amongst settlers towards populations guided by untamed (and un-timed) nature, and can be traced back to the earliest colonial observations of Aboriginal societies. The general manners in which nomadic movements were conducted evoked a sense of indolence and irregularity often appeared to European observers

as forms of indulgence. 'As a rule they are lazy travellers', Richard Brough-Smyth commented. 'It is generally late in the morning before they start on [their] journey, and there are many interruptions by the way.'[3] A perceived lack of discipline was reflected in the general appearance of family relations and daily life: 'the children are not educated in the slightest degree', a settler stated in his reply to one of the queries posed by the 1858–59 Select Committee. 'Their parents have not the slightest control over them'.[4] As the responses given to Question 38 in the list of queries suggest, settlers were not able to perceive any sense of regularity even in the most basic aspects of pre-colonial Aboriginal life:

> What number of meals do they have and what is their capacity for temporary or sustained exertion?
>
> *Mr. Murray* The prevailing food was originally chiefly animal, for which they trusted entirely to Nature for supply... Their meals are very irregular.
>
> *Mr. Smith* They have no regular number of meals, but eat when they have the opportunity, principally, however, in the mornings and evening.
>
> *Mr. Cooke* They are too idle to cultivate for themselves...They have on regular time for their meals, but seem to be always eating and sleeping, except when they are out hunting.[5]

This chronology of activities portrayed 'the wild life' as being (mis)guided by an erratic and haphazard timetable, suggesting a failure to appreciate the advantages of a uniform, predictable and repetitive timetable. 'Irregularity' was seen to have induced many of the hardships that supposedly afflicted Aboriginal people. 'The irregularity and uncertainty of their diet would be fatal to a white man', one settler wrote. They often remain at their huts in a listless state for days and nights together, when suddenly some of them will undertake a long and fatiguing journey travelling night and day, or other violent exercise, as the corrobboree, hunting, &c'.[6] The logic was taken to extremes by claims that infanticide (and subsequent cannibalistic feeding upon murdered infants) was a consequence of their failure to plan for the future.[7]

In later years, on the missions and reserves, it became common to blame Aboriginal deaths and illnesses on the refusal to abandon the seasonal calendar of nomadic life, rather than on the devastating consequences of colonisation (including the introduction of alcohol and disease). In a report from one of the missions, for instance, the station manager reported that five cases of fatal illness had occurred during the past year alone. But 'I would have it known',

he specified, 'that four out of the five who died were old blacks, of wandering propensities and dissipated habits, who would never remain on the station for any length of time.'[8]

The ubiquitous notion of 'irregularity' is a powerful and rather unquestioned aspect of colonial discourse which demands greater recognition for its role in bolstering the denial of Aboriginal peoples' attachment to the land. Regularity was fundamental to effective nomadic land uses: Aboriginal peoples made cyclical use of tracts of land within a larger, defined territory for a determined period and then proceeded to move on, keeping pace with the seasonal changes in their environment.[9] Successful hunter-gatherer economies required regularity and order – 'proof', historian Henry Reynolds argues, 'of their exploitation or "enjoyment" of the land'.[10] In practice, however, such land-uses were not recognised as sufficiently evident, especially given that (or perhaps, precisely because) the recurrence of such movements was based, once again, upon an understanding of time and regularity that was oriented around nature – not by a predictable and structured calendar or by the exigencies of an industrially and agriculturally oriented economy. In a Lockean sense, therefore, the regular calendars of agriculture and pastoralism could legitimately displace the irregular seasons of nomadic hunter-gatherers, subsuming them within the temporal order of a more 'civilised' relationship with the land.[11]

Constant seasonal migrations undertaken at the times determined by the availability of food, water and better climates failed to satisfy the prerequisite conditions for land ownership partly because those who described them as haphazard and irregular failed to understand, or refused to value, *inter alia*, the temporal order guiding and coordinating such movements – but also because it simply suited settlers to believe as much. Indeed, when staking a claim to soil that was 'unoccupied' at the time of their arrival, most settlers did not usually consider the fact that, with the changing of the local seasons and the regeneration of flora and fauna, the same land would be visited once again by its regular inhabitants. This kind of denial of nomadic land ownership was repeated over and over again. Thus, in what would have been one of numerous such occasions, when a group of settlers formally petitioned the Victorian government in 1858 to sell the 'empty' land set aside as the Aboriginal reserve of Mordialloc – now a suburb of Melbourne – their request was granted. This took place in spite of vehement protests from Assistant Protector William Thomas, who opposed the motion on the grounds that the land was still seasonally used by Aboriginal people.[12] On another occasion, the influential settler Edward Curr, who was eager in the late 1870s to vacate land around Melbourne for pastoralism and settlement, justified the proposal to remove the residents of one of Victoria's most vibrant communities (Coranderrk) by hinging his argument

on the seasonal nature of their ancestors' tenure over the land: 'They only went there in the summer time,' Curr responded to his critics. 'They never lived in the mountains; they went there occasionally... It was not at any time the headquarters of a tribe.'[13]

Recent history has shown that such misrepresentations of Aboriginal culture still carry enough power to ensure the continuing denial of Aboriginal land-rights in parts of Australia. In 1998, Edward Curr's representations of Aboriginal life and customs in his memoir, *Recollections of Squatting in Victoria* (1883), were adopted as a key source of evidence to support Federal Court Justice Olney's ruling on a Native Title claim by the Yorta Yorta people. Whilst in the nineteenth century the law had refused to recognise the temporal ties of nomads to their lands, in the twentieth century, this logic was reversed. Given that the Yorta Yorta no longer led 'traditional' elements of 'Aboriginal' life (instead of nomads, for instance, they had become sedentary and urbanised) they did not meet the requirement, under native title law, that claimants must be able to demonstrate a continuing connection to the land through the continuity of tradition with pre-colonial times. Even as a metaphor, time could be redeployed to justify the continuation of dispossession, Symbolically, Justice Olney ruled that the Yorta Yorta claim to native title had been 'washed away by the tide of history'.[14]

Europeans brought with them new rhythms and rituals to settler colonies such as Victoria. The introduction of a developed European industry, full-scale pastoralism and sedentary agriculture loudly drummed out a new 'beat', which at times complemented, and at times conflicted with, the older, pre-colonial rhythms of Aboriginal societies. As one settler noted in his reply to the Queries of the 1858-59 Select Committee, the Aboriginal population of Victoria had begun to respond to the introduction of these new pastoral rhythms by incorporating, and to a certain extent accommodating, them within their pre-existent mode of temporal reckoning: 'now they have the advantage of dating from the "Nip Nip", or Settlers' yearly regular shearing time. This seems to supply them with a mode of stating years, which before they had not.'[15] These 'new rhythms', however, would prove to come into direct conflict with the pre-colonial rhythms and ways of life. The settlers' 'yearly regular shearing time', which embodied the new rhythm of colonial Australia, was a commercial time driven by the exigencies of capitalist enterprise, whose most distinctive feature was precisely that constructed quality of 'regularity' by means of which it differentiated itself so starkly from the 'erratic' pace of life which it sought to supplant.

The Aboriginal peoples of Victoria were not a static culture, however, and adapted to the new rhythms remarkably quickly, given the force of the impact with which these were introduced following the onset of British colonisation. Already by the mid-nineteenth century, the surviving Aboriginal population

began to respond by integrating colonial-time within their temporal horizon. What the encounter with colonial society thus inevitably entailed was a shift from one source of external temporal authority to another. As Michael O'Malley states with reference to the same shift characterising western European society during the expansion of industrial capitalism: 'The crucial change... came not in a fall from some "task-oriented" state of Arcadian grace, but rather from a redefinition of time's authority. As the symbols, artefacts and ideas used to embody time's passage changed, they offered new models for social and political organization.'[16] [...]

1 [Footnote 72 in source] M. Perkins, 'Timeless Cultures: The "Dream time" as Colonial Discourse', *Time and Society*, vol. 7, no. 2 (1998) 335–51, 346.
2 [73] Ibid., 347.
3 [74] Ibid., 125.
4 [75] Peter Beveridge quoted in 'Replies to Circular Letter, With List of Queries', in *Report of the Legislative Council* (1858–59), vol. 1, 28.
5 [76] 'Replies to a Circular Letter', op. cit., 54–6.
6 [77] Philip Chauncey (J.P. District Surveyor at Ballarat), 'Notes and Anecdotes of the Aborigines of Australia', quoted in Brough-Smyth, *The Aborigines of Victoria*, vol. 2, 243.
7 [78] See Brough-Smyth, *The Aborigines of Victoria*, vol. 1, 8.
8 [79] AAV, B333, box 2, Robert Thwaites to Captain Page, Framlingham Station Report for the years 1882-83, in *19th Annual Report of the Board for the Protection of Aborigines* (hereafter: BPA), Appendix 2.
9 [80] N.M. Williams, *The Yolngu and Their Land: A System of Land Tenure and the Fight for its Recognition* (Canberra: Australian Institute of Aboriginal Studies, 1986) and Mike Donaldson, 'The End of Time? Aboriginal Temporality and the British Invasion of Australia', *Time and Society*, vol. 5, no. 2 (1996) 187–207, 192.
10 [81] Henry Reynolds, *Law of the Land* (1987) (Melbourne: Penguin, 2003) 16.
11 [82] For what it was worth, nomadic peoples' property rights had been addressed in European law, when the eminent philosopher Christian Wolff stated that nomadic people could not legally be dispossessed simply because their patterns of land-use were different from those of agriculturalists. 'For the purpose of assuring cattle or for some other purpose, the intention of wandering, which is governed by that intended use, gives sufficient evidence of the occupation of the lands subject to that use, although they have not established a permanent abode on them.' (Christian Wolff, *The Law of Nations* (1740-49), quoted in Reynolds, *Law of the Land*, 15–17).
12 [83] PROV, VPRS 4467, mf reel 4, items c /58/1340, c/5/420, William Thomas, 'Aborgnal Affairs Records'.
13 [84] Edward M. Curr, *Report of the Board Appointed to Enquire into, and Report Upon, the Present Condition and Manage of the Coranderrk Aboriginal Station, P.P. Victoria*, 1881 (hereafter: *Report on Coranderrk Inquiry*, 1882), in minutes of Evidence, 120.

14 [85] *The Members of the Yorta Aboriginal Community v The State of Victoria and Ors* (1998) at para 126 per Olney J. For a critique of Olney's use of Edward Curr's evidence in the above case, see: Samuel Furphy, 'Edward Micklethwaite Curr's *Recollections of Squatting*: Biography, History and Native Title', in P. Edmonds and S. Furphy (eds.), *Rethinking Colonial Histories: New and Alternative Approaches* (Melbourne: University of Melbourne, History Department 2006) 33–48.

15 [86] Godfrey quoted in, 'Replies to Circular Letter, With List of Queries', in *Report of the Legislative Council* (1858–59), vol. 1, 71.

16 [87] Michael O'Malley, 'Time, Work and Task Orientation: A Critique of American Historiography', *Time & Society*, vol. 1, no. 3 (1992) 341–58, 355.

Giordano Nanni, extract from *The Colonisation of Time: Ritual, Routine and Resistance in the British Empire* (Manchester: Manchester University Press, 2012) 77–81.

Sop
The Den 2//2020

THE LEFT SIDE IS SCRIPT
[...]

TWO

	THE RIGHT SIDE IS SOUND

Lockdown is eased and cleaves a gap between shielder and non-shielder.

squelchy, muddy, slow underwater sound with a high wind whistle

Where once we were the same, now we are not.

second voice doubles

Each relaxation of the rules increases the space between us, creating wide roads that I am not allowed to walk down.

a seesawing metallic element is added to the underwater sound, a pulsing squelch and a cooing bird

Differences assemble as a physical force, gathering to linger at my front door, pushing back at me to stay inside.

a second voice says 'advance, retreat' over and over

Every change destroys the things that I now know.
They shake me up and wipe me clean

and it takes longer and longer to adjust.
Just retreat. *second voice doubles*
I become fearful and hesitant. *a cold and airy tone rising, swelling*
The den is just five minutes from my *and hissing*
house but now it feels like miles.
It stops feeling like my own and this hurts.

I skip visits.

The cemetery is reopened to the public. *a second voice speaks over the first*
I don't visit the den
People are allowed out more than once a day. *the tone becomes choral*
I don't visit the den.
It is leaked that shielding will end soon. *the tone becomes metallic*
I don't visit the den.

Days become weeks become a month.
I made excuses: It rains, I cannot go.
I am tired, I cannot go.
It is the weekend, I cannot go.
It is medication day, I cannot go.

I become more like the shielder *second voice doubles*
I am supposed to be.
 the sing song sound of a dishwasher
Being physically shielded means that *with water falling*
I am also visually shielded.
I don't see the odd new world,
the queues, the empty streets.
I'm asked "what local shops are near me?"
and I can't answer. Since I moved here
I only leave the house to visit the den,
turning right to the woods, never left.

I stay in bed and go for a walk on Google maps.

THREE

 low hums of wind and the hiss
In the beginning, the government told *of a tape with nothing on it*
the public to look after us,

to protect the vulnerable.
No longer one of the ignored, disabled
and long term sick, but elevated overnight
to the most 'valuable' of society.

Suddenly noticed, they wanted us to live…
Well they didn't want us to die so conspicuously.

Rudely shoved into a spotlight:
You! Are! Extremely! Vulnerable!

the voice multiplies over itself
a deep bass sound like the playing
of a resonant string instrument with
choral overtones

It jarred and disorientated to be brought
so visibly to the public's attention.
I raged at the difference of yesterday's care
- the lack of it.
It felt uncomfortable and I was distrustful.

Before, I knew my lane,
that of the inconvenient sick,
hidden and out of view.
It wasn't right but I was used to it.
So I grieved retrospectively.

higher metallic notes sweep over

The attention is too late.
We have lost so many already.
Look at them. Just look at them!
But you can't… as they are shut inside.

a low tone with the sound of a
storm surging from left to right

My neighbour passes me a seedling
through the window and the tips
of our little fingers accidentally touch.

the storm passes

I think about it for hours.

a musical slow seesawing creak,
a second voice repeats 'I am the wood
and the wood is me'

FOUR
I need the wood. I want to consume it,
for it to leave its trace in me.
I pick nettles to eat later.

I gather logs, twigs and leaves.
I decorate my house, transcribing
the wood, bringing the den inside.

At home, my brain stretches out in hundreds *the second voice stops*
of sinewy feelers trying to understand risk. *thin, high, metallic hissing layers*
I sit at the safe centre of an
ever expanding web of danger. *the sound of a group of people on the*
 hill in the woods outside

The web stitches together people,
one person meets another,
that person has met ten people,
those ten people have met ten others.

How to negotiate seeing one person when *the metallic hissing layers intensify*
it feels like they have contacted hundreds?

'Rheumatoid Arthritis, is a condition *second voice doubles*
that will be with you for the rest of your life,
interrupting the harmony and balance
in your immune system.'

I am being told that I need to remember *scraping sounds, start, stop and stutter*
that I am sick, and that I should not *in different tones and volumes,*
stop taking my medication. *alongside the high hiss*

The drugs I take, successfully propping
up my dysfunctional body, could now kill me.
They are a death sentence on pause,
a deal made in the time just before.

My choices tie my hands.
I cannot go back
(stop taking the drugs)
and I cannot move forward
(in case of catching the virus.)

I am stalled.

Drugs change the message. *layers of sweeping high metallic bird*

Medicine creates diversions. *like sounds*
Follow this muddy path, not that one. *distorted bird calls echo*
Cells sleep, they rest, they are exhausted.

And meanwhile I get better.
I am guided into near normal health.
The rest of my body celebrates, *bird sounds screech*
I can walk again.

But I can't because I am not allowed to.

The drugs ensure a deeper level of shielding,
one that begins inside my body.
The first layer of restriction is my skin.
The second, the casing of the house around me.

The virus cannot enter, it cannot. *second voice doubles*

I move from bed to sofa, sofa to bed.
I spend so little time standing up that
it starts to feel alien. My body is turning
into a circle, a loop following my curved spine.
I creak like old wood. *a musical slow drawn out creaking sound*

[...]

Sop, extract from *The Den 2* (transcript, 2020), commissioned by Disability Arts Online and Unlimited.

Walking activates the creation of concepts. To walk is to move-with thought. Walking-writing is experimental and speculative.

Stephanie Springgay and Sarah E. Truman, 'Queering the Trail', 2018

WITH

Stephanie Springgay and Sarah E. Truman
Queering the Trail//2018

[...] Walking-writing is a thinking-in-movement. Walking-writing is a practice of concept formation. We do not conceptualise walking in one register and writing in another, any more than we understand our research-creation walking events as pre-writing. Walking activates the creation of concepts. To walk is to move-with thought. In addition, we understand writing as something more-than what exists on a page or in a book. Walking-writing is experimental and speculative. Walking-writing surfaces. It is viscous and intense. Walking-writing is collaborative.

Walk One: Queering the Euro-Western Walking Tradition

Read this section then go on a walk. Queer the trail. Defamiliarise Euro-Western traditions and other heteronormative, solo perambulations that link walking with unfettered inspiration.

Artists and writers experiment with different methods of walking and writing including poetic structures, the body, and land. For example, African American poet Harryette Mullen's (2014) book *Urban Tumbleweed* documents her daily walking practice through 366 Tanka poems written for each day in a year, plus one. Tanka is a traditional form of Japanese verse, and Mullen incorporates this sparse poetry with her walks in Los Angeles through diverse neighbourhoods, exposing the ephemeral, lived experience of her daily practice. Barbara Lounder's *Writing/Walking Sticks* (2007) is a set of 26 custom-made walking sticks, each one fitted with a small self-inking stamp on the bottom. Each stamp bears a different letter of the English alphabet and leaves a water-soluble inked impression on the ground. Vanessa Dion Fletcher investigates her relationship between language and land, specifically her Potawatomi and Lenape ancestry, in her walking projects. In *Writing Landscape* (2012), Dion Fletcher walks repeatedly on the land as a form of bodily writing.

 Blue Prints for a Long Walk is a project by Anishnaabe artist Lisa Myers whose walking practice maps invisible lines of family history, settler colonialism, and cultural memory. The project traces a 250-kilometre path along the northern shore of Lake Huron, Ontario, between Sault Ste. Marie and the town of Espanola. This path, often forged along railway lines, marks the route her grandfather took home when he ran away from a residential school, and subsisted for days on

wild blueberries that grew along the track. In addition to walking, she created 54 postcard-sized etchings of railway ties and screen-prints made out of blueberry pigments. These postcards map out a section of Myers' walk topologically, through its waterways and the path of the Canadian Pacific Railway. Walking becomes a means to interrogate and animate a personal and collective history that is shaped by land, rhythm, and the sensuous textures and tastes of blueberries.

Trans Black artist and activist Syrus Ware's practice takes on many different forms. As part of the *New Field* project (2017) organised by *Public Studio* and in partnership with *WalkingLab*, Ware collaborated with youth from the Lawrence Heights area in Toronto. *Future Rememberings* – a day-long walk on the Bruce Trail – incorporated wild foraging and off the grid sustainable living to inquire into environmental and socio-political crises. The walk, which took the form of an ecology and mobile drawing class, speculatively and experimentally imagined collective futures.

Latai Taumoepeau uses walking and performance to examine issues of climate change in the Pacific region. In her piece *Ocean Island Mine* (2016–2022), she moves a 500-kilogram block of ice using a shovel and by walking over a short distance repetitively. The work excavates the 'solid white' rock into invisibility. In *Stitching up the Sea* (2015), she walks, wearing brick sandals on her feet on broken glass. Using a Tongan mallet (which is typically used to beat plant fibres into pulp) to smash glass waste material, the durational walking performance, activates Indigenous knowledges and identities alongside larger questions regarding climate change.

In yet another example, queer Black writer Rahawa Haile walked the Appalachian Trail from Georgia to Maine and wrote about her long-distance solo-hike. As the only Black woman to walk the trail solo end to end, Haile's project examined the relationship between walking, race, and belonging. On the walk, she carried books by Black authors, which she left in trail shelters along the way.

In academic scholarship and popular literature, walking is extolled and prized because: it benefits health; inspires creativity; attunes the walker with landscape; and is a tactic for re-writing the city. While these fraught inheritances nudge at our practice, *WalkingLab* has intentionally sought out collaborations with women walkers, Indigenous walkers, queer and trans walkers, differently abled walkers, and people of colour to *Queer the Trail*. This is the ethical-political thrust of our walking-writing practice. [...]

Walk Four: Activation Device

Go on a walk and bring some kind of activation device. This could be a camera, sound recorder, some wool to felt, paper to write poems, postcards, a geothermal

measuring device, mirrors, or walk scores. Use the device on the walk, not to record or capture your experience of the walk, but to alter the function of the walk.

The activation device experiments with the walk and enables new ways of thinking-making-doing. Much like the speculative middle, the activation device pushes walking-writing to an edge. It forces something new to occur. The activation device is not intended to extract or collect information, but to insert itself within the walking-writing practice as a thinking-making-doing.

One possible activation device is an altered gait walk.[1] On such a walk, participants modify habits of walking through various modalities. For example, carrying a giant bouquet of helium balloons, walking backwards using a handheld mirror, carrying a bucket of water that reflects the sky, wearing high heeled shoes, wearing a roller skate on one foot, or filling your pockets with rocks.

Stephanie frequently hand felts wool around rocks as a 'writing' practice. Posing the question 'How to write as felt?' she interrogates the process of making felt with wool (felt as force and intensity), as affective feelings (felt as affect), and as a felt event (felt as transmaterial). She invokes these various *matterings* of felt in order to generate a practice of writing that engenders bodily difference that is affective, moving, and woolly. She is particularly interested in thinking about felt's engagement with touch, for felt invites, if not demands touch. Felt is a dense material of permanently interlocking fibres. It is a non-woven fabric made using natural fibres, a binding agent, and a process of agitating the fibres such as rubbing. Gilles Deleuze and Felix Guattari use different textile processes to flesh out the concepts of striated and smooth space. Because weaving has a warp (threads set against the loom) and weft (threads that move in between the warp) it creates a striated space that is delimited. Felting and some needlework like crochet and embroidery on the other hand, create what they call smooth space. This is space that vectors out, spreads, and surfaces.

Deleuze and Guattari call felt an 'anti-fabric', made by the agitation or entanglement of fibres.[2] It has no warp and weft, and 'is in no way homogeneous: it is nevertheless smooth, and contrasts point by point with the space of fabric'. Felt spreads out infinitely. Felt is irreversible. Once wool is felted it cannot be undone and the fibres returned to their original state. 'Felt comes into existence, comes to matter, as a result of an unpredictable interaction of tendencies (of the fibres, of the manner and the conditions in which they are worked)'.[3] Felting rocks while walking Stephanie describes as a touching encounter composed between human and nonhuman matter. Felting is a practice of writing as a *thinking-making-doing*. Felt, writes Jeanne Vaccaro, 'cannot be known mathematically, like textiles – calculated, quantified, or mapped on a horizontal-vertical grid.[4] It is the result of the destruction of a grid.

There is no pattern to follow'.[5] As felt emerges it builds into itself the possibility of improvisation; a rhythm without measure. Felting invokes the intimacy of touch.[6] To felt, scales of wool touch and entangle, and fingers and hands wrap around each other and the wet woolly mass. To felt demands friction, and friction is indebted to touch. To touch is the opening of one body to another; it is an interval, an event.

These examples, as we keep reiterating, are not methods of data collection or documentation. They rupture and queer the walk, they slow us down and change our gait, they problematise what it means to walk, they agitate and provoke. Activation devices are not required for every walk, but they might be necessary. They propel us into a speculative middle and churn our thinking. They surface. They function propositionally because we don't have a clear procedure of how they will activate the walk beforehand. They are prompts for further walking-writing, as opposed to a representation of the walk. Manning and Massumi, writing about thinking-making-doing at *SenseLab*, comment that terms like improvisation, emergence, and invention and a general sense of just letting things flow, lack rigour and focus, and risk being used in a cursorily manner.[7] We extend their arguments, to add, that activation devices can't sit outside of the walking-writing event. By this we mean they can't simply be creative activities, such as collaging data transcripts, that bear no weight on the walking-writing event inside the event. Activation devices need to mobilise thought, stimulate differentiation, and act as tensiles – capable of being stretched, but also in frictional tension.

Walk Five: 'With'

This walk requires a group of humans and/or nonhumans. The group can be of any size. The group composes only one aspect of 'with.' 'With' is about co-composition rather than inclusive collaboration. Bring a notebook and a pencil. A blanket or a ground cover is recommended but not necessary. Walk until you find a comfortable place to sit and write together.

Astrida Neimanis writes that transcorporeality, intra-action, relationality, companion species and other concepts that inform new materialisms and posthumanisms all engender a form of 'with.' She wonders, though, why the concept collaboration is rarely mentioned in the pivotal feminist texts that mark this burgeoning field. Perhaps, she argues, there is a danger in idealising the sentimentality of collaboration. We need, she contends, to differentiate different kinds of collaboration, to ask questions about the consequences of relating. 'Collaboration,' she writes, 'is sweaty work replete with tense negotiations'.[8]

WalkingLab organises *Itinerant Reading Salons*, where we gather groups of people together to walk and read. Sometimes readings are shared before the walk and we use the walk to discuss the readings closely. We might select a quote or a 'minor concept' that we work as we walk.[9] In other instances, we bring the readings on the walks and pause along our journey to read out loud together. Reading out loud changes the pace of reading, its tempo and shape, much like a walk alters our movements, rhythms, and pace.

One such 'with' walk took place on the Mornington Peninsula, Victoria, Australia, with *WalkingLab* collaborators Mindy Blaise and Linda Knight. Our week-long *Itinerant Reading Salon* began propositionally with the question: 'What if we stand speculative for a moment before the speculative turn and check our feminist itinerary again?'.[10] Having attended a number of academic conferences, where the new materialisms and posthumanism proliferated, but without any critical regard for its feminist genealogy, we felt the need to revisit some of the feminist contributions to the field and to ask questions about 'with': inheritance, relations, response-ability, friction, and situatedness.

We read together. Out loud. We took notes individually in our notebooks, and we scrawled concepts, questions, and ideas on chart paper and in the sand. We walked along the beach and over volcanic rock. We sheltered ourselves from the sea wind in a bower of Moonah trees to write. One of our writing propositions was 'tentacles.' We wrote for 30 minutes. Then each of us read aloud to one another. We followed this by asking further questions from which another writing proposition emerged. We wrote again. We continued until we reached a point where the wind and flies were no longer bearable. We walked back to our accommodation. More questions emerged as we cooked together and continued reading out loud, writing together and apart. 'With' 'demands work, speculative invention, and ontological risks... [and] [n]o one knows how to do that in advance of coming together in composition'.[11]

When walking-writing, the 'with' has to be held (in)tension all the time. It's not just that four feminist academics were working together, but that we were thinking, problematising, and speculating on 'with-ness,' response-ability, matters of concern, and situatedness as ongoing propositions. This 'with' can also be extended to include a politics of citation. Citational practices, argues Sara Ahmed, structure a selective history of disciplines.[12] She writes that these structures are 'screening techniques' where 'certain bodies take up spaces by screening out the existence of others'. The academic collective *Feminist Educators Against Sexism* (#FEAS), organised by Mindy Blaise, Linda Knight, and Emily Gray propose a 'Cite Club'.[13] FEAS has established an email group where members share their work and cite one another when possible. Cite Club addresses the call by Eve Tuck, K. Wayne Yang and Rubén Gaztambide-

Fernández to 'consider what you might want to change about your academic citation practices.¹⁴ Who do you choose to link and re-circulate in your work? Who gets erased? Who should you stop citing?'. 'With' requires that we walk-write-think-cite as a political practice of co-composition.

1 [Footnote 1 in source] The altered gait concept is borrowed from artist Donna Akrey.
2 [Editors' note: Gilles Deleuze and Félix Guattari, *A Thousand* Plateaus (London and New York: Continuum, 1987) 475.]
3 [Editors' note: Thompson, 2011, 23.]
4 [Editors' note: Jeanne Vaccaro (2010).]
5 [Editors' note: Jeanne Vaccaro (2010) 253.]
6 [Editors' note: Springgay, 2008.]
7 [Editors' note: 2014.]
8 [Editors' note: Astrida Neimanis (2012) 218.]
9 [Editors' note: Manning & Massumi (2014).]
10 [Editors' note: Åsberg, Thiele and van der Tuin (2015) 164.]
11 [Editors' note: Haraway (2008) 83.]
12 [Editors' note: Sara Ahmed (2013).]
13 [Footnote 2 in source] Feminist Educators against Sexism (FEAS) seeks to challenge and eradicate sexism and gender inequality in the academy. www.genderandeducation.com/issues/introducing-feas-cite-club/]
14 [Editors' note: Eve Tuck, K. Wayne Yang and Rubén Gaztambide-Fernández (2015).]

Stephanie Springgay and Sarah E. Truman, extract from *Walking Methodologies in a More-than-Human World: WalkingLab* (Abingdon: Routledge, 2018) 130–42. Reproduced by permission of Taylor & Francis Group.

Sarah Jane Cervenak
Jade Montserrat's *Peat*//2019

How might performance 'accentuate the elemental through communion', and, beyond that, indicate a relationality of 'inappropriable' expenditure? A 'way of walking lightly on the earth', as Fred Moten might say.[1]

Black British performance artist Jade Montserrat evokes these general questions from the vantage of *Peat*, a 2015 short film indexing the artwork's name and locale.[2] As a small cluster of scenes documenting her walking through, touching, standing with, and jumping on a peat bog, the so-called 'forgotten fossil fuel', Montserrat's *Peat* asks whether being-forgotten might offer something to Black-earthly performance. Something not often remembered but already there, something unextractive, what's been 'in place in the first place.'[3] What holds all earthly life together.

Powerfully, *Peat*, in its textural, visual, and sonic specificities, along with Montserrat's particular kinaesthetic and performative choices with respect to its traversal, evokes some nonextractive buoyancy, some inappropriable elemental communion. Parahuman occasionings of mixed up flesh/plant/water/atmospheric matter.[4] Collaborations that draw on their prior but forgotten alreadyness in sustaining vitalities of otherwise besieged flesh and earth.

The film begins with a beautiful close-up of a peat bog. According to the International Peat Society, peat is 'a heterogeneous mixture of more or less decomposed plant (humus) material that has accumulated in a water-saturated environment and in the absence of oxygen.'[5] It is in many ways a unique plant-water-elemental arrangement: 'The five basic elements of peat are C[arbon], H[ydrogen], O[xygen], N[itrogen] and S[ulfur]. The elemental properties of peat are generally between that of wood and coal. The elemental proportion of lowly decomposed peat approximates to that of wood, while highly decomposed peat resembles that of the lignite.'[6] Moreover, peat is chemically and elementally powerful enough to do everything from healing flesh to supporting plant growth to preventing erosion.[7] It is also, when not damaged by extraction, known as a carbon store, which helps to remove man-made carbon emissions from fossil fuel consumption.[8] Lastly, as a *National Geographic* report claims, as 'oil, coal, and natural gas are exported around the world, few outside northern Europe are aware of this energy source.'[9]

Peat's putative nonpreferentiality for energy-based extraction, along with its healing and restorative capacities, suggest some possible reasons why Montserrat chose the bog for her aerobic movement and sensorial figurings.

Just under six minutes, *Peat* begins with a full-screen glance of peat, the wispy movement of brown and green grasses. Coming into aerial view slightly off centre, a portion of a narrow, windy path appears along with the moving feet of its (the path's) traverser, the artist; soon, the camera moves downward to the path to meet them.

The film then shifts focus from earth to artist, with the camera tracking Montserrat walking and sloshing across the wet peat and high grasses. The sounds of crunching and splashing attend the movement of her muddy feet descending into and out of water.[10] After a set of takes of Montserrat's feet walking stealthily as she physically negotiates the wet and thick terrain, we soon see them (her feet) stop at and stand atop a grey-black, presumptively drier rock. At this point, the camera zooms in on her now elevated feet rotating clockwise. Following this full circular rotation, a similar series of cuts appear. Brush/peat/bog under water; the camera following the walker's stockinged legs and muddy feet as they, in real time and slow motion, traverse the terrain; alternating feet and waist-high views of the brush/peat/bog under water. The frame filling alternately with quiet and the crunch and wetness of the walked-through bog. So too are there shots of the vertical growing brush interspersed throughout and at one moment, a close-up of a puddle canopied by some green and white horizontal stitching of grass. Toward the end of the short film, Montserrat – once more filmed using tracking shots, this time at shoulder level – jumps repeatedly into the bog's water. This is interspersed with more images of her walking through the greener parts of the brush, as close-ups of brown water glistening on her feet and hands come into focus. After another, rather extended, jumping segment, this time more akin to a furtive running/splashing in place, the film's final image is an aerial view of Montserrat soundlessly, and in slowed down motion, jumping in the centre of a bog.

The conclusion is soundless, as the artist's slow-motion jumping in an open field disappears into the end credits. To be sure, this soundlessness, along with some slow-motion takes of Montserrat walking and pausing, twins with the sloshing and crackling throughout. I wonder then: why end with this soundless, slowed down image? What does the quiet and slowed down itself elucidate about the fullness of a sensorial/elemental relation not available to someone else's potentially extractive memory? I begin my analysis at the end precisely because what it sets into motion (and reminds one of the ongoing presence of) is what Macarena Gómez-Barris might call a non-extractive view, a belief in the invisible, unlocatable, uncapturable relationality engendered by Montserrat's performative and kinaesthetic engagement with peat itself.

As Gómez-Barris argues:

Extractive zones contain within them the submerged perspectives that challenge obliteration. I describe these transitional and intangible spaces as geographies that cannot be fully contained by the ethnocentrism of speciesism, scientific objectification, or by extractive technocracies that advance oil fields, construct pipelines, divert and diminish rivers, or cave-in mountains through mining. Seeing and listening to these worlds present nonpath dependent alternatives to capitalist and extractive valuation.[11]

Concerning Gómez-Barris's correlating a non-extractive view with a non-path-orientation to earth, there is, indeed, an anxiety around a pathiness that animates the film. On the one hand, the jumping, walking sounds of wetness and brush are repeated throughout the short film, suggesting an insistent presentness, the sights and sounds of one person's physical ambulation and enmeshment in a particularly textured and, as seen in the opening, pathed environment. There's also something about the sound and its conveyance of a hurriedness that suggests a deliberateness on the one hand and a fugitivity on the other. A trying to get somewhere fast. Put differently, the auditory expressivity of wet grasses, some uncultivated green, in conjunction with a black woman's visually pursued form indicates a kind of spatiotemporal, ecological resemblance to an anti-black plantational fetish coterminous with the pursuit and unmaking of (presumptively uncultivated) earth and flesh.[12] The enactment of whiteness as property's path, is nothing if not the bulldozing of prior paths, prior yearnings to get and be somewhere.

As Montserrat herself and curator Daniella Rose King observe, Montserrat's particular experience of that land, those bogs, is animated by the spectres and experiences of anti-blackness long haunting the British idyll:

> Montserrat (performance notes): 'The performances were acts of remembrance generated by the landscape and inherently, passively by personal histories. Heathcliff [a black character in Charlotte Bronte's classic of British Romanticism, the rurally (bog) set novel *Wuthering Heights*], representative of the dispossessed, and I are aliens dropped into this ancient landscape. Appearances suggest we were not meant to be here. Alienation is magnified by a landscape scarred by borders testimony to territorial ownership. The body can become heavy, sluggish, de-stablised, this is reinforced by isolation. The territory is bleak, remote, unforgiving, unhearing, without union or unity with other bodies.'[13]

Daniella Rose King and Jade Montserrat: 'Montserrat's childhood involved living off-grid with generated electricity (electricity switched completely off when not

in use) and no terrestrial television reception, traversing peat bogs, and daily travel through the longest fjord in Britain, just to reach home. She was shot at by a deerstalker – an event laden with complex specificities of class dynamics, divisions, and privileges nestled in the British countryside; the lays of that land – and for her it is very difficult to stress that this lived experience is real. It is a reality that has always been met with an incredulity and disbelief.'[14]

Powerfully, these histories resound in the audiovisual, ecological textures of the film, the repeated scenes of running/walking quickly and the camera's use of drone and uncomfortably close tracking shots.

Still, there are an equal number of scenes of an insistently other relationality with earth, a non-hurriedness. Scenes where the artist rocks her heels into muck, ambles in slow motion, stands still, rests as the path disappears and her muddy wet hands dry in the sun. Something about these other scenes suggests, as does the cinematography in these moments, a withness rather than a path-oriented 'for-ness' that the tracking shot conveys, perhaps some private journeying movements into what Toni Morrison calls 'what's in place in the first place.'[15]

In his writing about plants and what he calls 'the metaphysics of mixture', philosopher Emanuele Coccia argues that plants through their photosynthetic capacities elucidate the life-giving, earth-saving (or earth-breaking) force of togethernesses, a kind-of anoriginal and invisible witness, forged before violent separations pathed all life into a slow death march.[16]

He writes:

> Plants, then, allow us to understand that immersion is not a simple spatial determination: to be immersed is not reducible to finding oneself *in* something that surrounds and penetrates us. Immersion, as we have seen, is first of all an *action* of mutual copenetration between subject and environment, body and space, life and medium. It is impossible to distinguish them physically and spatially: for there to be immersion, subject and environment have to *actively penetrate each other*; otherwise one would speak simply of juxtaposition or contiguity between two bodies touching at their extremities.

and later:

> It is already *by existing* that plants modify the world globally without even moving, without beginning to act. 'To be' means, for them, *to make world* [*faire monde*]; reciprocally, to construct (our) world, to make world is only a synonym of 'to be.' […] If any living being is a being in the world, every environment is a being within beings. The world and the living are nothing

but a halo, an echo of the relation that binds them together. We will never be able to be materially separated from the matter of the world: every living being constructs itself starting from the same matter that makes up the mountains and the clouds. Immersion is a *material* coincidence, which starts under our skin.[17]

Through ritualistic exercises in immersion, ranging from submerging her feet into mud to jumping into those same puddles, Montserrat elucidates a being-with peat, a being with its life-giving energies that momentarily suspends the telos of extraction. The bogs are wet, covered in water… water seems to be, in fact, the place where artist and plant meet. That water is what keeps that carbon-storing, earth-preserving life force going. Its absence is often the sign of its (carbon's) decline, of its damagedness either by global warming itself or by the arbiters of extraction looking to speed up the process.

And just as the film is filled with water's insistent presence and unavailable sites/sounds/feels, it's already more than that. Where artist and plant meet is in mixture, in being mixed up together, hands and feet splattered with mud, feet splashing in one of the bog's many puddles. As Sasha Engelmann and Derek McCormack might say, such in/visible mixture indicates 'how [e]lemental processes might become coconspirators in the generation of different forms and arrangements of life.'[18]

Something bounties forth in such co-conspiracy. Something that holds and preserves and protects a vitality long there… long before walks were pursued and earth was plowed and pathed. All the way back where life's para-material coincidentality glimmered like an unextractable cosmos 'under the skin' (ibid). Returning to Coccia and Morrison together, perhaps what Montserrat created in *Peat* – and with its namesake matter – was a partially illustrated photosynthetic consciousness of their intrinsic co-immersiveness, the sharing of besieged earth and flesh's 'perfect memory… [its] forever trying to get back to where it [once] was.'[19]

1 The notion of the 'inappropriable' used in the previous sentence is inspired by Fred Moten's use of it in the context of the 'ecstatics of the aesthetics' with respect to sound, 'insurrection', and the photograph of Emmett Till. See *In the Break: The Aesthetics of the Black Radical Tradition* (Minneapolis: University of Minnesota Press, 2003) 201. Moten's quote from the footnoted sentence appears in an essay for the Serpentine Museum exhibition dedicated to the films of Arthur Jafa. See 'Black Topographic Existence', by Fred Moten from Serpentine Gallery's press release for Arthur Jafa's exhibition, 'A Series of Utterly Improbable Yet Extraordinary Renditions' (2017), Serpentine Galleries, UK.
2 Film made in collaboration with film-makers Webb-Ellis. Available at https://vimeo.com/155794300
3 Toni Morrison quoted in Avery Gordon's *Ghostly Matters: Haunting and the Sociological Imagination*

(Minneapolis: University of Minnesota Press, 1997) 4.

4 My use of 'parahuman' here is inspired by Monique Allewaert's use of the term when she describes how racist, colonialist figurings of Black people's presumptive proximity to nature indexed a fear of the relations that endanger propertising, taxonomising logics of an owned world. Instructively, in Allewaert's elaboration, the bog, and its relation to colonised people, historically figures as a site of 'disruption.' I quote from *Ariel's Ecology: Plantations, Personhood, and Colonialism in the American Tropics* (Minneapolis: University of Minnesota Press, 2013) at length: 'Colonial[s] typically conceived of Africans as a not-definitively-categorizable form of life. Moreover colonial organisations of labor power, particularly the plantation form, required that slaves (often of African descent) become deeply familiar with the properties of nonhuman animal and plant life. This meant that Africans in the diaspora, whether slave or maroon (self-emancipated slaves), had especially deft imaginings of the forms of power and agency that developed at the interstices between human and nonhuman life. [...] Consider that Caliban's repudiation of Prospero echoes Ariel's lyric disaggregation of the colonial body while vesting it with revolutionary potential: "All the infections that the sun sucks up / From bogs, fens, flats, on Prosper fall, and make him / By inchmeal a disease." I join Caliban's curse with Ariel's lyric to suggest that Africans in the Atlantic diaspora gained power through their recognition and exploitation of human and parahuman beings' relations with nonhuman forms. Existing colonial, anticolonial, and postcolonial analyses of the play have tended to divide Ariel from Caliban, but attending to the environmental fantasies that circulate in the play reveals that from the earliest moments of colonisation Anglo-Europeans imagined a tenuous and revolutionary alliance between tropical elemental forces and subaltern persons. [...] Moreover, Caliban's attention to the power and disruption that might emerge from bogs, fens, flats, and other natural phenomena figured nonhuman bodies, organic or not, as vectors for subaltern resistance, thus challenging the colonial assumption that any body that was not definitively human was an exchangeable product.' 7–8.

5 From 'What is Peat', *International Peat Society* (website) http://www.peatsociety.org/peatlands-and-peat/what-peat

6 Hu Jinming and Ma Xuehui, 'Physical and Chemical Properties of Peat', vol. 2 – Physical and Chemical Properties of Peat, available at https://www.eolss.net/Sample-Chapters/C08/E3-04-06-03.pdf

7 'Each spherical brown sporangium, or spore case, shrinks as it dries, creating internal pressure that casts off the lid (operculum) and shoots the spores as far as 10 cm from the plant. The metabolic processes of growing peat moss cause an increase in the acidity of the surrounding water, thus reducing bacterial action and preventing decay. Peat moss forms several types of bogs in northern areas. Compression and chemical breakdown of dead plants and other vegetable debris cause formation of the organic substance known as peat, which is harvested and dried for use as fuel. Dried peat moss has been used for surgical dressings, diapers, lamp wicks, bedding, and stable litter. It is commonly employed as a packing material by florists and shippers of live aquatic animals and as a seedbed cover and soil additive by gardeners, who value its ability to increase soil moisture, porosity, and acidity. Peat mosses are valuable in erosion control, and properly drained peat bogs provide useful agricultural land.' (www.britannica.com/plant/peat-moss).

8 www.iucn.org/resources/issues-briefs/peatlands-and-climate-change
9 www.nationalgeographic.org/media/peat-forgotten-fuel/
10 Caitlin Webb-Ellis conducted the editing and arrangement of sound.
11 Macarena Gómez-Barris, *The Extractive Zone: Social Ecologies and Decolonial Perspectives* (Durham: Duke University Press, 2017).
12 I want to acknowledge the influence of Tiffany Lethabo King's scholarship, particularly her essay 'The Labor of (Re)Reading Plantation Landscapes Fungible(ly)' on my thinking here. *Antipode* vol. 48, no. 4 (2016) 1–18.
13 See 'Burials'.
14 Jade Montserrat and Daniella Rose King '(some possibilities of) Rural Belongings' (www.womenandperformance.org/ampersand/28-3-rose-king-montserrat).
15 Erin Manning and Brian Massumi, *Thought in the Act: Passages in the Ecology of Experience* (Minneapolis: University of Minnesota Press, 2014) 8.
16 My use of 'anoriginal' is informed by Fred Moten's introduction of and use of the term with respect to black performances in his *In the Break: The Aesthetics of the Black Radical Tradition* (Minneapolis: University of Minnesota Press Press, 2003).
17 Emanuele Coccia, *The Life of Plants: A Metaphysics of Mixture* (Cambridge: Polity Press, 2018) 36.
18 Sasha Engelmann & Derek McCormack, 'Elemental Aesthetics: On Artistic Experiments with Solar Energy', *Annals of the American Association of Geographers*, vol. 108, no. 1 (2018) 246.
19 Toni Morrison, 'The Site of Memory', in *Inventing the Truth: The Art and Craft of Memoir*, (ed.) William Zinsser (Boston: Houghton Millian, 1995).

Sarah Jane Cervenak, extract from 'With: Jade Montserrat's Peat', *ASAP Journal* (August 2019).

Michael Marder
Walking Among Plants//2017

On the verge of a brief journey I'd love you to join me in, and as we get ready for a mental exercise in phyto-peripatetics, let us begin with a simple contrast. When we walk in a field, meander in a grove, or stroll in a garden, we move among plants that stay in place. It bears noting right away that the contrast is a little deceptive: vegetal being-in-place is not the opposite of movement. Plants move in the locales of their growth precisely by virtue of growing, irradiating outwards, unfurling themselves, and experiencing a lived time-space, which does not pre-date them as an empty continuum but which co-evolves together with and as them. Even so, human displacement among trees, shrubs, grasses, and flowers accentuates our locomotion against the backdrop of their presumably

stationary existence. And this bare beginning, discernible in the contrast which will accompany us all the way to the end, is not without significance.

The most unsympathetic interpretation would assert that, playing with the opposition between human mobility and vegetal immobility, we (however unconsciously) establish or reestablish our superiority over the flora. It is as though a walker is saying by means of the body's kinetic activity and, hence, without uttering anything:

> Look: I can linger for a little while under the shade of an oak or in front of a rose, but I can also move on, whether to another plant or to another place altogether. Or I might not linger at all, rather keeping a steady pace at which the vegetation around me coalesces into a kind of green blur. In these possibilities, reflecting my decision, lies my freedom – the freedom you, plants, cannot have.

I reject this cruel interpretation, especially in those cases when walking among plants is done for nothing, i.e., not in order to reach some other destination but to lose and perhaps discover (or rediscover) oneself in the vegetal world.

Backtracking for a moment, I must retrace my steps and comment upon peripatetic philosophy, as alive in Aristotle's Lyceum as in Jean-Jacques Rousseau's reveries. Peri + patein: walking around. Around what? Which perimeter does a walker-thinker circumscribe? Itinerant, philosophers may well walk among plants – or the colonnades that have supplanted plants as human reinventions of tree trunks in the academy of Athens – but they invariably revolve around themselves, notably their thoughts. In fact, the adjective 'peripatetic' makes no mention whatsoever of the context wherein walking around takes place, and it is this abstraction from the surroundings that invisibly prepares the ground for the abstract universality indifferent to its when and where. Such universality then passes for thought.

That said, the peripatetics realise, if only implicitly, that there is no direct route to oneself. Thought is activated thanks to detours and digressions, first, through physical walks prompting the body to move so as to shake cognition out of its stagnation, and, second, through the vegetal world. Plants, as well as their remainders or reminders, become the signposts for our movement, not so much helping orient us in space as orienting us in thought (recall [Immanuel] Kant's 'What Is Orientation in Thinking?' (1786)), referring us, who walk among them, back to ourselves. Do they do so by way of the contrast, with which we have started this foray, now resembling a constant digression? Do they give something to thought – to thinking as an activity and its own outcome; to be thought, infinitely, into the future – that cannot be found elsewhere?

Rousseau's peripatetic experience is nonetheless dissimilar to that which we encounter in classical philosophy. His returns to himself via the mediation of walking among plants are incidental; what prevails in his *Reveries* is the daydream, a freely associative, hardly self-conscious existence with and in the flora. His 'botanical expeditions,' the countryside strolls during which he collected the commonest of plant specimens, were intended to lose, rather than to find, himself. The ecstasy of the desired self-abandon was best achieved through the walker's contact with vegetation outside him, which drew him back to the vegetal dimension of his own life. For Rousseau, botany was a 'salutary science': a poison and a remedy, despite the pitfalls of scientific rationality, it held the potential of reorienting modern humanity away from the excesses of civilisation that, more and more, set us adrift. Along the same lines, it is possible to conclude that walking among plants is conducive to a salutary movement of thought, pulling against the cognitive tendency toward abstraction and thus embedding our ideas once again in sensuous experience.

The sensuous experience of the vegetal world reawakens in us another kind of thinking resistant to abstraction. Swathed in the sights and smells, tastes (if we are lucky enough to stumble upon berries or fruit) and tactile sensations (for instance, of grass against bare feet, but most often not those mediated by the hand, unless this typically privileged organ of touch is used gently to move aside a branch blocking the path), peripatetic explorers feel-think on the periphery of their sentient bodies, akin to plants that cognise the world on the outer edges of their extension (root tips, unfurling leaves, and so forth). Rather than objectifying, thinking of something, or representing, we discover what it means to think around while walking around – peripatetically, peripherally, perimetrically. In addition to the sensuous materiality of thought, whither plants recall us, they give us this other mode of thinking to think, the mode I have termed 'essentially superficial'. Our contact with them could not be more superficial than when we walk among – not past – them, the lived times and spaces of vegetal and human beings hardly brushing upon one another, which is what a genuine encounter looks and feels like.

Walking in the midst of plants, we above all cherish the difference between us and them, as well as among them. I resist the contemporary proposals, many of them inspired in the work of Gilles Deleuze and Félix Guattari, to become-X: here, to become-plant. Mature humanity, ready to share in difference with human and non-human beings alike, eschews the ancient mimetic need to become the other, the need betokening more than anything a certain anthropocentric imperialism. The rhythm of our walking and living among plants will not coincide with the rhythm, tempo, or temporality of vegetal vitality, its movements virtually imperceptible, because much slower than those of locomotion. But there is

nothing wrong with the dissonance between the cadences of human and plant existences, revealed in the course of phyto-peripatetic ventures. The discrepancy dispenses to each their own: it makes us alive to the otherwise taken-for-granted pace of our being in the world and to the underappreciated otherness of plants that are in the world in a distinct manner. Tangentially, peripherally, the act of walking among plants gives an intimation of ontological justice, appropriating neither side to the needs of the other, acknowledging the co-involvement and mindful of the divide between the vegetal and the human.

Michael Marder, 'Walking Among Plants', in *Four Walks*, (ed.) Gerard Ortín Castellví (Bratislava: 2017) 68–5 [reverse numbering in source].

Myriam Lefkowitz
In Conversation with Susan Gibb and Julie Pellegrin//2019

Julie Pellegrin [...] You often use the term 'practice' rather than 'project' or 'work' [...] Where does this notion of practice come from?

Myriam Lefkowitz I think it comes directly from my background in dance. For me, practice is very much connected to doing. Most of the time the way I work is by meeting my collaborator-friends in a dance studio, or an open and empty indoor place, to share modes of doing. We're not targeting a project, or let's say, we don't need a project in order to meet and practice. We're not necessarily rehearsing for something. We're exercising something together – different forms of touch, relations to space, ways to trigger our imagination. It's not rehearsing; it's more repeating, exercising sensorial, imaginary, and semantic tools.

The phenomenon of touching and being touched is one of the main principles we work with. Each time we meet, we are investigating what it is to encounter one another through touch. Whatever the set-up is – let's say we are exploring skin as an airy and silky surface, as an interface that is both super strong and totally porous – we always try to name what is happening and what could happen when we experience a specific touch. Touch composes a specific structure of support that is not entirely muscle-based. If we follow the example of airy touch, the emphasis on skin shifts our relation to gravity, making weight feel quite light and floaty, and most of all, it creates a very clear sense of the body's 360° volume. Our relation to space becomes more based on sensing and volume, than on vision and perspective. What this does to the relation between bodies is ask for the skin to become the centre of attention, and that each person use it to listen to one another and explore the question of sensorial reciprocity, the fact that we are constantly being touched and touching.

What I am engaged with through this is a tricky descriptive task. I'm trying to notice all the things that are actually happening, to name the direct effects of the exercise. I'm discovering as we go. We start a practice because we don't know how it's going to play out and what questions it will generate. We trust that the experience is going to produce effects. The work is to notice those effects and to play with them so that it keeps the practice going. The more unexpected effects there are, the more there is to study or practice. Maybe here those two verbs, study and practice, are describing the same activity. [...]

Susan Gibb Could you describe in more concrete terms an example of what one of these practices looks like?

Lefkowitz I can recount the accident that generated the practice, *How Can One Know In Such Darkness?* and which emerged out of *Walk, Hands, Eyes (a city)* – a silent walk for one viewer and one performer. In the walk, the viewer has her eyes closed and is guided by the performer using subtle touch. They drift through the city for an hour with the performer following a simple composition task based on contrasts in sound, light, terrain, or whatever variations appear. At different moments, depending on what is happening around them, the performer asks the viewer to open her eyes very quickly on different images-flashes. On one such walk I got stuck in a hallway of a building. The woman I was leading had her eyes closed so didn't know we were stuck as the walk is in silence. It was dark and I couldn't find the light. There was this constant sound, a vibration, coming from a corner of the hall. After a few seconds of panic, I decided to play with what was most likely going on for the woman instead of focusing on the possibility that we might be stuck forever! My hands were very lightly touching her, and the sound was becoming louder the more I listened to it. We could also move a little bit without touching the walls. After two or three minutes of this, someone came in and we could leave. After our walk the woman couldn't stop talking about this moment. She thought I had moved the sound closer to her, that the space was enormous, and that my hands had disappeared inside her body. She was describing a perceptual illusion: when one perceives something that is different from what is actually there. This shows how strong sensing already is as an act of imagination. [...]

Pellegrin I was wondering why you chose to work with certain public spaces or urban environments, such as streets, shops, gym halls, swimming pools, or libraries? [...]

Lefkowitz When I started doing *Walk, Hands, Eyes (a city)* I realised that what I was actually experimenting with, was a dialogue between this possible body that appears in the dance studio (the shift to the skin, the suspension of gravity, the relation to volumes, the subtle skin connection with a partner, the variation of rhythm…) and the social urban environment that we who live in cities inhabit every day, and in which we construct a series of perceptive and sensorial patterns that allow us to survive in these environments. We read these environments in a certain way depending on a very complex set of elements that have composed our empirical relationship to these spaces. Sadly, at least for me, most of the time these patterns repeat in quite a rigid way. I guess this is why

we call them patterns! So the question that appeared through *Walk* was how could those patterns be destabilised? Can they shift to generate another form of relation to the places we inhabit? When *Walk* operates, it's a transformative dialogue that loops the duet between performer and participant with the city. The sensorial effects of the practice resonate in the environment and vice versa. So what we perceive is not so much what is there but what could be there. What we have identified and organised into a certain grid is gradually transformed into something else, whatever that something else might be. A fiction that contains a kind of psychedelic potential that tells more than what one can imagine about how and where we could live. I know that this is why I ended up walking in cities for such a long time: to experience that fiction, which can only happen because nothing about the symphony of a city can be controlled.

This produces a counter-site, stealing from Michel Foucault's famous notion of heterotopia: a space that exists somewhere and functions in opposition to all the other spaces. This is how I understand that my collaborators and I ended up camping in two swimming pools, one gym hall, and one library. The three spaces are public places in which the relation to time, to the body, to others, to sound, to what it is that one practices (swimming, studying, exercising, zoning out) resonate very strongly with this notion of counter-site. Each of them creates a form of suspension in the use of time and space that we generally answer to. Each of them has a very specific mode of framing our attention. We camped and infiltrated these inhabited places by depositing different sensorial and conversational tools into them, in an attempt to tune to their mood and see how it would affect the practices, the encounters, and the questions. I say 'we' because it concerns several collaborator-friends who joined me – Jean-Philippe Derail, Valentina Desideri, Ben Evans, Alkis Hadjiandreou, Julie Laporte, and Géraldine Longueville Geffriaud – and who shared their respective practices and research by making them available for us all as a toolbox: different ways of walking, of listening, tarot cards and other divination practices, conversational practices, beverages, and all that was inspired by the place itself – new ways of reading books, playing in the water, taking advice from the life guards. [...]

Pellegrin There is reciprocity, in so far as the practice affects its environment. During *Walk*, for example, the body and the surroundings gain new faculties. The entire space is transformed by the experience. For example, a lot of people said that for them, narrow and busy streets became a wide desert with a distant horizon.

Lefkowitz Yes, and one of the factors that allows those images to appear is that we find ourselves in an augmented form of interrelation through closing one's eyes and being touched by someone – the skin again becoming a strong vector of

connection. I would say this is how the city, or whatever the space, changes. And you can't really say what produces what. Is it the skin that is changing because the perception of the environment is changing, or the opposite? It starts with skin and the desert image appears. It's a constant feedback loop between inside and outside, which produces a transformative effect. Maybe a dog that runs by creates a connection to the desert for some mysterious reason, and then one's attention moves to the hand, and from the hand it moves to the sensation of floating, which reminds one of another city they dreamed of. It's a network of associations that can move from very concrete and physical elements to something like... a thought or a memory. And maybe the thought becomes concrete because it plays a role in this web. I think this is dancing. It is this web that is dancing.

[...] Maybe what we're practising is a different way to associate things with one another and to question the way things have been identified, categorised, put in order. It's the possible suspension of that order that is performing. [...]

Pellegrin *La Bibliothèque* lasted ten days but you reiterated *Walk* for more than ten years. The fact that you develop and present all of your practices for so long, and in so many different places, implies a shift in the form of repetition.

Lefkowitz When I started *Walk*, I went back to the same street maybe 250 times! I knew everything by heart in terms of where things were, but I quickly noticed that I could never go back to the same moment. Time was a trigger of variation. What had happened once would never happen again. So repetition was probably a way for me to study variation. The same thing could be said for all my other practices. I constantly go back to them to make sure that I encounter variation again and again. Differences in cities, people, mood, light, dreams, languages... It's about tuning to those differences and observing how it affects our complex perceptive-sensorial mental machinery. So yes, 'shift' is exactly the word to describe what I'm looking for. [...]

Gibb One thing I've found very interesting when experiencing your work, is that I often find myself becoming very aware of my ears, of me listening, even though I'm not being told anything as the experiences generally take place in silence. It's a sensorial listening that's extending outwards to spatially attune. [...]

Lefkowitz *Walk* made me discover a very basic thing; what it is to drift, and not only in trajectory. Walking in a city generally means going from point A to B, rationalising the path as much as one can to save time. In Walk you have nowhere to go, point B doesn't even exist. So you're not only de-focusing your relation to space, as an effective or productive thing that you have to rationalise,

it's actually that the mental space operates in a completely different way. A body-mental-inventiveness starts operating. You can train that body-mind machine to go from A to B in the most rational way, or you can train it to operate in a different way, a strange, unknown, uncanny way.

Gibb Thinking about this mental space alongside dance and performance, and the spectator's gaze and where it is directed, one thing that I became very conscious of when experiencing your work is that my gaze goes inwards. Maybe the role one takes on as a spectator is more active – you are asked to walk, to lay down, it's often one-on-one. It's not simply sitting in a seat looking at a stage in the distance. But I never felt that I was what could be called a participant in your work, as I still maintained my spectatorship, but where my spectatorship sat was in this kind of inward space. Like sitting in the mind's eye, absolutely aware of where the mind's eye travels. I think that was de-focusing. My spectatorship moved towards all of the things occurring in my body that I couldn't see. Like what I was hearing, feeling – I always felt slightly behind my eyes, actually. The other thing I find interesting is how people incidently observe *Walk* for example, because it takes place in a city's streets, or the *Darkness*, which you've now opened up so people can view the practice. […] In *La Piscine* and *La Bibliothèque*, there are also peripheral spectators. I actually think that once people become familiar with the fact that this work is taking place, the legibility of the relationships between the bodies also starts affecting the environment. There's something to do with a kind of vulnerability or porosity which shifts… or contaminates… or affects the environment.

Lefkowitz I'm starting to think that maybe these viewers can see a third body between the performer and the spectator. We're just walking, lying down, moving blankets, or reading a text quietly. If you look at it, there is actually not much to see. Maybe what is contaminating the environment is actually this ether that happens to exist inside inhabited social space like a swimming pool, a street, or a library. And the peripheral spectators guarantee its existence even if they are not conscious of it. In a way, we don't need to understand what is at stake for this ether to exist. I guess it's also because what you see from the outside is a very vulnerable and silent duet, so people seem to hold the space not to disturb anything. Like people start to smile, to hold doors, to stop and look, or to lower their voices when they speak… Different little gestures signify 'I notice', as if what was contaminating was a suspension.

Extract from 'Myriam Lefkowitz, a Conversation with Susan Gibb and Julie Pellegrin', *collection Digressions* #07 (Valence: Captures éditions and Ferme du Buisson, 2019) 22–34.

Steve Graby
Wandering Minds//2011

In March 2011 the Centers for Disease Control and Prevention (CDC) proposed the addition of a new diagnostic code to the International Classification of Diseases (ICD) for 'wandering behavior' in people diagnosed with autism or other cognitive impairments, which will come into effect in October 2011, meaning that 'wandering' will be diagnosable by doctors and can be officially recorded in people's medical records.[1] This replaces previous sub-codes of the codes for Alzheimer's disease and dementia, and extends the medicalisation of 'wandering' to affect a much wider group of people. While the new 'wandering' code is supported by parent-led, and often cure-oriented, 'autism advocacy' organisations, such as the National Autism Association (NAA) (who recommend various biomedical 'treatment' options as well as 'behaviour modification' techniques for autistic children), it has been strongly opposed by autistic-led advocacy organisations and other disabled people's lobby groups. The collaborative working group AWAARE (Autism Wandering Awareness Alerts Response and Education), set up by the NAA to promote the establishment of the diagnostic code, includes the notorious Autism Speaks as well as several other organisations whose publicly stated goal is the 'cure' or elimination of autism.[2] These organisations claim that the ICD code will prevent injuries and fatalities caused by autistic children wandering into dangerous situations, such as falls and drowning, which they present as a matter of 'natural' rather than social risk, and focus exclusively on children in their promotional material, despite the fact that the ICD code does not mention children or any other age group, and thus could be applied equally to autistic adults.

The introduction of the 'wandering' code is opposed by groups including the Autistic Self Advocacy Network (ASAN), anti-discrimination lobby group Change. org, the Autism National Committee (AUTCOM) and many other disabled people's organisations, who argue that it pathologises, and thus denies the possibility of meaningful reasons for, autistic people's attempts to remove themselves from oppressive or abusive situations, deal with sensory overload, or simply walk freely in their local communities. ASAN's press release on the subject states:

> No research exists to classify 'wandering' as a medical rather than a behavioral phenomenon and the code has no definition that would differentiate wandering as a medical symptom from behavior of individuals who simply wish to move from one place to another for any number of reasons.

By turning the behavior of wandering into a medical diagnosis, people with disabilities with the most significant challenges in communication could be made more vulnerable. For many adults and children who cannot speak, attempting to leave a situation is one of the few options available to communicate abuse, a sensorily overwhelming environment or boredom from repetition of the same tasks over and over. By creating a medical code for wandering, professionals could misinterpret behavior as a medical symptom and miss the legitimate concern the individual is trying to communicate.[3]

In a joint letter with 40 other organisations, they also state:

The research which CDC relies on to make the case for this coding is weak. For example, one of the statistics that CDC cites (that 92% of families of children on the autism spectrum report at least one or more incidents of wandering) comes not from a high quality research study, but instead from an online poll on the website of an advocacy organization. This is not in line with the high standards for research and evidence that CDC's bases its other decision-making on.[4]

Many individual autistic people have also expressed their concerns about and opposition to the code on blogs and forums online; for example, Lisa Daxter (who blogs under the name 'chaotic idealism') describes her own childhood 'wandering' to escape from domestic violence, and goes on to say:

The 'wandering' code would do very little good, and much harm.... So how do we keep people safe without ruining their autonomy and ability to communicate danger or distress?

Well, first of all, 'wandering' of this sort needs to be seen as what it is: A behavioral choice; a purposeful decision. Just like any behavior, it can be communicative. People do things for a reason, and leaving your school or your nursing home or your parents' house is no different. The solution is not to physically contain the person; it's to find out what they needed that caused them to leave and then to provide that thing – whether it's safety, meaningful activity, privacy, or something else.[5]

In response to which, several anonymous commenters also describe their childhood 'wandering' experiences.

Many autistic people have also written, even before the proposed ICD code, about the ways in which 'walking while autistic' has been pathologised as 'wandering' – for example, Joel Smith describes the risks of being questioned by police, arrested and even institutionalised simply for displaying non-normative

mannerisms while walking in public,[6] and Amanda Baggs says, discussing the use of 'wandering' as a derogatory and pathologising description of autistic people's actions:

> When non-autistic people walk out of their homes, they are 'taking a walk' or 'walking somewhere' or something like that.
> When autistic people walk out of our homes, we are... wandering!
> I don't know what it is that gives people that impression. But I have been accused of wandering when:
> - Taking a walk.
> - Waiting outside rather than inside for staff to show up.
> - Trying to take a bus.
> - Running away from a fight that broke out at a day program.
> - Leaving the room to avoid reacting physically in anger.
> - Trying to escape institutions.
> - Going on long walks to explore the geography of an area.
>
> The assumption in all of these cases and many more is that we are just kind of moving around without any point to it. I suppose this should not be surprising, since most of what we do is described as purposeless and pointless.
> Not all those who 'wander' are lost. Or even wandering.[7]

This stigmatising use of the word 'wandering' to describe behaviour in disabled people that it would not be used to describe in non-disabled people invites investigation of language and metaphor. Rebecca Solnit, in her history of walking, *Wanderlust*, says: 'Walking and travelling have become central metaphors in thought and speech, so central we hardly notice them.'[8] In this metaphorical framework terms such as 'wandering', which refer to uncontrolled or undirected movement in physical space, are used in phrases such as 'wandering minds' as metaphors for a disordered state such as that stereotypical of dementia. In a later chapter on gender and walking Solnit also states: 'A woman who has violated sexual convention can be said to be strolling, roaming, wandering, straying', suggesting that 'wandering' is used as a metaphor for deviance in 'moral' as well as bio/psychological paradigms.[9] Solnit's work draws attention to a school of thought arguably overlooked by the academic mainstream, that of psychogeography.

Psychogeography is generally held to have its origins, as a term if not as a retrospectively identified body of theory, in the writings and practices of the Situationist International of 1950s Paris. The first use of the term is generally attributed to SI founder Guy Debord, who defined it in his 'Introduction to a Critique of Urban Geography' as 'the study of the precise laws and specific

effects of the geographical environment, consciously organized or not, on the emotions and behavior of individuals',[10] while Coverley locates it at 'the point where psychology and geography collide'[11] and Ball claims that 'Psychogeography' was the word introduced to foreground the whole area of mental states and spatial ambiences produced by the material arrangements of the urban scene'.[12] This means that psychogeography has an obvious, if perhaps overlooked, relevance to Disability Studies, given that the social model of disability is concerned with the disabling effects of both conscious and unconscious organisation of the human-made physical and social environment on impaired individuals, and its focus on 'emotions and behaviour' is particularly relevant to a perspective which takes into account 'psycho-emotional disablism' as described by Reeve.[13] While disability was almost certainly not even on the radar of the Situationists, their intent to record the emotional and behavioural impact of urban space on individual consciousness in order to promote construction of a new urban environment that reflects and facilitates the desires of its inhabitants is surely relevant to any attempt to create a more accessible/inclusive and less disabling society.[14]

One of the key practices of Situationist psychogeography was the dérive (French for 'drift'), a form of apparently destinationless urban walking that could be practised alone or in groups and described by Ball as 'a kind of roving research along the margins of dominant culture'.[15] In Debord's 1958 'Theory of the *Dérive*', generally regarded as the definitive text on the *dérive*, he states:

> *Dérives* involve playful-constructive behavior and awareness of psychogeographical effects, and are thus quite different from the classic notions of journey or stroll.
>
> In a dérive one or more persons during a certain period drop their relations, their work and leisure activities, and all their other usual motives for movement and action, and let themselves be drawn by the attractions of the terrain and the encounters they find there.[16]

In theorising psychogeography and the *dérive*, the Situationists arguably built on the earlier Parisian concept of the flâneur, most coherently theorised by Marxist literary critic Walter Benjamin in his writings on the poet Charles Baudelaire – a solitary and seemingly aimless stroller in the arcades of 19th-century Paris, observing but refusing to take part in the city's economic life. While the 19th-century flâneurs certainly did not possess a consciously stated political critique or form any kind of organised movement, several authors, including Solnit and Coverley, have placed them in the 'prehistory' of psychogeography, and the Marxist psychologist Grahame Hayes draws on the alienated outsider/observer

status of the flâneur to suggest a new, radical form of psychology research focusing on people marginalised by capitalist modernity.

Hayes calls the flâneur 'part and also not part of social relations'[17] and 'the other of modernity, the marginalised of capitalist life', having 'an alienation from sociality, and a fragmented sense of self', but argues that there is 'a "positive" dimension to this otherness, marginality and detachment', giving the flâneur 'the freedom to see, to criticise even, from the 'outside''.[18]

All these phrases call to mind common descriptions of autism, both in the othering and pathologising depictions in mainstream literature and in autistic people's own accounts of their experiences of struggling for understanding and acceptance in a predominantly neurotypical society, in which phrases such as 'part but not part' and 'alienated from society' are common.[19] Autistic writers have also frequently referred to the self-perceived advantages of an 'outside' viewpoint on mainstream society, enabling them to more clearly observe and critique its hypocrisies and contradictions.

A similar resonance with autistic experience can be found in Situationist and other conceptualisations of psychogeographical practice; for example, Coverley's statement that 'The *dérive* may lack a clear destination, but it is not without purpose'[20] calls to mind the assumptions about autistic 'wandering' that it is 'purposeless' due to lack of a clear (or rather easily perceived by non-autistic people) destination – when, as has been shown, the purpose of 'wandering' may not be so much a 'to' as a 'from', or it may instead be one of discovery and understanding of an environment, or simply enjoyment. Similarly, when Debord refers in his 'Introduction to a Critique of Urban Geography' to 'certain wanderings that express not subordination to randomness but complete insubordination to habitual influences' (an obvious reference to early dérives), this recalls the common dismissal of autistic people's behaviour, when it is difficult for non-autistic people to understand, as random or without meaningful motivation (when in fact it is often motivated by sensitivities that are real but not obvious to those who do not share them), and autistic people's 'failure' to follow social scripts, frequently seen by non-autistic people as 'irrational', but by ourselves as following rational motivations rather than arbitrary custom.

This suggests not just that autistic people are particularly suited to conscious and critical forms of 'destinationless' walking, but that the 'wandering' pathologised by the new ICD code can itself be regarded as a form of political resistance, not merely in the sense that 'the personal is political' (relating to the circumstances of particular individuals' 'wandering'), but also in a wider and more general sense as a practice that challenges, perhaps even threatens, the norms of capitalist modernity. The question remains open as to whether this

is due to something intrinsic to autism as an impairment (such as differences in sensory perception or information processing), to the particular social and political conditions of disablement experienced by autistic people, or to some combination of both and/or other factors altogether, and thus it may be problematic to refer to autistic people in general as 'natural flâneurs' or 'natural psychogeographers' – despite my own strong identification as such as soon as I encountered the concepts – but flâneury, psychogeography and the dérive certainly provide strong conceptual frameworks for a radical, pro-liberation analysis of autistic 'wandering' as a form (whether consciously or unconsciously so) of resistance to capitalist systems of disablement and pathologisation.

'Wandering' also needs to be placed in a historical context of struggles by oppressed and marginalised people to access both urban and rural public space. The rural walking movements of the early 20th century, which included the Naturfreunde (Friends of Nature) in Austria and Germany and the Ramblers' Federation in the UK, campaigned for freedom of movement in areas of natural beauty which were privately owned by the aristocracy, and attracted huge memberships from among the growing urban working classes, who desired to get out of their restrictive home and workplace environments at the weekends. In the UK, this culminated in the great Mass Trespass of 1932 on Kinder Scout, the highest point of the Peak District (which was privately owned and forbidden to walkers because it was used for grouse shooting), by the British Workers' Sports Federation, which resulted in a mass confrontation between hundreds of ramblers and gamekeepers and police, and the arrest and trial of five ramblers including activist organiser Benny Rothman.[21] The public reaction to this political trial led to a long, slow process of establishing the 'right to roam' in British law. Inspired by this legacy, the activist comedian Mark Thomas walked the entire length of the barrier between Israel and Palestine and titled the resulting book and tour 'Extreme Rambling'. In that book he describes meeting a Palestinian rambling group for whom rural walking is an act of defiance against Israeli state oppression, to 'create the illusion of a more free and open space for ourselves'.[22]

The risks undertaken by walkers in occupied Palestine may seem remote from the lives of most people in countries such as the UK and US, but autistic or otherwise developmentally disabled people can and do experience comparable dangers, in particular when disablism intersects with other axes of oppression and discrimination. There have been numerous reported cases in recent years, in countries including Canada, the UK and US, of autistic people who have been arrested, and in some cases charged with crimes and imprisoned, for nothing more than being outside and perceived by police as 'suspicious'. One of the most prominent recent cases is that of Neli Latson, a young African-American autistic man who was arrested while sitting outside a library in Virginia in May 2010,

racially harassed by police and charged with several violent offences for which there was no evidence, and subsequently transferred from prison to a state psychiatric hospital, in which as of September 2011 he is still incarcerated.[23] Latson's mother was quoted as saying 'He'll walk five or 10 miles, it's nothing to him. Sometimes he walks five miles just to grab a bite to eat at Chili's. Walking is his release.'[24] Similarly, 18-year-old Dane Spurrell was arrested and jailed while walking home at night in Newfoundland in April 2009 by police who 'assumed [he] was drunk... because of the way [he] was walking and speaking'.[25]

There are inescapable parallels here with the treatment of women by state authorities in 19th century Europe (and in many parts of the world today). Solnit describes how 19th century women 'were often portrayed as too frail and pure for the mire of urban life and compromised for being out at all if they didn't have a specific purpose', and in particular the commonplace arrest and imprisonment of working-class women for 'prostitution' (i.e. simply being outside at night and in the 'wrong' areas) by the '*Police des Moeurs*' (usually translated as 'Morals Police', or vice squad, but the word *moeurs* can also be translated as 'manners' or 'habits', suggesting a normativity going beyond the sexual) in Paris in the 1870s – the same time and place in which the exclusively male flâneur was such a celebrated archetypical figure. Much more recently, the 'Reclaim the Night' movement – women marching en masse at night through areas associated with sexual assaults and harassment – was started in 1977–78 in Germany, the UK and the US in response to a serial killer who targeted female sex workers and a police response which was 'to tell women not to go out at night, effectively putting them under curfew' (London Feminist Network, 2010), and more recently still the advice from a Toronto police officer to students at York University that, in order to avoid being raped, women 'should avoid dressing like sluts' resulted in mass mixed-gender protest marches called 'Slutwalks'.[26]

In recent years disabled people, including myself, have been enthusiastic participants in such events, with the express intent of drawing parallels between the paternalistic oppression of women and of disabled people, and of building links between feminist and disabled people's liberation struggles. While gender-based and disability-based oppressions are clearly not identical, parallels exist and have been recognised by both feminist and disability rights activists; in this case, restrictions on the freedom of movement of the oppressed group have been 'justified' by paternalistic arguments about protection from (real or imagined, moral or physical) danger, despite the greater danger being from the 'protectors' themselves, and behaviour which would be regarded as 'normal' and unproblematic if undertaken by members of the privileged group (i.e. non-disabled men) is treated as unacceptable and in need of intervention by authority (whether state, religious or medical).

Determining what action is 'radical' can thus depend on the standpoints of the people doing it – while, when practised by (white, male, non-disabled and, mostly, class-privileged) Marxist intellectuals in 1950s Paris, the *dérive* seems pretentious, perhaps even ridiculous, when claimed as a revolutionary act, it appears as something quite different when – as for working-class women in an earlier Paris, for Palestinians under Israeli occupation, or for visibly disabled people in many parts of present-day Britain and North America – it carries risks of state-sanctioned violence and institutionalisation. While more spectacular forms of protest and direct action (both within the disabled people's movement and more generally) have, perhaps inevitably, received more media and academic attention, perhaps investigating and theorising acts as simple as walking in public as acts of political resistance is not only worthwhile – particularly in the light of feminist politics of the personal – in documenting disabled people's struggles for liberation, but also can counter medical discourses which insist on pathologising, and thus removing the possibility of agency behind such acts.

Solnit describes a general trend in contemporary Western society of the erosion of public space, influenced by trends of commercial privatisation of urban space and prioritisation of cars and drivers over walkers, meaning that 'to be a pedestrian is to be under suspicion' in many modern urban communities.[27] A culture of fear of both walking in unfamiliar spaces and of 'suspicious' people who might be encountered in them (suspicious perhaps because their motivations for walking in public space cannot be understood) can be placed in the context of the 'global risk society' as theorised by Ulrich Beck, in which perception of life as full of dangers to be feared is influenced by neoliberal capitalist processes of globalisation/individualisation and the erosion of welfare states.[28] While these general trends affect everyone in modern society, if only at relatively low 'background' levels, where they intersect with specific systems of oppression – such as disablist paternalism and pathologisation of disabled people's behaviour – the people affected by those systems suffer disproportionately great consequences.

In summary: The introduction of the 'wandering' ICD code shows that behaviour is pathologised in autistic (and otherwise impaired/disabled) people that is not pathologised in non-disabled people. Although the same actions can be otherwise stigmatised or punished in other oppressed groups, and close parallels with other axes of oppression exist, the particular form of medicalising denial of agency experienced by disabled people is distinct and specific, at least in the present day, to disablement in an impairment context. To consciously and deliberately engage in such pathologised behaviour, despite the (real and serious) risks involved, can and should be seen as an act of political resistance.

Freedom of movement is still important and contested, even within the late-capitalist 'West', and particularly so for those whose very personal struggles for it have been depoliticised and dismissed as 'pathology' – who, ironically, are often those to whom, on an immediate personal level, it matters most due to specific impairment-related sensitivities.

Psychogeography has been overlooked by, but is potentially extremely useful to, a critical/activist Disability Studies, both as an 'outsider discipline' which is particularly suited to theorising and 'disabling' capitalist, patriarchal (etc.) norms from a consciously 'abnormal' perspective, and as a conceptual framework for analysing issues around freedom, accessibility and public space which complements and enriches the social model of disability. Those who seek new and unexplored directions in disability research may find fertile ground for their enquiries by wandering towards a psychogeography of disability.

1 Centers for Disease Control and Prevention, 'ICD-9-CM Code for Wandering' (2011) available at https://web.archive.org/web/20111113234342/http://www.cdc.gov/ncbddd/autism/code.html

2 National Autism Association, 'National Autism Association Applauds Approval of Medical Diagnostic Code for Wandering' (2011) available at https://web.archive.org/web/20120222144554/http://national autismassociation.org/press072111.php

3 Autistic Self Advocacy Network, FAQ on proposed ICD-9-CM wandering code (2011) available at https://web.archive.org/web/20111112191607/http://www.autisticadvocacy.org/modules/smart section/item.php?itemid=131

4 Autistic Self Advocacy Network, 'Joint Letter to CDC on proposed ICD-9-CM wandering code' (2011) available at https://web.archive.org/web/20111017101606/http://www.autisticadvocacy.org/modules/ smartsection/item.php?itemid=135

5 Lisa Daxter, 'Wandering' (2011) available at http://chaoticidealism.livejournal.com/92327.html

6 J. Smith, 'Walking While Autistic' (2007) available at http://web.archive.org/web/20071012094125 /http://thiswayoflife.org/blog/?p=217)

7 Amanda Baggs, 'Wandering' (2005) available at http://ballastexistenz.wordpress.com/ 2005/08/ 01/wandering/

8 Rebecca Solnit, *Wanderlust: a History of Walking* (New York: Penguin, 2001) 73.

9 Ibid, 234.

10 Guy Debord, 'Introduction to a Critique of Urban Geography' (1955) trans. Ken Knabb (2006) available at http://library.nothingness.org/articles/SI/en/display/2

11 M. Coverley, *Psychogeography* (Harpenden: Pocket Essentials, 2010) 89.

12 E. Ball, 'The Great Sideshow of the Situationist International', *Yale French Studies,* no. 73, Everyday Life (1987) 21–37.

13 D. Reeve, 'Psycho-emotional Dimensions of Disability and the Social Model ', in *Implementing the Social Model of Disability: Theory and Research,* eds. C. Barnes and G. Mercer (Leeds: The Disability Press, 2004) 83–100.

14 M. Coverley, *Psychogeography* (Harpenden: Pocket Essentials, 2010) 89.
15 'The Great Sideshow of the Situationist International', op. cit.
16 Guy Debord, 'Theory of the *Dérive*' (1958), trans. Ken Knabb (2006) available at http://library.nothingness.org/articles/SI/en/display/314
17 G. Hayes, 'Walking the Streets: Psychology and the Flaneur', *Annual Review of Critical Psychology*, vol. 3 (2003) 50–66, 52.
18 Ibid., 57–8.
19 For example: J. Meyerding, 'Diagonally Parked in a Parallel Universe', *Social Anarchism*, no. 26 (1998) available at http://library.nothingness.org/articles/SA/en/display/251 and J. Meyerding, 'The Autistic Way of Being in the World' (2003) available at https://web.archive.org/web/20101102225823/http://www.planetautism.com/jane/way.html
20 *Psychogeography*, op. cit., 96.
21 B. Rothman, *The 1932 Kinder Trespass* (Timperley: Willow Publishing, 1982).
22 M. Thomas, *Extreme Rambling* (London: Ebury Press, 2011) 204.
23 Amanda Baggs, 'Regarding Neli Latson' (2010) available at http://ballastexistenz.wordpress.com/2010/06/23/regarding-neli-latson/ and K. Reibel, 'Teen with Asperger's Arrested: Were Callers Racial Profiling?', *Huffington Post* (2010) available at http://www.huffingtonpost.com/ken-reibel/teen-with-aspergersarres_b_610530.html
24 'Teen with Asperger's Arrested: Were Callers Racial Profiling?', op. cit.
25 CBC News 'Complaint filed against RNC after autistic teen jailed' (2009) available at http://www.cbc.ca/news/canada/newfoundland-labrador/story/2009/04/21/autistic-jail.html
26 R. Kwan, 'Don't Dress Like a Slut: Toronto Cop', *Excalibur* (2011) available at https://www.excal.on.ca/uncategorized/2011/02/16/dont-dress-like-a-slut-toronto-cop/
27 *Wanderlust*, op. cit., 10–11 and 11.
28 Darryl S.L. Jarvis, 'Theorizing Risk: Ulrich Beck, Globalization and the Rise of the Risk Society', available at https://ams-forschungsnetzwerk.at/downloadpub/risk_RR3_u_Beck.pdf

Steve Graby, 'Wandering Minds: Autism, Psychogeography, Public Space and the ICD', presented at the Critical Disability Studies conference *Theorising Normalcy and the Mundane 2011*, at Manchester Metropolitan University on 14 September 2011.

Amanda Cachia
Carmen Papalia's Prosthetic Extensions//2015

In Merleau-Ponty's theory of embodiment, objects or entities in the spatial field – devices to extend or replace the senses – mediate the experience of the self and the world of the person who uses them. How do artists with impairments use object body extensions in embodied, performative acts? How can the performance of prosthetics by disabled artists shed light on experiences of the disabled body, both for performer and audience? Miho Iwakawa proposes that Merleau-Ponty introduced 'the innovative idea that the body 'extends' an object, for example a cane for the blind, so that it literally becomes a part of the body'.[1] Such bodily extension and scrambling of the senses offer counter embodiments and complex embodiments [...] I would like to suggest that the cane is a type of prosthesis; just as a body extends itself into a cane, an amputee's body extends itself into a prosthesis. What imaginative and metaphorical opportunities can be affixed to current standardised usages of the prosthesis in contemporary art practices if we consider the prosthesis as a new form such as the cane?

For example, in Carmen Papalia's performance piece, *Blind Field Shuttle* (2017), relationships of trust and explorations of the senses unfold as the artist, who identifies as a non-visual learner, leads walks with members of the public as part of his experiential social practice. Forming a line behind Papalia, participants grab the right shoulder of the person in front of them and shut their eyes for the duration of the walk. Papalia then serves as a tour guide, passing useful information to the person behind him, who then passes it to the person behind him or her, and so forth. As a result of the visual deprivation, participants are made more aware of alternative sensory perceptions such as smell, sound, and touch, so as to consider how non-visual input may serve as a productive means of experiencing place.

Papalia uses 'extensions' in similar ways that synthesise with Merleau-Ponty's theories about phenomenological knowledge. Papalia's cane 'leads' a new kind of sensorial and prosthetic experience for a group of participants, as they rely on under-used senses, but they also rely on the prosthetic extension of Papalia's cane and the shoulder of the person in front of them. They must learn to walk again under entirely new circumstances with an alternative set of tools, not unlike the experience of an amputee walking with new legs. The long chain of people walking one after the other is a type of prosthetic extension into public space, as they feel their way along and around the streets, curbs, sidewalks, and pedestrians. Sensorial possibilities are expanded by the expansion of the prosthesis itself, as it is loaded with phenomenological opportunities, as well

as imagined and metaphorical ones, often seen in contemporary art practice. The prosthesis in this context is endowed with knowledge and guidance: it is also practical as it comes to be useful for people with limited experience around the prosthesis. In other words, the prosthesis can become a shared, communal experience much like the objectives of a socially-engaged art practice itself.

Papalia's additional work, *Long Cane* (2009), is a comical mobility device: a walking cane that, when used, draws attention to the user as an obstacle. Papalia developed the idea for what he calls his 'performance object' because he did not feel comfortable with the institutionalisation of the white cane as a symbol for blindness or blind people. He remarked that the white cane was a lightning rod for attention, and that the cane separated him from his peers and identified him as different, therefore creating a hierarchy, reinforcing the binary of ability and disability, and marking and organising bodies. The artist recognised the distance that the cane was creating between his body and other bodies on the street; the cane tended to push people away, as they would often jostle to scurry out of his way and avoid bumping into it. Papalia's *Long Cane* makes the force field bigger, where he exaggerates the distance between himself and other public bodies to occupy public space with more agency.

Through his antagonistic performance, Papalia is hoping that his prosthesis as performance object will generate productive dialogue about disability. Further, the artist seeks to challenge the standardising of any prosthesis attached to a disabled body, such as a cane for blind people, arguing that a prosthetic can be personalised, radical, and powerful. Papalia hopes that his fellow pedestrians will become more self-aware of any discomfort they might express toward disabled people through their body language and gestures. In this context, Papalia's fictive prosthesis brings with it comic and guerilla qualities that can be seen as a radical form of trespass, both immobilising and destabilising entrenched assumptions around access for disabled people.

1 Miho Iwakawa, 'The Body as Embodiment: An Investigation of the Body by Merleau-Ponty' in *Disability/Postmodernity: Embodying Disability Theory*, (eds.) Mairian Corker and Tom Shakespeare (London and New York: Continuum, 2002).

Amanda Cachia, extract from 'The (Narrative) Prosthesis Re-Fitted: Finding New Support for Embodied and Imaginative Differences in Contemporary Art', *The Journal of Literary and Cultural Disability Studies*, vol. 9, no. 3 (October 2015) 101–14.

Chus Martínez
Ingo Niermann: The Reinvention of the Sock//2018

Ingo swam ashore and forgot to ask the other expedition members, who went by dinghy, to bring his shoes. When the group went for a hike on a gravel path, all that Ingo had to protect his feet was a pair of blue Uniqlo cotton socks. The socks did an amazing job: the gravel ached Ingo's feet and he made quite an effort not to step into any bigger goolie (the colloquial term in New Zealand for a stone or pebble) but even after an hour of walking his feet didn't get injured and didn't redden. The moment he stopped walking all pain disappeared. Even back in the salt water his feet were just fine. The socks also didn't have any apparent damage.

Ingo was so impressed that his first research on the expedition didn't address the ocean but the history of the sock. The oldest intact knitted (or to be more precise: *naalbinded*) socks are from 300 to 500 AD and were discovered in Egypt. The tangerine-coloured pair has split toes for use with sandals and is meant to be tied at the top with little integrated ribbons. Long before, people wrapped their feet in different materials, like leather, felt, or fabric (foot-wraps) before putting on their shoes or sandals but there's no knowledge of the existence of proper socks before the second century AD in Rome.

Strangely, the word sock and its numerous European variations have their origin not in the Latin word for sock – *udone* – but in the Latin *soccus*, a slipper with a thin sole that was originally reserved for comic actors. Tragic actors would wear the *cothurnus* (buskin), a high boot with up to five-inch-thick soles, to elevate themselves above the other actors and to make their steps more weighted. *Socci* would make comic actors appear relatively small and light-footed. *Cothurnus* became a synonym for tragedy, *soccus* a synonym for comedy.

It was only in the third century AD that the Romans, in the beginning mainly women, started wearing *socci* in normal life. The popularisation of *socci* goes hand in hand with the decline of the Roman Empire. Things started getting soft.

But how to get from the *soccus* to the sock? Historians don't seem to really care. Language is just too random, so why bother? But then again, why not? Why bother about every tiny interstage of natural evolution and not of such an essential element of contemporary clothing? Ingo develops three theories.

Theory 1: As *socci* were only convenient indoors, the next consequent step in the Romans' softification was to replace *socci* with just as lavishly decorated socks, eventually with a leather sole. The design of the latter can still be found in certain contemporary house shoes like the alpine *Hüttenschuh* and in baby shoes.

Theory 2: Romans started to wear sturdier sandals on top of their *socci* when going outdoors. As this was not too comfortable, they replaced the *socci* with *udones* just as lavishly decorated – therefore still calling them *socci*.

Theory 3: Socks got reintroduced in the Middle Ages, still hundreds of years before the invention of the knitting machine in 1589, and became a brightly coloured status symbol of the nobility, covering the lower part of trousers. As these garments were lavishly decorated like *socci*, Europeans started calling them *socke, socka, sokkur,* or *sok*.

All three explanations root the name of the sock in its decorative function. Today, we experience a certain renaissance of this function (pushed by brands like Happy Socks) while at the same time there is the even bigger fashion trend of the no-show socks. What both, seemingly opposite, trends have in common is an urge to distract from the functionality of the sock – and thereby the underlying weaknesses of our feet: they sweat (up to 120 millilitres of perspiration a day), they get easily cold (even in shoes), and they need protection from what is supposed to protect them (shoes). There seems to be the need of a rebrand to openly embrace the basic qualities of socks.

A solution is already underway: the reinvention of the sock, similar to Ingo's experience, as an outdoor shoe. A couple of years ago, the sneaker industry was taken aback by research on the problematic effects of all-too-cushioned running. While purists pleaded for barefoot running, the sneaker industry was quick in inventing ever leaner, more flexible, and sockish shoes like Vibram FiveFingers, Nike Free, or Adidas NMD City Sock, it was only a matter of time until some company would launch an actual sock for running. Last year, a Kickstarter campaign for Skinners, stretchy synthetic socks with a thin rubber ground, generated more than $600,000 (aiming at only $10,000), and they are now for sale for just over $30. The only problem: they look and feel utterly ugly.

What could help is a DIY movement to create your own outdoor socks: take whatever pair you like and paint it with hot rubber (colour by choice) on the ground. Alternatively, you could fill your socks with an arch support or, more naturally, as expedition member Eduardo did halfway through Ingo's journey, a couple of big strong leaves. They smell good and might even be a form of skin care.

Sock shoes – short: sockoes – might not last long but a ragged pair can make a great souvenir. Your collected sockoes of several years fit into a single drawer or decorate a wall. Very special sockoes might be stuffed or framed. [...]

Chus Martínez et al., 'The Current II Expedition #1: "Spheric Oceans"', *e-flux Criticism* (2018). Available at https://www.e-flux.com/criticism/241951/the-current-ii-expedition-1-spheric-oceans

Kate Fletcher
Walking in Skirts//2019

[…] Walking, and sometimes running, in the hills in a skirt is a revelation. It is an exercise in rare freedom. I urge you to try it. Trousers can bunch and pull on the thighs, reining in the limbs and muscles; but a skirt is all space. A skirt is a modest, but as commodious, version of a birthday suit. It seems to me that a skirt also holds promise of a different sort of natural understanding: the same stretch of land seems altered when you navigate it in a skirt, you notice different things about it. A skirt is a kaleidoscope, it brings new things into view. Isn't that what we need? To see the world more fully?

It goes without saying that not all skirts enable unencumbered stepping. Scottish clans knew this and the pleated kilt is perhaps the obvious model of an outdoor working, walking, running skirt. I don't own a kilt. But I do have other skirts and dresses and they have granted me an education in both natural features and ergonomics.

The first thing I learned is linked to skirt length. For me, wearing a skirt in the hills that falls way below the knee is like wearing a blind fold: exciting but dangerous. I have fallen over and slipped and tripped many times because my boots blithely strike out over invisible ground, cloaked by the folds of my skirt. The cloaking effect happens especially when walking up hill or climbing over a wall when the distance from waist to ground shortens and the skirt's fabric pools forward; gravity acting to cascade it downwards and directly in the line of sight of the feet. To avoid this you need a spare hand to hoik the skirt up, or a fastening of some sort to gather up the fabric length on a climb. Or just a shorter skirt. So it is that topography draws skirt length. In flat lands, long skirts are A-OK. For hills, take out the scissors and hem your dress higher.

The second thing is related to a skirt's fullness. It is almost impossible to walk fast and loose if stride length is curtailed. A skirt with a small circumference, as measured at the hem, forces a tottering step. Sometimes this may be desired. But its disadvantages seem to be exaggerated outside a level, paved environment of a bar, a dancefloor, or a city. But if your preference is for all-terrain walking and running, this demands a skirt of a stride-length-and-a-bit as the bare minimum for fullness. Given that all legs are different lengths, this measurement varies. But the bit extra is essential for the moments where a bound, not just a step, is required. I once forded a shallow river in a skirt, leaping between stones. As I shaped to jump onto the far bank, the limits of the A-line skirt's cone shaped silhouette girdled my legs and I fell in. I needed

more fabric in the flare. I probably needed pleats. That said, generous pleating is not the only precondition for easy walking. I have calculated that for me to avoid a hobbled stride, the minimum angle of flare necessary for a knee-length skirt made from a woven, non-stretch fabric is 58°. It's a reckoning contingent on many factors, not least whether a skirt has a split, and the likelihood of any route offering the opportunity for long, languid strides (my favourite type). In my experience long strides are inevitable when walking downhill. This makes the maxim: the tighter the contour lines, the looser the skirt. Or let the skirt decide. Tight skirt? Flat path.

An in-motion body is also influenced by a dress or skirt's cloth and garment construction. A knitted fabric, perhaps with added elastane, does away with much of the constricted movement of a tight skirt in a woven cloth. This opens the door to a figure-hugging but limber walking silhouette. For fabric with little give, good pattern cutting, including well-placed darts and pleats, is an ally of ready movement. My interest is in the clothes I already have, and most of mine fall into this latter category. I look at the skirts and dresses on my hanging rail in terms of capabilities, of what they will allow me to do, of how they might expand real freedoms. I also consider them in light of the weather. Will they keep me warm enough or too hot? How will they cope in a breeze? A strong wind plays havoc with a full skirt.

At midsummer a few years ago I walked for a week in the northernmost part of Sweden, on a route across an exquisite area of tundra inside the arctic circle. Before I left I asked Ingun, a Norwegian friend of mine, well used to the far north, what she would recommend I wear. Smart as a whip she replied a skirt, a silk skirt. I wasted no time and rifled through my chest of drawers for something suitable. Her thinking was that such an item was light in a rucksack, it packed down small, and silk dries fast. Besides it meant that layers could be added or removed as the temperature dictated without fully stripping off and waterproof trousers could pulled on quickly in a sharp shower yet still the outfit would not get too bulky or hot. In my wardrobe I found a bias cut silk dress from the 1950s that had been my grandma's. It was a delicate beige with an orange and mid brown irregular stripe. The fabric was thin and torn in places and I decided to cut across the bodice to make a skirt, adding a wide elasticated waistband and darts, and to shorten it a little, to sit just below the knee. On the first day of the trip I put the skirt on over thick woollen leggings. It was an unusual get up, like a babushka or an onion. Layers of hand-me-down woollen jumpers, a scarf, leggings and old silk. When she saw me, Karen, the friend who I was walking with, was laughing and disbelieving. What was my motivation she wanted to know? Was I trying to get attention, to flirt, to pull? I insisted that the skirt was practical; practical not sexual. She raised an eyebrow. She did not know about

walking in skirts. I think she took the skirt as a sign that I wasn't serious about the trip. That my mind was elsewhere. And in some ways she was right. I was the opposite of serious. I was easy and spacious and free. I was walking in a skirt.

Kate Fletcher, extract from 'Walking in Skirts', *Wild Dress* (Axminster: Uniformbooks, 2019) 26–9.

Steffani Jemison
A Rock, A River, A Street//2022

[…] I began to wonder, the philosopher said, whether my body belonged to me at all, or whether it might not in fact be part of a collective. The idea was not my own, but was gifted to me by Huey P. Newton; I had travelled to Boston to see him speak of communalism and revolutionary enthusiasm during my first year of college, and it made quite an impression. You see, my relationship to classical dance had involved a corps; the beauty of it was getting lost in the group. Yes, there was something uniquely attractive about groups. And this was how I became interested in attraction. My question was this: how was it that I got stuck to others, as part of a flock?

I took a biology class and began to wonder whether there wasn't in fact something chemical about it. After all, atoms, molecules, are made up of little… pieces, let's say… that are energetically connected to one another, sometimes temporarily, sometimes nearly permanently, although of course those bonds can always dissipate or be violently severed – I learned that too.

I started to think about my own body as something temporary, something that had arrived, had its day, and would dissipate as well. I also started to think about my body in dialogue with others. Me and my partner and my neighbour, weren't we all made out of the same… kinds of atoms? The same little bits? The same stuff? And then I gave this performance about pomegranate seeds for a special event put on by the theatre club. I still remember the rehearsal studio where I came up with the piece. It was sunny with dusty wood floors that I had to clean carefully before I began. Of course, I couldn't escape the footsteps of the dancers that had come before me, those invisible palimpsests on the floor of the studio. Those little marks were exactly the point. The challenge was how to find them. I somehow knew that erasing the new would get me closer to the old, and it felt important to start fresh, sweeping and mopping before I even tried to begin. These days I never sweep, as I'm sure you've noticed – I say that as an aside, no need to include it in your document. […]

But when I was a student, the ritual of cleaning was quite important to me. I couldn't see the ones who had come before, but I could feel them. I would walk slowly around the studio, eyes peeled, staring at the floor, all of my receptors vibrating, listening for a clue. I thought if I could excavate – energetically, I suppose – the history of this dance floor, I might be able to tap into something they had left for me, maybe make something new out of it. I began to go to the room late at night, with a candle – we weren't meant to be working overnight, but I had learned how to rig the door when I left so that it only appeared to be locked – to wait for the spirits to show up. I became convinced this was the only legitimate way to build a practice. There was no creation, there was only listening. There was no invention, there was only re-connection. I didn't know where to look except for the ancestors.

It sounds… it sounds… I suppose it sounds mystical. But it's true. It is the only place to look. [...]

Fast forward to two months later, when we finished stitching. The bind, as we liked to call it, attached us back to back.

We could walk by shifting side to side. We had to go everywhere together. Our friends could only talk to one of us at a time. Sex – with each other, had we wanted to, or with anyone else for that matter – was entirely impossible. We could not sit, but we could lean.

People understood that this was not us, this was a 'project'. But they also assumed we were sleeping together, even though there was nothing sexual in it. In fact, the entire performance was a kind of extended audition for summer study he hoped to undertake in Paris, presumably without me. Having been introduced to Alexander Technique as an instrumentalist, he was now planning to study strategies of self-use with a student of Jacques Lecoq's. We both went to both of our classes – there were only a few areas of overlap. In his 'Renaissance Humanism' lecture, he faced the professor while I looked toward the ground, practising Spanish in my head. When I sat in my 'Red, White, and Black in the Americas: The Initial Confrontation' seminar, I have no idea what he thought about.

We walked slowly and methodically, almost as though we were doing Tai chi. We were so attuned, it was impossible to tell who led and who followed. We developed a strategy for kneeling while he positioned the cello off to his left, my right. We were one body and two bowing, twisting, forking heads.

It was an experiment in the plural body, which we saw as necessary research for understanding the possibilities of the collective body [...], or at least for understanding the limits of the physical individual. It seemed so clear that skin was porous and not a limit. Our physical selves had so many holes for a reason. They were not intended to be impenetrable. Hard as I was, mean as I was, I was not made of marble. Flesh was less solid than it seemed.

'I didn't mind', the philosopher said and stood up as though she were going to the window, or to get a glass of water, but she didn't go anywhere at all. She put a hand on her chair, as if to steady herself.

'The way we propped each other, were props for one another', she said. 'I didn't mind at all.'

Steffani Jemison, extract from *A Rock, A River, A Street* (New York: Primary Information, 2022) 96–103.

Jason Allen-Paisant
On Blackness and Landscape//2021

Why do I now want to talk about the woods? After all, I grew up surrounded by woodland. In Coffee Grove, the village in Jamaica in which I spent my early childhood, I was surrounded by farmland, by animals, and by the bush. Why then had I never felt this urge to stand still in the woodland, or walk placidly, contemplating it? I realised, as I express in the poem 'Walking with the Word "Tree"', that for my family, nature was functional. As farmers, my grandparents shaped the land, waited for its yields, saw their living as connected to the earth. They were not contemplators of scenery; their hands were *in* the earth. These were environmentalists without a title.

Later, at the age of five, I went to live in a town with my mother who was a school teacher. All of a sudden I was propelled into a different lifestyle. We would continue to be 'poor' but now at least we lived in a small town. We never got 'coming out of the bush' to coincide with 'upward social mobility', which became a source of frustration. Poverty can create feelings of enclosure. I believe it is, first and foremost, an affect (the absence of commodities and resources does not in itself equal poverty). We were living a half-rural, half-urban life, always with the aspiration of leaving the rural behind, because the rural was perceived to be an index of poverty. On the one hand we were trying to escape the rural, elemental lifestyle; on the other hand we couldn't afford the trappings of middle-class lifestyle. We went to the beach once a year, for example…

Now that I think about it, the whole idea of middle class in Jamaica is about turning your back on the elements. The middle-class ideal entails distancing yourself from the natural, the woodland, any space associated with the 'primitive' – and that includes folklore and myth, in which the woodland is the space of spirits, 'duppies'.

Given the attempts to distance Africans from ancestral practices, Blacks in the New World were forced to internalise a colonial epistemology of nature. The fact, for example, that African spiritual practices (including pharmacopeia and various healing practices) were viewed as suspect by the colonisers rendered more problematic an already complicated relationship to the land. The urban space is the locus of progress. Nature belongs to the rural, not the urban. Nature is disorder, 'dirt', that which drags us down. There may well be links here with nineteenth-century Europe, in which there emerged the utopia of doing without nature, of replacing soils with a kind of chemical soup, since nature, it was thought, needed to be controlled, even eliminated.

So in the small town of Porus where I lived from the age of five, people often pave over their front lawn. There is this obsession with covering the green. Modern upward mobility is concrete. The fracture that we experience between ourselves and nature, the desire and obsession to put distance between ourselves and the natural world, is rooted in slavery and colonialism. We try to distance ourselves from the 'poor condition' of living with the earth. To compound matters, violence and criminality deter us from venturing into the outdoors. Landscape and the possibilities of landscape are underpinned by socio-economic dynamics rooted in a colonial history and its afterlives. History – the past and present of social violence – make the woodland in Jamaica anything but a place of leisure. We live in a deep-seated social fracture that keeps us distanced from the natural.

The question of Blackness and landscape is a complex one. For the Black body, walking is complicated, and to walk in a dark, veiled place is seldom an innocent act. Histories of the hunted Black body form part of the collective memory of the African diaspora. If the city often proves to be a dangerous space for Black people, as recent events have demonstrated, the fact is that, in the Black imaginary, it is the city that is perceived as the site of *relative* safety, while the outdoors continue to be associated with the 'constant necessity and activity of running away, of flight', as Fred Moten puts it.

How then do we walk? How then do we inhabit leisure? What is 'nature' to us?

I am thinking about spatial enclosure. To what extent are my past experiences and feelings of enclosure rooted in colonial ideologies and histories? My current poetic project is one of writing (against) enclosure.

[...] While thinking about these issues, I encountered the work of photographer Ingrid Pollard. I have been particularly interested in a series of photographs Pollard took and exhibited in the late 1980s. It is quite interesting that the issues Pollard was grappling with in the 1980s are still just as present today.

In *Pastoral Interlude*, Pollard takes familiar sites and makes them legible in new ways, playing with the viewer's sense of what seems natural or not so

natural, forcing us to give attention to the ideological workings of landscape. The photographs involve 'reading' the ways that land has been marked, culturally speaking.[1]

In the first photo, a Black woman, perhaps the artist herself, sits on a stone wall. Behind her a fence marks one boundary of a landscape of rolling hills. She is clad in white jumper, beige trousers tucked into mid-calf-height green socks; her head wrapped in a green scarf. She sits with a camera on her thigh. Her eyes look intently at something outside of the frame; whatever it is, she seems to be watching it with curiosity. The caption begins: 'It's as if the black experience is only lived within an urban environment. *I thought I liked the Lake District;* where I wandered lonely as a black face in a sea of white.'

The evocation of Wordsworth in 'I wandered lonely as a...' is, of course, evident. Through the ironic evocations of Wordsworth's iconic poem, the artist challenges the Romantic associations attached to wandering on foot through the land – leisure, relaxation, finding oneself – while highlighting the absence of bodies like her own in the landscape, and in cultural representations of the English countryside. There is an ambivalence in the speaker's feelings: the artist depicts herself as *wanting* to be there, as discovering the pleasures of the Lake District ('I thought I liked the Lake District'); and, at the same time, as feeling a strange sensation of 'unease; of dread...'. The suspension dots suggest an ongoing question, a kind of inability to fully explain why such feelings of unease exist and persist.

Wordsworth's poem speaks of rest – the rest that allows one to observe the daffodils 'fluttering and dancing in the breeze', and the rest that such an experience gives to the mind. By contrast, the body language of the woman in the photograph does not strike me as being entirely restful. Her facial expression and her legs and knees that press against each other suggest a state of tension, that she might not feel entirely safe in this environment.

In one interview, Pollard was asked whether there was any personal experience that triggered her interest in the British rural, its mythologies and overwhelming Whiteness. She replied:

Just going on holiday. We only had a couple of holidays as a family – we didn't have that kind of income – but we went camping a couple of times. When I left my parents, I used to go with friends to the Lake District. I wouldn't see another black person for a week, and you would notice. It was hard. My white friends would be going to relax, and it would create anxiety for me. I appreciate the countryside, but it wasn't particularly relaxing. I just wanted to do something about that.

[...]

Where the relationship between Blackness, nature and history is concerned, a few observations are necessary. I will state these baldly. Firstly, in disrupting relationships with nature (dwelling practices), colonialism disrupts ways of knowing the world (knowledge practices). Secondly, the work of coloniality is based on control over nature. Thirdly, part of that control is the control of the othered (dangerous, out-of-place, to be controlled) Black body.

The assimilation of the Black to nature is central to the functioning of coloniality. But this is, of course, paradoxical, since, while the dynamics of coloniality assimilate the Black to nature, it also, at the same time, separates her or him from it. In the New World, as Sylvia Wynter points out, the African 'himself served as the *ox* for the *plough* of the plantation system which brought about the technical conquest of Nature'.[2] The history of European colonialism in sub-Saharan Africa reveals similar logics with respect to the control of bodies and land.

Yet, in the New World, the African presence '*rehumanized Nature*, and helped to save his own humanity against the constant onslaught of the plantation system by the creation of a folklore and folk-culture'. The Africanist construal of the land as always *Earth*, the centre of a core of beliefs and attitudes, would constitute 'the central pattern which held together the social order'. Through sacred rituals (dance, drum rhythms, forms of 'earthing' through possession rites, masquerades that enacted the drama of the gods), Afro-Caribbeans created a different temporality. Thereby, they maintain a sense of the sacred, and the affirmation of ancestral ties that bind the community to Earth, enabling humanness despite social death. The results of these attempts to 'grapple with a new Nature' are well known: Haitian Vodou, Santería, Obeah, Pukkumina, the Orishas, the Shango Baptists, Rastafari, among other forms of sacred practices which sought to animate a life whose aim was to produce groundless individuals.

However, these forms of resistance, if they help to create alternative realities and perpetuate ancestral worldviews, also highlight the nature-culture fracture that begins during slavery and persists today. A part of slavery's violence was that 'the enslaved was excluded from responsibility for the land in which she lived and worked', as Malcom Ferdinand writes.[3]

Our relationship to land, our ability to relate to Earth in a certain way determines our freedom, but also another fundamental human urge, which is the urge of belonging. Here it is worth pointing out, as Raymond Williams has done, that the etymology of 'nature' ties it to 'native' and also 'nation'…[4]

How does a Black history of exclusion from land influence how we think about Black futures in nature and the environment?

I had been busy writing poems about the police and white cops killing Black people and black anger and rage and that kind of stuff. And then I realised that

the time we spend pouring our souls into that kind of writing and thinking robs us of time. There is no doubt that we must continue to write about these issues; we have no choice. But I am forced to think about the relationship between coloniality, racism, humanness and time. This brings me back to my work and its central theme of time.

The observation of process is a political act linked to a reclamation of time. It highlights the fact that racism pushes us into an attitude of always reacting: to hurt, anger, provocation, exclusion. This is a theft of time, a robbery of the connection we are meant to have, as humans, with real life. In that sense, the poems in *Thinking with Trees* are an expression of my taking time, in a societal context that creates the environmental conditions that disproportionately rob Black lives of the benefits of time: leisure, relaxation, mental and physical well-being, etc.

Right now, I'm standing beneath what used to be, I imagine, an impressive tree. It is split down its bole, it is still alive, has sprouted green leaves that will be rustling way into September. But at its base and lying athwart the clearing is the severed part that looks so dead and yet so alive. The colour of brown has weathered to near-grey and the footfall of walkers has covered the wood with a layer of dust. And yet the part that has fallen among the spikenard and hungry shrubs seems so alive in its death.

> Disintegrating and flourishing
> frail and green
> The raspberries feed on its breath
> and beetles thrive in the slurry middle where the bole rots

Process. The wax and wane of objects, the feeling of life coming into me. The feeling of self as part of life.

Slowness. I am talking about time, a defence of time. I'm talking about the robbery of time from Black life. I am talking about the ability to be slow. I am talking about the ability of our bodies to *be here*. I'm talking about the ability of my body to be in the woods. Thinking about people, the people who find me strange because I am just standing here, the people who look at me while talking, look at me suspiciously, because I decide to stand and listen and look, because I am not going anywhere. Because I'm just standing.

I'm thinking of how we have been workers. I'm thinking of how my ancestors have been the workers, just the workers. I'm thinking of the Congo and how one man had a land almost eighty times the size of Belgium as his personal estate. I'm thinking of the cruelties of work among my people. I'm thinking of my ancestors who were enslaved. I'm thinking of rest, I'm thinking of slowness, I'm thinking about reclaiming time:

> I am talking about reclaiming what middle-
> class people call leisure.
> I realise now what I have missed all these
> years.

Poetry is the expression of a profound connection with life. Listening and seeing are our avenues of connection, and this is poetry's gift: that through poetry I can stop, listen, observe and participate, rather than *simply react*. The purpose of racism is a life that is constantly reacting, being affected, being hurt, being angry. Poetry's gift is a different sense of time, not one marked by utility, accumulation, greed and blind progress – in a word, the logics of capitalist accumulation and its bourgeois ideals that produce wars, genocides, various human catastrophes. Poetry's gift to me is a sense of deep time, and that is its sense of wholeness, of connection. Poetry is a reclamation of time. Of connection, rather than reaction. Inevitably, the poems do sometimes convey my sense of unease and uncertainty while in the veiled, hidden spaces of the woods. But they also highlight the fact that I must be there.

The sun splashes its light on the trees. Their exposed skins glisten. The evening glow penetrates me and I move into it. Inside me a living thing is ripening. In this month of December when night falls in early afternoon, it is a struggle to get here. And now that I see it, I am living. I was made to live. Not to schedule appointments or solve clashes on an online calendar. I was not made to spend a day in front of my computer.

There is a sadness that returns. A sadness for the boy I once was, growing up in Porus. What was my poverty? Wasn't it living in a space that was too little, not being able to go very far? The poverty of being blind to living and a slave to always doing:

> We had no time to waste
> To go far might have been just
> to enter the woods
> behind the house.
> But there was a wall separating me from it.

The positioning of the Black body always *outside of land*, with all its privileges in regard to leisure, well-being, health, and so on, is a key aspect of the narrativising of power and of the determinism that shapes geographies of Blackness that inscribe Black culture as always already within urbanised space, and much less within the 'outside spaces' of freedom, leisure and escape.

The consequences of the disproportionate exclusion from land (and land *as leisure*) have been powerfully demonstrated in recent times, through the inequalities revealed throughout the COVID pandemic. The issue of the pernicious effects of unequal access to land (on physical and mental health and well-being) have suddenly become no longer a matter of theoretical gesticulations but of vividly obvious power structures and embodied realities. While everyone was 'under lockdown', at least in theory, the access to natural space, anywhere from a backyard garden to a manorial estate, was clearly not a given for everyone. Likewise, therefore, the ability to 'cope' with the state of exception that had been created.

Coda

I'm really not interested in hearing any more middle-class people screaming that people shouldn't be going outside at all when your back garden is the Hundred Acre Wood.
– @SammiLouui, Twitter

Let's return to the question posed earlier: How does a history of colonialism that has weaponised land against Black lives in the Caribbean, America, Africa and Europe, how does a black history of exclusion from land, influence how we think about black futures in nature and the environment?

I propose that a Black future in nature must include an altered relationship to time.

I believe this can be achieved, collectively, through art. Art offers to racialised people an alternative space (a counter-analytic) to Babylon. And art for us must be togetherness, community. A way in which humanness becomes a matter of connection, again. We must form connection around the type of consciousness that frees us from the System, from the consciousness of the capitalist machinery that seeks to devour us. Can this be a point of departure for new forms of socialities for Black lives and of political awareness based on our sense of deep time? That implies the need for solidarity. And if solidarity involves connection to the more than human world, then it is also, necessarily, connection amongst ourselves.

1 [Editors' note: Ingrid Pollard, 'Ingrid Pollard on How She Had to Fight for Black Representation: Interview', *Elephant Magazine*, no. 42 (Spring 2020) (https://elephant.art/ingrid-pollard-fight-black-representation-glasgow-international-womens-library-lesbian-archive-photography-rural-landscape-britishness-07022020/#.XqgFNGJm23C).

2 [Editors' note: Sylvia Wynter, 'Jonkonnu in Jamaica: Towards the Interpretation of Folk Dance as

a Cultural Process', in *We Must Learn to Sit Together and Talk About a Little Culture: Decolonizing Essays 1967–1984*, (ed.) Demetrius L. Eudell (Leeds: Peepal Tree Press, 2018) 192–243.]
3 [Editors' note: Malcom Ferdinand, *Une écologie décoloniale: Penser l'écologie depuis le monde caribéen, Seuil Anthropocène* (Paris: Seuil, 2019).]
4 [Editors' note: Raymond Williams, *Keywords: A Vocabulary of Culture and Society* (New York: Oxford University Press, 2015).]

Jason Allen-Paisant, 'On Blackness and Landscape: Reclaiming Time', *PN Review*, 257, vol. 47, no. 3 (January–February 2021) 31–4. © Jason Allen-Paisant, 2021, reproduced by kind permission by David Higham Associates.

Annie Dillard
Footprints//2016

On the dry Laetoli plain of northern Tanzania, Mary Leakey found a trail of hominid footprints. The two barefoot prehumans walked closely together. They walked on moist volcanic tuff. We have a record of those few seconds from a day about 3.75 million years ago – before hominids chipped stone tools. Ash covered the footprints and hardened like cement. Ash also preserved the pockmarks of the raindrops that fell beside the two who walked; it was a rainy day. We have almost ninety feet of their steady footprints intact. We do not know where they were going or why. We do not know why one of them paused and turned left, briefly, before continuing. 'A remote ancestor', Leakey guessed, 'experienced a moment of doubt'. We do know we cannot make anything so lasting as these two barefoot ones did.

After archaeologists studied this long strip of record for several years, they buried it again to save it. Along one preserved portion, however, new tree roots are already cracking the footprints, and in another place winds threaten to sand them flat; the preservers did not cover them deeply enough. Now they are burying them again.

Giacometti said, 'The more I work, the more I see things differently; that is, everything gains in grandeur every day, becomes more and more unknown, more and more beautiful. The closer I come, the grander it is, the more remote it is.'[1]

1 Alberto Giacometti, *Scritti* (Milan: Absondita, 2001).

Annie Dillard, 'Footprints', from *The Abundance* (Edinburgh: Canongate Books, 2016) 191–2.

Slowness. I am talking about time, a defence of time. I'm talking about the robbery of time from Black life. I am talking about the ability to be slow. I am talking about the ability of our bodies to be here.

Jason Allen-Paisant, 'On Blackness and Landscape: Reclaiming Time', 2021

Biographical Notes

Jason Allen-Paisant is a scholar, award-winning poet and writer.
Katherine Bailey completed her PhD at Lancaster University in 2018, and now lives and works in London.
Tanya Barson is Curatorial Senior Director at Hauser & Wirth, London.
Vivienne Bozalek is Emerita Professor at the Department of Women's and Gender Studies at the University of the Western Cape.
André Brasil is a professor in the Communication Department at the Universidade Federal de Minas Gerais.
Amanda Cachia is a curator, consultant, writer and art historian who specialises in disability art activism.
Sarah Jane Cervenak is Professor of Women's, Gender, and Sexuality Studies and of African American and African Diaspora Studies at the University of North Carolina.
Annalee Davis is a visual artist, cultural activist and writer.
Jacques Derrida (1930–2004) was a philosopher.
Annie Dillard is a writer and poet.
Dwayne Donald is a Professor in the Faculty of Education at the University of Alberta
Darby English is the Carl Darling Buck Professor of Art History at the University of Chicago.
Kate Fletcher is a fashion and sustainability pioneer, design activist, writer and research professor.
Laura Grace Ford is a London-based artist and writer.
Susan Gibb is a curator and writer.
Édouard Glissant (1928–2011) was a writer, poet, philosopher and literary critic.
Steve Graby is an independent scholar-activist in the field of Disability Studies and the Disabled People's Movement.
Antje von Graevenitz is an art historian, art critic, educator and author.
Stefano Harney is Professor of Transversal Aesthetics at the Academy of Media Arts Cologne.
Emily Hesse (1980–2022) was a multidisciplinary artist, writer and activist.
Tehching Hsieh is a performance artist.
Elise Misao Hunchuck is a transdisciplinary researcher, editor, writer and educator.
Kathleen Jamie is a poet and writer of non-fiction.
Tom Jeffreys is a writer and editor who lives in Edinburgh.
Steffani Jemison is an artist in Brooklyn, New York.
Carl Lavery is Professor of Theatre and Performance at the University of Glasgow.
JeeYeun Lee is an interdisciplinary artist based in Chicago.
Myriam Lefkowitz is a performance artist based in Paris.
Michael Marder is Ikerbasque Research Professor of Philosophy at the University of the Basque Country.
Chus Martínez is head of the Institute of Art Gender Nature FHNW Academy of Arts and Design, Basel.
Siddique Motala is a Senior Lecturer in the Department of Civil Engineering at the University of Cape Town.

Fred Moten is Professor in the Departments of Performance Studies and Comparative Literature at New York University.

Giordano Nanni is an Honorary Fellow of the School of Social and Political Sciences at the University of Melbourne.

Camilla Nelson is a language artist, small press publisher, creative programmer and freelance academic.

Gabriella Nugent is an art historian and curator based in London.

Sonia Overall is a writer, tutor and academic based in Kent, UK.

Roger Owen is Lecturer in Theatre and Theatre Practice at Aberystwyth University.

Julie Pellegrin is an art critic and curator.

Isobel Parker Philip is Director, Curatorial and Collection at the National Portrait Gallery, Canberra.

Jane Rendell is a writer, researcher and educator.

Issa Samb (1945-2017) was an artist and founding member of the Dakar-based collective Laboratoire Agit-Art.

Caroline Filice Smith is a doctoral candidate in urban planning at Harvard University.

Cherise Smith is Professor of African and African Diaspora Studies and Art History at the University of Texas at Austin.

Rebecca Solnit is a writer, historian and activist.

Sop (them/they/theirs) is an artist and musician.

Stephanie Springgay is Professor and Director of the School of the Arts at McMaster University, Hamilton, Canada, www.stephaniespringgay.com.

Tentative Collective is a gathering of artists, curators, teachers, architects and collaborators from different backgrounds.

Amanda Thomson is an artist, writer and lecturer at the Glasgow School of Art.

Sarah E. Truman is an Australian Research Council DECRA Fellow and Senior Lecturer at the University of Melbourne, Australia, www.sarahetruman.com.

Bibliography

Abbs, Annabel, *Windswept: in the Footsteps of Remarkable Women from de Beauvoir to O'Keeffe* (London: Two Roads, 2022)

Andrews, Kerri, *Wanderers: A History of Women Walking* (London: Reaktion Books, 2021)

Bachelard, Gaston, *The Poetics of Space*, trans. Maria Jolas (Boston: Beacon Press, 1964)

Bailey, Elizabeth Tova, *The Sound of a Wild Snail Eating* (Dartington: Green Books, 2010)

Baldwin, James, 'The Language of the Streets' in *Literature and the Urban Experience: Essays on the City and Literature*, eds. Michael C. Jaye and Anne Chalme Watt (New Brunswick: Rutgers University Press, 1981)

Beaumont, Matthew, *The Walker* (London: Verso, 2020)

Benjamin, Walter, *The Arcades Project*, trans. Howard Eiland and Kevin McLaughlin (Cambridge, Mass.: Harvard University Press, 2003)

Berg, Mette Louise and Nowicka, Magdalena (eds.), *Studying Diversity, Migration and Urban Multiculture* (London: UCL Press, 2019)

Biserna, Elena (ed.), *Walking from Scores* (Dijon: les presses réel, 2022)

Biserna, Elena (ed.), *Going Out: Walking, Listening, Soundmaking* (Brussels: umland editions, 2022)

de Bruyn, E.C.H., 'Topological Pathways of Post-Minimalism', *Grey Room*, no. 25 (Fall 2006) 32–63

Diament, M., 'Disability Advocates At Odds Over "Wandering Proposal" Disability Scoop' (2011) available at http://www.disabilityscoop.com/2011/03/18/cdcwandering/12602/

Elkin, Lauren, *Flâneuse* (London: Chatto & Windus, 2016)

Evans, David (ed.), *The Art of Walking: A Field Guide* (London: Black Dog Publishing, 2012)

Foá, Maryclare, Grisewood, Jane, Hosea, Birgitta, McCall, Carali, *Performance Drawing: New Practices Since 1945* (London and New York: Bloomsbury, 2020)

Fulton, Hamish, *Mountain Time Human Time* (New York and Milan: Charta Books, 2010)

Fulton, Hamish, *Walking in Relation to Everything* (Birmingham: Ikon Gallery, 2012)

Gleber, Anke, *The Art of Taking a Walk: Flanerie, Literature, and Film in Weimar Culture* (Princeton: Princeton University Press, 1998)

Gowen, Amy (ed.), *Rights of Way, the Body as Witness in Public Space* (Eindhoven: Onomatopee, 2021)

Greenwidge, Kaitlyn, 'The Black Female Flaneur in Raven Leilani's "Luster"', *Virginia Quarterly Review*, University of Virginia, vol. 96, no. 2 (Summer 2020) 210–214

Hall, John, 'Foot, Mouth and Ear: Some thoughts on prosody and performance', *Performance Research: 'On Foot'*, vol. 17, no. 2 (2012) 36–41

Hallett, Alyson and Smith, Phil, *Walking Stumbling Limping Falling: A Conversation* (Axminster: Triarchy Press, 2017)

Hazan, Eric, *The Invention of Paris: A History in Footsteps*, trans. Fernbach, David (London / New York: Verso, 2010)

Ingold, Tim, *Correspondences* (Cambridge: Polity Press, 2021)

Jeffreys, Tom (ed.), *Iman Tajik: Welcome to Portobello* (Edinburgh: Art Walk Projects, 2022)

Kaprow, Alan, *Echo-logy* (New York: D'Arc Press, 1975)

King, Tiffany Lethobo, *The Black Shoals: Offshore Formations of Black and Native Studies* (Durham, London: Duke University Press, 2019)

Kwan, R., 'Don't Dress Like a Slut: Toronto Cop', Excalibur (2011) available at https://www.excal.on.ca/uncategorized/2011/02/16/dont-dress-like-a-slut-toronto-cop/

Lloyd, Alison, 'Contouring: Women, Walking and Art' (Loughborough: Loughborough University, Doctoral Thesis, 2019)

London Feminist Network, 'Why Reclaim the Night?' (2010) available at http://www.reclaimthenight.org/why.html

Long, Richard, *Walking and Marking* (Edinburgh: National Galleries of Scotland, 2007)

Malpas, William, *Richard Long: The Art of Walking* (Maidstone: Crescent Moon, 1995)

McDonough, Tom, 'Situationist Space', in *Guy Debord and the Situationists: Texts and Documents* (Cambridge MA: MIT Press, 2002) 241–66

Murphy, Jacqueline Shea, *Dancing Indigenous Worlds: Choreographies of Relation* (Minnesota: University of Minnesota Press, 2022)

Nicholson, Geoff, *The Lost Art of Walking* (Chelmsford: Harbour Books East Ltd, 2008)

Ortega, Kirsten Bartholomew, 'The Black Flâneuse: Gwendolyn Brooks's "In the Mecca"', *Journal of Modern Literature* (Summer 2007), vol. 30, no. 4, 139–55

Parsons, Deborah L., *Streetwalking the Metropolis* (Oxford and New York: Oxford University Press 2000)

Pujol, Ernesto, *Walking Art Practice: Reflections on Socially Engaged Paths* (Axminster: Triarchy Press, 2018)

Reeve, Sandra, *Nine Ways of Seeing a Body* (Axminster: Triarchy Press, 2011)

Rice, Alan, 'Jade Montserrat's Fugitive Traces and Earth-Splattered Bodies: Making African Atlantic Homespace in Alien Environments Then and Now (1758–2018)', *Kalfou*, vol. 7, no. 1 (Spring 2020)

Rousseau, Jean-Jacques, *Reveries of the Solitary Walker*, trans. Russell Goulbourne (Oxford / New York: Oxford University Press, 2011)

Solnit, Rebecca, *A Field Guide to Getting Lost* (Edinburgh: Canongate, 2006)

St Claire Drake, John and Clayton, Horace R., *Black Metropolis: A Study of Negro Life in a Northern City, Vol. 1* (New York: Harper & Row, 1962)

Ulrich, Matthias and Hesse, Fiona (eds.), *WALK!* (Frankfurt: Schirn Kunsthalle Frankfurt, 2022)

Warner, Tony, *Black History Walks* (London: Jacaranda books, 2022)

Woolf, Janet, *The Invisible Flâneuse: Women and the Literature of Modernity, Theory, Culture & Society*, vol. 2, no. 3, 37–46

Zaug, Remy, *The Art Museum of My Dreams* (Zurich: Sternberg Press, 2013)

Index

Allen-Paisant, Jason 233–40, 241
Alÿs, Francis 83, 86n12
Amsterdam 13, 54, 58, 59, 60, 61, 63
Aristotle 80, 207
Australia 12, 13, 20n4, 47, 182–7, 198

Baggs, Amanda 217, 223n7, 224n23
Bailey, Katherine 13, 50–2
Barbados 18, 19, 179–82
Barson, Tanya 80–7
Baudelaire, Charles 145, 146, 147n5 and 8, 218
Benjamin, Walter 11–12, 14, 145–7, 218
Biserna, Elena 19
Black Arts Movement 12, 34–42
Bleakley, Mark 17, 20n15
Bozalek, Vivienne 18, 152–9
Brasil, André 17, 113–6
Brazil 19, 81, 114
Brouwn, Stanley 17–19, 22, 53–66

Cachia, Amanda 225–6
Cadogan, Garnette 14, 20n9,
Canada 27, 33n3, 176, 220
Cape Town 18, 152–9
Cervenak, Sarah Jane 12, 200–6
Chicago 18, 37, 98, 171–8
Cowan, Leah 43, 49n1

Davis, Annalee 18, 179–82
The Dazzle Club 14, 20n11
Debord, Guy 13, 169, 170n6, 171n8, 217–24
Democratic Republic of Congo 19, 167–71
Derrida, Jacques 16–17, 110–12, 118–20
Delambre, Jean Baptiste Joseph 66–72
Deleuze, Gilles and Félix Guattari 159n14, 196, 199n2, 208
Dillard, Annie 16, 240
Dion Fletcher, Vanessa 194

Donald, Dwayne 10–11, 19, 21, 25–34
Dungavel House Immigration Removal Centre 18, 43–9
Dunkerque 18, 66–72

English, Darby 88, 126–8
Everard, Sarah 14–15

Fletcher, Kate 229–31
Ford, Laura Grace 136, 148–51

Galindo, Regina José 13, 16, 50–2
Gibb, Susan 210–14
Glissant, Édouard 18, 90–4
Gómez-Barris, Macarena 201–2, 206n11
Graby, Steve 13, 215–24
Graevenitz, Antje von 17, 53–66
Guatemala City 13, 16, 50–2

Harney, Stefano 6, 100–4
Haile, Rahawa 195
Hesse, Emily 18, 138–9
Hsieh, Tehching 19, 138
Hunchuck, Elise Misao 107–9

Ingold, Tim 28, 32–3

Jamaica 14, 19, 233–40
Jamie, Kathleen 72–9
Jeffreys, Tom 10–20, 43–9
Jemison, Steffani 17, 18, 231–3
Johnson Publishing Company 35–42

Karachi 18, 160–6
Karenga, Ron 40, 42n15
St Kilda 73, 77
King, Martin Luther, Jr. 34–42, 173,
Kinshasa 13, 167–71
Kivland, Sharon 15, 144–8
Komatsu, André 84–5

Kongo Astronauts 13–14, 167–71

Lavery, Carl 16, 17, 116–20
Lee, JeeYeun 18, 171–8
Lefkowitz, Myriam 17, 18, 210–14
London 14, 15, 126, 145, 148–51, 221
Long, Richard 58, 127, 134
Lounder, Barbara 194

Macfarlane, Robert 75–9
Marder, Michael 17, 206–9
Martínez, Chus 227–8
Martinique 18, 19, 190–4
Marx, Karl 97, 145–6, 148n12, 218, 222
Massumi, Brian 158n11, 197, 199n9, 206n15,
McQueen, Steve 126–8
Mechain, Pierre François André 66–72
Meireles, Cildo 82, 83
Montserrat, Jade 12, 200–6
Montgomery 12, 34–6, 38, 41 see also, Selma, Alabama
Montt, Efraín Ríos 13, 50–2
Morawetz, Sara 17–18, 66–72
Morrison, Toni 203–4, 205n3, 206n19
Motala, Siddique 18, 152–9
Moten, Fred 6, 100–4, 200, 204n1, 206n16, 234
Mullen, Harryette 194
Myers, Lisa 194–5

Nanni, Giordano 13, 182–7
Nazareth, Paul 113–16
Nauman, Bruce 58, 113–14
Nelson, Camilla 128–32
Neimanis, Astrida 19, 197, 199n8
Niermann, Ingo 227–8
North Saskatchewan River 31
Nugent, Gabriella 13–14, 167–71

Ortega, Kirsten Bartholomew 14, 20n8
Overall, Sonia 19, 24–5

Owen, Roger 12, 120–5

Paris 66–7, 70, 117, 144–5
Papalia, Carmen 17, 225–6
Pellegrin, Julie 210–14
Philip, Isobel Parker 12, 66–72

Rendell, Jane 15, 144–8
Rousseau, Jean-Jacques 80, 91, 207–8

Samb, Issa 104–6
Selma, Alabama 12, 34–42 see also, Montgomery
Situationist International 13–14, 168–9, 171n9, 217–19, 223n12, 224n15
Sleet, Moneta, Jr. 12, 34–42
Smith, Caroline Filice 15, 140–4
Smith, Cherise 12, 34–42
Smith, Mikey 100–4
Solnit, Rebecca 13, 16, 18, 20n13, 34n24, 80, 85n1, 95–100, 117, 217, 218, 221, 222, 223n8
Sop 187–91
Springgay, Stephanie 19, 155, 158n9 and n10, 192, 194–9

Tajik, Iman 18, 43–9
Taumoepeau, Latai 195
Tentative Collective 18, 160–6
Thomson, Amanda 12, 133–5
Torres-Garcia, Joaquín 82
Truman, Sarah E. 19, 155, 158n9 and n10, 192, 194–9

WalkingLab 158n9, 194–9
Ware, Syrus 195
Wordsworth, William 78, 101, 127–8, 235

Zvyagintseva, Anna 107–9

ACKNOWLEDGEMENTS

Editor's acknowledgements
I would like to thank everyone who has contributed to the making of this book. Firstly: the artists and writers whose work I am delighted to be able to include. Thank you, in particular, to Isobel Parker Philip and Elise Misao Hunchuck for the newly commissioned texts. Thank you to Jade Montserrat for agreeing to be on the cover and for many important conversations via email.

I would also like to thank those directly involved in the editing and production process for their wisdom and diligence throughout: series editor Anthony Iles, interim publications manager Sophie Kullmann and designer Justine Hucker. Thank you also to the brilliant Filipa Ramos, whose early pointers helped enormously.

Thank you to the incredible people whose walking has at various times shaped my thinking (and whose thinking has shaped my walking), including: Kirsty Badenoch, Jussi Kivi, Camilla Nelson and Iman Tajik. Above all, thank you as ever to Crystal Bennes, this time for the thorough and uncompromising responses to my introductory essay, and for all the ways we continue to walk together.

Publisher's acknowledgements
Whitechapel Gallery is grateful to all those who gave their generous permission to reproduce the listed material. Every effort has been made to secure all permissions and we apologise for any inadvertent errors or omissions. If notified, we will endeavour to correct these at the earliest opportunity.

Supported using public funding by
ARTS COUNCIL ENGLAND